STUDIOS BEFORE THE SYSTEM

FILM AND CULTURE

JOHN BELTON, EDITOR

FILM AND CULTURE

A series of Columbia University Press

EDITED BY JOHN BELTON

For the list of titles in this series, see page 297.

STUDIOS BEFORE THE SYSTEM

Architecture, Technology, and
the Emergence of Cinematic Space

BRIAN R. JACOBSON

Columbia University Press

New York

Columbia University Press
Publishers Since 1893
New York Chichester, West Sussex
cup.columbia.edu
Copyright © 2015 Columbia University Press

Library of Congress Cataloging-in-Publication Data
Jacobson, Brian R.
Studios before the system : architecture, technology, and the emergence
of cinematic space / Brian R. Jacobson.
pages cm.—(Film and culture)
Includes bibliographical references and index.
ISBN 978-0-231-17280-6 (cloth : alk. paper) — ISBN 978-0-231-17281-3
(pbk : alk. paper) — ISBN 978-0-231-53966-1 (ebook)
1. Motion picture studios—United States—History—20th century.
2. Motion picture industry—History—20th century. I. Title.
PN1993.5.U6J225 2015
384'.809730904—dc23
2015007610

Columbia University Press books are printed on permanent
and durable acid-free paper.
This book is printed on paper with recycled content.
Printed in the United States of America

c 10 9 8 7 6 5 4 3 2 1
p 10 9 8 7 6 5 4 3 2 1

Cover and book design: Lisa Hamm
Cover image: Cinémathèque française, Bibliothèque du film,
Service Iconographique

References to websites (URLs) were accurate at the time of writing.
Neither the author nor Columbia University Press is responsible for URLs
that may have expired or changed since the manuscript was prepared.

TO MY PARENTS

CONTENTS

LIST OF ILLUSTRATIONS

ACKNOWLEDGMENTS

THIS BOOK BEGAN at the University of Southern California, where I was fortunate to study under the direction of two inimitable scholars and mentors, Vanessa Schwartz and Anne Friedberg. I want to thank Vanessa, first and foremost, for her unwavering dedication to the project in all its phases. She encouraged my turn to the history of technology and to all things French, and she has pushed my work to greater heights by being both its fiercest supporter and, just as importantly, one of its toughest critics. I first recognized that I had an idea for a book like this during a conversation about architecture with Anne at the California Science Center in the spring of 2007. With some trepidation, I proposed an architectural history of the Black Maria. I'll never forget Anne's enthusiastic response; I only wish I could see her reaction to the book it became.

I am indebted to many others for their support and contributions. At USC, Akira Mizuta Lippit, Priya Jaikumar, and Steve Ross offered generous feedback. Valuable advice and encouragement at conferences and other presentations came from Jonathan Auerbach, Ed Dimendberg, Noam Elcott, Phil Ethington, Jane Gaines, Saverio Giovacchini, Anne Higonnet, Kara Keeling, Rob King, Brian Larkin, Richard Meyer, Vivian Sobchack, and Kristen Whissel. At Oklahoma State University and the University of St Andrews, I received generous support from my colleagues, especially Jeff Menne and Tom Rice who read portions of the manuscript in progress.

It has been a pleasure to work with the team at Columbia University Press. I would like to thank Jennifer Crewe and John Belton for taking an interest in my project; the anonymous reviewers for their close attention

to the manuscript and valuable feedback; Roy Thomas for his impeccable work and guidance; and Kathryn Schell for steering me through the process.

Many archivists and librarians provided invaluable assistance during my research. I am thankful for the support of the teams at the Bibliothèque du film, the Musée Gaumont, the Archives de Paris, the Fondation Jérôme Seydoux-Pathé, the Bibliothèque historique de la ville de Paris, the Thomas Edison National Historical Park, the Museum of Modern Art Film Study Center, the Margaret Herrick Library, the Bronx Department of Buildings, and the Los Angeles Department of Building and Safety. For their exceptional generosity, I thank Régis Robert and Karine Mauduit at the Bibliothèque du film, Mélanie Herick at the Musée Gaumont, Paul Israel at the Thomas A. Edison Papers Project, and Leonard DeGraaf at the Thomas Edison National Historical Park.

Funding from numerous institutions helped make this book possible. A Fulbright Fellowship allowed me to conduct research in Paris. The Social Science Research Council's International Dissertation Research Fellowship and Dissertation Proposal Development Fellowship, both with funds from the Andrew W. Mellon Foundation, supported research in France and the UK.

Chapters 1 and 2 include revised portions of essays first published in *History and Technology* 27.2 (Routledge, 2011) and *Early Popular Visual Culture* 8.2 (Routledge, 2010).

I've had the good fortune and great pleasure to research and write this book in a community of supportive friends and colleagues. Very special thanks go to James Leo Cahill, Ryan Linkof, Raphaelle Steinzig, Mike Godwin, Erin Sullivan, Joel Maynes, Brian Adam Smith, Anderson Blanton, Seth Wood, Ariel Ross, Michael Boaz, and Amy Wallace. My family's unfailing support and love made this book possible. I dedicate it to my parents.

Finally, thanks beyond words go to Catherine Clark, whose knowledge, wit, and keen eye have shaped every page. Our walks and runs, endless puns, (just enough) *apéros*, and (not quite enough) adventures have kept me going. Ready? On y va!

STUDIOS BEFORE THE SYSTEM

INTRODUCTION: STUDIOS AND SYSTEMS

Since the dawn of history men have built cities, some for refuge, some for defense and some for habitation, but never before in the history of the world has a city been built expressly for the purpose of making amusement for the rest of the world. It is the magic city of make-believe and one never knows, as they stroll about the streets of this city, whether they are looking at the real or unreal.

—*The Facts and Figures About Universal City* (1915)[1]

BY THE TIME Universal Pictures opened its studio "city" to curious visitors in 1915, the film studio had become a well-known, if still tantalizingly mysterious, site of cultural production. Universal's "magic city of make-believe," as promotional materials described it, represented only the largest version of the hundreds of studios found across the United States and Europe. As advertisements suggested, the tourists who traversed its backlot sets on guided tours found unreal city streets bearing the innumerable signs of reality that had become studio cinema's stock-in-trade. Like film viewers, Universal's visitors traveled from Old Western towns to New York City streets and from ancient Greek agoras to Chinese pagodas with the immediacy of a film cut. Cinema's impossible on-screen voyages, the tour revealed, had tangible counterparts in studio-made cities.

To movie-savvy visitors, this likely came as no great surprise. The popular and trade press had made basic knowledge of studio cinema a banality of the growing film industry, and studio tours only reinforced many audience members' assumptions about the real places that produced

film's unreal spaces. In only two short decades, the film studio had already become an assumed feature of—and actively disavowed necessity for—illusionary forms of cinematic representation. But as contemporary observers made clear, to disregard the studio was to miss something profoundly unsettling about cinematic reproduction. Reflecting on the eerie strangeness of the studio's artificial worlds after a tour of Germany's Ufa studios in 1926, Siegfried Kracauer wrote:

> the things that rendezvous here do not belong to reality. They are copies and distortions that have been ripped out of time and jumbled together. They stand motionless, full of meaning from the front, while from the rear they are just empty nothingness. A bad dream about objects that has been forced into the corporeal realm.[2]

Kracauer's "bad dream" well describes the tensions between reality and artifice, meaning and depthlessness, and physical surfaces and the "empty nothingness" behind them that characterized studio cinema from its earliest inception. And yet, like so many others since, Kracauer, in focusing only on the surfaces—the studio sets—that so troubled him, looks past the buildings that structured the meaning and nothingness, the reality and artifice that lay just beyond most audiences' and critics' attention.

Almost a century later, the studio remains a kind of "empty nothingness" in standard film histories. Indeed, the studio may be the most taken-for-granted of the fundamental developments that shaped cinema's earliest years. This despite the fact that in the decade following Universal City's grand opening, film studios would come to define one of the salient aspects of the modern film industry. As filmmaking in America became identified with a place, Hollywood, its business model took its name from a spatial system, "the studios." While the term *studio* continues to serve as a common metonymic substitute for American commercial cinema and a ready identifier for the business entities that dominate popular moving-image culture, such familiarity belies the scant attention that has been devoted to the studios' pre-Hollywood origins or to their architectural forms and functions in any period.

Studio architecture—the always present but rarely visible frame that lies just beyond the visual field of studio films—has played a key, but

rarely acknowledged, role in the history of filmmaking. Cinema's first architectural forms shaped early film form by helping determine lighting quality, shooting angles, and set sizes. They contributed to film content by housing workshops for set, prop, and costume design; storage depots; dressing rooms; and writing departments. Their physical layouts shaped filmmakers' working practices by creating spatial relationships between different phases of production. And they conditioned cinema's early industrial practice in the first darkrooms, editing and coloring ateliers, and printing facilities.

Studio practices also went beyond film production. Especially at the largest companies, studios often included factories for manufacturing film devices and housed research and development laboratories for developing both film and non-film technologies. Such spaces made studios important sites of interaction between film professionals and workers from diverse industries, from theater and vaudeville performers to scientists and engineers. In this way, studios became important nodes in the intellectual, cultural, and political networks through which the young film industry entered the modern world. And as studio tours like Universal's, studio photographs in the trade and popular press, and "behind-the-scenes reports" like Kracauer's made studios part of public discourse about film culture, their architectural forms helped cultivate ideas about the industry they housed. In sum, while we tend to think of studios simply as places in which to make films, such a narrow view has helped obscure the studio's fundamental importance to film history.

This tendency to overlook the studio is especially surprising given that film historians have long been aware of individual studios' basic details. Thanks in part to early filmmakers' efforts to stake out their place in the medium's invention by writing their own histories, the first descriptions of the studios date to the era of their creation.[3] The first amateur and professional film historians also paid due attention to the studios as part of an effort to catalog the inventions and industrial practices that led to modern cinema.[4] But just as they characterized early cinema as little more than the rudimentary training ground for Hollywood and interwar European classicism, these historians seldom treated the studios as anything more than the "primitive" precursors to more modern replacements.[5]

More recent histories have done little to change that view. Historians have recuperated early cinema as not simply a precursor to modern cinema but as a rich period of film history in its own right, with diverse production, distribution, and exhibition practices, aesthetic forms, and models of viewing and experiencing moving images.[6] This book does something similar for the studios. While the importance of exhibition contexts, audience experiences, and spectatorial identities—key points of revision in early film history that also countered the authority of apparatus and psychoanalytic film theories in the 1970s—must not be ignored, their place in early film historiography has tended to turn our attention away not simply from the apparatus but from early film production altogether. Rather than revalorizing the apparatus, however, this book takes a middle path that rejects technological determinist approaches to film history while nonetheless highlighting the important role that film technologies and production spaces have played in shaping film texts and cinematic culture.[7]

It does so, in part, by emphasizing the diverse ways that film studios worked. To encapsulate the many practices they housed in cinema's first two decades, I define studios broadly as structures designed for moving-image production, including the pre- and postproduction, research and development, manufacturing, marketing, and publicity practices that tended to develop alongside studio stages.[8] While all studios included space for recording films, this definition insists upon the importance of the many non-shooting and even non-film-specific activities that shaped studios' working practices. It also captures the diverse material forms that studios took before momentarily settling into a relatively standard model in the United States and Western Europe in the mid-1910s.

I focus on studios built by six of the largest American and French producers—the Edison Manufacturing Company, American Mutoscope and Biograph, American Vitagraph, Georges Méliès's Star Films, Gaumont, and Pathé Frères—as well as companies including Selig Polyscope and the American Film Manufacturing Company that built the first studios in Southern California. Although not all-encompassing, their studios are representative of the major spatial precursors, design elements, building materials, and working practices that shaped studio cinema in its first two decades.[9] They run the gamut of early studio

design, from wooden stages built in gardens, parks, and on city rooftops to experimental rotating structures, greenhouse-like glass enclosures, and large factories built in brick and reinforced concrete.[10] Their studios are significant, in part, because these companies were among the first and most successful in the prewar era. But I will also argue that companies like them became successful in no small part because of the significance of the studios they built.

A SHORT HISTORY OF FILM STUDIOS TO 1915

Like early moving-image technologies, studios appeared first in the eastern United States, France, Germany, and the United Kingdom. They developed in a similarly independent fashion, driven by designers—initially filmmakers themselves—likely working without direct knowledge of their competitors' models but drawing on related influences. Within two decades, studios based on similar material and spatial designs would be found across the United States, from New York, Philadelphia, and Chicago, south to Jacksonville and San Antonio, and west to San Diego, San Francisco, and Los Angeles. Similar structures emerged in European countries including Italy, Russia, Spain, Sweden, and Denmark, and studios could also be found in Brazil and Japan.

The world's first studio predates the first Lumière screening by almost three years. Built by W. K. L. Dickson and commonly known as the "Black Maria," it housed Edison Company film productions in West Orange, New Jersey, from early 1893. By 1897, film companies had opened studios in New York City, Philadelphia, Berlin, and on the outskirts of Paris. In New York, the Vitascope Company organized an open-air studio on the roof above its offices at 43 West 28th Street in 1896, and early the following year Dickson built an open-air, rotating studio on the rooftop of 841 Broadway, home of the American Mutoscope and Biograph Company's offices.[11] The following year, American Vitagraph organized a rooftop studio above its top-floor offices in the Morse Building at 140 Nassau Street and Siegmund Lubin established his first studio on a Philadelphia rooftop.[12] Around the same time, in Berlin, Oskar Messter established a rooftop studio enclosed in glass.[13] And in late 1897, Georges Méliès built

France's first studio—a stand-alone glass-and-iron structure—in the eastern Parisian suburb of Montreuil-sous-Bois.

Within five years, the major American, French, and British companies had all built their first studios, most using glass-and-iron forms similar to the first Méliès studio. R. W. Paul and the British Mutoscope Company built the first English studios in 1898. Paul's studio, located in the London suburb of New Southgate, featured a glass-roofed stage with sliding doors positioned opposite a separate camera platform mounted on wheels (fig. I.1).[14] British Mutoscope built a Dickson-designed rotating studio in London near the Tivoli Theatre and Charing Cross Station.[15] Other early British studios included G. A Smith's at St. Anne's Well and Wild Garden in Brighton (1899), Cecil Hepworth's studio in Walton-on-Thames (ca. 1900), James Williamson's studio in Brighton at Cambridge Grove (ca. 1902), and A. C. Bromhead's studio, built with backing from Gaumont, in Southwest London at Loughborough Junction (ca. 1902–1904).[16]

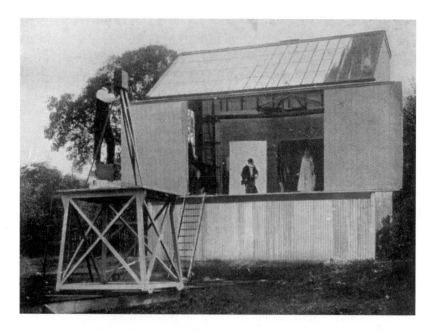

FIGURE I.1 R. W. Paul Studio (b. 1898). From Frederick A. Talbot, *Moving Pictures: How They Are Made and Worked* (rev. ed., 1912), n.p.

In the United States, Edison replaced the Black Maria in 1901 with a new glass-enclosed studio at 41 East 21st Street in Manhattan. Late the following year, American Mutoscope and Biograph began preparations a few blocks away at 11 East 14th Street for the world's first studio lit entirely by artificial means. Pathé Frères had begun production on an open-air garden stage in winter 1897–98, but by 1902 it had also built a glass studio just outside Paris in Vincennes. Gaumont similarly began production on a small stone terrace in 1898 but covered it in glass by 1902.[17] And in the northwestern Paris suburb of Asnières, Auguste Baron built a glass-and-iron studio where he may have recorded sound films as early as 1898.[18] Finally, in Germany, Oskar Messter moved from his rooftop structure to a glass studio in Berlin circa 1905.[19]

Beginning around 1903, film companies began to devote greater resources to their production infrastructure and often entrusted studio designs to professional architects. At the larger companies, this meant more and larger studio stages, new material forms and technologies to enhance studio lighting, and new attention to organization within and between buildings to facilitate efficient industrial practice. In France, Pathé and Gaumont led French cinema's industrialization by dramatically expanding their studio bases. Pathé built a new studio in Montreuil (close to Méliès's studio) in 1904 and added extensive studio and manufacturing facilities in Joinville-le-Pont in 1906. Gaumont built a glass-enclosed studio in 1904 that would be one of the largest in the world before World War I. Over the next decade, Gaumont built its *Cité Elgé*—more than two dozen buildings housing facilities for all phases of film production and distribution, research and development, and manufacturing—around this central production stage. In an effort to close the growing gap between Star Films and these larger competitors, Méliès added a second studio to his Montreuil estate in 1907.

Similar degrees of growth could be found in the United States. In 1905, Vitagraph began a substantial construction project in Brooklyn's Flatbush area. Within five years the site included three production studios enclosed in experimental forms of glass and with electrical lighting systems as well as extensive ateliers and manufacturing facilities for pre- and postproduction work. Responding in part to Biograph and Vitagraph's studio-supported market growth, Edison built another new

studio beginning in 1905. The company moved north to the Bronx, where it could obtain enough cheap land to expand its facilities, which included multiple large production stages enclosed in glass and supplemented by electrical lighting. In 1912 Biograph traded its electrically illuminated studio for a new studio in the Bronx, again with larger glass-enclosed and electrically lit stages.[20]

Sizeable studios also appeared in Chicago and Philadelphia. In Chicago, the Selig Polyscope Company built a large studio at the corner of Irving Park Road and Western Avenue in 1907 and enlarged it in 1911.[21] Essanay built its first studio at 62 North Clark Street in 1907, moved to a larger facility at 1055 Argyle Street in northern Chicago in 1909, and added an additional building to the latter site in 1913.[22] In Philadelphia, Siegmund Lubin built a new studio with electrical lighting at 926 Market Street in 1907, then moved to a larger facility that came to be known as "Lubinville" at 20th Street and Indiana Avenue in 1910 (fig. I.2).[23] In 1914, Lubin moved again, this time to a 500-acre estate known as "Betzwood," located northwest of Philadelphia.[24]

By the early 1910s, the largest studio factories found at Vitagraph, Gaumont, and Pathé were competing with new studios across Europe and dozens of smaller studios built by companies hoping to profit from

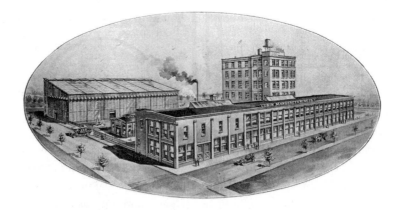

FIGURE I.2 Lubin Manufacturing Company, Philadelphia (*Moving Picture World*, March 26, 1910)

expanding exhibition markets. Studios dotted the suburbs around Paris, including Lux's studio in Gentilly (1907), Éclair's in Epinay-sur-Seine (ca. 1906–1908), Eclipse's in Boulogne-sur-Seine (1908), the Film d'art studio in Neuilly (1908), the Société des auteurs et gens de lettres studio in Vincennes (1908), and a short-lived studio built by Raleigh & Robert in Montreuil in 1909. Nordsk Films Kompagni built a glass studio in the Copenhagen suburb of Valby in 1907, and the same year the Drankov Company built the first Russian-owned studio.[25] Finally, the studios that would later house Germany's Universum Film AG began to take shape around 1912 when Projektions Union built new studios at Tempelhof.[26]

A range of appellations and associations were used to describe these new buildings, which regularly defied conventional architectural and aesthetic expectations. The term "studio" appeared as early as the first accounts of the Black Maria, but other common descriptors included "theatre," "plant," and "factory."[27] In France, the English "studio" was not well established until the 1910s; instead, commonly used terms included "théâtre de prises de vues," "théâtre de poses," simply "théâtre," and "atelier" or workshop. Like their English-speaking counterparts, the French also described studios as "usines" (factories).

No matter what they called the studios, observers often went to great lengths to associate them with more recognizable visual forms. Attempts to clarify studio aesthetics began with the Black Maria. In addition to its now standard name—a term for late-nineteenth-century police vehicles—other points of comparison included coffins and caverns, and in their account of the studio, W. K. L. and Antonia Dickson compared it to "the unwieldy hulk of a medieval pirate-craft or the air-ship of some swart Afrite."[28] While few studios seemed as strange as the Black Maria, writers rarely failed to emphasize their novelty. Even as late as 1908, one journalist could still note about Edison's new production facilities in the Bronx that "the odd looking structure attracts the attention of every passerby, while comments upon its probable use are varied and often ludicrous. Some are sure it is an electric power house . . . others think it is a dynamite factory."[29] And a 1916 *Los Angeles Times* article could joke that "the outside of a movie studio looks like a class A baseball park, and the inside looks like a remnant sale of a Kansas cyclone."[30]

Common naming conventions and the less imaginative associations that observers drew between studios and contemporary sites like factories go some way toward explaining where film's first production spaces fit in turn-of-the-century architectural norms. But where did studio designs and styles originate? What architectural forms inspired the first studios' material and structural forms and functions? And how did their forms affect the forms of the films produced in them? This book argues that early cinematic space was the product of a confluence of architectural influences and spatial precursors derived from nineteenth-century developments in architecture, building technology, and urban infrastructure. In shaping cinema's physical production sites, its virtual film worlds, and, as others have argued before, its viewing practices, those developments played a fundamental role, not only in the emergence of cinematic space, but more generally in the formation of cinematic culture.

THE EMERGENCE OF CINEMATIC SPACE

However odd they might have looked, the first studios were neither rudimentary nor haphazardly designed. Indeed, the first buildings for cinematic production were as much the concrete product of a cinematic imagination as the films produced there. In order to generate imaginary worlds *on* film, filmmakers had to create new worlds *in which* to film. To do so, they necessarily looked outside the new world of cinema to spaces and spatial models that included "topoi of modernity" like those that, as Giuliana Bruno and Anne Friedberg have shown, helped define the spaces and practices of early film viewing.[31] Just as cinematic time, as Mary Ann Doane has described, emerged as part of "a more general cultural imperative" that structured ideas about and practices associated with modern temporality, so the emergence of cinematic space both followed and contributed to broader processes of spatial production and efforts to understand the new spatial experiences of urban industrial modernity.[32] Studio designers drew inspiration from a range of nineteenth-century building types, including photography studios, theatrical stages, scientific laboratories, hothouses, factories, and mills. Borrowing from these sources, filmmakers and architects conceptualized a new type of architectural,

industrial, and artistic space that would shape the future content and form of moving images and help transform modern visual culture within and beyond the studio's walls.

Early studio designers took inspiration from spaces with three principal qualities: luminosity, plasticity, and precision. First and foremost, they replicated existing spaces of visual cultural production, especially photography studios. The first rooftop stages, whether open air or enclosed in glass, strove for the same access to light that motivated urban photographers to take transparent shelter above the city beginning in the mid-nineteenth century. As I discuss in chapter 1, Dickson most likely modeled the Black Maria on stand-alone photography studio designs outlined in contemporary books such as Matthew Carey Lea's *A Manual of Photography* (1868) and Henry Peach Robinson's *The Studio and What to Do in It* (1891). In his capacity as laboratory photographer, Dickson would have been familiar with these spaces, and indeed he built a photography studio at Edison's West Orange laboratory in 1889 and conducted early moving-image tests in it before moving to the Black Maria.

Méliès similarly drew on photography studios in his design for cinema's first glass house. Although most commonly compared to his Robert Houdin theater, Méliès's studio was just as likely inspired by the photography studio on the Robert Houdin's roof. Originally built by André-Adolphe-Eugène Disdéri (inventor of the *carte de visite*), the studio was the largest in Paris at the time of its opening in 1854. Four decades later, in 1895, a photographic portraitist and former Lumière factory employee named Clément Maurice took over the studio, where he continued to do work for the Lumières and often met with Méliès. As I describe in chapter 2, while Méliès may have reproduced the tricks and stage setups used in his theater, the studio bore closer material and functional likeness to the Disdéri-Maurice studio.

Much as they did for portrait photographers, photography studios offered early filmmakers a working prototype for developing the well-lit spaces they needed, first for rapid exposures, then for longer working hours. They also provided concrete models of spatial plasticity. The painted backdrops with which studio photographers produced a variety of interior and exterior locations prefigured the same strategy by which studio filmmakers learned to transform their working spaces into an

endless array of virtual worlds for the screen. Thus while the backdrops and tableau format used in theatrical staging no doubt influenced early studio production, strategies for creating the studio's spatial plasticity also had roots in earlier photographic recording spaces.

Bright light may have been the dominant requirement for early studios, but not just any light would do. Studio filmmakers also depended on precise control of the filmmaking environment. Dickson's design for the Black Maria underscores this need for controlled spaces. By mounting the studio on wheels and a circular track, Dickson responded to the photographic studio's initial inadequacy for film production. Dickson needed more than just light; he needed well-regulated light and the more legible images it produced. Other filmmakers demanded similar, if less strict, degrees of control in their studios. Méliès, for instance, draped thin layers of fabric beneath his glass enclosure, a strategy that filmmakers would reproduce well into the 1910s to diffuse light and eliminate sharp shadows.

By the early 1900s, studio architects were building such requirements into their designs. They used combinations of older and cutting-edge materials to shape studios' light spaces according to emerging norms for studio recording. They also took inspiration from other light-dependent spaces that offered new models for creating bright, controllable, and flexible working environments. In particular, studios came to look and operate more like factories and mills, not only on the assembly lines that turned out cameras and projectors but also on studios' growing production stages. As I describe in chapter 3, the introduction of electrical lighting in the early 1900s offered new degrees of luminosity and precision, while new building materials including reinforced concrete, steel, and prismatic glass allowed architects to increase solar illumination (much as they did in modern factories) and expand stage sizes without the need for the internal support columns that might block camera angles or cast unwanted shadows.

As studios increased in size and expanded to multiple buildings, architects organized stages, dressing rooms, design ateliers, storage rooms, and processing facilities with an eye to maximizing efficiency. Chapter 4 examines how luminosity spread from the stage to specialized set design workshops and how the precision seen on set spread out to include the

movement of workers, set pieces, props, and film stock. That expanded, architecturally conditioned precision came to define the studios' new industrial organization. Cinema's capitalization, this chapter shows, had an important spatial component that can be read in the blueprints and studio maps that gave these principles visual form.

Finally, the same desires for luminosity, plasticity, and precision that produced the first studio designs also drove filmmakers' work beyond the studio walls. As I discuss in chapter 5, as filmmakers left their urban studios in the late nineteen aughts for seasonal filmmaking trips south and west, they applied studio-shaped ideals about film space to exterior shooting sites. Companies like Kalem developed mobile studio setups designed to create on-site versions of studio control. Such efforts to transport studio principles to non-studio locations achieved fullest expression in director Romaine Fielding's "Collapsible Studio," a modular structure designed to allow film crews to generate studio conditions on any site within hours. But even those who did not seek to reproduce studio-like spaces still looked upon the landscape with studio practices in mind. Describing the filmmaking possibilities at a Los Angeles–area location, for instance, one critic noted that it offered "one of the greatest storehouses of beautiful outdoor moving picture backdrops in Southern California."[33] The common idea that natural settings were like studio supply closets helped shape the emerging concept of "location" and gave rise to the early studio backlot.

The first studios' complex architectural forms and diverse spatial inspirations contributed to the equally sophisticated character of early films. While studio designs and studio filmmaking almost always endeavored to remove any direct trace of the studio frame from the filmed image, studio forms had direct, and sometimes easy to identify, effects on their film products. I trace these formal developments from what I term the "framed aesthetic" of the Black Maria and similar Dickson-designed studios (chapter 1), to the fluid and "plastic" forms produced in the first glass-and-iron studios (chapter 2), to the cinematographic innovations and increased realism engendered by the large studios of the Nickelodeon era (chapters 3 and 4), and, finally, to the studio-inspired formal techniques by which filmmakers captured natural landscapes and backlot sets (chapter 5).

Different strategies for producing studio luminosity generated visibly distinct film spaces. The Black Maria's precise illumination, for instance, defined its unmistakable "framed aesthetic." By the early 1900s, competing architectural forms using different combinations of electrical and glass-mediated natural lighting created a hierarchy of visual quality that did not escape the audiences or critics whose aesthetic judgments often came in direct response to studio developments. Studios' plastic, controlled spaces contributed to filmmakers' early experiments with film space, especially in the first glass-and-iron studios in which Méliès, Edwin S. Porter, G. A. Smith, Ferdinand Zecca, and others developed film's first special effects. Méliès's first studio, for instance, gave him the consistency and control necessary to develop and refine his subsequently famous tricks. More conceptually, his film tricks came to function much like his studio's transparent glass enclosure, which worked—much as Giuliana Bruno has described the effect of urban glass architecture—"[to explode] the division between interior and exterior in favor of a fluid light space."[34] Finally, larger stage sizes, enhanced control of studio lighting, and the orchestrated movement of sets, props, and players from staging areas to shooting stages contributed to new forms of studio-style realism in longer multi-shot films. In sum, while the studio's role in shaping film form was by no means all determining, shifting studio designs set limits on and created new possibilities for film space, and they have never ceased to do so.

By the 1920s, filmmakers, architects, and theorists would make architecture's close relationship to cinema a common refrain. As René Clair most famously remarked, "the art that is closest to cinema is architecture."[35] Clair encapsulated similar ideas expressed by innumerable contemporaries, from Abel Gance, Sergei Eisenstein (a trained architect), and Siegfried Kracauer (also an architect) to the architect and set designer Robert Mallet-Stevens, art historian Elie Faure, and Le Corbusier.[36] This attention came, in part, as a result of the numerous and practical interactions between architects and filmmakers that arose in the context of expanding studio production and modernist intermedial experimentation. Architects built enormous film sets and commissioned filmmakers to document modern architecture's novel forms. Filmmakers used modernist buildings as filming locations while also debating the vices and virtues of studio versus location shooting.[37] And early critics and theorists of

modernism explored the similarities between filmmakers' and architects' treatments of space.

As I demonstrate in what follows, these ideas and interactions were nothing new. In the previous three decades, a long list of since-forgotten architects had come to play a critical role in film production. They included the likes of Hugo Kafka, a Czech-born immigrant and student of Gottfried Semper, who brought film architecture to the Bronx at Edison's 1906 reinforced concrete and glass studio; Arthur Rendle, a prize-winning exposition architect and patent holder in glazing techniques, who designed Edison's glass enclosure; Auguste Bahrmann, a Paris-based residential and industrial architect who orchestrated the dozens of buildings that became Gaumont's Cité Elgé; Eugène and André Laubeuf, the latter a graduate of the École National des Arts et Métiers, who worked on rail stations for the Chemin de fer de l'Ouest and studio buildings for Pathé in Vincennes; and Théodore-Léon and Georges Moisson, the latter an École des Beaux-Arts graduate, who built Pathé's compound in Joinville-le-Pont. While their better-known counterparts in the 1920s have made interactions between the two arts cause for celebration and analysis, it was these more anonymous precursors who first defined cinema's relationship to architecture.[38]

CINEMA, TECHNOLOGY, AND NATURE

Art and technology represent two different ways of shifting the boundaries of visuality . . . by either misusing or circumventing the sun.[39]
—Friedrich Kittler

The filmmakers and architects who defined cinema's early relationship to architecture drew on developments in building technology that were changing the character of the modern built environment. Studio architects used the same glass and iron that had been part of the reconfiguration of Western urban spaces since the mid-nineteenth century as well as the newest materials and designs that were modernizing cities like New York and Paris.[40] In doing so, they made cinema part of a broader series of changes that historians of technology have characterized as the construction of

a "human-built world." In what follows, I use this concept as a way of framing the studio's—and early cinema's—relationship to the built environment of modernity and, more broadly, the technological changes that conditioned cinema's emergence.[41]

Studio architects and those who were reshaping modern cities shared the need for better regulated architectural spaces. They strove for what Reyner Banham has termed "well-tempered environments," architectural spaces designed to produce suitable climates by regulating natural environmental conditions. The first studios were built in what Banham terms the "selective mode," designed "to expel unwanted conditions from within and to admit desirable conditions from without."[42] Méliès's glass house, for instance, used its combination of transparent and diffusing glass and hanging fabric to admit a desirable form of natural light while also blocking light that was too bright and expelling heat through open glass frames. It was this architectural formation that made Méliès, as Apollinaire fittingly put it, an "alchimiste de la lumière."[43] The ability to manipulate light through the same selective process would characterize studio architecture's well-tempered environments well into the late 1910s.

Dickson's Black Maria produced a more radical version of this architectural selection. Its retractable roof admitted sunlight, while the remainder of the studio barred light that might corrupt film exposures. By mounting the studio on its rotating track, Dickson enhanced the building's selective function, allowing it not simply to admit desirable conditions but to secure the most desirable ones. In synching it with the sun, Dickson highlighted the studio's—and cinema's—paradoxical relationship to the natural environment. Cinema depended on nature—in the interaction of sunlight and the light-sensitive materials it activated—even as studio architects and engineers sought to dissociate filmmaking from the natural world by selecting, manipulating, and/or simulating its desirable features. As Kittler might have put it, they found better ways to misuse or circumvent the sun.

In the first decade of the twentieth century, the studio's selective mode achieved heightened degrees of complexity thanks to new architectural designs for open interior spaces that were supported by modern building materials. The introduction of artificial lighting allowed many studios to assume what Banham has termed the "Regenerative mode," an

architectural form in which applied energy is used to regulate the natural environment.[44] Studio lighting and climate control units, almost always used in combination with features of the selective mode, allowed architects to produce more manageable studio environments by simulating sunlight and eliminating rain, wind, snow, heat, and cold—except, of course, in the controlled, artificial forms that filmmakers used to produce illusionary cinematic worlds.[45]

In tempering the natural environment in this way, early studios made cinema a key component of the "human-built world." Defined as the process in which modern technologies came not so much to dominate the natural environment as to replace it with artificial alternatives, the idea of the human-built world has guided efforts to rethink the history of Western technological change.[46] Arguing against the idea that the Industrial Revolution was the epochal shift that defined modern existence, historians have situated technologies including electrical lighting, the internal-combustion engine, airplanes, wireless communications systems, synthetic chemicals, and new consumer objects, from the bicycle and chemical dyes to the telephone, camera, and phonograph, in a longer history of technological developments that coalesced in the early twentieth century to transform everyday life in the West. As Rosalind Williams argues, "never before nor since has there been such a concentrated period of technological change affecting ordinary people."[47]

This book argues that cinema, despite being almost entirely absent from these histories, must be understood as one of this process's most significant technologies.[48] Indeed, film studios and studio films should be seen as quintessential human-built worlds. In their new studios, filmmakers produced not simply films, but artificial worlds that were on par with the synthetic spaces of the modern built environment. They made architectural and technological change the stuff of early cinema, not only in urban actualities but also in studio films that re-created the modern built environment and its infrastructural features, often in order to produce incisive commentaries about their potential dangers. And they contributed to the destabilization of ostensibly clear distinctions between nature and technology and between reality and artifice.

A remarkable photograph of Gaumont's first shooting stage illustrates this kind of destabilization in action (fig. I.3). Gaumont's set designers

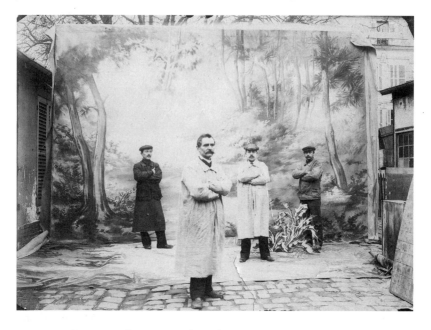

FIGURE I.3 Gaumont's first stage with set designers (ca. 1897). (Cinémathèque française, Bibliothèque du film, Service Iconographique)

pose proudly in front of a painted backdrop that depicts a wooded scene, supplemented by a small artificial bush that leans against one of the designers' legs. A small gap between the suspended canvas and the top of the photo reveals real trees that seem to escape from the painting itself, as if nature and artifice were on a continuum rippling at the frame's edge. In its reproduction of a forest that seems to lie just beyond the set, this backdrop underscores the ways that studio filmmaking, from its earliest incarnations, so often produced cinema as the reproduction of the natural environment outside. This re-creation of nature in artificial form marked a seemingly contradictory but common early step in studio production. The need for environmental and spatial control drove filmmakers to dissociate production from the realistic spaces of nature and location shooting, only then to turn to studio technologies to reproduce ever more realistic versions of the places they left behind.

The studio's role in producing these kinds of contradictions has not been lost on film theorists. Walter Benjamin, for instance, underscored this paradoxical production of reality through a naturalistic metaphor. "In the studio," he writes,

> the mechanical equipment has penetrated so deeply into reality that its pure aspect, freed from the foreign substance of equipment, is the result of a special procedure, namely, shooting from a particular camera set-up and linking the shot with other similar ones. *The equipment-free aspect of reality here has become the height of artifice*; the sight of immediate reality has become the 'blue flower' in the land of technology.[49]

Benjamin's "blue flower," as Miriam Hansen explains, refers to the German Romanticist "*blaue Blume*," a metaphor for "the unattainable object of the romantic quest."[50] For Benjamin, the studio makes "immediate reality" the unattainable object. Ensconced within technology, the real becomes more artificial than fiction itself, accessible only, and paradoxically, through the camera's lens, the single location from which one can imagine the artificial scene free of illusion.

This book places these kinds of readings of studio artifice in a broader theoretical framework drawn from the history of technology. It uses the idea of studios as technological systems for environmental control and films as human-built technological worlds to offer a speculative rereading of cinema's ontology through noncinematic theories of technological change. In short, it proposes that we understand cinema as a technological form of environmental regulation and reproduction that made film a kind of virtual world long before the "virtual age" and should push us to understand cinema's early role in the widespread, machine-made changes to the natural environment that have become such cause for concern today.[51]

By the 1930s, cinema's complex status as a technology, its place in the "machine age," and its unique relationship to nature had become part of broader technological discourses. Lewis Mumford, for instance, classified cinema and photography as "specific arts of the machine," an enticing, if underexamined fragment of his sweeping history of technology.[52] For Mumford, the emergence of cinema marked not only a reshuffling

of modern notions of time and space but also new and contradictory possibilities for experiencing nature technologically.[53] Lamenting that "it has been so stupidly misused," Mumford proposes that "the motion picture nevertheless announces itself as a major art of the neotechnic phase. Through the machine, we have new possibilities of understanding the world we have helped to create."[54] Mumford's view of cinema in many ways echoed contemporary thinkers such as Kracauer, Béla Balázs, and Benjamin, particularly their emphasis on film's epistemological potential for accentuating human perception, for instance in Benjamin's idea of the "optical unconscious."[55]

But Mumford's analysis also suggests a less tangible and more provocative potential in cinema's reproduction of the lived world. In response to film's presentation of "the direct and immediate experience of living itself," he proposes that "we must directly see, feel, touch, manipulate, sing, dance, [and] communicate before we can extract from the machine any further sustenance for life."[56] In one sense, Mumford was simply repeating a common (and still persistent) warning about the dangers of accepting technological substitutes for lived experience. "The machine is worthless," Mumford insists, "indeed it is actually debilitating."[57] But more than simply a call to reject technological mediation altogether, Mumford also suggests that cinema might unlock a hidden, vital potential in modern technology. At the moment, in Mumford's view, when machines threatened to replace nature with manufactured alternatives, cinema and photography offered a last chance to encourage new forms of liveliness between human beings and the natural world.[58]

In this respect, Mumford seems to have shared Benjamin's sense that film might counteract other technologies' damaging effects on nature. As Miriam Hansen has argued, Benjamin saw in cinema the possibility for a new form of "interplay between nature and humanity" based on film's capacity "to reverse, in the form of play, the catastrophic consequences of an already failed reception of technology."[59] By "nature," Benjamin did not, of course, imagine—nor does this book—a pure environment sealed off from the forces of history.[60] Rather, he recognized that industrial capitalism had already come to dominate both the natural world and its meaning. Cinema, he hoped, might counteract the latter as part of a broader reformation of humanity's relationship to the material world.[61]

Mumford and Benjamin were not alone in recognizing new potentials in technology to extract something typically unseen from nature. At the same moment, Martin Heidegger was formulating a theory of technology with an equally compelling vision of its relationship to the natural environment. In addition to being a specific machine art, cinema should be understood as an exemplary instance of what Heidegger would theorize under the similarly inflected category of "modern technics" and the modern attempt to conquer the world as an image. For Heidegger, as for Mumford, the condition of modern technics was characterized by a shift in the relationship between nature and technology.[62] Whereas premodern technologies sought to work around nature's limitations, modern technologies fundamentally alter our conception of the natural environment by changing its nature through reordering. Heidegger distinguishes between the wooden bridge that provides passage over the Rhine without altering its flow and the hydroelectric plant that, in halting its flow, changes the very essence of the river, placing it on reserve for exploitation.[63] Heidegger's view that modern technologies dominate the natural environment differs significantly from Mumford's more optimistic analysis of technology as a human-built alternative to nature and his hope that film and photography might revitalize humanity's relationship to it. And indeed, as Anne Friedberg notes, Heidegger offered no more optimistic a view of modern media, which he believed threatened to destroy the senses.[64]

But Heidegger also argues that this alteration carries a crucial representational function—"the conquest of the world as picture."[65] The natural environment reserved for human use is also ordered for representation, framed and set before the human subject as an image.[66] In this respect, Heidegger offers an important way of thinking about film technologies that complements my understanding of cinema as a component of the artificial reproduction of nature in modernity. The film studio serves precisely this function of ordering nature to produce a well-tempered environment for reproduction. As Samuel Weber describes, Heidegger fittingly terms this process *enframing* or *emplacement* (*Gestell*), a term that captures the spatial character of modern technology's manipulation of the natural environment.[67] For Heidegger, the notion of the frame, or enframing, may never have been more, as Friedberg argues, than "a metaphor for the 'enframing' implicit in modern thought and experience."[68] Even so, it

offers a powerful metaphor for cinema's technological function, especially the studio's forms of environmental regulation. As I describe in chapter 1, the studio was a machine for enframing the world and placing it on reserve for the production of moving images. Filmmakers used film technologies to order and reorder nature by enframing it in the camera lens, on the celluloid strip, and on the editing table, before sending it off to be reframed in projection and, metaphorically, in the subjective experience of viewing.

This book analyzes cinema's—and especially the film studio's—role in this reordering of nature as an image in industrial modernity both in Mumford's terms, as a prototypical example of an artificial technological environment, and in Heidegger's, as a technology for rendering the world as picture. By emphasizing Mumford's rare invocations of cinema and pushing Heidegger's metaphor of *enframing* beyond technologies to include technological representations, I want to underscore the value of creating better dialogues between the histories and theories of technology and cinema that I address in historical terms more generally. I explore the film studio's dynamic history as the product of a range of architectural traditions, technological developments, and filmmaking needs. And I emphasize its uniquely heterogeneous status as a filmmaking site, an architectural form, and a technological space. In doing so, I hope not only to close the gap between disciplines and methodological approaches but also to create space for further theoretical and interdisciplinary explorations of the relationships between space, place, architecture, technology, and cinema.

The importance of these relationships remains as poignant as ever today as virtual reality, networked societies, artificial intelligence, cloning, and genetically modified food make fears about technological reproduction and artificial environments ever-present in the news media and popular culture. Just as the first film studios provided an important site for both creating and evaluating artificial worlds, so moving-image media and their production spaces continue to be key spaces and tools for imagining our technological future. We would do well to remain attentive not only to those imagined futures but also to the technologies with which we imagine them.

· 1 ·

BLACK BOXES AND OPEN-AIR STAGES

FILM STUDIO TECHNOLOGY AND ENVIRONMENTAL CONTROL
FROM THE LABORATORY TO THE ROOFTOP

It obeys no architectural rules, it embraces no conventional materials and follows no accepted scheme of color. Its shape, if anything so eccentric can be entitled to that appellation, is an irregular oblong. . . . Its color is a grim and forbidding black, enlivened by the dull lustre of myriads of metallic points . . . the uncanny effect is not lessened, when, at an imperceptible signal, the great building swings slowly around upon a graphited centre, presenting any given angle to the rays of the sun and *rendering the apparatus independent of diurnal variations.*
 —W. K. L. Dickson and Antonia Dickson (1895)[1]

IN LATE 1892 at Thomas Edison's laboratory in West Orange, New Jersey, William Kennedy Laurie Dickson designed an architectural space like few seen before. Soon dubbed the Black Maria—a colloquialism for police paddy wagons—the building was variously described by contemporary observers as a coffin, cavern, or outright conundrum. Today it is better known as the world's first film studio. Dickson developed the studio concurrently with two of Edison's better-known moving-image machines, the Kinetograph and Kinetoscope, and the studio was integral to Dickson's work on these devices. Each operated on the same principles: the juxtaposition of light and dark, the interplay of movement and stasis, and the technological reproduction of nature. Much like the camera and projector, studios like the Black Maria allowed Dickson, Edison, and the inventors, artists, and image-makers who followed to create new forms of

visual representation and to contribute to the emergence of new concep-
tions and experiences of modern technological space.

The Black Maria remains an often-celebrated icon of early film history
and a companion "first" to Edison's moving-image apparatuses. Unlike
those devices, however, historians and theorists have paid insufficient
attention to its formal genealogy and, as a result, its importance for theo-
rizing film space.[2] Indeed, observers dating to Dickson himself have too
quickly accepted the idea that the studio was simply a singular, idiosyn-
cratic form, and that "modern" studios soon made its "primitive" design
little more than a souvenir of film history. Such characterizations deny
the complexity of the structure's form and function, its historical roots,
and the spatial predecessors that contributed to Dickson's design. These
spaces—which included the Edison laboratory, Eadweard Muybridge
and Étienne-Jules Marey's respective research laboratories, photography
studios, and civil engineering designs—point to the varied artistic, archi-
tectural, scientific, and technological contexts that guided early cinema's
development.[3]

By examining the spaces and forms that influenced the Black Maria's
design, the films produced in the studio, and the studios and films that
came after it, this chapter argues that cinema emerged as a key component
of a broad reformation of the relationship between nature and technol-
ogy in the late nineteenth century. Beginning with Lewis Mumford in the
1920s, historians of technology have argued that the turn of the twentieth
century marked a new stage in the greatest technological revolution in
history: the construction of an artificial world founded not simply on
our domination and exploitation of nature through machines, but rather
on nature's outright replacement by human-built technological environ-
ments.[4] The devices and materials undergirding this new technological
world emerged from late-nineteenth-century research laboratories such as
Edison's. Here, the craft-shop model of collaborative labor and invention
encouraged overlaps and intersections among new inventions that helped
lead to the production of the broad technological systems that shaped
industrial modernity.

Cinema should be understood as a significant component of that pro-
cess. The film technologies that emerged from the laboratory would offer
a powerful system of world-building of their own, with the studio as their

spatial locus. At the Edison laboratory, the problem of inventing cinema became not simply a question of creating a camera or projector but also an *architectural* problem of producing the necessary space for capturing movement. The Black Maria was Dickson's solution. The result went beyond mere motion capture; it also defined an aesthetic form and the conceptual frame for a modern type of technological space—film—that would be no less technological in its future studio and non-studio forms.

While the Black Maria may be the best example of the film studio's direct link to the laboratory, the studios that followed should equally be understood as technological spaces, or as machines. From their origins, the first studios were designed to defy the dictates of day, night, weather, and location in order to frame the production of artificial environments. This framing produced a version of what Martin Heidegger described as "enframing"—the process by which technologies extract "the energies of nature" and place them on reserve.[5] The Black Maria, this chapter argues, enframed sunlight as a raw material needed to activate the chemical processes for recording movement. Edison filmmakers such as Edwin S. Porter and James White used the studio as one key component of the basic apparatus for producing literal versions of Heidegger's metaphoric "world picture": films that set the world before the human subject and rendered it knowable as a series of *moving* images.[6]

THE BLACK MARIA: STUDIO, MACHINE, UNKNOWN FORM

The few existing images of the Black Maria may explain the tendency among observers, critics, and historians to disparage the studio's "primitive," "rudimentary" form, while variously describing it as a "dismal-looking affair" and a "rambling building of cheap construction." In one of only three known photographs of the studio's exterior (fig. 1.1), reportedly taken in 1903, the structure appears as a ramshackle hodgepodge of geometric forms, crudely cobbled together and ready, at any moment, to collapse into only so many odd building blocks and irregular detritus.

Within only a few years, the seldom-used and now-dilapidated building would indeed be demolished, perhaps taking its place, like so many provisional machines and outworn technological spaces, alongside the

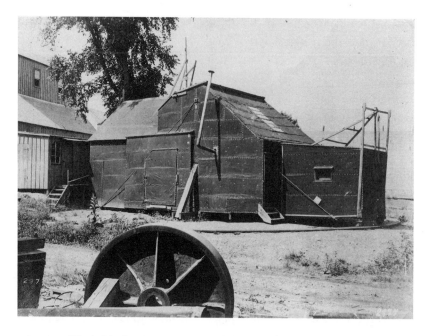

FIGURE 1.1 Black Maria, summer 1903. (Courtesy of U.S. Dept. of the Interior, National Park Service, Thomas Edison National Historical Park)

discarded railroad wheel posed in the photo's foreground. Only a few years earlier, however, the studio was the center of Edison's film production and a hive of laboratory activity. In its more than half a decade of use beginning in 1893, the studio framed the production of thousands of films featuring contemporary vaudeville stars, local performers, miscellaneous celebrities, and Edison lab employees.

Dickson developed the studio's design in late 1892 as part of the laboratory's preparations for the 1893 World's Columbian Exposition in Chicago. Edison hoped to feature a series of Kinetoscopes there, and Dickson recognized that a dedicated production space with good lighting would be necessary to furnish these machines with sufficient films.[7] A team of laboratory staff, led by John Ott, one of the laboratory's most skilled machinists, and several freelance carpenters assembled the studio according to Dickson's design during the winter, completing the job in February for a total cost of $637.67.[8] It was built of wood

covered in tarpaper (a material typically used for waterproofing roofs) attached with tin nails, and extended approximately fifty feet in length and fifteen in width, with a height varying from seven to twenty-two feet (fig. 1.2).[9]

Far from being primitive in form, the studio had a complex design for capturing sunlight, highlighting moving objects for the Kinetograph, and facilitating efficient film production by increasing the available working hours and providing consistent, specialized workspaces for shooting, developing, and processing films. Dickson placed the studio stage beneath two perpendicularly intersecting gabled roofs, the taller of which rose to twenty-two feet and could be opened on one side to admit sunlight. Behind the stage, the lower 18-foot roof covered the "black tunnel" that gives the Black Maria films their distinct black background. On the other side of the stage, just beyond the roof opening, Dickson added a 9 × 7 foot darkroom for loading and unloading film from the Kinetograph, which could be mounted on tracks running between the darkroom and the filming area. The entire structure was mounted on a central graphite pivot with wheels at each corner, perched on a circular track. Using two large

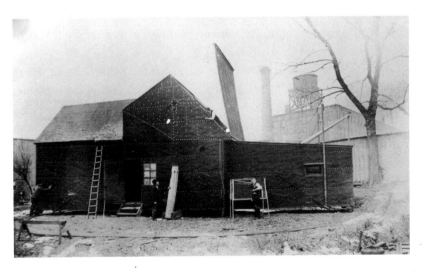

FIGURE 1.2 Black Maria, circa winter 1893–1894. (Courtesy of U.S. Dept. of the Interior, National Park Service, Thomas Edison National Historical Park)

boards extending from the center of either side, several workers could rotate the studio in order to adjust the angle of sunlight illuminating the stage through the open roof.

As performers and the press began to visit in 1893, the studio, initially referred to simply as the "revolving photograph building" or the "Kinetographic Theatre," quickly acquired both a new moniker and a reputation for being an especially strange structure, even at the Edison laboratory. Lab personnel coined it the "Black Maria" after judging that the studio bore closest resemblance to police vehicles of the same name.[10] For Dickson, the studio resembled a "medieval pirate-craft," and its interior evoked images of dungeons, torture, and death.[11] Likewise, Edison Company lawyer Frank Dyer recalled the studio's "lugubrious interior,"[12] and one press report noted that it "reminded everybody of a huge coffin."[13]

Contemporary illustrations such as Edwin J. Meeker's ink drawing (fig. 1.3) for an 1894 *Century Magazine* article by Dickson and his sister, Antonia, must have reinforced such descriptions. In Meeker's drawing, the studio appears slightly elongated, and the darkroom's exaggerated length indeed helps evoke the shape of a casket. The lightly sketched, spare landscape stands in sharp contrast to the darkened studio's imposing presence. Meeker's shading lines on the building's forward section parallel the open roof, creating a sense of movement into the interior, as if the studio might swallow elements of its surroundings.

In what might be read as a visual metaphor for the process by which modern technology, in Heidegger's theory, extracts energy from nature, an adjacent tree dangles over the open roof, bending as if it were being sucked into the studio.[14] To the left, a darkly shaded stump suggests both the Black Maria's material origins and nature's future fate at the Edison lab, where trees were just as likely to become picket fences, bridges, or studios. The wood-plank bridge in the immediate foreground further inscribes such an idea of progress into the image, both by offering a crude counterpart to the studio's modernity and by recalling Dickson's comparison of the studio to another modern nineteenth-century technology, the swinging river bridge.[15]

The uncertainty and imaginative creation expressed in Dickson's and other witnesses' early attempts to associate the new building with some

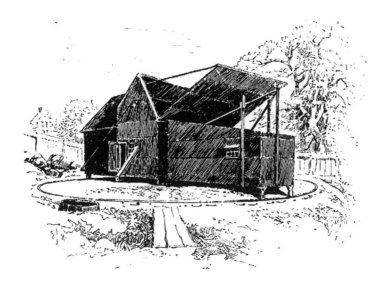

FIGURE 1.3 "Exterior of Edison's Kinetographic Theatre, Orange, N.J." Ink drawing by Edwin J. Meeker, *Century Magazine* 48 (June 1894): 214.

familiar form suggests not so much the building's inherent strangeness as the novelty of the film studio. While a more conservative observer could very well have described the Black Maria as a strange but not altogether unworldly pitched-roof house in need of windows and paint, its status as a film studio—a previously unknown entity—contributed to doubts about its form and function. Indeed, like the motion picture machines used in it, the studio represented a novel invention and an unfamiliar technology whose sources of inspiration and formal influence remained unclear. Contemporary observers did not have to look far, however, to find more precise models for the studio's design, both in the Edison laboratory itself and in the technologies produced there. Like other contemporaneous sites of cinematic invention, the West Orange laboratory framed early cinema's technological ontology. Within and according to the principles of these laboratories and workshops—the first "studios" of sorts—cinema's inventors and first practitioners developed an idea of what cinema would become.

LABORATORIES, WORKSHOPS, ATELIERS—ENVIRONMENTAL CONTROL IN THE FIRST "STUDIOS"

You can't help but have noticed that Boulevard cafes aspire to become successors of the Faculté des science. Below the room where one drinks glasses of beer, there is a basement in which highly decorated gentlemen perform lectures and experiments on cinema, the praxinoscope, and radiography. Enter: there are vials, batteries, accumulators, wires, and tubes: it is the laboratory.

—Leo Claretie (1896)[16]

The laboratories and workshops where scientists, inventors, technicians, and tinkerers created the first film technologies became not only early exhibition sites but also, by default, the first film production spaces. From Lyon, Berlin, and Leeds to New York, Washington, D.C., and rural New Jersey, spaces of technological research and development yielded the first fragments of moving images. Like the early photographers who reproduced scenes in and from their workshops, the first filmmakers made their workspaces and themselves early test subjects for new film technologies. The spaces and machines with which they worked and the images they produced developed in tandem. Together, they helped establish the aesthetic form and content of early moving pictures and created the initial norms that defined studio film production, norms which first emerged in a more general culture, practice, and spatial model of laboratory research and development.[17]

The professional research laboratory became a key site of scientific and technological creativity and labor in the nineteenth century. Experimental labs and workshops have existed in varying forms since at least the seventeenth century. But only in the early 1800s in Western Europe and by the second half of the century in the United States did scientists and inventors institutionalize distinct spaces of experimentation, research, and development.[18] Fueled by industrialization and the increasing rigor of empirical science, laboratories found institutional support from governments, universities, and corporations, and they quickly became potent symbols of modern industrial society.[19]

The design principles developed in early laboratories would come to condition early studio "laboratories" like the Black Maria. First in chemistry, then in fields such as physics and astronomy, scientists established norms for these physical spaces according to the practices of scientific research, teaching, and training. In order to obtain rigorous and replicable experimental results, they focused on producing highly coordinated and controlled spaces with consistent temperatures and architectural stability. Architects met these requirements through close attention to building orientation—to control temperature in relation to solar trajectories—and material structure, including the use of deep support columns for increased stability, concrete foundations to control ground temperature, and nonmagnetic materials to avoid interference with experiments and machines.[20]

Like their scientist counterparts, inventors such as Edison followed similar principles to create private industrial research laboratories. They profited from the growing market for invention that drove the development of the engineering profession and innovation in major technological systems such as the railroad and telegraph. In the second half of the nineteenth century, support for industrial research developed on a wide scale with laboratories such as Edison's at Menlo Park.[21] Established in 1876, the Menlo Park lab, which Edison famously dubbed an "invention factory," became a model for the organization of the first generation of modern research laboratories in the United States.[22] Combining the shop tradition of collaborative labor and experimentation with specialized machines, highly skilled craftsmen, and workers versed in pure and applied sciences (supported by a large library collection), Edison aimed to streamline invention into a profitable enterprise.[23]

By 1887, when he moved the laboratory to West Orange, Edison had developed a system of small-scale invention supporting specific consumer industries and existing contracts that he used to fund the lab's larger development projects, which included the still-developing electrical industry, magnetic ore-separation, and the electric storage battery.[24] At West Orange, he would use his earnings from the electrical lighting business, his experience from Menlo Park, and modern principles of laboratory design to create the most advanced research laboratory in the world. The lab's spatial organization, material design, and culture of experimental

practice would ultimately determine the material and spatial character of the world's first film studio.

THE EDISON LABORATORY, WEST ORANGE, NEW JERSEY

In 1897, Edison appeared in a film that seemed to offer its viewers a rare behind-the-scenes glimpse of the world of invention he had created in West Orange. The film, *Mr. Edison at Work in His Chemical Laboratory*, presents a lively, lab coat–clad Edison, surrounded by all the trappings of a scientific laboratory and in the midst of an unknown chemistry experiment. Whatever the film's viewers may have been led to believe, the film was not filmed in the chemical laboratory. Although the film's producers, James White and William Heise, may have modeled the set from a well-publicized photograph of Edison in the laboratory's chemical building, they produced Mr. Edison's "experiment" a few steps away in the more suitably lit Black Maria. The studio was no chemical laboratory, but it was no less a space of experimentation. Indeed, in transposing the chemical lab to the film studio, White and Heise restaged a process that had already taken place half a decade earlier. As Dickson searched for the technologies, experimental practices, and *spaces* that would lead to the creation of motion pictures, he found inspiration and models throughout the West Orange laboratory.

For historian of technology Thomas Hughes, early inventors such as Edison were "like avant-garde artists resorting to the atelier" where they could be free to create "a new way, even a new world, to displace the existing one."[25] If the West Orange lab was Edison's "new world," the technologies produced there were aimed at not simply displacing the world outside, but *replacing* it with a modern technological environment. From within the artificial spaces of the laboratory, Edison contributed machines, materials, and techniques for a new vision of industrial modernity. The Black Maria and the films produced in it paralleled that project. The studio, operating according to the same principles as the lab around it, produced an artificial environment and a series of technological products that contributed to a broad process of technological change based on environmental mastery, control, and mechanical reproduction.

For the West Orange lab, Edison initially envisioned, in Hughes's words, "a monumental and prestige-enhancing building in the French mansard style" that would hide its technological function behind an impressive façade (a strategy, discussed in chapter 3, that Edison would later use for his film studio in the Bronx).[26] He entrusted the design to New York–based architect Henry Hudson Holly, who had also built Glenmont Estate, Edison's new home on the hill above the laboratory. Holly transformed Edison's rough proposal into a more traditional three-story factory design, retaining the spirit of prestige from Edison's design by decorating the building's principal façade with three two-story arched windows.

Behind this public face, Edison planned a dynamic space of invention with an encyclopedic collection of materials and objects, specialized rooms for every branch of science and engineering, and flexible spaces for improvised experimentation and collaboration.[27] Recognizing that a single 250 × 50 foot structure would not be sufficient, Edison reconceptualized the laboratory as a multibuilding campus with an interior courtyard, surrounded by an exterior wall. The design, which Edison entrusted to a new architect, Joseph J. Taft, added four specialized buildings, each 100 × 50 feet, arranged perpendicularly to the main building.[28]

These four buildings—originally housing a galvanometric workshop, a chemistry lab, a pattern-making and carpentry shop, and a metallurgical lab—were designed according to principles derived from nineteenth-century laboratory standards. The galvanometric building, in particular, strictly conformed to common guidelines for architectural stability and magnetic purity to facilitate electrical experiments requiring high degrees of precision. Taft built the structure using nonferrous materials, including copper for the nails and pipes and granite for the roof. The building stood on deeply lain brick pillars topped with black marble and a concrete floor, and it was isolated from the other buildings by a courtyard.[29]

The laboratory opened in 1887 with a staff of approximately seventy-five men led by four main experimenters, including Dickson, who also served as the lab's photographer.[30] It operated on a model of versatility, both in terms of its personnel (who collaborated in experimental teams on multiple simultaneous projects) and its spaces of experimentation (which shifted function to accommodate different areas of research).[31]

The machine shops, in particular, became central sites through which experimenters routed their designs and prototypes.[32] The laboratory housed machine shops on the first and second floor of the main building. Surrounding the second-floor shop, Edison arranged a series of experimental rooms assigned to specific projects, initially including Dickson's ore-milling experiments. Among these rooms was also the so-called "photographic room," Number 5, where Dickson conducted the first motion picture tests.[33]

The versatility of the laboratory and its personnel, combined with the overlap between projects created by spatial proximity and multitasking, left a mark on all of the lab's products.[34] Cinema was no exception. The Kinetoscope and Kinetograph were shaped by the interactions of Edison employees engaged simultaneously in broadly diverse areas of research that ranged from ore milling (Dickson), electric lamps (Charles Brown), and telegraphy (William Heise) to precision electrical testing (Arthur Kennelly), the phonograph, and precision machine work (John Ott).[35] Edison's early idea of recording images on a rotating cylinder, for instance, derived from the lab's common use of cylinders in such devices as the phonograph and telegraph. In his second motion picture caveat (1889), Edison proposed using a common chemical laboratory tool, the Leyden jar, to illuminate objects for recording.[36] And when Edison and Dickson shifted from the cylinder design to a system involving strips of celluloid film, they fell back on their familiarity with moving strips of paper through the automatic telegraph machine.[37] Just as these various machines and experimental devices transformed the experience of industrial modernity, so would the cinematic technologies to which they helped give form.

The first film studio developed through a similar form of appropriation. In a series of spaces developed between 1889 and 1892, Dickson drew on a range of sources, many at the lab itself, to craft a controlled space of experimentation—a technological environment—suitable for photographically reproducing movement efficiently and on a large scale. While these spaces differed in form, their function remained consistent. They were sites of both image production and continuing technological development, an imperative that helped condition their photographic and cinematic products.

FROM ROOM #5 TO THE BLACK MARIA: PRODUCING SPACES AND IMAGES IN WEST ORANGE

Dickson's motion picture experiments began in the room set aside for his work as the West Orange laboratory photographer, Room #5.[38] Unlike many parts of the lab, the room remained locked, and during experiments lab personnel reportedly had to pass notes, supplies, and food through a small portal.[39] As Paul Spehr suggests, this strict regulation may have been due to the secret nature of Dickson's motion picture experiments. But it was just as likely an effort to protect the sensitive chemicals and photographic negatives housed there. This attention to the effects of light and its necessary regulation would be the key feature and driving force behind Dickson's designs, first for an outdoor photography area and photographic studio, and, ultimately, for the Black Maria. Through these successive spaces, Dickson transposed the strict attention devoted to environmental control at the laboratory into the film studio and its practices.

Dickson designed the exterior photography area and the so-called "photographic building" in 1889 while Edison was in Paris for the Exposition Universelle. These new structures may have become necessary due to the problem of vibrations produced by the machine shops and elevator adjacent to Room #5. More importantly, the room's windows did not provide sufficient light for Dickson's advancing motion picture experiments.[40] Although Dickson had already used arc lights in his role as laboratory photographer and experimented with light from laboratory tools such as the Leyden jar and Geissler tube in his motion picture tests, these artificial sources of illumination remained too weak for satisfactory rapid exposures.[41] Dickson needed a better-lit and controlled area in which to continue his tests, and he found inspiration in several sources: contemporary photography studios, Eadweard Muybridge's *Animal Locomotion* plates, and Étienne-Jules Marey's Station Physiologique.[42]

There can be little doubt that Dickson consulted, perhaps first, the laboratory's copy of Matthew Carey Lea's *A Manual of Photography* (1868), a well-known publication at the time with a section outlining plans for a photography studio, or "glass room."[43] Lea's diagrams offered

three variations on a structure providing "front-upper-side light" through glazed openings.[44]

For the photographic building, Dickson created a slightly altered version of these models. His design consisted of two main sections: the 18 × 20 foot studio and an adjacent, two-story portion with two darkrooms on the first level and a projection room above. The studio area had a gabled roof, glazed on both sides but joined by a solid brick support across the center, with sliding glass windows covering one wall.[45] The building was conveniently located adjacent to the metallurgical building where Dickson conducted his ore-separation experiments, and several freelance builders began working on it in August 1889.[46]

During the new building's construction, Dickson designed and built a second, exterior area in which to continue his experiments. Although few details about this facility remain, Dickson reportedly also built it along the side of the metallurgical building and may have continued its use even after the photography studio's completion.[47] The inspiration for this setup came, most likely, from Muybridge and Marey. Edison received a selection of Muybridge's plates in November 1888 that one lab worker later remembered being displayed in the library for "some months" afterwards.[48] As Dickson may have learned from Muybridge's earlier 1888 lecture in Orange, New Jersey, or during Muybridge's subsequent visit to the Edison laboratory, Muybridge photographed his motion studies against a black cloth hung against a wooden structure built at the University of Pennsylvania in 1884.[49] Dickson may also have been aware of Marey's exterior shooting method, which, although more advanced by 1889, began similarly with a plain black cloth suspended on a wooden frame with movable panels.[50] While this exterior space gave Dickson the bright light he lacked in Room #5, it did not offer the environmental control that came with the photographic studio. Dickson's move inside anticipated similar shifts by later filmmakers who began filming on exterior sets before moving indoors to escape the vagaries of wind, rain, and snow.[51]

The new photographic building, completed in late September or early October 1889, seemed to promise the conditions Dickson desired. An interior photograph (fig 1.4) of the studio area shows that he equipped the room with shades for controlling sunlight and a flat black background

similar to the one probably used for the exterior shed.[52] In a preview of the Black Maria's later use, the building became a site of both image production and continued experimentation. While Dickson regularly took advantage of the new studio's improved lighting conditions in his capacity as laboratory photographer, the building's main purpose remained the motion picture experiments, which advanced in late 1889 as Dickson and his assistants—working in both Room #5 and the new building—adapted the motion picture machines to use new Eastman film stock.[53] After a hiatus during which Edison and Dickson refocused their efforts on the ore-milling project, the motion picture experiments again accelerated in the latter months of 1890.

During 1891 Dickson shifted his efforts to producing moving images in the photographic building.[54] The film fragments that survive offer an early glimpse of the image form produced by Dickson's evolving studio architecture. Like Marey's early motion studies, Dickson and his new assistant William Heise's films feature figures in white set against stark black

FIGURE 1.4 Interior View, Photograph Building, photograph signed by W. K. L. Dickson. (Courtesy of U.S. Dept. of the Interior, National Park Service, Thomas Edison National Historical Park)

backdrops that dominate the frame. The photographic studio frames an artificial space designed to efface itself in favor of a new space—the space of the image rendered mechanically through the precise recognition of light reflected by moving figures. The success of the environmental control in the laboratory is registered here by the clarity of the figures outlined against an empty backdrop.

An early camera test known as *Dickson Greeting* (fig. 1.5) offers a reflexive example of the artificial reality that Dickson discovered in his experimental photographic laboratory-studio. In this prototypical early lab image, Dickson doffs his hat to test his own recognition by the reproductive apparatus. His greeting addresses the viewer in an act of acknowledgment—"attracting" attention. But it also points up the success of the image's spatial effect—the creation of a lifelike technological world in miniature.

The success of these early tests and further advances in the Kineto-scope, Kinetograph, and the processes for developing their films led to

FIGURE 1.5 *Dickson Greeting* (Dickson and Heise, 1891)

new efforts to expand film production. Despite this success, however, Dickson recognized that the photographic building would not be suitable for further testing and image production. While the photo studio offered a degree of control over the filmmaking environment, it was not versatile enough for large-scale production and high enough quality images. Dickson lamented, in particular, the appearance of side shadows caused by the studio's fixed position relative to the sun.[55] He designed the Black Maria to solve this and other problems by returning to his earlier sources—Lea's *Manual* and Marey's Station Physiologique—combined with a new set of ideas about how to regulate the experimental space more precisely.

A NEW DESIGN FOR ENVIRONMENTAL CONTROL

Dickson's design for the Black Maria shared characteristics with the earlier photographic building, but it also marked a profound and somewhat surprising break with its predecessor. Rather than designing a better equipped and positioned "glass room," Dickson chose to abandon glass altogether, a move that materially distinguishes the studio from the majority of those that appeared over the next two decades. Such changes did not, however, alter Dickson's principal goal and the studio's basic purpose: precise environmental control for both image production and technological experimentation.

Dickson's primary concern appears to have been reflecting the brightest light possible at an exact angle from the figures on the stage back to the Kinetograph's lens. The new studio would thus be, first and foremost, a highly refined machine for regulating light. For this purpose, he needed a more dynamic structure than the photography studio. Dickson introduced four major changes to the previous design: (1) he rejected the transparency of glass in favor of the most opaque isolation possible, hidden beneath a retractable roof; (2) he subtly transformed the roof's shape to direct light more precisely onto the stage (and perhaps in an effort to help control heat in the enclosed space); (3) he traded the flat black background used in the photographic studio in favor of a "black tunnel" like the one used by Marey; and (4) he made the entire structure mobile, allowing it to be rotated according to the position of the sun.

The new roof design most likely came, once again, from Lea's *Manual of Photography*.[56] In the same section detailing methods for constructing a "glass room," Lea offers several design variations for moderating high temperatures. As later accounts show, visitors often complained about the sweltering heat in the Black Maria, a problem that Dickson may have anticipated from the beginning, perhaps due to excessive heat in the photographic building. While contemporary drawings of the studio often omit this feature, photographs of the Black Maria (as well as a diagram drawn by Dickson later in life) show a gap between the peak of the studio's roof and the opening of its retractable portion. This design roughly corresponds to Lea's suggestion for regulating the temperature by leaving a "space between the southern slope of the ridge and the ceiling on that side."[57] Although Dickson's design would not have produced the exact effect that Lea proposed, it did restrict the amount of light entering the studio to the smaller area of the stage, thus reducing solar exposure and shaping the future films' aesthetics by determining the outline of the filmable space.

Dickson's decision to opt for an open-air roof rather than creating a glass covering may also have been motivated by a desire to regulate temperature. He would have recognized that enclosing the studio on all other sides would already reduce the effects of wind, and at this early date rainy conditions would halt filming even in a glazed studio. More likely, however, Dickson's choice was driven by cost, speed, and weight. Ordering custom glass for his design would have been much more expensive and taken too long for the studio to be completed in time to produce films for the upcoming exposition in Chicago. More importantly, glass would have made it difficult to rotate the studio, thus hampering its most novel and, for Dickson, most crucial function.

The ability to rotate the studio according to the position of the sun would allow Dickson to avoid the problem of side shadows that plagued his productions in the photographic studio. Such control became necessary because Dickson's evolving recording device required more exposures per second and thus even more light on the filmed subjects.[58] Ensuring that all of the sunlight admitted to the studio would reach the stage at an exact angle was thus crucial to Dickson's success. In order to achieve this result he sought a radical solution: synching the studio's operation

with the movement of the sun. By "rendering the apparatus independent of diurnal variations," as he would later describe, Dickson highlighted a profound and lasting tension in cinematic production between *control of* and *reliance on* the natural environment.[59] This tension mirrored the conditions of scientific experimentation in the surrounding lab, where architectural materials and designs maintained the strict environmental conditions necessary for producing machines capable of reproducing and, at times, replacing nature.

While the studio allowed Dickson to regulate light in a way that had previously eluded him, he remained not only subject to variations in weather but also to the earth's ceaseless rotation. Nonetheless, the ability to maintain maximum light in the studio throughout much of the day changed the character of Dickson's experimental space and took film production a step closer to independence from nature's intractable laws. Cinema demanded natural light, and the studio captured it architecturally by ordering and reordering the sun's rays with each studio rotation.

Far from primitive, then, the Black Maria should be understood as a cinematic version of modern technics designed to make natural light a technological form and place the sun on reserve.[60] This basic principle would define the film studio. Indeed, efforts to dissociate filmmaking from the strictures of nature drove studio architecture and technology through the first decades of the twentieth century, as architects and filmmakers sought new styles of open and dynamic architectural space, new forms of reflecting and refracting glass, and, ultimately, technologies for electrical illumination. They also linked cinema to the more general efforts of architects and inventors to design materials and spaces that reproduced desirable features of the natural environment—including regulated light and heat, shelter from wind, rain, and snow, and access to clean and fresh air, food, and water—while eliminating their undesirable counterparts. Technologies produced in laboratories such as Edison's helped make these new "well-tempered" environments possible, and films gave them another form.

Dickson further enhanced the Black Maria's reproductive capacity by more closely following Marey's formula for obtaining sharp and rapid exposures of movement at the Station Physiologique. Although he may have read Marey's descriptions of the shooting procedure used at the

Station before constructing the photographic building, Dickson seems to have initially ignored the details of Marey's report. Upon closer inspection, Dickson would discover that Marey was an expert on the subject, having already designed a series of experimental recording spaces with successively more favorable results.

Indeed, Marey recognized, as Dickson would later, that the background against which he exposed his subjects had a crucial effect on the images produced. In other words, prefiguring the importance of architectural design to film form in the Black Maria, Marey's laboratory-studios synched image production with architectural form. Having begun his experiments in 1882 against a simple wooden platform covered in black and set at a 45-degree angle to the camera, Marey soon discovered that the background reflected too much light on his glass plates. He built a new background the following year after a chemist, Eugène Chevreul, suggested photographing his subjects in front of a black box. The new "black hangar," a 3-meter-deep shed, initially had a background painted in black that Marey and his assistant, Georges Demenÿ, later covered in even darker black velvet.[61] The new hangar produced markedly sharper figures against its self-effacing black background, pushing Marey to reduce his exposure times even further in an effort to produce as many images as possible on a single glass plate.

As he described in an 1887 *Scientific American Supplement* article that Dickson almost certainly read, during his experiments Marey discovered that over the course of these exposures, even "small quantities of light, accumulating their effect over the whole surface of the plate, end by fogging it completely."[62] He suggested having not simply a black background but a deeply *recessed* area behind the figures to be recorded. For this purpose, Marey had built a third structure in 1886, now ten meters deep and equipped with curtains to change the width and height of the opening to keep reflected light to an absolute minimum.[63] The new background allowed Marey to produce new experiments with birds in flight and to begin new experiments on the recording apparatus itself in an effort to find a more flexible technology that might be used for recording movement outside the laboratory.[64]

Dickson would use these principles and Marey's images as part of the inspiration for both the Black Maria and its early productions. The

studio's "black tunnel" was a product of Dickson's closer reading of Marey's findings and, as in Marey's research, contributed to greater success in Dickson's motion picture production. As with the motion studies, this black tunnel also gave the Black Maria films their distinct visual form. The studio produced an aesthetic of observation and investigation that remained consistent with the studio's continued use as an experimental laboratory and which defined early cinematic space in both the studio and its films.

THE FRAMED AESTHETIC: EARLY STUDIO SPACE AND FILM FORM

The architectural solution to the problem of photographically reproducing movement necessarily shaped its aesthetic form. The Black Maria films, produced largely between mid-1893 and early 1896 (and more sparsely into 1901), share a basic spatial form—a *framed aesthetic*—defined by their stark background, bright ground plane, and the central area of action that emerges between them, typically limited to a single continuous shot from a fixed camera position. Contained within the enclosed studio space, their form was equally framed within a particular visual aesthetic. The play of black, white, and gray in these films produces a kind of zero degree of film space—a simulated three-dimensionality created through the appearance of movement registered by varying intensities of reflected light. This basic setup varies, with the floor plane occasionally omitted in figural close-ups and the purity of the empty space at times interrupted by spare set pieces, especially in the latter years of the studio's use. But the consistent repetition of spatial form in the Black Maria films offers a glimpse of the initial spatial logic—the *enframing* of light and objects— that defined early studio filmmaking and, to a degree, has remained in place (if hidden) ever since.

The Black Maria's framed aesthetic emerged as a direct result of the developments in Dickson's experimental spaces—and Marey's before him—that yielded a method for registering sufficient light on film. Dickson solved the problem of recording movement architecturally in two main parts. First, by absorbing light in the studio's recessed black tunnel,

he created a void of unmoving space that dominates the films, typically accounting for as much as 85 percent of the frame. While at times enough light enters the studio to reveal the recessed background behind the stage, more often this space registers in the images as a kind of non-space, an empty abyss of impenetrable darkness that places the films' moving figures in distinct relief. Before and beneath this blackened void, Dickson created its counterpart, the brightly lit stage that gleams in grays and whites beneath the studio's open roof, interrupted only by the shadows of the figures performing above.

These light and dark spaces define and delimit the studio's most basic architectural form and function. The filmed images acquire the illusion of three-dimensionality with the introduction of figures and props into the area where light and dark intersect. Suspended between the blackened recess and the illuminated base, Dickson created a plane of filmic visibility. Here, the movement of bodies and objects across the frame, reflecting light back to the Kinetograph lens, activates and deactivates portions of the image as the visible space shifts between light (figure) and dark (empty space). The results are particularly stunning in films that operate precisely on this logic of fluctuation, such as in the abstract white forms of *Amy Muller* (1896) (fig. 1.6) and *Crissie Sheridan* (1897) or the gray clouds of smoke that paint the background of *Annie Oakley* (1894) (fig. 1.7).

The logic of the studio frame and the bounds of its visibility were strict. In *Robetta and Doretto* (1894) (fig. 1.8), for instance, a rare early attempt to point the camera outside the space designated by Dickson's architectural design leads to virtual decapitation and dismemberment as the performers exceed the studio's visible plane. Such rare "mistakes" suggest the degree to which the studio's form and function shaped the form of the films produced in it. This strict regulation of the space (and thus often the content) of the Black Maria films corresponded to the rigorous experimental imperatives that shaped the studio's design.

In this respect, the framed aesthetic contributed to what Tom Gunning has termed the "cinema of attractions," but it did so on the basis of experimental imperatives that had little concern for visual shock or spectacle and that had different long-term effects on film form.[65] Like the cinema of attractions, the framed aesthetic was defined by Dickson's intention to show something—to demonstrate the apparatus's ability to register

FIGURE 1.6 *Amy Muller* (Heise, 1896)

FIGURE 1.7 *Annie Oakley* (Heise, 1894)

FIGURE 1.8 *Robetta and Doretto* (Dickson and Heise, 1894)

movement. On the other hand, it was the product of his attempts, prior to any concern with entertainment or an eventual audience's response, to control light and generate a closed experimental world in which to do so. Thus while the framed aesthetic emerged from a system of environmental control that enhanced cinema's ability to generate attractions, its visual form was characterized by abstract principles of clarity, legibility, and precision more than direct address, shock, or astonishment.

Indeed, if the architectural space and aesthetic form that Dickson and Heise created in these films produced entertaining scenes of performance and visual pleasure, they did so only by satisfying the experimental necessities that had inspired them. Drawing on Marey's experimental spaces as well as his research subjects, Dickson's framed aesthetic was, first and foremost, observational and investigational. Like Marey and Demenÿ at the Station Physiologique, Dickson made local athletes among the first subjects to "perform" in this experimental laboratory. To be sure, Dickson did not use these films or others, such as *Annie Oakley*, to analyze bodily movement or the behavior of projectiles. Rather, the initial film subjects

allowed Dickson to investigate the performance of his experimental moving-picture apparatus. The task of investigation and observation that drove his image-making practices from the first "monkeyshines" tests in the photographic building to the earliest test films in the Black Maria left its mark on the entertainment films that followed. These tests confirmed the functionality of the studio's architectural form and systematized the basic procedures for capturing movement that would remain consistent for commercial film production.

Given the typical subjects filmed in the studio—composed largely of vaudeville performers and variety acts—one might even argue that the investigational practice of the earlier experimental films remained both viable and desirable for entertainment-seeking audiences. The entertainers that paraded through the studio by the hundreds in the mid-1890s may not have been subjects of scientific analysis, but their acts invited close observation of their impressive corporeal feats. Especially given these films' initial viewing context—through the eyepiece of the Kinetoscope—such acts take on the character of bodily experiments offered up for investigation to scientist-like viewers peering as if into a microscope. These practices and experiences are consistent with the "operational aesthetic" that, as Neil Harris explains, had attracted audiences since the early nineteenth century by simply putting the processes of recording and reproducing movement on display.[66]

Alongside its use for recording commercial films, Dickson continued, moreover, to treat the studio as an experimental laboratory until his departure from the company in 1895.[67] Using Room #5, the photographic building, and the Black Maria, Dickson modified the Kinetograph while also attempting to develop commercially viable projection methods and sound systems. Perhaps the most striking instance of this continued experimentation appears in the *Dickson Experimental Sound Film*, produced in 1895. The film, which features Dickson in the Black Maria playing the violin while two laboratory workers dance, is the only surviving example of a series of subjects made for the experimental Kinetophonograph, a device with which Dickson attempted to combine the new motion picture apparatus with Edison's phonograph.[68]

Although Edison only began manufacturing the system in 1895, the idea of linking moving images to phonograph discs dated to the earliest

motion picture tests and may have even contributed to Dickson's design for the Black Maria. The Edison laboratory had a phonograph recording studio on the third floor of the main lab building, and Dickson may have been inspired by the purity of its isolated space, either anticipating the film studio's use for sound and image recording or in simply drawing a parallel between their mutual need for precise environmental control.[69] Dickson's attempt to create a synchronous sound system—one of his final projects for the Edison Company—not only reveals the continuing experimental imperative that conditioned the working space of the first film studio; it also anticipates the complete environmental control that filmmakers would seek as inventors and engineers adapted cinema to synchronous recorded sound over the next three decades.

In April 1895, Dickson left Edison to join a competing motion picture firm, leaving film production and development in the hands of Heise and James White. Although the two continued making films in the Black Maria, within a year it had fallen into disrepair and its use waned until Edison had the studio demolished in 1903. The end of the Black Maria was by no means, however, the end of the framed aesthetic. Dickson repeated much of this process for American Mutoscope and Biograph, the company that would emerge as Edison's principal American competitor. In 1896 he reproduced the Black Maria's basic functionality (in pared-down form) for Biograph's first studio.[70]

Located on the roof of the Roosevelt Building at 841 Broadway, where Biograph rented its offices, it consisted of a small shed housing the Mutograph camera and an open-air wooden stage surrounded on three sides by a system of poles for hanging backdrops and props (fig. 1.9). The two sections stood on a connected steel platform that could be rotated 180 degrees on a pivot below the camera shed, once again to follow the sun's path. As in the Black Maria, the camera could be moved on tracks to and from the stage. Production began in mid-1896, and by the fall Dickson had already produced a small catalog of films for the company's Mutoscope exhibitions.[71]

The new studio produced a similar aesthetic as its predecessor. Although Dickson did not equip it with the deep black recess that defined the Black Maria's films, he continued to use a stark black backdrop that, thanks in part to Eastman's increasingly sensitive film, still rendered

FIGURE 1.9 American Mutoscope and Biograph Company Rooftop Studio, ca. 1896. From Frederick A. Talbot, *Moving Pictures: How They Are Made and Worked*, 104.

performers in sharp relief. In films with familiar vaudeville subjects such as *Sandow* (1896; fig. 1.10) and *Chimmie Hicks at the Races* (1900), the new studio reproduced the framed aesthetic.[72] Other films produced at the studio reenacted the development from the basic to increasingly complex representational backdrops seen in Edison's films, all coexisting during the Black Maria's use up to 1903.

Dickson reproduced this studio form two more times for Biograph, first in London near the Thames in 1898, then in Courbevoie, France, in 1899. According to Spehr, the latter studios were less elaborate than their predecessors, but Dickson never entirely abandoned the basic rotating capacity that defined his original design.[73] The formal film developments engendered by these studios' architectural forms also expanded beyond Dickson's studios and film productions. The framed aesthetic that Dickson created in the Black Maria returned independently in the numerous workshops, laboratories, and other early film studios that produced the first moving images. Such continuity should come as little surprise given the similarity of the fundamental imperatives driving Dickson and other inventors and filmmakers. The abstract re-creation of moving objects within precisely controlled experimental environments shaped the creation of both early moving images and film aesthetics in many contexts.

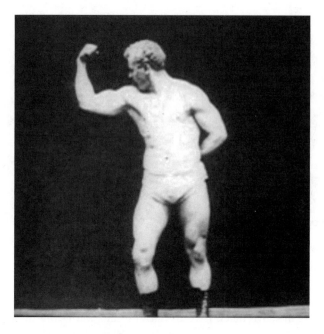

FIGURE 1.10 *Sandow* (Dickson, American Mutoscope and Biograph, 1896)

This process defined the genealogy of early studio space and film form, and it would continue to shape cinematic production into the early twentieth century, both inside the studio and out. In contrast to the cinema of attractions, which went "underground" around 1906 with the rise of film narratives, the framed aesthetic continued to shape film production through silent cinema and beyond.

CONCLUSION: FILM TECHNOLOGY AND THE HUMAN-BUILT WORLD, OUTSIDE THE STUDIO

Studio "enframing" remained important to cinematic picture making outside the studio walls. Much like painters and photographers before them, filmmakers left the studio with ideas about the nature of (film) space and techniques for representation that would be critical to how they framed

their non-studio subjects. As art historian Svetlana Alpers has argued, as early as the seventeenth century the studio became, for some artists, "not simply the site *where* they worked, but the very condition of working."[74] As later painters such as Paul Cézanne shuttled between their studios and local landscapes, their experimentation with light and form in the studio necessarily shaped the way they painted outside it.[75] For filmmakers such as Porter and White, the studio similarly conditioned their techniques for capturing film space, whether they were working in the studio or using its principles to guide their work on location. Born from and as spaces of technological and formal experimentation, studios offered filmmakers the space and conditions for developing their craft in ways that would shape representation beyond cinema's first working interiors.[76]

As quickly as inventors created the first film technologies in their laboratories and workshops, they left those spaces to test the new devices in the world outside. The environments they captured were no doubt subject to few of the constraints placed on the artificial environments created in the first laboratories and studios, but the cinematic results were equally technological. Whether fictional films or actualities, films made out-of-doors should be understood, like their studio-produced counterparts, as the product of human-built worlds. By mechanically reproducing the natural environment—to the awe of early spectators who were captivated by early actuality films such as Birt Acres and Robert W. Paul's *Rough Sea at Dover* (1895)—early filmmakers contributed to the process by which humans increasingly experienced space through technological mediation.

Conditioned by the contexts of invention and industrial development that produced early film technologies, the first filmmakers left the laboratory and studio with devices and techniques ready-made for framing and *enframing* the world outside through both a literal and metaphorical technological lens. Not surprisingly, the subjects they filmed often included the spaces and technologies that contributed to the transformation of the modern Western world. From common scenes of workers leaving the factory to trains, bridges, and tunnels, the modern built environment offered a perfect setting for early cinema. Films such as the Lumières' *La Sortie des usines Lumière* (1895), Edison's *Union Iron Works* (1898), and countless others made by companies including Pathé in France and Mitchell and Kenyon in Britain, produced recognizable scenes of industrial

experience.[77] Railroad films, such as Edison's repeatedly remade *Black Diamond Express* (1900), and films of flying machines, steamships, and automobiles both cataloged and, especially in the so-called "phantom rides," reproduced the conquest of space and time experienced in modern forms of travel.[78] Films of civil engineering feats such as Edison's *Passaic Falls* (1898) similarly emphasized the spread of technological conquest in urban and rural settings alike.

Featured categories in early film catalogs such as the "machinery" film, the "industrial," and "railroads" attest to these subjects' popularity. Such films both reflected and contributed to the experience of modern space as increasingly technological, urban, and artificial, an experience that was celebrated at international expositions and in the films that documented them. At the Paris 1900 Exposition, for instance, Edison Company producer James White, taking leave from the Black Maria, recorded stunning images of the architectural and technological novelties that captivated festival attendees and later film audiences, including the Palace of Electricity, the Eiffel Tower and its elevator, and the Exposition's moving boardwalks. These spaces and technologies offered filmmakers a seemingly ideal testing ground for the new film technologies produced in their laboratories and studios. In Paris, for instance, White used a new rotating tripod head to create panoramic films that offered viewers a technological experience of space that, although consistent with earlier experiences in panoramas and dioramas, constituted a new form of modern spatial experience. As Anne Friedberg has argued, these films reproduced the effect of the Exposition's transport technologies and created their cinematic equivalent through virtual mobility across space and time.[79]

The following year at the Pan-American Exposition in Buffalo, White and new Edison employee and future studio head Edwin S. Porter used the rotating tripod technology to produce similar cinematic effects in the "City of Living Light." Like the Exposition's extravagant electrical light display, these films referred, in Kristen Whissel's words, "to the subordination of nature by modern technology."[80] Each evening the Exposition lights were slowly brought to full brightness just before dark, only to be slowly turned off to reproduce the sunset. As one commentator described, "it is a new kind of brilliancy. You are face to face with the most magnificent and artistic nocturnal scene that man has ever made."[81]

In mid-October, Porter and White produced this event's cinematic analog, a panoramic testament to cinema's power to reproduce and control the effects of the sun. They created the film, *Pan-American Exposition by Night*, by commencing the panorama during daylight hours, rotating the camera approximately ninety degrees to face the Exposition's Tower of Electricity before turning the camera off to wait for the sunset; after dark, they turned the camera back on, continuing the pan at the same constant speed, thereby creating the effect of a sudden transformation from day to night.

The Edison Company catalog described the film as "pronounced by the photographic profession to be a marvel in photography, and by theatrical people to be the greatest winner in panoramic views ever placed before the public." As Whissel argues, it "simultaneously enacted and aestheticized technological modernity's transcendence of the natural order through electricity's disassociation of light from time."[82] This disassociation—produced at the very moment when White and Porter abandoned the Black Maria in favor of Edison's new studio in Manhattan—recalled the studio's own radical attempt to defy nature through film technology. The Exposition's reproduction of the effects of nature through the precise ordering of its technological environment paralleled the techniques used in contemporary film studios to replicate the effects of nature needed for film production. In their films of the Exposition, Porter and White took advantage of these conditions to build cinematic worlds that were continuous with the technologies on display both in the City of Living Light and, increasingly, in cities across the Western world.

The practice of choosing and changing the spaces of non-studio film production was repeated in less extravagant form in the growing practice of outdoor shooting that emerged at the turn of the century (and later on studio backlots). In extending their studio techniques to location filming, to what degree did these filmmakers also extend the studio's technological enframing of nature? As I suggested at the beginning of this chapter, Martin Heidegger's visual metaphor for technological enframing offers one way of understanding the relationship between film technology and nature outside the studio. As Samuel Weber describes, for Heidegger technology produced "the world *brought forth* and *set before* the subject, whose place thus seems secured by the object of its representation."[83]

Cinema did so literally: filmmakers secured views of the world and sent them back to fascinated audiences who came to know it increasingly through its photographic reproductions. As Mumford similarly described, as a "specific art of the machine," cinema provided an important way of experiencing the world that was consistent with the broader experiences of technological change. For Mumford, film gave its viewers a contradictory form of access to the fleeting experience of nature. Precisely by capturing it mechanically, cinema made nature newly accessible—as a technological "world picture"—to audiences conditioned by the technological experience of the modern world.[84]

This view of the relationship between cinematic technology and nature reflects the contradictions involved in early filmmakers' constructions of film space, first in the studio, but also in the changing built environment. With the Black Maria, Dickson created a remarkable machine for producing images through precise environmental control that was nonetheless constrained by the natural processes it sought to escape. The tension between technology and nature in film production would continue to condition the design of film studios into the new century, perhaps no more clearly than in the "glass house" studio designs inaugurated by Georges Méliès in France in 1897 and Robert W. Paul in Britain the following year. While these studios did not derive from the precision spaces and practices of laboratories such as Edison's, they shared a need for rigorous environmental control. Their designers created it by drawing on a different set of influences that contributed to new ways of generating, controlling, and manipulating film space. Even if the dictates of scientific observation and investigation were shed during the development of the studio as a space of film production, the strict regulation of space continued to shape the practices and forms of film, as well as the nature of film space—a highly regulated, ordered, artificial reproduction of the natural environment.

· 2 ·

GEORGES MÉLIÈS'S "GLASS HOUSE"

CINEPLASTICITY FOR A HUMAN-BUILT WORLD

IN DECEMBER 1937, only a month before his death, Georges Méliès recalled his early role in cinema's development with a characteristically bold exclamation: "I built the first studio in the world!"[1] Méliès was already recognized, much as he is today, as the inventor of "trick" or science fiction cinema, but in the waning moments of his life he felt compelled to lay claim to another title: the architect of the world's first film studio. True or not, Méliès could confidently insist upon his place at the forefront of cinema's initial forays into architecture.[2] In 1897 he had designed and oversaw the construction of the first French studio on his family's estate in the Parisian suburb of Montreuil-sous-Bois. Méliès's "glass house"— a greenhouse-like iron frame with plate glass tiles—represents the first instance of what would become the predominant studio form through World War I and into the 1920s.

Although based on similar aims as Dickson's Black Maria—especially precise control of light and temperature—glass studios developed from a different architectural tradition that had important effects on the first studios' forms, functions, and film products. This chapter situates Méliès's glass house in the history of glass-and-iron architecture, with emphasis on three building types that shaped early studio design: winter gardens and international exposition structures such as London's Crystal Palace (1851) and the Galeries des Machines that wowed visitors at Paris's nineteenth-century expositions; the glass-and-iron photography studios found on Paris rooftops in the second half of the nineteenth century; and industrial spaces such as rail stations and factories that used large glass

windows and iron-supported frames to bring light and air into increasingly large interiors.

The first glass-and-iron studios and the films made in them reproduced the formal characteristics and oft-cited experiences that fascinated critics and theorists of late-nineteenth-century architecture: spatial plasticity, fluidity, and artificiality. They housed early cinema's most celebrated formal innovators, including Méliès and Ferdinand Zecca in France, Robert W. Paul and G. A. Smith in Britain, and Edwin S. Porter in America. Departing from the Black Maria's "framed aesthetic," these filmmakers developed the formal techniques that later inspired critics such as art historian Elie Faure to celebrate cinema's "moving architecture" as an "art of cineplastics [*la cinéplastique*]."[3] The spatial manipulations and abstractions that defined this budding cinematic plasticity were of a kind with the artificial materials underpinning glass-and-iron studio architecture. Just as glass and iron could be forged, shaped, easily transported, and applied to a growing variety of architectural forms and building practices, so glass studios allowed for a diverse set of formal techniques and cinematic innovations in both content and style. Glass and iron opened the studio to passing figures, objects, and most importantly, sunlight. And in turn, the new films "opened" film space to new types and degrees of motion across the frame's borders, within the frame itself, and across multiple locations. Put simply, versatile studio spaces fostered filmmaking experimentation. In the years that followed, film's early experimenters would, in turn, help inspire new studio designs.

Beyond these formal developments, the first glass studios also contributed to developments in set design and storytelling that allowed filmmakers to produce stunning responses to the changes shaping modern life and the "human-built world." Méliès's Jules Verne–inspired "voyages extraordinaires" represent only the most apparent examples of this period's widespread fascination with and commentary on technological changes to the built environment. His use of cinematic technologies—including the studio—offers important insights into how films simultaneously used and represented the technological developments that produced cinema in the first place. By examining Méliès's science fiction and trick films in relation to the origins of his studios, this chapter recasts Méliès as more than a magician-turned-filmmaker or special effects innovator. Armed with an

imaging technology and a built space that could reproduce, record, and transform the varied and shifting built world, Méliès became an insightful observer of the technological environment of modernity and posed film as an *interpretation* as much as a *representation* of that new technological environment.

A HISTORY OF THE "GLASS HOUSE": IRON AND GLASS ARCHITECTURE IN THE NINETEENTH CENTURY

The "glass house" film studio must be understood as part of a long history of glass architecture and industrial technologies that set the stage not only for cinematic experience, as film historians have often noted, but also for film's first production sites and the conceptions of space and artifice that they engendered. Closely following the developments of the Industrial Revolution, architects and engineers used new materials to fill increasingly large spaces with natural light, while also sheltering them from rain, snow, cold, and, with the addition of ventilation and cooling systems, heat. Historians of technology have argued that these changes marked the climax of the greatest technological revolution in history: the construction of artificial, human-built worlds.[4] Iron-and-glass architecture and glass house film studios were quintessential products of that revolution.

The first glass house—an iron conservatory in Stuttgart—was completed in 1789, the same year that James Watt perfected the steam engine, the machine that literally drove the large-scale iron projects of the nineteenth century.[5] By the mid-nineteenth century, a period of large-scale and increasingly complex building led to new spatial designs and structural techniques, the mass production of iron, and, after 1870, the availability of cheap steel. Structures such as the monumental Jardin d'Hiver in Paris (1848) and Joseph Paxton's Crystal Palace (1851) matched the artificiality of their materials with their unprecedented designs.[6] Foremost among these buildings were the series of Galeries des Machines built at the Paris expositions of 1855, 1867, 1878, and 1889.[7] The Galeries opened architectural frames for light and movement, creating spaces that required, in Sigfried Giedion's words, "new aesthetic reactions."[8] Commenting on the 1878 Galerie, for instance, French architect Louis-Auguste Boileau

neatly encapsulated contemporary visitors' inability to comprehend the new materials and forms. "The spectator is not aware of the weight of transparent surfaces," Boileau wrote. "These surfaces are to him [*sic*] air and light, that is to say, *an imponderable fluidity*."[9]

The "imponderable fluidity" of interiors seemingly enclosed by nothing more than "air and light" created new visual aesthetics and spatial paradoxes that helped define the modern built environment. The widespread use of iron and glass in the second half of the nineteenth century made brightened spaces of fluid motion a common experience in Western cities. Parisian architects notably used iron and glass in François Duquesney's Gare de l'Est station (1847–1852), Henri Labrouste's Bibliothèque Nationale (1858–1868), Victor Baltard's Les Halles market pavilions (1853–1855), and Eiffel and Louis Charles Boileau's Magasin au Bon Marché (1876).[10]

By the early twentieth century, these new forms—which seemed to confound traditional distinctions between interior and exterior, public and private, and nature and artifice—had become a source of fascination for architects and critics. As Wolfgang Schivelbusch argues, the use of "ferro-vitreous architecture created a novel condition [in which] light and atmosphere were . . . no longer subject to the rules of the natural world."[11] Critics located these tensions in new building materials. In a 1907 treatise on iron construction, German architectural historian Alfred Meyer, for instance, argued that, "iron inspired a certain distrust because it was not immediately furnished by nature but instead had to be artificially prepared as a building material."[12]

Meyer's recognition of the "distrust" created by mechanical synthesis would be an important source of inspiration for Walter Benjamin's *Arcades Project*. Continuing in the vein of his earlier and better-known argument about the ontological status of art in the age of photography and film, Benjamin uses Meyer to make a similar argument about architecture. Just as mechanical reproducibility displaced artworks from their natural state, so too it would transform both the practice and character of architecture. To wit, iron's "technological derivation," Benjamin recognized, did more than simply modernize building materials. It altered the very character of modern technological space by becoming, in Benjamin's words, "the signature of everything now produced."[13] Those changes

escaped neither nineteenth-century architects and observers (like Boileau) nor the public who experienced them *en masse.*

Inspired by Benjamin, film historians have shown that these architectural developments set the stage for cinema's emergence. Three decades before the architects, filmmakers, and theorists of modernism debated the realities of architectural and cinematic spaces, iron-and-glass buildings shaped visual perception and institutionalized practices of viewing in the spaces of the modern city. Architectures of spectacular display and new technologies of movement—from window shopping, museums, and the Paris Morgue to panoramas, elevators, and moving walkways—reconfigured spatial and perceptual experience for the urban inhabitants who soon became film's first spectators.[14]

In their tendency to focus on film exhibition and reception, however, scholars have overlooked the degree to which nineteenth-century architecture simultaneously shaped cinematic production. Indeed, the cinematic spaces that urban modernity would condition most directly would be the first studios. For early spectators, film viewing often meant gazing (unknowingly) back into glass-and-iron worlds not unlike the ones they left behind when they stepped from arcades, department stores, and exhibition halls into darkened theaters.

MÉLIÈS AND THE FIRST FRENCH FILM STUDIO—MONTREUIL-SOUS-BOIS, 1897

The virtual circuit linking Paris's arcade-goers back to film's glass-and-iron production studios ran through the Méliès estate on Paris's eastern periphery. In May 1896, Méliès began making films in the garden of his family's property and at locations around Paris.[15] Although he produced eighty films that year, Méliès found outdoor production laborious and inefficient due to the often-changing weather conditions that destroyed his sets and ruined his exposures. Finally, as he would later write, "I was becoming famous, success seemed assured, and a quite simple idea came to me: to avoid all of that, let's take shelter."[16] Méliès's seemingly simple decision to escape the vagaries of the often moist Parisian skies marked a profound shift in cinematic production—the decided movement away

from the natural environment and toward the artifice of studio sets—that filmmakers and theorists would debate into the 1920s and beyond. Like Dickson before him, Méliès recognized the competing demands created by film's reliance on natural light and the filmmaker's need to regulate the production environment. He sought to resolve this tension through studio architecture.

Méliès designed the studio himself using his Théâtre Robert-Houdin and contemporary photography studios as a guide. After hiring a carpenter to build a wooden frame, Méliès faced a major and costly setback that Dickson had avoided by electing to enclose the Black Maria in wood and tarpaper: the frame was too weak to support the glass panes for the walls and roof. Discouraged but resilient, he elected to reinforce the wooden frame with iron rather than rebuilding from scratch, doubling his already large investment to 70,000 francs (fig. 2.1).[17]

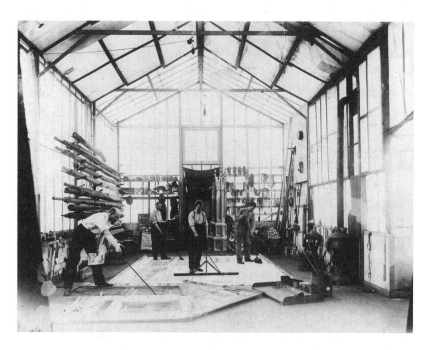

FIGURE 2.1 Studio A, interior, taken facing away from the stage. Méliès is the leftmost figure. The absence of a cavern for the camera indicates that the photograph was taken before 1900. (Cinémathèque française, Bibliothèque du film, Service Iconographique)

FIGURE 2.2 Georges Méliès, Studio A (ca. 1897). (Cinémathèque française, Coll. H. Langlois. Bibliothèque du film, Service Iconographique)

In its initial form, the studio consisted of a simple quadrilateral frame, 17 × 6 meters with 4-meter-high walls and a triangular roof that reached six meters (fig. 2.2). Méliès covered all sides in frosted glass with the exception of several rows of transparent glass facing the stage, and he oriented the studio to the south-southwest so that the stage was frontally lit at approximately one o'clock each day. In order to control the amount and direction of light, he equipped the studio with retractable cloth shutters as well as a darkroom for developing film.[18]

Historians have almost exclusively associated Méliès's first studio with his Théâtre Robert-Houdin, emphasizing the ways that the studio replicated the stage setup, trap doors, rollers and winches, and electric projectors found in the theater.[19] But while Méliès did note the similarities between his studio and the Robert-Houdin, he also emphasized their key differences and highlighted the importance of photography studios. In the same often-cited text in which he describes the studio as "a small-scale likeness of a *théâtre de féerie*," Méliès first compares it to a photographic

studio "in gigantic scale."[20] Indeed, the photography studio was a more important spatial precursor.

Photography studios had become a recognizable feature of the Parisian landscape in the second half of the nineteenth century. As art historian Elizabeth Anne McCauley has described, commercial photography studios spread rapidly in the late 1840s and reached their peak of production in the late 1860s, with 368 studios in Paris in 1868. By the mid-1880s, the number of studios leveled off at just over 300, a figure that remained consistent through the first years of cinema.[21] For photographers, the studio offered practical solutions for regulating both the shooting space— using lighting and climate control—as well as the spaces depicted in their images. Like cinema in its first decade, photography depended on vast amounts of sunlight for its lengthy exposures, and entrepreneurs seeking suitable lighting conditions would purchase or rent the upper floors of existing structures, where they added glass-and-iron enclosures.[22]

Historians have rarely noted these photographic spaces' influence on early cinema, even within the plentiful work on the ontological relationship between film and photographic media.[23] This neglect has obscured the important influence on early cinema that came not only from modern spaces of urban exhibition and spectacular experience but also from spaces of image production. In their material similarities to glass-and-iron structures such as train stations and market halls, photography studios reflected and contributed to the artificiality, opening and fluidity of space, and incorporation of light that defined modern space more generally. And as spaces of image production, they provide a more direct link between these themes and the creation of moving-image worlds.

What's more, photography studios trouble common assumptions about what cinema took from photography—namely, indexical realism. Especially in its studio form, cinema also inherited photography's capacity for both creating spectacular fiction and making the unreal look real. In each medium, the artificiality of the studio provided the basis for indexical reproductions of unreal productions, the results of which struck a delicate balance between realism and artifice. That balance would become crucial to early cinema, perhaps no more so than in Méliès's films. While many historians have tied Méliès's filmmaking to his magical stage work, his blending of realism, artifice, and spectacle

had as much to do with nineteenth-century photography studios as his theatrical experience.

Méliès likely forged a mental link between theater and photography long before he ever imagined moving images, much less a studio for producing them. From his earliest days as a spectator and later as a magician at the Robert-Houdin, Méliès would have found theater and photography housed under the same (glass-and-iron) roof.[24] Since the 1850s, the building at 8, boulevard des Italiens housed theatrical productions on the first two floors and photographic reproductions above. In 1854, André-Adolphe-Eugène Disdéri, portrait photographer and inventor of the *carte de visite*, set up his studio above the Maison Robert-Houdin.[25] This magic theater and part-time diorama show was managed by Robert-Houdin's brother-in-law and fellow magician, Pierre Etienne Auguste Chocat.[26] The building itself offers a striking instance of the spatial links between spectacular displays that characterized the experience of "modern life" in the latter half of the nineteenth century in Paris. Positioned in the heart of the city's burgeoning boulevard culture, it encompassed theater, magic, and diorama shows, scientific and technical exhibitions (including electrical automata and the first public demonstration of the telephone in 1878), and Disdéri's photography studio, the largest in Paris at the time of its opening.[27]

Disdéri remodeled the studio in 1860 to bring a new, more holistic spectacle to the portrait sitter's visit. The experience began at the street, where visitors passed through "a Moorish door in an oriental façade . . . up a well-carpeted staircase, by Hamilton's [Robert-Houdin] theatre on the second floor, and into the first of Disdéri's three waiting rooms," which he filled with exotic objects, paintings, and sample cartes de visite.[28] The Robert-Houdin offered one magical view in an entrance that, like earlier nineteenth-century attractions such as Etienne-Gaspart Robertson's phantasmagoria (first opened in 1799), used a series of displays to condition the visitor for the main attraction to come—in this case, the uncanny spectacle of photographic reproduction.[29] As with Robertson's phantasmagoria, as visitors moved past the magic theater to Disdéri's studio, they found themselves positioned in the interstices of science and superstition, rationality and spectacle, and photography and magic.[30]

The tension between reality and artifice established in the entryways would have been most marked, however, in the studio itself. Here, Disdéri combined the indexical certainty promised by mechanical reproduction with an artifice guaranteed by backdrops, props, and costumes. This combination signaled the spatial paradoxes of the studio's materiality—the same uncanny blending of interior and exterior that characterized contemporary observers' accounts of other glass-and-iron structures. The artificiality of the materials used (glass, iron, props, costumes, and the camera itself) betrayed architecture and photography's respective dissociations from both the natural environment and indexical reality.[31] The same paradoxes and tensions would come to define glass-and-iron film studios and their films.

UNE CHUTE DE CINQ ÉTAGES—REALISM AND SPECTACLE, MÉLIÈS AND THE LUMIÈRES

To what degree might Méliès have been conscious of these conditions? Do his films—marked, as they so often were, by experiments with space, time, and technology—betray a canny awareness of the changing qualities of modern spaces and materials? In 1906, Méliès produced a film titled *Une Chute de cinq étages* (*A Mix-Up in the Gallery*) that put these conditions to comic use.[32] The film's setting—a rooftop photography studio—suggests that Méliès did, in fact, reflect upon the character of the spaces of modern image making and perhaps his own studio's origins.

Disguised with a long beard and wig, Méliès plays a studio portrait photographer whose boisterous demeanor recalls frequent characterizations of photographers as hucksters.[33] The film begins with a stereotypical shoot in which Méliès's efforts to take a couple's portrait are thwarted by an incompetent assistant who first drops a stack of sample photographs, then, just after Méliès uncovers the lens to record an image, falls from a ladder, knocking everyone to the floor and sending the camera flying out the window. In the second scene, set on the street below, the camera lands on an unsuspecting woman who is mistaken by bystanders for a beast with tripod legs for horns. After knocking over a lamppost, the woman/beast "battles" an épée-weilding *gendarme* before being unmasked and rolled

off in a wheelbarrow. Just behind her, the couple from the studio beat a quick retreat despite Méliès's pleas to return (instead, they return him a parting kick in the pants). The film concludes with the photographer tumbling through the street over the remains of his shattered apparatus.

Although easily overlooked among his more canonical trick films and longer narrative subjects, the film suggests a great deal about Méliès's studio production. First and foremost, it points to his knowledge of photographic studio designs and to the similarities between the forms and functions of photography and film studios. The first scene's mise-en-scène reproduces a rooftop studio in striking detail. Méliès created the scene using a painted backdrop for the studio's rear wall and roof, a wooden frame for its left wall, and a cluttered wall of real shelves, paintings, and books on the right. The backdrop depicts distant rooftops seen through simulated glass and includes drapes on two of the painted rooftop panes that mimic the method Méliès used to control light in his film studio. This backdrop extends to the left of the frame, creating an illusion of depth and transparency behind the open wooden skeleton of the left wall, the materiality of which becomes clear when the camera goes through the window in the film's title "*chute*" (fig. 2.3).[34]

By setting the film in a photography studio, Méliès subtly reveals the kind of artifice that filmmakers—like photographers—used to produce image spaces, realistic or otherwise. The set features all the trappings of a studio like Disdéri's: a sculpture of a ballet dancer, a faux-marble column, oil paintings, a table of photographs, and the portraitist's painted backdrop of a natural setting—precisely the artificial objects that allowed photographers to generate artificial scenes. In Méliès's film studio, these objects served a dual function. The backdrop and props replicate a "real"

FIGURE 2.3 *Une Chute de cinq étages* (1906)

photography studio, making the film realistic, while also emphasizing the artifice of the film studio—a space built from artificial materials that uses artificial objects to generate artificial screen worlds.

Put another way, the rooftop photography studio becomes a symbolic representation of—or *mise-en-abyme* for—the film studio, with Méliès the photographer standing in for Méliès the *cinema*tographer. As a substitute for the film studio in which it was shot, the photography studio offers viewers a glimpse into the artificial film world that most often lies hidden just beyond the frame lines. Like a film set, the photographer's shoot generates a virtual world using an imaging machine, props, and a simulated background scene, all subtended by a regulated image-making environment. The photographer's painted backdrop fittingly depicts a nature scene that promises to transport the clients (and the future photograph's implied viewers) out of the confines of the glass-and-iron studio (and indeed out of the built world) to a more natural environment. In the same way, filmmakers such as Méliès used painted backdrops to transport viewers into artificial but seemingly natural worlds beyond the screen. At a moment when architecture and technology pushed nature further from everyday urban experience, cinema offered its own contradictory access to the natural environment through imaging technology. The painted backdrops used in this film—the glass-and-iron wall that mimics reality and the natural scene that reveals its artifice—underscored the illusionary effect of the film's set by reminding the viewer of how this artificial reality was created (and implying that the illusion could easily come crashing down).

In addition to this subtle entry into the artificial world of studio filming, the film also stages a number of the paradoxes that film and photography studios shared and invites a further reconsideration of the distinction so often made between fiction films and actualities in early cinema. The film's intricate layering of backdrops and its simulated architectural frame would have been difficult to complete outside of a dedicated studio. But these spatial manipulations reveal more than just the versatility that the studio provided to filmmakers seeking to create compelling realistic and/or fantastic displays. They also suggest the ways that filmmakers such as Méliès focused—often before any concerns with narrative—on fabricating spatial illusions that re-created the paradoxes of space in the modern built environment.

In this film, Méliès plays on the collapsing distinction between interior and exterior and the uncertain materiality of glass-and-iron architecture. He highlights the simulated studio's boundary between inside and out by literally projecting the image-making apparatus through the "glass" surface and into the city below. This movement of the camera becomes a kind of metaphor for the fluidity that contemporary observers identified in modern spaces. In an instant, the faux-glass wall—which initially seems like a stable divider separating the photo studio scene from the film studio around it—is revealed to be both material and traversable. What seemed like little more than a simulation—another painted world—acquires a new degree of realism and becomes an active component of the film's staged reality. That it does so in the moment of recording—just after the diegetic Méliès-photographer opens the lens to activate the recording apparatus—seems apt, as if Méliès means to illustrate the dynamic interaction between pro-filmic spaces and the machines that turn them into lively virtual worlds.

The subtle references to the filmmaking process continue as the film shifts to its second scene on the boulevard below.[35] Here, Méliès turns the common distinction between studio-produced fiction and urban actualities on its head through what might be read as an implicit reference to urban filmmaking and even to the Lumières. Such a reading is supported by the history of the photography studio above the Robert-Houdin, a history that includes a seldom-acknowledged link between Méliès and the Lumière family business.

By the time Méliès took over the Robert-Houdin, Disdéri had gone bankrupt several times, opened a second rooftop studio in the adjoining building, and, in 1875, departed for Nice, leaving both studios in the hands of new photographers.[36] During the spring of 1895, another notable photographer moved into the studio on Méliès's roof. Clément Maurice, a former worker at the Lumière factory in Lyon, took over the studio as part of his continuing work for the Lumières in Paris.[37] Maurice organized the famed first public screening of the Cinématographe at the Salon Indien, and Antoine Lumière, father of "les frères," reportedly invited Méliès to the screening outside the Robert-Houdin after one of his frequent visits to Maurice upstairs.[38] Remarkably, at the moment of cinema's "birth," the nominal inventors of cinematic realism and fiction

shared an address. Their physical proximity evokes the close relationship and often-porous boundaries between realism and spectacle that photography and early cinema shared, especially, but not exclusively, in their studio-produced forms.[39]

Méliès highlights this mix of realism and spectacle in the second scene of *Une Chute de cinq étages* by overturning the idea of the Lumière operator who simply documents *actualités* for a spectator who is invited to view these scenes as reproductions of reality. Instead, the camera itself becomes the event of spectacular chaos and misapprehension—perhaps a joke about the chaos that street filming caused in this period.[40] The bystanders' confused response to the woman-as-beast implies the kind of staged illusion that often structured the *actualité*'s depicted reality. Whether or not the film is a direct reference to the Lumières or Clément Maurice, it draws a striking comparison between the "fictional" and "real" settings of the studio and the street. Like the juxtaposition of Méliès and the Lumières at 8, boulevard des Italiens, the film's two scenes suggest that fiction and reality were never far apart in early film production. Neither the studio nor the street offered privileged access to the real or its imitation. In a metropolis increasingly marked by artificial spaces and synthetic materials, filmmakers recorded unnatural scenes with every turn of the "manivelle."

BUILDING CINEMATIC SPACE IN THE GLASS HOUSE—
ARCHITECTURE AND EARLY FILM FORM

Méliès's studio played a significant but underappreciated role in his development of a multifaceted system for constructing and manipulating cinematic space. Indeed, it seems no coincidence that many of cinema's earliest formal innovators were also the first to work in glass-and-iron studios: Méliès in 1897, R. W. Paul in 1898, G. A. Smith in 1899, Cecil Hepworth in 1900, Edwin S. Porter in 1901, and Ferdinand Zecca at Pathé's new studio beginning in 1902.[41] Here, Méliès developed not only the "tricks" for which he is typically remembered but also multi-shot films, entrance and exit continuity of characters and objects across shots, dissolves and fades between shots, and basic narrative structures.

Although historians have noted that the studio contributed to Méliès's technical proficiency, they have only begun to explore how the studio may have affected cinematic form. Barry Salt, for instance, has argued that the studio, by providing a consistent working space, made Méliès's understanding of spatial continuity possible.[42] But while Salt is right that Méliès's studio gave him an element of continuity that was initially (although not for long) rare for other filmmakers, he too quickly moves past the pressures that the studio itself put on how action was shot and space constructed.

The studio provided more than simply a site for repeated filmmaking, which many filmmakers used even as early as 1897, whether on rooftops, makeshift outdoor stages, or gardens, not to mention Dickson's Black Maria. As direct physical links to the changing architecture of the late nineteenth century, the studios also placed filmmakers and filmmaking in the framework of that period's new conceptions and uses of space. In Méliès's case, the fluidity, plasticity, and artificiality that defined architecture would reappear in both the content and form—the early roots of Elie Faure's notion of "cineplastics"—of his studio films.

Much like the "imponderable fluidity" that visitors identified in international exposition halls, Méliès's early trick films were remarkable, in no small part, because of the new forms of spatial dynamism they generated. These films worked by demonstrating the new medium's ability to activate pro-filmic spaces in ways that made their on-screen corollaries "imponderable."[43] Having quickly identified the diverse kinds and combinations of movements that "moving images" offered, even without ever moving the camera during a shot, Méliès produced this imponderability through a dynamic tension between stillness and the fluid motion that linked his tricks, shots, and settings. The basis of his earliest innovation—the stop-action substitution trick, or jump cut—plays, for instance, on the tension between still and moving images.[44] By stopping the camera during shooting and changing some aspect of the mise-en-scène, Méliès could make objects and characters appear, disappear, and transform in ways that generated dynamic on-screen worlds.

Such dynamism depended on precise control of the pro-filmic environment. For Tom Gunning, Méliès's use of the substitution effect created narratives of "non-continuity" in which transitions from shot to shot are

"emphasized (and explained) by a discontinuity or disruption on the level of story."[45] Such dis- or non-continuity did not define the films' spaces. Rather, their success came from the spatial (and narrative) continuity that framed the films' hidden suspensions, or cuts.[46] These films' magical transitions seem so magical because the pro-filmic space in which they were performed remains unchanged. In other words, precisely regulated, unmoving, stilled studio interiors made fluid transitions possible.

The difference is easily seen if one compares an early film such as *Escamotage d'une dame chez Robert-Houdin* (1896) with similar films made in the new studio. In the earlier film, shot, most likely, in the Montreuil garden, the key substitutions do succeed, but they appear as conspicuous interruptions more than smooth transformations. Within a year of opening the studio, in contrast, Méliès could emphasize the fluid seamlessness of the substitution trick by transforming objects in rapid motion. Films such as *Le magicien* (1898) and *La lune à un mètre* (*The Astronomer's Dream*, 1898) feature endless streams of objects that appear, disappear, and transform with astonishing immediacy. Méliès would soon emphasize such tricks by transforming running and jumping characters and objects in mid-flight with a seamlessness that would have seemed unimaginable only months before. To be sure, this was, in part, a case of practice makes perfect. But by ensuring these tricks' consistent success, the studio helped encourage Méliès to repeat and revise them in future films.

The kind of dynamism generated using these tricks helped define many of the films' story worlds. In films with such titles as *Le Château hanté* (*The Haunted Castle*, 1897), *L'Auberge ensorcelée* (*The Bewitched Inn*, 1897), and *L'Auberge de bon repos* (*The Inn Where No Man Rests*, 1903), Méliès used the studio's regulated environment to create irregular diegetic ones. In worlds that transform with a rapidity and irregularity that pushes characters to madness, objects flip, turn, expand, contract, change locations, or simply disappear. Méliès repeated this basic scenario throughout his career, even up to his last film, *Le Voyage de la famille Bourrichon* (1913).[47] In other films, characters themselves transform their surroundings, typically in order to fool or torment their adversaries. In *Le Tripot clandestine* (*The Scheming Gamblers' Paradise*, 1906), for instance, crooks alter their gambling den to outwit the police, and in *Le Locataire diabolique* (*The Diabolical Tenant*, 1909), a man deceives

his landlords by magically filling and emptying his apartment with items taken from only one suitcase. These spatial transformations would become even more complex in Méliès's multi-shot films, but already in his single-tableau works, Méliès used substitutions not only for magic tricks taken from his stage acts but also to create a spatial dynamism that appears across his oeuvre.

The critics and theorists in the 1920s who recognized film's unique ability to manipulate space were often simply recognizing the outgrowth of these kinds of formal developments from the 1890s. Indeed, the "new plastic impressions" that astonished Elie Faure at his local cinema make for a fitting definition of the spatial plasticity first seen in Méliès's films. To use Faure's words, the cinematic space produced in Méliès's studios was "ceaselessly renewed, ceaselessly broken and remade, fading away and reviving and breaking down, monumental for one flashing instant, impressionistic the second."[48]

The on-screen space that appeared in Méliès's films was consistent with a studio space in which anything was possible—a blank slate that could be remade in any desirable form. This functional plasticity echoed the architectural plasticity that underpinned the studio's very existence. Although long prefigured by theatrical stage sets and artists' studios in which props and backdrops could simulate worlds of all sorts, the studio reproduced a new kind of plasticity that was proper to industrial modernity. The interchangeability of modular glass-and-iron structures defined a new plasticity formed from the synthetic ("untrustworthy") materials that Walter Benjamin recognized as part of a world changed by mechanical reproduction. Méliès's films represented the logical extension of that world and the plastic spaces—like his studio—that it produced. Put another way, the studio's function followed its form.

The films' form—their *cineplasticity*—followed the studio's formal and functional plasticity. Much as stop-motion substitution generated spatial dynamism by activating the studio's blank slate, two of Méliès's other common effects—multiple exposures and matte inserts—created cineplasticity by using film technology to capitalize on the potential embedded in the studio's plastic pro-filmic space. Méliès used multiple exposures—rewinding the film in the camera and rerecording over already-exposed film—at least as early as 1898 in *Un Homme de tête*

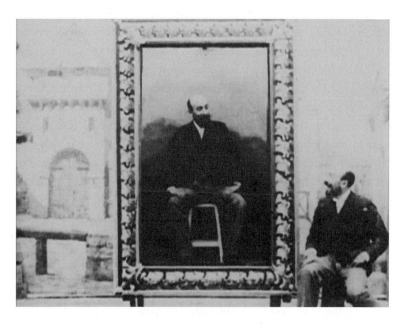

FIGURE 2.4 *Le Portrait mystérieux* (1899)

(*The Four Troublesome Heads*) to create the illusion of three disembodied heads singing while Méliès plays the banjo. Early the following year, he used a matte insert—again involving shooting on the same film stock multiple times but with portions of the emulsion masked—in *Le Portrait mystérieux* (*The Mysterious Portrait*, 1899) to create two Méliès figures on screen, one framed as if in a painting (fig. 2.4).

Using these techniques, Méliès created shifting screen spaces by combining different versions of the studio set in a single image. As Faure might have put it, this was the studio "ceaselessly renewed, ceaselessly broken and remade" on screen. Méliès reveled in creating multiple versions of himself, as in *L'Homme orchestre* (*The One-Man Band*, 1900), or transfiguring his image, as in *L'Homme à la tête en caoutchouc* (*The Man with the Rubber Head*, 1901). But he also emphasized his ability to generate worlds defined by impossible movement and fluidity. In *L'Homme-mouche* (*The Human Fly*, 1902), for instance, he uses a double exposure to combine two shots: one of several women standing in front of a black backdrop on opposite sides of the frame; the other taken from above the studio floor (which is

painted to look like a wall) on which an acrobat performs stunts. The double exposure creates the effect of a man who defies gravity to walk (or fly) on the wall while the women look on in amazement.[49]

In other films, Méliès uses the transparency created by the double exposure to animate the space with ghosts, phantoms, and apparitions that fly across the top of the frame. In films such as *La Guirlande merveilleuse* (*The Marvelous Wreath*, 1903) and *Le Coffre enchanté* (*The Bewitched Trunk*, 1904), for instance, he uses double exposures combined with dissolves to make characters float in midair and slowly appear or disappear. As with the substitutions, these films play on the spectacle of magically produced presence and absence, here further animated by "reviving and breaking down" the space through the dissolve.

Just as the studio's glass-and-iron architecture presented unique spatial qualities and aesthetics in the unity of interior and exterior, so Méliès produced dynamic cinematic spaces by blending contrasting studio sets into a single film image. He most often relied on black backgrounds—akin to Muybridge and Marey's motion studies and the Black Maria films— to create locations in the frame that could be transformed. These blank frames within the frame—typically in the form of doors, windows, or fireplaces, but also picture frames, cavern walls, and the night sky—recur throughout Méliès's films and may be the dominant characteristic of his décor.[50] Indeed, his 1903 film *Le Portrait spirite* (*Spiritualistic Photographer*) suggests just how accustomed audiences must have become to Méliès's combination of black backgrounds and dissolves (fig. 2.5).

FIGURE 2.5 *Le Portrait spirite* (1903)

The film begins with an announcer holding up two signs (in French and English) that read: "Spiritualistic Photo. Dissolving Effect Obtained Without Black Backdrop. Great Novelty." Méliès then uses a framed white background to dissolve an actress dressed as a sailor into her own drawing on the white canvas. The film's "great novelty" is somewhat exaggerated—the main change in the trick is the color of the background. But the film nonetheless shows how consciously Méliès explored new techniques to manipulate film space. Whatever their color, the blank sections Méliès used to produce this cineplasticity served the same function as the studio itself, which became a kind of what Michel Foucault termed the "heterotopia," a unique and typically modern space that could be transformed to fit any purpose or serve as any location.[51]

As he shifted to multi-shot films, Méliès's cineplastics became even more pronounced as the studio began to function not only as a different location for each new film but also for related locations that had to be linked within a single film narrative. The multi-shot film allowed Méliès to expand his creation of cinematic worlds, while also requiring new formal techniques for making those worlds intelligible to audiences. Méliès became a key innovator in the development of a formal language for linking shots and locations (even if aspects of this language were abandoned later). Devices such as "correct" entrance/exit directions and dissolves between shots expanded Méliès's use of the studio space while also extending the fluidity and plasticity that he used in the single-shot films.

While the latter remained the norm until at least 1900 and multi-shot story films did not become common until around 1903, Méliès produced notable long examples in the pre-1903 period as well as numerous others in 1903.[52] As Richard Abel has noted, these early fairy tale films (or *féeries*) "forced Méliès to consider various means of producing spatial coherence through an episodic sequence of tableaux."[53] Given Méliès's work at his Théâtre Robert-Houdin and his use of stage actors in the films, there can be little doubt that he drew, at least in part, on the theatrical tradition for this spatial logic.

As Maurice Noverre has described, shortly after production began in 1897, Méliès modified the studio by adding features of the Robert-Houdin, including trapdoors, rollers, and winches. In order to retain the size of the tableau and utilize both the trapdoors from below and the winches from above, Méliès also dug a pit three meters below the stage, built a balcony

above, and raised the portion of the roof directly overhead. These features began to appear in films by 1898, and over the next two years Méliès also added a hanger for building and painting backdrops as well as annexes on each side with large doors to allow cars, trains, horses, and people to pass across the stage from outside.[54] With these additions in place, the studio became, as Méliès later described it, "a small-scale likeness of a *théâtre de féerie*."[55] The new features added to the spatial dynamism already being created through substitutions, double exposures, and matting effects by allowing characters to enter and exit from all sides of the film frame.

Méliès also used these stage devices to create new levels of depth and virtual movement within single shots. In *Faust aux enfers* (1903), for instance, Faust's descent into hell with Mephistopheles is represented through a series of changing scene décors. Méliès raises and lowers partial backdrops to move the characters incrementally through the cavern. Although the camera does not move, the changing set pieces create the illusion of movement into the depth of the frame. This film demonstrates that Méliès did not, however, simply use the studio to re-create theatrical scenes in single tableaux. In Faust's descent, Méliès uses a dissolve to reintroduce Faust and Mephistopheles into the cavern in a new shot. Similarly, in the final tableau of *Barbe-bleue* he uses the trapdoor to raise cutout ghost figures of Blue Beard's dead wives that are then transformed by a jump cut into live actresses.

While Méliès's use of theatrical devices helps to explain how he developed his conception of cinematic space, the theater was only one influence on his formal strategies. Unlike the single-shot trick films, in which he maintained spatial continuity by retaining the scene's basic mise-en-scène across jump cuts or around matte inserts, for the multi-shot films Méliès faced the more complex problem of building an intelligible story world by creating spatial continuity between shifting versions of the studio's malleable interior. Salt and Gunning note that Méliès quickly identified the importance of entrance/exit directions for creating this continuity through mise-en-scène, with films such as *Le voyage dans la lune* (1902) becoming early prototypes for the continuity developed more fully in the "chase" film.[56]

Méliès also combined these strategies with the camera effects that he mastered in the trick films. An important example of such techniques is his use of the dissolve to transition between scenes. As others have noted,

Méliès did not use the dissolve to signify the passage of time but instead seems to have used it in part as an attraction that emphasizes the "trick" of having multiple shots at all.[57] Many critics have ignored Méliès's use of this device because, as Salt argues, it works against claims that Méliès "invented" classical editing forms. Those who do discuss the dissolve have dismissed it as a "dead-end" that was quickly replaced by the "more efficient" and soon standard straight cut.[58] But rather than seeing this technique as a failure to develop classical editing strategies, we should understand it as an important example of the ways that Méliès used editing to develop his conception of cinematic space.

Méliès used the dissolve as another means to create links between diegetic spaces, especially for an audience that could not necessarily be assumed to understand the spatial logic of the straight cut. Dissolves create a visual link between two unlike spaces, signifying their spatial unity by momentarily making them a single space on the screen, as in the scene in *Cendrillon* in which a dissolve links Cinderella's house with the ball, which she arrives at moments later. At times the dissolve also creates symbolism through spatial juxtaposition. In *Barbe-bleue*, for instance, after the queen leaves Blue Beard's forbidden chamber, the dissolve creates an image of his former wives' hanging bodies suspended over the now-sleeping queen, as if to show her dreams, or perhaps as a foreboding image of her possible future.

Given Méliès's well-known claim that the stories in his "narrative" films were only an excuse for staging tricks, we should be attentive to the ways that such strategies for linking shots were, like the tricks themselves, about the production of intelligible spaces for spectacular displays.[59] And despite Méliès's claims about his own disregard for narrative, we should also take note of the ways that his strategies for constructing space influenced the development of early narrative form. These strategies bear striking resemblance to the spatial characteristics of late-nineteenth-century architecture and the "imponderable fluidity" and plasticity that observers identified with it. The plasticity of the studio's shifting interior, combined with the various forms of fluidity that Méliès created both within and between shots, mirrored the flexible materials and versatile designs that gave form to glass-and-iron studios.

Thus while it would be too much to say that Méliès drew direct inspiration from the studio's semitransparent and malleable physical form for his

dynamic treatment of film space, two points should be underscored. First, the studio allowed Méliès to test his ability to generate dynamic on-screen worlds by manipulating the studio's interior. It did so by providing not just a consist location, but a controlled environment that facilitated technical precision thanks to consistent lighting, stable sets and cameras, a ready supply of props, and doors and windows that could be opened easily to move objects through the scene. And second, the technological changes that shaped the experience of fin-de-siècle architecture—especially spatial fluidity, plasticity, and artificiality—suggest new ways of conceptualizing Méliès's well-known tricks and formal innovations as recognizable components of the new spatial character of the modern built environment.

It should come as no surprise that filmmakers used the developing forms of illusionary, studio-produced realism seen in such films as *Une Chute de cinq étages* to explore the technologies that created modernity's new architectures and artificial spaces. Méliès had even greater motivation to do so. A son of industry, he grew up playing in his father's glass-and-iron-roofed shoe factory near Paris, where he later developed technical skills repairing factory machines. Although he ultimately rejected his place in the family business, his films nonetheless betray this industrial upbringing.[60] Many of Méliès's most popular films made new technologies and technological environments—both real and imagined—popular early film subjects. These films were also allegories for the possibilities and uncertainties created by new technologies, and by extension cinema itself. As urban populations adjusted to the artificiality of built space, cinematic technology offered a means both to reimagine the built environment and to re-create artificial worlds on the screen. In this context, Méliès's world-building became exemplary of a system of production and representation that would come to define studio cinema and which gave filmmakers an important means for evaluating technological change.

CINEMATIC TECHNOLOGIES AND TECHNOLOGICAL CRITICISM FROM THE "JULES VERNE OF CINEMA"

In the advertising campaign for *À la conquête du pôle* (1911), Pathé Frères, the rival company for whom Méliès ironically made his final films,

proclaimed Méliès the "Jules Verne of cinema."[61] The title is somewhat misleading. The film was loosely based on Verne's *Voyages et aventures du Capitaine Hatteras* (first published serially between March 1864 and February 1865), but it was one of only four "adaptations" of Verne's work, including *Le Voyage dans la lune* (inspired, in part, by Verne's story *Autour de la lune*, published serially in 1869), *Le Voyage à travers l'impossible* (1904, from the play completed in 1882 and staged in 1882–83), and *Vingt milles lieus sous les mers* (1907, published serially between 1869 and 1870).[62] Pathé must have hoped to build on the success of these earlier films and Verne's stories by linking Méliès's newest *voyage* with his earlier adaptations, all of which included thrilling representations of travel and technology.

Despite so few Verne adaptations, the "Verne" moniker remains suggestive because the Verne-inspired and other technology-themed narratives represent such a crucial and oft-celebrated component of Méliès's work. Such films demonstrate that Méliès was more than just a magician or special effects wizard. In his "voyages extraordinaires," as well as films depicting more familiar technologies such as trains and automobiles, Méliès proves to be an insightful commentator on the technologies that transformed the built environment.

In this respect, Pathé's Verne comparison underscores a key feature of Méliès's films. As many scholars have noted, Verne based the technological environments depicted in the *Voyages Extraordinaires* not on far-flung images of the future but on tangible components of late-nineteenth-century modernity.[63] Méliès's representations of technology similarly reflected contemporary concerns more than visionary predictions. If Méliès was the "Jules Verne of cinema," it was not because he created visions of the future or the unknown, but because he shared Verne's critical eye toward the technological cutting edge of their society.[64]

Like Verne, Méliès repeatedly used technological change, scientific discovery, and global exploration to guide his films and only rarely portrayed unknown or futuristic machines.[65] From *Visite sous-marine du Maine* (1898) and *Chirurgie fin de siècle* (1900) to *Le Raid New York–Paris en automobile* (1908) and *À la conquête du pôle*, Méliès drew his subjects from current events, technological developments, and scientific discoveries. While Méliès's representations do, at times, stray into seemingly

unfamiliar technologies (and carry travelers to unknown worlds), more often they represent forms of transit and technological spaces commonly found in turn-of-the-century Western cities.

In *Le voyage dans la lune*, for instance, the industrial landscape and machine workshop represent familiar sites of the Industrial Revolution—the same technological settings that produced the ideas about space travel that inspired Verne and Méliès. Méliès replicated these spaces in *Le voyage à travers l'impossible* and *À la conquête du pôle*, along with viaducts, railroad stations, ateliers, and laboratories. These familiar settings underpin both the known devices (balloons, automobiles, trains, submarines, and flying machines)[66] as well as the more fantastic scenarios (space travel, flying trains, lunar inhabitants, and polar monsters) that Méliès depicts. More importantly, they provide a frame for both the films' fantastic components and their critical portrayals of new and potential future technologies.

Méliès did not simply *populate* his films with new technologies; like Verne's stories, the films also cast a critical eye on the dangers and uncertainties that new technologies produced.[67] Indeed, Méliès rarely depicts a technology that does not put its users in peril. Such fantastical machines as the rocket to the moon in *Le Voyage dans la lune* and the flying train in *Le Voyage à travers l'impossible* suffer devastating crashes from which their passengers narrowly escape. Even more frequently, Méliès's characters suffer at the hands of such common technologies as automobiles, railroads, and the machinery in workshops, laboratories, and factories.

These kinds of technological disasters and workplace injuries were common in the late nineteenth century. Méliès likely based images of railroad catastrophes such as those depicted in *Le Voyage à travers l'impossible* and *Les Quatre cents farces du diable* (1906) on real events such as the June 1891 collapse of a railway bridge built by Gustave Eiffel near Münchenstein, Switzerland, in which seventy-three passengers died and 171 others were injured.[68] Such major accidents represent only the most memorable of a more pervasive experience of technological danger in urban modernity. As Ben Singer has shown, the turn-of-the-century pictorial press put the quotidian disasters of electric trolleys, automobiles, factory machines, and tenement architecture into stark, if exaggerated relief.[69] Méliès's representations of technological danger may

have been packaged in seemingly fantastic narratives, but they offered much more pointed criticisms and parodies of the technological hazards of modernity.[70]

The technologies Méliès depicted and allegorized also shared an intimate relationship to his studios. Much as he made contemporary machines and modes of transport the stuff of his films, so Méliès filled his fictional worlds with modern glass-and-iron spaces. From the photography studio in *Une Chute de cinq étages* to the glass-enclosed atelier in *La Photographie électrique à distance* (1908) and the machine shops in *Le Voyage dans la lune*, *Le Voyage à travers l'impossible*, and *À la conquête du pôle*, the spaces of the modern built environment that shaped Méliès's filmmaking world became the spaces of the films produced there. Not surprisingly, these spaces at times uncannily resemble the very studios in which they were produced. Such similarities underscore the degree to which the process of creating imaginary worlds *on* film was inextricably tied to the process of creating new worlds *in which* to film. In 1911 Méliès brought these two processes closer than ever in the production of *À la conquête du pôle*, the film for which he earned the "Verne" moniker and in which his second studio made the artificial worlds of cinematic production and representation one and the same.

STUDIO B AND *À LA CONQUÊTE DU PÔLE*—STUDIOS AS ARTIFICIAL (ON-SCREEN) WORLDS

In 1907 Méliès designed and built a second studio (Studio B) as an extension to the family home on his estate in Montreuil.[71] Méliès enclosed the roughly triangular structure in glass but also equipped it with Cooper Hewitt mercury vapor lamps for artificial lighting.[72] He built the new studio in an effort to take advantage of distribution offices established by his brother Gaston Méliès in New York and the company's impending inclusion in Edison's Motion Picture Patents Company. With the new studio in place, Méliès produced hundreds of films during 1907–1909, his most active period of production.[73] Within two years, however, he was on the verge of bankruptcy, had ceased film production of his own, and would make only five more films, ironically for his rival Pathé Frères.[74]

FIGURE 2.6 Méliès's Studio B doubles as an industrial workshop in *À la conquête du pole* (1911).

Among these Pathé productions was *À la conquête du pôle*, the longest (at thirty minutes) and perhaps most ambitious film of Méliès's career. Méliès's use of the second studio—both for the film's production *and* as a setting in the film itself (fig. 2.6)—typifies the close relationship between technological and cinematic production that he had helped establish more than a decade earlier.

À la conquête du pôle continues in the tradition of travel film parodies from Méliès's earlier career. In this case, Méliès lampoons the polar expeditions captured on film by adventurers and filmmakers such as Robert K. Bonine and Thomas Crahan for Edison in 1898, Baldwin and Ziegler for the Warwick Trading Company in 1901, and Sandon Perkins in 1908.[75] Méliès's Arctic voyage follows a Dr. Maboul (Méliès) and his crew (comprised of caricatured delegates from America, England, Germany, Spain, China, and Japan) as they construct a flying machine, suppress a group of suffragists who want to accompany them on their voyage, and avoid a series of technological disasters (and one Arctic monster) on their trip to

the North Pole and back. In many ways, the film merely reproduces the basic parodies and technological criticism found in Méliès's earlier *Voyages*. Its significance, however, lies in Méliès's use of the second studio as the centerpiece of what is arguably a subtle depiction of the spaces and practices of filmmaking, represented in the film by the creation of a flying machine.

The film opens in a reception hall (shot in Studio A, recognizable by its wood plank floor) with a brief survey of contemporary modes of transport. The would-be polar voyagers pitch schemes involving balloons, automobiles, trains, sleds, ships, and submarines before Maboul finally introduces his own bid to fly over the Arctic Ocean. His proposed aluminum and bronze "Aero-Bus" represents the most fantastic of the proposed machines, but once again reflects contemporary technological developments, in this case the well-publicized efforts of numerous aircraft designers such as French aviator and engineer Henri Farman to turn early flying machines into viable military tools and modes of transport.[76]

Following the selection of the Aero-Bus and its passengers, Maboul leads the crew on a tour of his laboratory and production facilities, a tour that also becomes a virtual presentation of the film's own production. Maboul begins the "tour" in his design studio, which is sparsely furnished with a drafting table, several small chairs, and drawings of planes and balloons. Here Maboul presents the crew with a model of the Aero-Bus suspended from the ceiling on thin strings. For the audience this demonstration (by Méliès, no less) offers a preview of the film's later flying sequences, in which Méliès uses the same model to simulate the voyage over the Arctic. This scene introduces a set of parallels—Maboul/Méliès and crew/audience—that structure the remainder of the film. As Maboul presents his factory and the construction of the flying machine to the crew, Méliès gives the audience a kind of behind-the-scenes tour of the film's production.

Maboul/Méliès, crew, and audience proceed from the model presentation into a large "electrified factory" (again in Studio A, fig. 2.7) with props and a painted backdrop that recalls the 1889 Galerie des Machines. A quick review of the factory machines sets up the next scene, in which the tour continues with an examination of the Aero-Bus flying machine's production. Here, in a smaller factory workshop (Studio A, fig. 2.7), eight

FIGURE 2.7 *À la conquête du pôle*: Studio A as the "electrified factory" and a workshop with the flying machine

workers put the finishing touches on the Aero-Bus. Maboul and the crew watch as two women in the foreground sew canvas for the machine's wings, a man shaves boards for its body, two others affix panels to the roof, and the man and child in the center of the frame prepare and apply solder to the machine's joints.

While this scene can easily be read simply as a representation of the Aero-Bus's construction, it also documents the production of the film's main prop: the life-size "flying" machine. Remarkably, the "characters" in this staged workshop are not only Maboul's workers; they are also Méliès's film crew. In this key scene, Méliès draws a subtle parallel between the preparation for the voyage in the film world and the production process in the studios.

Méliès's use of painted backdrops *and* Studio B itself as a diegetic space underscores this duality. The left edge of the workshop scene's backdrop resembles not only the 1889 Galerie's glass-and-iron skeleton but also the front wall and door of Méliès's second studio. The flying machine faces this simulated glass wall, anticipating the following scene, in which the completed machine is rolled out of Studio B (fig. 2.8).

Following the Aero-Bus's launch, the studio reappears several scenes later (fig. 2.6), this time viewed from the front, with doors open to reveal a group of men (the workshop/studio crew) who watch as a caravan of automobiles passes by. With the exception of the rolled-up tableau suspended from the ceiling, the space bears no ready markers of its cinematic

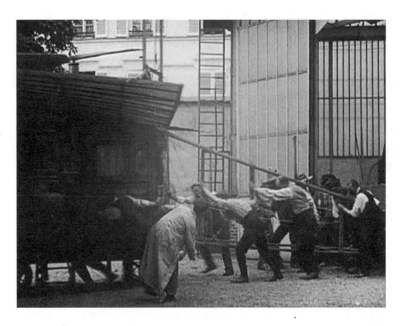

FIGURE 2.8 *À la conquête du pôle*: Workers roll the flying machine out of Studio B.

function. Rather, the glass-and-iron exterior, large hanging lights, and ladder reproduce the workshop space created earlier in Studio A using props and a painted backdrop. Méliès's choice to use the studio rather than painting another large backdrop is not surprising—the studio easily passes as a machine workshop. More importantly, the studio does not simply *look like* a workshop; indeed, it *was* a space of industrial production. While its malleable interior allowed the studio to perform as virtually any setting in Méliès's films, this interior was always framed, just off the screen, by the same glass-and-iron surface that framed industrial architecture. The duality that Méliès creates by using the studio as the workshop highlights cinema's close relationship to these technological spaces and the industrial practices that gave rise to the "human-built world."

In *À la conquête du pôle*, Méliès thus creates a compelling link between two kinds of world-building that defined both the modern Western city and early cinematic space: the construction of industrial buildings such as film studios and the production of artificial environments on film.

To understand the consequences of this circuit of production and reproduction, it is necessary to locate cinema at the intersection of the architectural and technological changes of the late nineteenth century. Cinema was deeply embedded in these changes from its origins, and as industrial modernity became the subject of early films, film technology became more than just a product of industrial developments; it became a powerful means for evaluating them. Films such as *À la conquête du pôle* leave us to wonder just how cannily early filmmakers recognized cinema's unique place in this process of building and rebuilding, assessing and reassessing artificial worlds, physical and virtual alike.

CONCLUSION

Lewis Mumford did not overlook cinema's value for evaluating the modern world. Despite its "stupid misuse," cinema possessed, in Mumford's view, a unique relationship to the technologies and experiences of urban industrial modernity. Cinematic motion replicated the technologically driven movement of the automobile, railroad, and assembly line, while its mechanical reproduction of images mimicked the artificiality of mass industrial production. For Mumford, cinema offered a means not only to record and preserve but also to understand those changes. As a machine itself, cinema seemed to provide unique access to the experiences of the modern industrial world.

But while Mumford was right that its relationship to technology made cinema uniquely poised to represent and help us understand our new technological world, he failed to recognize that cinema would also play an important role in that world's very creation. Filmmakers such as Méliès used the artificial environment of the studio not only to reproduce modern spaces on film but also to build cinematic worlds that were themselves key components of an increasingly artificial, human-built environment. In doing so, they made cinema the key medium for representing and evaluating technology that Mumford and others would recognize years later.

Méliès, in particular, produced pointed cinematic commentaries about technological change and its potential future dangers. At the same time, he used the studio to evaluate the present and future of technology as

well as the future of cinema, which he saw as centrally linked to such technological discourse. Just as his "'voyages extraordinaires" explored where new technologies might lead, so Méliès's films offer an exploration of where cinematic technology and the studio would take future film audiences. In the first decades of cinema, these two concerns were not so far apart. The studios that produced cinematic worlds were of the same materials and character as the factories, laboratories, ateliers, hothouses, photography studios, department stores, office buildings, and exhibition halls that were redefining built space and modern experience. Those links would become even more critical and readily apparent as film companies grew and expanded their infrastructural resources in the first decade of the twentieth century.

· 3 ·

DARK STUDIOS AND DAYLIGHT FACTORIES

BUILDING CINEMA IN NEW YORK CITY

New York! It is the epitome of the horror of the age. I hate it. I loathe its artificial way of living, its mannerisms, its ways of thought. It has but one redeeming feature, that it is getting so impossible that people must leave it or become crazy.

—Thomas Edison (1905)[1]

IN THE FIRST decade of the twentieth century, the major film corporations that had emerged in America and France in the 1890s significantly expanded their filmmaking infrastructure. They replaced open-air and rooftop stages with larger studios inspired by the glass house form as well as features of modern structures such as skyscrapers and factories. Using novel materials and building technologies—especially electrical lighting, concrete, and new forms of glass—studio architects contributed to the physical transformation of cities like New York and Paris. This chapter and the following one develop a materialist history of cinema's early architectural development that emphasizes how studio architects responded to the conditions of urban architecture and infrastructure in the century's first decade. By situating the resulting studios in infrastructural changes to the modern built environment, these chapters call attention to the tangible ways that architectural and urban development shaped cinema. In short, they argue that cinema developed not simply *in* but also *in concert with* urban architecture.

This approach offers new ways of thinking about cinema's association with the city, an often-explored relationship that has been analyzed

almost exclusively in terms of film's role in representing urban spaces or of the city's importance as a site of cinematic spectatorship. Early film historians, for instance, have emphasized how the conditions of urban modernity affected cinematic spectatorship and how early films in turn shaped spectators' experiences of the city.[2] Other scholars have celebrated how "city symphonies" such as Paul Strand and Charles Sheeler's *Manhatta* (1921), Robert Flaherty's *Twentyfour-Dollar Island* (ca. 1926), and Paul Florey's *Skyscraper Symphony* (1929) made modern urban space a subject of cinema's modernist experimentation in the 1920s. Such films have become key early examples of cinema's close and lasting connection to cities like New York.[3] But film's relationship to the city has long gone well beyond the latter's importance as a site for location filming and the less tangible ways that urban experience may have helped condition cinematic experience (and vice versa). Urban cinema, in other words, is about more than just spectatorship and representation.

In New York, cinema's architecture took shape as part of the struggle for American film industry dominance between Biograph, American Vitagraph, and the Edison Manufacturing Company. In the midst of far-reaching changes to New York's architecture and municipal infrastructure, these companies contributed to the city's "artificial way of living" by using advanced building technologies to construct new studios. The professional architects upon whom film companies increasingly relied made New York an important center of America's studio film production.[4]

Shaped by new architectural forms and building technologies, the new studios reached greater degrees of independence from the natural environment. Most importantly, the same techniques used to create artificial light and to enhance "natural" illumination in urban architecture more generally allowed architects to develop designs focused on the specific needs of film production. New urban studios still used rolled plate glass façades and roofs, much like Méliès and R. W. Paul had done first in the 1890s. But architects also introduced innovations such as the extensive electrical lighting setups that would soon define "dark" studios as well as designs borrowed from industrial architecture, including prismatic glass windows and "daylight factory" designs that used large, open building façades supported by reinforced concrete to allow greater access to sunlight. In short, studio architects made the materials and designs that would come

to define modern architecture's well-tempered environments the basis for early studio film production.

These designs and materials underscore cinema's place and role in creating a "human-built world." Like Dickson and Méliès before them, studio designers focused on enhancing natural light and dissociating studio filming from the dictates of weather and seasonal climate changes. Building studios in cities both contributed to and complicated their efforts. On the one hand, architects could draw inspiration from a wealth of designs and materials for projecting sunlight to the interiors of urban buildings. At the same time, however, they faced new degrees of oversight from municipal building officers charged with enforcing reforms to make cities safer and healthier. Those conditions shaped the human-built environments of cities like New York, and they would help condition cinema's built worlds, both in the studios and their films.

Architects' ability to reproduce favorable features of the natural world allowed filmmakers to develop novel and more efficient ways to create artificial film worlds, seemingly at will. Their ability to expand working hours and take advantage of larger, better-lit, and more efficiently arranged studio stages drove the Nickelodeon era's success and made their studios models for American cinema's industrialization over the next decade.[5] By 1910, these spaces had also helped make studio production the norm. The result of cinema's ultimate reliance upon modern building materials and designs would be a striking continuity between the spaces of modern urban life, the sites of film production, and the cinematic worlds they produced. As this chapter will demonstrate, that circuit of materials, designs, and built worlds defined cinema's place in New York and made film a product of architectural modernism two decades before Sheeler and Strand made the city a focus of "modernist" cinema.

MODERNIZATION AND THE "CREATIVE DESTRUCTION" OF MANHATTAN

New York's first film studios emerged during a period of extensive changes to the city's infrastructure. By the end of the nineteenth century, massive immigration, a daily influx of commuters, new concentrations of

corporate power, and the introduction of novel building technologies had created what one historian has described as "an urban landscape entirely new in the history of civilization."[6] The consolidation of the boroughs in 1898, which made New York officially the largest city in the United States, centralized administrative authority over the city's increasingly strained utilities and transportation networks. Faced with mounting concerns over pollution, unregulated development, overcrowding, and limited natural resources, municipal leaders implemented new technological systems designed to take advantage of the city's natural resources while also overcoming the restraints of the natural environment.[7]

Historian Max Page has described the resulting modernization as the "creative destruction of Manhattan."[8] As Page and other historians have shown, New York underwent the most rapid period of change in its history at the turn of the century as the water and sewer system expanded, bridges and tunnels connected Manhattan to the boroughs, elevated trains and subways created new networks of mass rapid transit across the city, skyscrapers replaced brownstones and slums, Central and Prospect Parks provided human-made "natural" recreational spaces, and electrical lights began to transform daily life.[9] These developments fundamentally altered the city's and its residents' relationships to nature by reproducing it in artificial forms.[10] New Yorkers would experience that reproduction perhaps no more so than in the use of electrical lighting, a technology that, as David Nye argues, "astounded people because it violated the natural order" of sunlight.[11] Emerging industries capitalized on this wonder by drawing on natural iconography, and cinema was no exception.[12]

On the cover of its 1901 sales catalog, for instance, the American Mutoscope and Biograph Company used one such icon to announce the "Age of Movement" (fig. 3.1). Framed by electrical wires and menaced by a bolt of lightning emanating from clouds in the upper right corner, the title bursts forth in a luminous glow like the headlight of an oncoming locomotive, the source of which appears to be the interior of the catalog itself. While the cover's allusions to light and movement make reference to the basic components of the projectors and films for sale within its pages, it is notable for the absence of any direct reference to or representation of film itself. Instead, the catalog's iconography evokes the technological context that framed and shaped moving images in the early twentieth

FIGURE 3.1 "The Age of Movement." (American Mutoscope and Biograph Film catalog cover, 1901)

century. As inventors, industrialists, and governments introduced technologies such as electricity and electrical lighting to the Western world, filmmakers embraced them as both the subjects of early films and the basis for new production strategies and formal techniques. In New York, that process would take form through the competitive studio expansion that began with the construction of Edison's second studio in 1901.

EDISON'S "SKYLIGHT STUDIO"—FILMING ABOVE MANHATTAN

New York's first purpose-built film studio reproduced the basic character of Méliès's studio on the outskirts of Paris, transporting its photography studio–like design to a Manhattan rooftop at 41 East 21st Street.

America's first "glass house" studio replaced the dilapidated and by then seldom-used Black Maria. Its location not only put Edison's production center just steps away from the city's entertainment hub (and its star performers and theaters); it also contributed to the rapid architectural changes taking place around Broadway and Fifth Avenue, the street that, in Page's words, "exemplified more than any other place on the island the nature of what Henry James called the 'provisional city.' "[13] The new location offered Edison Company filmmakers an ideal location from which to explore the city and capture its provisional state in city films such as *What Happened on Twenty-Third Street, New York* (1901), *Opening of New East River Bridge* (1903), and *Opening Ceremonies, New York Subway, October 24, 1904* (1904). It would also give the company an edge in the increasingly competitive industry at a moment when studio resources became key aspects of corporate strength.

Edison executives hoped that the studio would provide a more consistent output of films than the Black Maria or its production licensees, thereby capitalizing on the company's current position of industry dominance. Thanks to a momentary victory over Biograph for patent infringement and the resulting industry-wide stagnation as film companies awaited word about the legal status of their filmmaking apparatuses, Edison held a brief monopoly on film production from the middle of 1901 to March 1902.[14] During this period, the company's lead filmmakers, Edwin S. Porter and George Fleming, used their new studio to meet market demand and explore new filmmaking techniques and aesthetic forms.

Porter later recalled proudly that the studio was "the first skylight studio in this country."[15] It occupied almost the building's entire roof, approximately 90 by 20 feet, and was enclosed in glass and iron for $2,800 by the Hinkle Iron Company and the Metropolitan Fireproofing Company.[16] On October 23, 1900, Hinkle Iron reported that the city building department had approved plans for the "Photographic Studio," which it completed by mid-January 1901.[17] Porter outfitted the floor below the studio with a small room lit through an 8 by 10 foot skylight. He also included an electrically lit section of 10 by 25 feet that contained dressing rooms and a darkroom for film processing (although large-scale developing and printing of Edison films still took place at the West Orange

laboratory).[18] The studio opened in February and was paying tangible dividends by the following winter as Porter and Fleming produced numerous short studio films while Biograph released only a few actualities.

Aside from its economic benefits, the studio also housed celebrated cinematic innovations, perhaps most visible in Porter and Fleming's *Jack and the Beanstalk*, produced in May and June 1902. Like Méliès's *Le Voyage dans la lune*, released only a few months later, the film featured noticeable developments in spatial fluidity between shots, in particular in the sequence during which Jack descends the beanstalk, exiting the bottom of the frame in each shot and reappearing from the top of the subsequent frame. Just as with Méliès's first glass house, the space of filming and the techniques that filmmakers learned there left both tangible and more conceptual marks on the films they produced.

Like Méliès, Porter recognized the continuity between his new studio and the rooftop photography studios that had helped inspire it. Shortly after taking charge of the new studio, Porter and George Fleming produced a film that, in its comical representation of portrait photography, prefigures Méliès's *Une Chute de cinq étages* (1906). The film—*The Old Maid Having Her Picture Taken* (1901)—turns on the old joke that one could be so ugly as to break a mirror, expanding the affliction to apply to any manner of studio objects. Using a combination of studio tricks and stop motion, Porter and Fleming use the old maid's "ugliness" to wreak havoc on the simulated studio: sample photographs fall from the wall, the studio's clock hands spin wildly before the clock joins the photos on the floor, and a full-length mirror breaks, confirming the joke. When the photographer finally attempts to take the old maid's picture, the camera itself rejects her gaze, exploding in a puff of black smoke.

Much as Méliès would later, Porter and Fleming took advantage of their studio's glass-and-iron design to simulate the film's fictional studio world. The backdrop's painted glass panes mimic the film studio's rooftop glass enclosure and glass-and-iron walls, which also contribute to the illusion by appearing in the film itself, reflected in the imperiled mirror (fig. 3.2). More than simply underscoring the similarities between film studios and other spaces of visual cultural production, the studio's appearance on screen—however rare—suggests that filmmakers like Porter and Méliès may have recognized such continuities and thought about

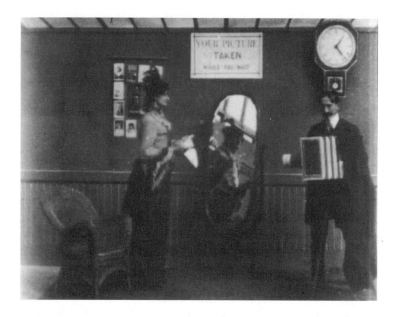

FIGURE 3.2 *The Old Maid Having Her Picture Taken* (1901). The glass-and-iron wall of Edison's new rooftop studio appears reflected in the mirror of a simulated rooftop photography studio.

the nature of their working environments. In Porter's case, the changing city that shaped and framed that environment left an evident mark on the kinds of studio films he produced.

Over the next four years, while he used the studio to build a broad repertoire of film effects inspired by filmmakers like Méliès and facilitated by the studio, he also took inspiration from the city's numerous building projects and city films produced by Edison and its competitors. In *Building Made Easy, or How Mechanics Work in the Twentieth Century* (1901), for instance, Porter uses stop- and reverse-motion effects to animate bricklaying and carpentry, creating both a visual metaphor and a cinematic equivalent to the additive, step-by-step building processes found on construction sites throughout the city and enhanced by films like Frederick Armitage's *Demolishing and Building Up the Star Theatre* (Biograph, 1901). As such films suggest, the city's construction not only became the subject of early city actualities; it also inspired fictional

studio-produced narratives that make clear how attentive early filmmakers were to the new built environment.

Although Edison's Manhattan studio briefly represented the most modern design in America, in Europe Méliès's first studio predated it by almost four years, and British filmmakers including R. W. Paul, G. A. Smith, and Cecil Hepworth were also working under glass and iron by 1900. While the studio may have allowed Edison to out-produce his open-air–based American competitors during cold months, the short winter days still limited production and left Porter and his colleagues subject to the dictates of the natural environment. For, although the Edison studio did have a small electrically lit room, artificial light was *not* used for film production. How ironic that the company that brought electrical lighting to New York should fail to recognize that artificial lights would make the rooftop studio inadequate in only a few short years. Adding insult to injury, it would be Edison's chief rival, Biograph, that would take the first important steps toward bringing electrical lighting to the American film industry.

AMERICAN MUTOSCOPE AND BIOGRAPH'S "DARK STUDIO"

Less than a year after declaring the "Age of Movement," Biograph would make the reference to electricity on its catalog cover the physical reality of its film practice. Using newly developed mercury vapor lamps, the company outfitted the world's first entirely artificially lit, or "dark" studio in lower Manhattan. Biograph's shift to artificial lighting would mark a new step in the process of divorcing cinematic production from the dictates of the natural environment that began with Dickson's rotating Black Maria and Méliès's glass-and-iron studio. It would also secure Biograph's place in the industry and help drive cinema's expansion in the Nickelodeon era.

In contrast to its proclamations about the "Age of Movement," in the year before its studio expansion, Biograph's business was going nowhere fast. In the wake of Edison's copyright infringement victory in 1901, the company's future was in doubt. Although the court allowed production to continue under restrictions during the appeal process, the company also faced declining sales due to both the limitations of its proprietary

70mm film format and an industry-wide lag in audience interest.[19] Finally, in March 1902, an appeals court overturned the Edison Company's victory and allowed its competitors to return fully to production and sales. Biograph responded with a corporate makeover, complete with a gradual shift to the industry standard 35mm film and plans to open a new artificially lit studio.[20] The use of electrical lights for both production and exhibition would expand cinema's relationship to other technologies of the second industrial revolution. In Biograph's case it would do so by bringing the company into contact with one of Edison's chief noncinematic rivals, George Westinghouse.

Westinghouse had emerged as one of Edison's main competitors during the early days of electricity. Beginning in the 1880s, Westinghouse and Edison headlined the highly publicized "battle of the currents" that pitted Edison's direct current system of electrical production and distribution against Westinghouse's alternating system. Despite the Edison Company's early success with its Pearl Street Station in Manhattan, other power stations and electric trolley networks, and the incandescent light bulb, by the end of the 1880s its DC system faced rising competition from AC schemes developed by Nikola Tesla at Westinghouse and by several European companies.[21] By the early 1890s, with relatively reliable AC motors and transformers available, more and more businesses and municipal governments chose Westinghouse's system. Even Edison's increasingly spectacular attempts to denounce alternating current as dangerous, including films such as *Execution of Czolgosz* (Porter, 1901) and *Electrocuting an Elephant* (1903), could not shift the move away from the AC system.

In 1892, facing declining profits and the reality that AC represented the future of large-scale electrification, Edison's investors, led by J. P. Morgan, sold Edison General Electric to the Thomson-Houston Company in the merger that created General Electric, effectively squeezing a bitter Edison out of not only the company's name but also the electricity business altogether.[22] Edison used his considerable profits from the sale to fund new projects involving ore drilling, an electrical storage battery for automobiles, and the Portland cement that would help drive the growing concrete industry in America (and later give form to Edison's own film studios). Although Edison was no longer involved directly

in electrical lighting, his name was symbolically tied to both GE and the industry as a whole. How fitting, then, that one of Edison's biggest technological rivals—Westinghouse—would help his chief American film foe—Biograph—rise to the top of the film industry in the prelude to the Nickelodeon boom.

CINEMA GOES "DARK"—MERCURY VAPOR LAMPS AND ARTIFICIAL DAYLIGHT

Biograph's reorganization coincided with fortuitous developments in the electrical lighting industry. By the 1890s, inventors and investors had shifted their attention away from the "battle of the currents" to innovations in lighting sources in an effort to replace the incandescent bulb with brighter and more efficient systems.[23] Westinghouse, in particular, sought new lighting technologies that would undermine the large market share that General Electric enjoyed thanks to its ownership of Edison's patent for the incandescent globe.[24] Peter Cooper Hewitt, grandson of industrialist Peter Cooper and son of former New York City mayor Abram S. Hewitt, began working on his own system of lighting with mercury vapor tubes in the late 1890s. He and Westinghouse first met in fall 1899 and reached an agreement in March 1900 that led to the formation of the Cooper Hewitt Electric Company with Westinghouse's backing in 1902.

It is unclear how Biograph first came to use the Cooper Hewitt lamps, but already by the end of 1903 the company had plans for the world's first studio to be lit exclusively by artificial lights.[25] The new Biograph studio introduced a film production practice that would become so extensive that by 1919 an industry observer could remark: "needless to say, motion-picture studios are the very best customers a power supply company can hope for."[26]

Biograph built the new studio in an apartment and basement of a brownstone at 11 East 14th Street, only a few blocks from its offices and rooftop studio at the Roosevelt Building and, like Edison's Manhattan studio, close to the Broadway and Fifth Avenue entertainment district. In January 1903, the company received consent from its real estate broker to perform alterations on the interior of the building, including

enlarging a doorway (presumably to create space for the stage and for moving cameras and décor) and installing heating units, gas and water fittings, and electrical wiring. The broker also granted Biograph authorization for "erecting galleries, stairways and appliances for electrical lighting and stage work, and making [a] trap door from [the] Music Hall to [the] basement," all in accordance with codes enforced by the Department of Water Supply, Gas, and Electricity (DWSGE) and the New York Board of Fire Underwriters.[27] The studio went into operation almost five months later, beginning on a reflexive note with a prank film—A Shocking Incident—in which a "bad-boy" character delivers electric shocks from a hidden battery.

By allowing the company to shoot films around the clock and throughout the year, the Cooper Hewitt lamps quickly brought Biograph to the head of American film production, easily surpassing output at Edison's formerly dominant rooftop glass house.[28] Biograph began production with several large banks of Cooper Hewitts, each of which contained eight mercury vapor tubes and was mounted on wheels or later suspended from the ceiling. Inspection reports from the DWSGE's Electrical Bureau, the Board of Fire Underwriters, and Biograph's electricians, Fred S. Chute and the Weed Electric Co., show that the company repeatedly enlarged its electrical setup between 1906 and 1909 to include more mercury vapor tubes as well as arc lamps. These additions were prompted by the need for additional production space to meet the demands of the flourishing exhibition market.[29]

Business and industry users opted for the original Cooper Hewitts for their increased efficiency and because they were said to be less tiring on the eyes than earlier incandescent bulbs. Because they lacked red and violet rays, the lamps produced an unusual greenish-white light that, in one contemporary observer's words, gave them "an unnatural, indeed a ghastly, appearance."[30] The Cooper Hewitts were particularly well suited for cinema and photography because the actinic value—the ability to expose light-sensitive chemicals—of this "ghastly" but otherwise bright light was not affected by its lack of red and violet rays.[31] One trade journal noted, "the very quality of eliminating the red rays is what makes the Cooper Hewitt lights so valuable in photography. [Their] pictures . . . stand out as clear and sharp *as any daylight pictures ever made.*"[32]

Such proclamations suggest the degree to which film studios attained new degrees of independence from the natural environment in the early twentieth century. Combined with glass-mediated sunlight, the addition of electrical lighting meant that filmmakers could seemingly create artificial cinematic worlds at will, a flexibility that helped make the Nickelodeon period possible. After Biograph began using artificial illumination, filmmakers working in glass house studios soon adopted electrical lights in an effort not only to maintain production levels during the winter season but also to find the best exposure conditions year-round.

While most producers and critics agreed that filmmaking outside in unimpeded sunlight was the optimal technique, filmmakers since Dickson and Méliès had recognized that such conditions were rarely available, especially in urban locations. As Thomas Bedding, former editor of the *British Journal of Photography*, described, "climatic uncertainties . . . make outdoor moving picture photography something of a luxury."[33] The search for favorable climatic conditions or, in their absence, substitutes for sunlight thus became one of the major driving forces in the development of early cinematic production. Bedding noted optimistically in *Moving Picture World* in 1909, "a perfect substitute for daylight has to be discovered, although thereotically [*sic*] it seems easy enough to make an artificial spectrum exactly corresponding, ray for ray, to the solar spectrum."[34]

Lacking this "ray for ray" re-creation of the sun, filmmakers settled for a shifting and uncertain combination of various forms of glass, diffusing cloths, reflectors, Cooper Hewitts, arc lamps, and incandescent bulbs (fig. 3.3). Bedding himself could in one breath state "it may be taken as axiomatic . . . that a daylight studio is the best all around in moving picture making," and in the next concede that "the ideal combination of lights is daylight and electricity."[35] A 1910 trade press article similarly provides a telling example of the paradoxes of early electrical lighting, as well as how filmmakers understood technology as a substitute for the natural environment. Glass house studio managers, the article notes, often mimicked the sun with banks of Cooper Hewitt lamps hung "directly against the skylight so that they may be turned on to help out the natural light on a dark day and will also give the operator his accustomed direction of light after dark."[36]

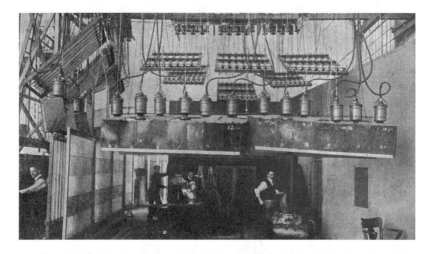

FIGURE 3.3 Interior of an unidentified studio combining glass and electrical lighting (using both Cooper Hewitt and arc lamps). From John B. Rathbun, *Motion Picture Making and Exhibiting* (1914), 59.

The only real consensus about film lighting seems to have come from film reviewers and industry observers, who increasingly decried what Bedding referred to as the "harshness and unreality of illumination" as a result of over- or underexposure, shifting levels of brightness, dark shadows, and unwanted highlights—in other words, anything that ruined the illusionary reality of a "natural" scene.[37] This search for realistic lighting techniques contributed to the gradual transition to narrative cinema in America and the implementation of new systems of representation and narration in France at Gaumont and Pathé Frères.[38] Just as audiences and critics increasingly demanded more "realistic" narrative subjects, filmmakers sought ever more artificial ways to construct and light realistic film spaces. Their efforts were prompted not only by market demands for more, longer, and more realistic films but also by the growing number and success of films shot on location in the southern and western United States. Already, though, before filmmakers began to seek alternative filming venues and awe-inspiring exteriors, studios competed for lighting setups that could manufacture realistic scenes in the urban built environment.[39]

ARTIFICIAL LIGHTING AND MODERN INDUSTRIAL SPACE—FROM THE STUDIO TO THE FACTORY

The film industry's increasingly rabid appetite for artificial light created a new market for industrial-grade lighting systems. By 1908, a number of lamp manufacturers such as the Aristo Company, which produced the "flame-arc" lamps installed at Biograph in 1909, had expanded their theatrical lighting services to include film studio lighting.[40] Such links between theatrical and cinematic lighting should by no means suggest that filmmakers simply copied techniques from the stage, as film historians have previously argued. "Instead," as Janet Staiger rightly contends, "the motion picture industry and the theater both take their place in the larger development of arc and incandescent lighting."[41] Indeed, film studios adopted electrical lighting technologies from a variety of nontheatrical sources that included street lighting and search lighting.[42] And as the histories of the later Vitagraph and Edison studios will also demonstrate, developments in building technologies and designs using glass and concrete must also be included in the history of film lighting.

Biograph itself provides evidence of this broader context and the infrastructural links that developed between the film studio and the spaces of modern industry. In 1908, the company equipped its factory in Hoboken with the same types of arc and incandescent lamps used in its studio, again installed by Weed Electric and approved by the Board of Fire Underwriters. The inspection reports for both the studio and the factory are notable for using ink stamps for "Direct Current," "Arc Lamps," and "Cooper Hewitt Lights," illustrating how common these artificial lights had become by 1906. The Cooper Hewitts were known as efficient and effective substitutes for incandescent lights in a variety of industrial settings. As an article about the lamps' use for photography studios remarked, they were also "said to be the most desirable form of light for factories, machine shops, and work-rooms of architects and draftsmen, as well as for all classes of photographic work."[43]

The Cooper Hewitt lamps filled a growing need in the spaces of American industry that, as David Nye explains, demanded qualitative changes in lighting conditions in order to extend working hours and allow for new

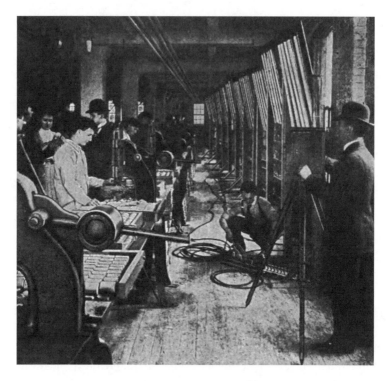

FIGURE 3.4 Cooper Hewitt lamps on location placed directly in front of the factory windows, replicating the method used in many contemporary glass house film studios. From Rathbun, *Motion Picture Making and Exhibiting*, 57.

degrees of precision to support turn-of-the-century industrial growth.[44] As corporations including GE and Westinghouse invited film companies to record these changes for publicity and worker training, filmmakers often turned factories into temporary studios (fig. 3.4).[45]

One of the most striking examples is the series of films made by Billy Bitzer at the Westinghouse Works in 1904. Less than a year after Biograph began production at its new, Cooper Hewitt–lit studio, Bitzer underscored the company's link to Westinghouse by using the new lamps to make a series of films at Westinghouse's factories in Pittsburgh. In these films, Bitzer took early cinema's pursuit of the city's infrastructural technologies from the streets and studios to their origins—the machine works that produced modern industry and the industrialized metropolis.

Biograph's sales catalogs featured twenty-nine films from the Westinghouse Works, depicting everything from the company's electric sign, the factory steam whistle, and workers punching time cards, to fixed-camera shots showing aisles of workers winding coils, long takes of machine tests, and panoramas of the factory's interior.[46] Bitzer reproduced the technologies and techniques that produced industrial modernity by transporting viewers into its prototypical artificial environment. Such films prefigured the association that Walter Benjamin later drew between factory labor and cinematic perception. While Benjamin notes that the process "which determines the rhythm of production on a conveyor belt is the basis of the rhythm of *reception* in the film," in the Westinghouse films the structure and pace of mechanical production sets the rhythm for cinematic *reproduction*.[47]

Much like the city films produced by Biograph during this period, the processes of filming at the Westinghouse Works often reproduced the infrastructural character of the technologies they recorded. In *Westinghouse Air Brake Company*, for instance, the dual assembly lines that slowly transport air brake molds serve as the on-screen corollaries of the unseen film reel that captures their endless circular trajectory. Bitzer enhances the infrastructural parallels between cinema and industry by reproducing the conditions of image production in the "dark" studio for the factory, most notably in the series' interior panoramas. Here, Bitzer uses the Cooper Hewitt lights to stunning effect by suspending them alongside the camera on overhead rigging systems, thus creating sweeping aerial views. Just as in his later film *Interior NY Subway 14th Street to 42nd Street* (1905), in which he illuminated a subway car with a bank of Cooper Hewitt lamps on a parallel track, here Bitzer binds the Cooper Hewitt lamps and the film camera with technologies of modern industry. At Westinghouse, the same systems that transported machinery through the factory become tools for moving the camera and viewer. Much like the fragments of metal that exit the Works as completed machines, Bitzer's panoramas comprise mechanical assemblages, in this case of factory-produced *images*.

In *Panorama View, Street Car Motor Room*, for instance, the hanging camera and lights traverse the length of the factory, doubling the street-car motors that swing in and out of the frame. At one point the camera pauses as sparks and debris, emanating from just above the frame,

shower the factory floor below, just as the unseen Cooper Hewitt lamps throw light onto the scene. The Cooper Hewitts highlight the center of the frame, creating a tunnel of light that was necessary, first and foremost, to expose the film but which also results in a striking composition. The factory's other primary source of illumination, its large rough plate glass windows, line the left edge of the frame, providing a counterpoint to the Cooper Hewitts' artificial illumination. The combination of "natural" and electrical lighting, which appears throughout the Westinghouse series (fig. 3.5), was a common strategy used by both studio filmmakers and the architects charged with providing light for modern industry. Just as in glass house studios, structures such as the Westinghouse Works that were built before and during the early days of electricity often featured this amalgam of lighting techniques.[48]

Even as electricity became more common, studio architects continued to search for new ways to capture sunlight. While the electrical lights that

FIGURE 3.5 *Panorama of Machine Company Aisle* (Bitzer, 1904). The factory's large rough plate glass windows appear throughout the series, often helping illuminate the scenes.

illuminated Biograph's studio seemed to promise an electrically illuminated filmmaking utopia, in reality "dark" studios would not become the industry standard for more than a decade. In the meantime, film companies employed techniques taken from contemporary factories, department stores, and skyscrapers. The American Vitagraph and Edison studios built in Brooklyn and the Bronx beginning in 1905 illustrate the links that developed between the first studios and early modern architecture, each of which was driven in part by this contemporary quest for light.

PRISMATIC GLASS AND EARLY MODERN ARCHITECTURE—AMERICAN VITAGRAPH, BROOKLYN

By 1911, Vitagraph's facilities in Brooklyn would represent the height of American cinema's early industrialization. It featured facilities for all phases of production and postproduction, from a carpenter shop, set design workshops, and a wardrobe department, to a writing department and four studio stages, to developing, printing, tinting, and joining rooms. In addition, the studio housed manufacturing facilities for Vitagraph projectors, a publicity department, and business offices (see fig. 3.6). In sum, the studio came to represent, in one trade review's estimation, "a model institution."[49] The history of this model highlights the important role that studio infrastructure played in film companies' success in the century's first decade. Vitagraph's Brooklyn facility also offers a key example of cinema's place in the changing materials and designs of modern architecture.

Vitagraph had begun the twentieth century producing films on a Manhattan rooftop and running an exhibition circuit as an Edison licensee. When the Edison Company opened its new studio in 1901, Vitagraph's focus shifted to exhibition, in part due to Edison's copyright victory over Biograph the same year. As Jon Gartenberg notes, when the appeals court overturned Edison's victory in 1902, Vitagraph expanded autonomous production and, in response to the growing exhibition market that it helped create, began construction of a new studio. By the end of 1907, Vitagraph would be producing more than twice the number of films as its closest American competitor, Biograph, with Edison a distant third.[50] Using advanced architectural forms and lighting technologies, the studio

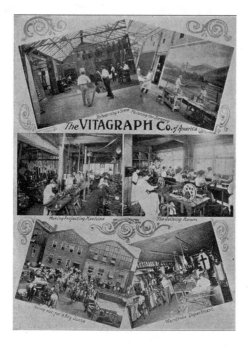

FIGURE 3.6 "The Vitagraph Co. of America," *Moving Picture World* (June 8, 1912): 907.

and the production practices to which it helped give rise would become paragons for the further industrialization of American cinema.

Vitagraph built its studio in the sparsely populated Flatbush area of Brooklyn at 15th Street and Locust Avenue (fig. 3.7). In addition to production stages, the structure initially included a power station, machine shop, darkroom, and business offices. The company's rapid success would lead to large-scale expansion in the form of additional studios and offices to replace its former facilities in Manhattan.[51] By 1910, *Moving Picture World* emphasized the studio's grand scope, reporting, "the Vitagraph village takes on an aspect of activity and prosperity that is an imposing tribute to the growth of the moving picture business," a view echoed by *The Nickelodeon*, which expressed similar wonder at Vitagraph's "large proportions."[52] Its large smokestack—which still stands today—gave physical and symbolic form to the American film industry's growth. And indeed, the studio would set the standard for a series of large American

FIGURE 3.7 Vitagraph Studio, Brooklyn, New York. Note the studio's rock-faced concrete block frame. The upper windows are composed of diffusing prismatic glass, as is the unseen roof. From "The Vitagraph Plant and Personnel," *The Nickelodeon* 5.1 (January 7, 1911), 9–10.

filmmaking centers built by Selig Polyscope (1907) and Essanay (1909) in Chicago, Siegmund Lubin's "Lubinville" studio (1910) in Philadelphia, and later studio centers in Southern California.

The most significant feature of Vitagraph's new studio was not so much its size as its approach to studio lighting. The studio combined a Cooper Hewitt light installation with a prismatic glass wall and roof that one trade journal described as a "special apparatus and stage . . . for taking novel pictures with special scenic effects."[53] Like Cooper Hewitt lamps and diffusing cloths, Vitagraph's prismatic glass enclosure provided a bright, evenly distributed light that avoided the shadows and uneven illumination that critics such as Thomas Bedding and trade journal editors had bemoaned in the years leading up to 1910.

Film industry appeals for improved lighting conditions echoed the demands of urban inhabitants, commercial businesses, and industrialists. As architectural historian Dietrich Neumann has described, inventors and architects met those demands with novel forms for capturing sunlight that included the rough plate and corrugated glass used in factories since the 1880s as well as reflecting materials such as white enameled terracotta and large mirrors mounted on building façades. In this context, prismatic glass became, in Neumann's words, "the most sophisticated and complex

development among the many attempts in the last decades of the nineteenth century to bring more daylight into the dark interiors of factories and densely built urban centers."[54]

Prismatic glass had been used since at least as early as the eighteenth century to light basements and the interiors of ships, and similar forms of light-directing glass were commonly used in the nineteenth century in commercial architecture. The success of new prismatic glass enterprises that emerged in the 1890s, notably including Chicago's Luxfur Company, where Frank Lloyd Wright designed prismatic glass tiles, came as a result of the growing desire to light urban interiors using the sun's rays rather than gas or electrical systems. This desire reflected the high cost of electricity as well as architects' initial reluctance to adapt architectural styles to fit technological imperatives.[55] The search for new ways to capture natural light was also prompted by a renewed desire for contact with nature in the increasingly technological metropolis.

Prismatic glass offered a "natural" (because not electrical) solution to the unnatural darkness created by sun-blocking elevated trains and skyscrapers. The idea that sunlight transported into darkened interiors by building technologies such as prismatic glass was somehow "natural" reflects the more general condition of artificiality that had come to define modern cities such as New York. As urban inhabitants spent more and more time in built spaces, manufactured versions of nature such as Prospect Park in Brooklyn and Central Park in Manhattan came to replace the natural environment itself, offering simulated oases from the urban built world. Prismatic glass produced an especially paradoxical version of this escape from urban artifice. As Neumann notes, thanks to prismatic glass's translucency, "an office or store brightly lit by daylight could be isolated from the reality of the city outside."[56] In other words, customers could trade one form of urban reality for another, no less artificial one. This creation of artificial worlds sequestered from the modern metropolis similarly characterized the development of film studios like Vitagraph's that produced miniature filmmaking cities within the city.[57]

Cinema's gradual industrialization—suggested in part by the frequency with which observers began to refer to new studios as "plants" and "factories"—remained consistent with the film studio's steady progression toward independence from the natural environment. But as the

combination of electrical and glass lighting used by most studios demonstrates, this desire for artifice remained in tension with both the slow technological development of electrical networks and artificial light sources. Even as electrical lighting became more common in studio production, filmmakers still faced high electrical costs and poor exposure from artificial lights, and they again sought solutions rooted in nature.[58] Prismatic glass was thus a logical fit for cinematic production because it offered a financially suitable solution to the problem of creating diffusely lit spaces by packaging a rationally enhanced, purified version of the natural environment.

EARLY MODERN ARCHITECTURE AND EARLY CINEMA

By the 1920s, architectural illumination using electricity and glass would become a key component of modern architecture's own pure forms, especially in the early designs of the International Style and the Crystal Chain group. Such structures would inspire a generation of architects, filmmakers, and critics to celebrate the links between architecture and cinema's respective abilities to produce new, dynamic forms of space. As Frances Guerin notes, "the foundation of modern German architecture's engagement with technological modernity" was precisely the "interaction of both artificial and natural light with glass."[59] German films of this period, Guerin shows, echoed the "new modes of perception and representations of time and space within the industrial landscape" imagined by modernists such as Bruno Taut, Walter Gropius, and Mies van der Rohe.[60] The correspondence between architecture and cinema did not, however, develop first in the 1920s. Rather, the ties between architecture and cinema that helped define modernism were the product of the parallel developments in turn-of-the-century architecture and early cinema that intersected in the first film studios.

Indeed, by the time Vitagraph was installing its prismatic glass enclosure in Brooklyn, architects including Luis Sullivan, William Le Baron Jenney, and Frank Lloyd Wright were making prismatic glass an important element of the new technologies and rational designs that drove early modern architecture in America. In Europe, architects including

Adolf Loos, Pierre Chareau, Le Corbusier, Taut, and the founders of the Bauhaus embraced prismatic glass, especially in new forms such as the Glasseisenbeton (invented in 1909) that combined prismatic tiles with reinforced concrete.[61] Moreover, the associations between early cinema and modern architecture do more than simply support later claims for the two mediums' similar approaches to the production of modern space. Their link is deeper and more structural than that, for both early cinema and modern architecture shared a place in the more general creation of an artificial built environment—a rationally constructed world that approximated nature using cinematic and building technologies.

In addition to its use of prismatic glass, the Vitagraph studio offers another example of how such material changes conditioned the construction of early film studios. Vitagraph built both the studio's original building and the exterior wall that isolated it from the street using concrete blocks. Photographs of the studio suggest that the blocks were likely a form of rock-faced hollow concrete that became a popular material for cheap, fireproof construction beginning around 1905 (see figs. 3.6–3.7).[62] As architectural historian Pamela Simpson has described, the use of concrete blocks for private dwellings and commercial and industrial architecture increased rapidly in the early 1900s. With rising brick and lumber prices, concrete became an increasingly attractive alternative. Costs were low because Portland cement (reinforced concrete's main ingredient) was increasingly cheap and widely available.[63] Cheap concrete blocks would have helped Vitagraph offset the high cost of its prismatic glass, which Neumann notes was on average ten times as expensive as plain plate glass and five times more expensive than factory ribbed glass. No doubt, their fireproof qualities would also have been attractive given the risks associated with celluloid, risks that we most often think of in early theaters but which also plagued film studios.[64]

But Vitagraph's interest was not limited to such functional concerns. The concrete blocks also offered the formal benefit of giving the studio the false appearance of being built from natural cut stone. Contemporary observers noted the effect. As one described, the studio consisted of "mysterious looking buildings of gray stone."[65] Whether Vitagraph was aiming for mystery or realism, it must have hoped that its new rock-faced concrete studio would leave an aesthetic and symbolic impression.

That symbolism would put the studio in compelling dialogue with long-standing architectural debates about synthetic materials, debates that also related to Vitagraph's concurrent turn to "quality" films.

Despite industry interest in the possibilities offered by concrete construction, many architects, including Frank Lloyd Wright, became outspoken critics of ornamental blocks. As Simpson explains, for Wright and others, such ornamentation violated ideas about architectural purity and the rule (dating to the ideas of John Ruskin and William Morris) that "one material should not imitate another."[66] On the other hand, for middle-class builders and homeowners—and perhaps for Vitagraph—rock-face concrete was valuable *precisely because* it successfully imitated real materials. By covering the façade of its studio in expensive-looking "stone," Vitagraph presented the public with an artificial image of wealth and success, an ornamental anti-modernism that would be expressed no less in the company's film remakes of classical works of literature and theater.[67]

Vitagraph's use of architecture to project a corporate image in this way would become a common strategy for the companies that devoted significant resources to their studios in the years that followed. Indeed, as studios became larger and film companies achieved and cultivated greater publicity, film production spaces became symbolic representations of the vitality of the businesses they housed.[68] It would thus be fitting that the buildings of companies like Vitagraph that made imitation and mass production the stuff of modern culture should be wrapped in mass-produced material simulation.

Vitagraph's success during the Nickelodeon period brought further studio expansion. Even as it established the Los Angeles–area studios discussed in chapter 5, the company continued to add to its Brooklyn base. By 1912, the Vitagraph "plant" was already recognized as one of the country's most efficient producers. As Louis Reeves Harrison described in his "Studio Saunterings" report about it, "the factory resources of the Vitagraph Company can be imagined when it is realized that they are turning out five releases of thousand-foot reels each week, a rate of production that involves the use of a complicated and well-organized force in all departments."[69] The following year, Vitagraph added a new, 55 × 110 foot glass studio and an additional open-air stage across the street that

was large enough to hold an 85 × 40 foot painted backdrop.[70] By 1914, the building covered "several acres" and consisted of more than a dozen buildings, including five studio stages and large factory floors powered by dynamos in the basement.[71]

Details of how Vitagraph arrived at its studio designs or how its architects interfaced with municipal building restrictions remain scarce, but we can be sure that studio planning in early twentieth-century New York was anything but haphazard.[72] As the history of Edison's Bronx studio shows, studio construction was a highly coordinated affair that at times involved multiple architects, engineers, and contractors, both design and redesign phases, and negotiations with city building officials. The complexities of this process help illustrate cinema's place in the shifting architectural and regulatory context that developed as nineteenth-century materials and designs gave way to materials like prismatic glass and concrete blocks and the methods that would define early modern architecture and film studios in the decades to come.

"DAYLIGHT" FACTORIES AND CONCRETE STUDIOS—EDISON IN THE BRONX

By late 1904, Edison executives—like their counterparts at Vitagraph—recognized the need for additional, better-equipped production spaces to compete with output from Biograph's new studio. Without electricity or space for electrical lights, Edison's rooftop studio in Manhattan suffered intermittent halts in production and variable quality, even during consistent periods of filmmaking. One Edison employee later recalled, "every time we started to take a picture we would have to run out on the roof next door and see if the sun would pass over a cloud."[73] Edison's solution to the problem would be similar to Vitagraph's—a concrete-and-glass studio equipped with electrical lighting and built outside of central Manhattan to avoid high land prices. The Edison Company purchased a plot of land in the Bedford Park area of the Bronx for $15,000 in June 1905 and filed its first architectural plans with the Department of Buildings in September. Four years, three architects, and numerous revisions later, the studio was completed, with an additional extension, at a total cost of approximately $48,000.[74]

The studio was eventually built from reinforced concrete composed of Edison's own brand of Portland cement, which the company had been developing since the late 1890s. While it ultimately remained true to the spirit of its initial design, the studio's development was marked by a series of building permit violations, petitions, and amendments that led to long delays in construction and important changes to its material and structural form. This long process reflects the complicated state of urban construction that included new governmental regulations, including New York's Tenement House Act of 1901 and a general revision of the city building code in 1906, the year before the Bronx studio's construction began.[75] This changing architectural and legal landscape would have important affects on the studio's form, beginning with Edison's choice of architects (fig. 3.8).

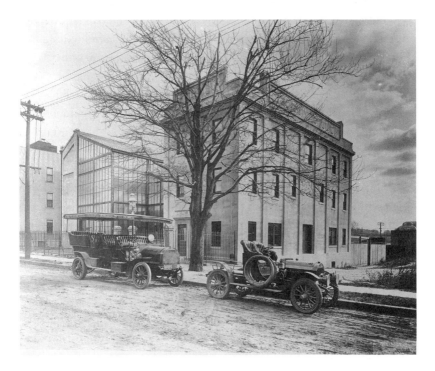

FIGURE 3.8 Edison Bedford Park Studio, Bronx, New York (Kafka and Sons, architects), ca. 1907. (Courtesy of U.S. Dept. of the Interior, National Park Service, Thomas Edison National Historical Park)

Edison initially hired two New York–based firms to design and construct the studio—Hugo Kafka and Sons and Arthur E. Rendle's Paradigm Skylight and Side Lighting Systems. Their respective credentials make Edison's choice clear. Hugo Kafka, a Czech-born immigrant who studied at the Polytechnikum in Zurich under architect Gottfried Semper, had gained fame at the 1873 Vienna International Exposition, where he won the Medal of Art and caught the eye of Hermann Schwarzmann, lead architect for the 1876 Centennial Exposition in Philadelphia.[76] Kafka immigrated to America to assist Schwarzmann on the 1876 Exposition's buildings, notably including the Horticultural Hall, at the time one of the world's largest glass-enclosed buildings. Rendle came with similar credentials, including two medals for his own Horticultural Hall at the 1885 New Orleans Exposition and important patents for the glazing techniques that would be used to enclose the studio's stage.[77]

While the influence of earlier "glass house" film studios made experience with glass-and-iron construction desirable for film studio design, in this case the two firms also brought another important form of expertise to the project: familiarity with the rules and regulations that governed urban architecture.[78] After the 1876 Exposition, Kafka established his firm in New York City, where he gained experience in private, commercial, and industrial architecture. In 1903, Kafka's sons—Hugh, a Columbia University–trained architect, and Frederick, a civil engineer—joined the firm to aid their ailing father. Although archival records suggest that Hugh Kafka, Jr. handled the paperwork for the Edison studio, its initial design bears significant similarities to the elder Kafka's earlier work, most compellingly a factory he had built on New York's upper west side in 1885.[79]

The Joseph Loth & Co. Silk Ribbon Mill in Washington Heights (designated a New York City Landmark in 1993) suggests the kind of experience that would have been valuable for a studio designer (fig. 3.9).[80] The mill was unusual, in part, simply for being designed by an architect. In the late nineteenth century, engineers familiar with machines and manufacturing methods typically designed mills according to standard codes developed by insurance companies. In this case, however, Loth and Company, like Edison later, needed an architect who could adapt standard mill architecture to the requirements of its urban locale and the city building code.

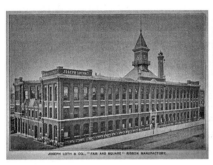

FIGURE 3.9 Joseph Loth & Co. Silk Ribbon Mill (Hugo Kafka, Architect), ca. 1892. Landmarks Preservation Commission, *Joseph Loth and Company Silk Ribbon Mill* (LP-1860).

Three primary concerns drove the mill's design: meeting codes for fireproof construction, providing adequate lighting, and maximizing unobstructed interior dimensions. Twenty years later, similar concerns, with markedly different results, would also shape the designs for Edison's studio. Kafka met these demands with an unusual "K"-shaped structure that anticipates the "I" or "H" shape of Edison's studio. The mill's "K" plan consisted of a central factory floor and two long wings, all of which needed to be narrow enough—less than thirty feet wide—to be built without the internal columns or firewalls that would otherwise have been mandated by the city's building code. Kafka's design also facilitated efficient illumination using a combination of electrical and natural light similar to what would be found later in film studios. Its unobstructed rooms allowed for effective natural lighting through the mill's large glass windows, while also facilitating both power transmission for the factory floor through long drive shafts and electrical wiring for the plant's artificial lights, still a relatively new feature for mills in the mid-1880s.

Materially, the Loth and Company mill was typical of late-nineteenth-century industrial architecture. The mill followed the New York City building code practice of supporting brick walls with wooden beams and cast-iron columns. Kafka used especially large column spans to frame the mill's plate glass windows, an early version of the strategy that architects used in the late nineteenth century to achieve greater internal

illumination. Kafka and Sons repeated these strategies in the initial proposals for Edison's studio.

Kafka submitted the initial plans for the "photographic studio" (as it was designated in the building application) to the Department of Buildings on September 15, 1905. The original design consisted of a single "I"-shaped structure composed of two three-story wings joined by a central atrium, and called for a concrete-and-stone base and a foundation of "reinforced Portland Cement concrete."[81] The 64 × 23 foot wing for offices, storage, and laboratory facilities would be built from stone-covered brick with Georgia pine girders, columns, and floors, all supported by internal wooden posts and floor beams. The 32 × 30 foot atrium and 62 × 43 foot production studio wing would be enclosed in galvanized iron and glass with steel girders, columns, and peaked roof trusses, with the exception of the rear section of the studio, which would use brick, wood, and stone.

The plans for the studio remained consistent with the basic design principles found in the earlier Loth and Company Mill. The studio's "I" shape, in particular, recalled the strategy used in the factory to maximize unobstructed internal space by limiting room widths (here to less than twenty-five feet, perhaps in anticipation of the amended building code that would be adopted in 1906). Kafka restricted the office and laboratory wing to twenty-three feet to allow for open interior working space. He seems to have hoped that enclosing the rear section of the studio wing in brick would convince the building examiner that it would be strong enough to support the glass-and-iron enclosure without the need for internal columns or beams, which would have disrupted movement and sight lines and created unwelcome shadows. By separating the two wings with an atrium, Kafka left the studio with unimpeded access to the northern sun, while also helping protect the non-studio area from the threat of fire.

Such choices were not, of course, left to chance, and contemporary observers recognized that architectural designs had important and tangible affects on filmmakers' production practices and the visual forms of their films. As Thomas Bedding described in 1909, for instance, "Anybody familiar with the making of moving pictures can see that some of the American manufacturers are restricted in the choice of subject by exiguity of stage space. Their plays are produced in very shallow rooms, and so

the scope for dramatic action is limited."[82] Indeed, an architect's ability to create a versatile working space allowing for multiple large sets lit by both bright sunlight and, by the mid-nineteen aughts, electrical lighting, while also satisfying new city building restrictions, could mean the difference between success and failure. In this case, Kafka would have to go to great lengths to appease the city building examiner and give the Edison Company the studio it needed to maintain its position in the industry as the studios of its principal American competitors, Biograph and Vitagraph, began to out-produce it.

The Department of Buildings rejected Kafka's initial design on September 29, two weeks after it was filed, leading to a series of petitions, amendments, and important changes to the studio's material structure. The studio suffered in part from a problem of classification in the city's building code. In the absence of a more suitable category, Kafka submitted a permit application for "brick" buildings that were subject to laws governing "warehouses," a catchall term for everything from factories, mills, and power houses to markets, railroad buildings, and observatories, none of which very well described the proposed studio, which, in the eyes of the law, was just another, if odd, industrial space that had yet to acquire any recognized rules or design standards.

From the city building inspector's perspective, the main problem with Kafka's proposed studio was the glass-and-iron enclosure on the studio wing. The inspector considered the studio's walls unlawful for two reasons: first, glass was not recognized as a "hard, incombustible material," and second, each wall was required to be at least twelve inches thick.[83] In the absence of the required wall thickness, Kafka was required to prove that the building's girders, beams, and trusses would be of sufficient strength to support the upper walls and roof. The examiner rejected this claim straightaway, however, noting that the building's supports, both for the production studio area and the brick-and-wood office wing, would be too weak.

Two months after the application was rejected, Kafka submitted an amendment calling for augmentation of the wood girders and beams and an increase in the pitch of the glass-and-iron roof that would reduce the load on its iron supports.[84] The amendment also included a petition requesting an exception to the city's building code to allow for "a

structural steel frame-work covered with sheet metal work and glass" that Kafka claimed would be "exceptionally rigid" and use no combustible material. The petition cited "practical difficulties" owing to the building's proposed use for "special photographic purposes," underscoring the novelty of studio architecture vis-à-vis the city's building standards, which were rapidly becoming outdated.[85]

Although the Department of Buildings accepted the new glass-and-steel framework, the examiner again rejected Kafka's enlarged wooden beams, and two weeks later Kafka relented, replacing all of the structure's brick walls and wood components with reinforced concrete made from Edison's own patented form of Portland cement.[86] The new amendments were finally approved on December 27, and in mid-January 1906 Kafka submitted the initial bills to the Edison Company urging prompt approval so as to initiate the process of obtaining steel.[87] After several minor delays, contractors completed the studio in late 1906.

The new studio led to marked improvements in Edison's film output that critics associated with the studio's design. A 1909 article in *Moving Picture World* touting "Edison Progress" noted that "our own criticisms of the company's work have, from week to week, borne testimony to the improvement in photographic quality which Edison pictures have recently maintained."[88] Written just after the completion of a concrete addition in late 1909, the article associates Edison's picture quality and high film output with the company's attention to modern methods of picture making and its "capacious" studio space, which allowed for up to five or more simultaneous productions (fig. 3.10). Both the studio's sheer size and Kafka's attention to the ways that architectural design affected lighting and, as a result, photographic quality, had successfully brought Edison back, in the article's words, to "the forefront of the world's moving picture makers."[89]

CONCRETE STUDIOS AND MODERN ARCHITECTURE

The new studio's success owed much to its architects' deft recognition of the need to implement the day's most advanced materials and designs. As was the case at Vitagraph's studio in Brooklyn, Edison's Bronx home

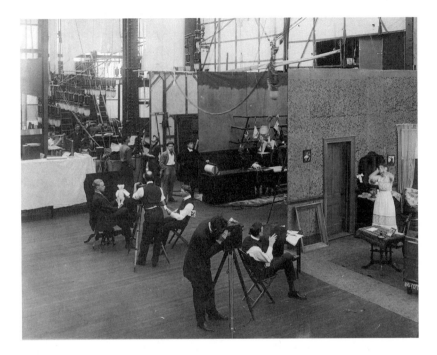

FIGURE 3.10 Interior, Edison Bedford Park Studio, Bronx, New York. Like many
contemporary studios, Edison's was large enough to accommodate multiple simul-
taneous shoots and/or scene changes. (Courtesy of U.S. Dept. of the Interior,
National Park Service, Thomas Edison National Historical Park)

brought cinema into its earliest relationship with modern architecture. In
late 1905, Kafka and the Department of Buildings had transformed the
studio from the iron, brick, and wood that defined nineteenth-century
factories into the reinforced concrete and steel that would define early
twentieth-century modernism. Indeed, as architectural historian Reyner
Banham has shown, at this very moment architects began to replace wood
and brick with reinforced concrete frames, creating what Banham terms
"Daylight Factories," so-named for the increasingly large windows that
provided more natural interior lighting.[90] The implementation of rein-
forced concrete frames contributed to a revolution in materials and designs
that transformed industrial (and, with studios such as Edison's, film stu-
dio) architecture and would help inspire architectural modernism.[91]

As Banham explains, by the mid-1910s photographs of American fac-
tory architecture were making a profound impression on European archi-
tects such as Walter Gropius, Le Corbusier, and Antonio Saint'Elia, who
were inspired by the grace of these structures' spare functional forms.[92]
While the resulting European designs from the 1920s (and the analogous
film sets created by architects working in the film industry) have become
the most commonly cited origins of the relationship between architec-
ture and cinema, the Edison studio predates such associations by almost
two decades. The Bronx studio and those that followed comprise an ear-
lier history of cinema's relationship to architecture—a material history
founded on infrastructural changes to the modern built environment.

The Edison Company contributed to those very changes, alongside the
cinema business, through its efforts to develop a new form of Portland
cement concrete. Edison had grandiose visions for Portland cement that
had striking consistency with modern architects' later utopian ideals for
reinforced concrete. The first decade of the twentieth century witnessed
a virtual explosion in reinforced concrete construction, in part thanks to
the large-scale expansion of Portland cement production at the end of
the nineteenth century.[93] Edison began working with the material in the
late 1890s and created the Edison Portland Cement Company in 1899.[94]
By 1901, the company had invented a new form of cement roasting kiln
and had plans for a concrete structure—the "Edison Poured Concrete
House"—that Edison claimed would revolutionize low-income housing
in cities such as New York (fig. 3.11).

As was so often the case with Edison's highly publicized inventions,
the press seized on the concrete house, reporting on it incessantly in the
early 1900s, even before one was ever built. In January 1908, one article
went so far as to hail the yet-to-be-completed invention as one of the new
"seven wonders of the world," which notably included the skyscraper and
Edison's "camera phonograph" (fig. 3.12).[95] In an article published the fol-
lowing year, Edison himself ranked the concrete house as "the most won-
derful advance in science and invention that the world has ever known, or
hoped for."[96] Motion pictures had to settle for runner-up.

Edison hoped to reform New York City's rapidly transforming
urban environment (for him, the "epitome of the horror of the age")
through the creation of a concrete utopia built with his mass-produced,

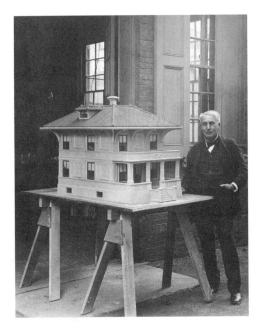

FIGURE 3.11 Edison with a model of the "Concrete House," ca. 1910. (Courtesy of U.S. Dept. of the Interior, National Park Service, Thomas Edison National Historical Park)

low-cost concrete dwellings.[97] In the end, the plan scarcely came to fruition, and only a few concrete houses were ever built. But Edison's Portland cement work—especially the rotary kiln he developed and that competing cement companies used into the 1920s—did support developments in reinforced concrete construction that contributed to another set of utopian visions in 1920s European modernism and concrete film studios worldwide.[98]

By 1910, the Portland Cement Company's catalog, the *Edison Aggregate*, boasted dozens of reinforced concrete structures built using Edison's Portland cement (fig. 3.13). The "daylight factories" featured in the catalog, which included Edison's Phonograph Works in West Orange, were but a step removed from those reproduced later by Gropius and Le Corbusier. And they were even more closely linked to early cinema. Only a few months after the completion of the Bronx studio in October 1907, Edison

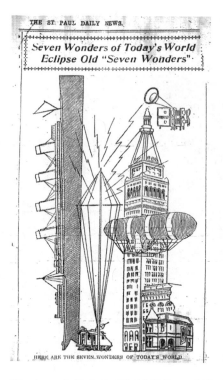

FIGURE 3.12 "Seven Wonders of Today's World Eclipse Old 'Seven Wonders,'"
St. Paul Daily News, January 27, 1908 (Edison Papers Project). The seven wonders
include "New York's 48-story office building" (the Metropolitan Life Insurance
Tower, the tallest building in the world for four years beginning in 1909), the *Lusitania*, European "war airships," Marconi's wireless telegraph, the electric locomotive,
the "camera phonograph," and "Edison's $1,000 concrete house."

hired one of his chief allies in the cement business—architect Horace
Moyer, a concrete specialist—to design a reinforced concrete extension
that he added in 1909 at a cost of $20,000.[99]

Each of these projects contributed to a new architectural landscape
that helped lay the groundwork for future developments in industrial,
modern, and studio construction. Each also helped define modern spatial experiences, physical and virtual alike. The link between Edison's
Portland cement and cinema businesses underscores the important role

FIGURE 3.13 *The Edison Aggregate*, March 1910 (Edison Papers Project)

that architecture played in shaping cinematic space from the beginning of the century. It should thus come as no surprise that filmmakers, architects, and theorists in the 1920s would celebrate the relationship between cinema and architecture—they were stating a point that had been in the making for nearly twenty years. We should not, moreover, allow the immaterial associations that those observers drew between cinematic and architectural spaces to delimit our understanding of the two mediums' lasting relationship. Indeed, this chapter has described a tangible history of how the film industry and those working in it were shaped by, adapted to, and left their mark on architecture and urban environments in cinema's earliest days. Similar histories should be written about the periods that followed.

CONCLUSION: UTOPIAN VISIONS AND FUNCTIONAL DESIGNS

The demands of cinema created a simple architecture; new construction materials such as reinforced concrete worked in the same manner. The results should thus lead towards the same goal, and if we add to this the present "economy" that does not allow for excess and our current taste for the fundamentally pure and geometrical "machine," we should arrive at a unity of conception between cinematic architecture and architecture as it is really lived.

—Robert Mallet-Stevens (1925)[100]

The same year that Horace Moyer put the finishing touches on Edison's Bedford Park studio, the first permanent film studio was built in Los Angeles. Within a decade Hollywood and its concrete studios would house a filmmaking utopia, or "dream factory system," that used functional techniques of modern manufacturing to create cinematic "dream" worlds. The latent tension between the "dream" and the "factory," the fantastic and the functional in Hollywood's concrete, glass, and "dark" studios mirrored the blending of pragmatism, utopianism, and a romantic vision of American industrial modernity in modern architecture. Indeed, when Walter Gropius instructed architects participating in a 1919 competition to "go into buildings, endow them with fairy tales . . . and build in fantasy without regard for technical difficulty," he could just have well been describing the task of studio filmmakers—or studio architects.[101]

Early filmmakers and the first film studios played a small, if significant role in driving the "age of movement" that produced images and ideas for an artificial urban environment that, not coincidentally, would later seem perfectly designed for cinematic representation. In the century's first decade, filmmakers endowed the modern built environment with "fairy tales" by documenting Manhattan's "creative destruction," while studio architects adopted the newest materials and designs of urban reconstruction to "build in fantasy." Put another way, before *Manhatta* and Mallet-Stevens, cinema had Hugo Kafka and Horace Moyer. Before Hollywood's massive sets and false-front cities, it had prismatic glass and Portland cement. It was in those guises that cinema developed lasting links to modern architecture and became part and parcel of a new twentieth-century built environment.

· 4 ·

STUDIO FACTORIES AND STUDIO CITIES

PARIS'S *CITÉS DU CINÉMA* AND

THE INCONSISTENCY OF MODERNITY

IN EARLY 1923, critic Louis Delluc traveled to northeast Paris to tour the studios at Gaumont's Cité Elgé (fig. 4.1).[1] Writing in the *Magasin Pittoresque*, he emphasized the modernity and fortitude of what he described as a *"véritable cité . . .* a great factory, [composed] of buildings made of brick, glass, and metal."[2] Delluc's description must have been welcome news for an industry struggling to find its footing in the face of Hollywood's postwar ascendance. Indeed, his visit may have been prompted by the mounting praise for Allan Dwan's *Robin Hood* (United Artists, 1922), the spectacular sets of which dazzled critics and filled the pages of advertisements and press releases in French film journals. In his own review of the film, Delluc underscored the importance of these sets—which he compared to those in Cecil B. DeMille's *Joan the Woman* (1916) and D. W. Griffith's *Intolerance* (1916)—while also emphasizing Dwan's skillful incorporation of their "splendor" into the film's larger "rhythm."[3]

Published on the two pages preceding his review, Delluc's report about Gaumont reads as a kind of preemptive consolation—an effort to assure readers that Hollywood was not the only place with facilities like the Pickfair studios where Dwan re-created Nottingham. Marveling at the studio's size and remarkable efficiency, Delluc holds up the Cité Elgé as an emblem of France's filmmaking infrastructure and grounds for optimism about the industry's future. He illustrates the studio's plenitude by leading readers on a virtual tour of everything from supply closets and electrically lit stages to projection rooms and processing facilities, which he describes as "a great factory in the factory-center of cinema [*une grande usine dans la cité-usine de cinéma*]." For Delluc, these features

FIGURE 4.1 "Vue de la Cité Elgé," Gaumont catalog, 1913. Sales catalogs and other corporate publications increasingly advertised studio infrastructure in the early 1900s. Gaumont's publications celebrated the company's growth in prints that represented corporate evolution as the literal and figurative expansion (across the picture plane) of physical infrastructure. (Courtesy Musée Gaumont, Paris)

made the Cité Elgé nothing less than an equal of "les studios américains d'Hollywood."[4] With such a grand "ville-cinéma," he implies, how could France possibly fail to regain its once dominant position in the global film trade?

Delluc had reason to be confident. In the decade before the disruption caused by World War I, Gaumont's Cité had become one of the largest and most active film sites in the world. When measured not solely by film receipts but also its output of machines, patents, and publicity materials, few companies could rival Gaumont's productivity. While others had their stages and processing rooms, only the largest studios—including Gaumont's Paris neighbor, Pathé Frères—could match the Cité Elgé's manufacturing capacity, printing facilities, research labs, design workshops, and artists' studios. The prewar strength of Paris's film titans was built, in no small part, on the considerable infrastructural resources of these "studio cities" and their factory centers.

Delluc's 1923 account well describes the achievements of the studio designers and architects who, in the previous two decades, had shaped Gaumont and Pathé's studio expansion. In the early years of the French film industry's postwar struggle against Hollywood, these buildings

offered visible evidence of the industrial development that many, like Delluc, hoped might still put the brakes on the American invasion. The studios represented the outward manifestation of the industry's capitalization and systematization from around 1903 to 1912. During this period, as historian Georges Sadoul argued, cinema broke free from its artisanal roots to become a huge industry.[5] But what, precisely, did becoming an industry involve? What allowed companies like Gaumont and Pathé to trade artisanal practices for industrial ones? And how did those changes fit in the broader industrialization of Paris that had already been in the works for half a century (and was still shaping urban infrastructure)?

This chapter answers such questions by examining the processes and products of French cinema's early industrial growth. It focuses on the too often overlooked buildings that supported industry expansion, the new technologies they produced, and the films and filmmaking practices they engendered. Studio modernization involved an array of operations and facilities that grew up around—and went well beyond—the filming completed in studios' often-remarked-upon production stages. At large companies these included power stations to support studio lighting and factory machines; factory floors for manufacturing both film apparatuses and non-film devices; facilities for processing and storing film stock; ateliers where artists churned out painted backdrops, set pieces, and broadsheet poster art; printing workshops for catalogs, journals, and advertisements; and storehouses that stocked vast collections of sets, costumes, and props. The spatial proximity of these diverse activities contributed not only to the emergence of efficient production practices but also to the invention of new machines and techniques for pre- and postproduction work in new studio factories. As the studios became large centers of film production and manufacturing that looked and operated like industrial complexes, film companies adopted the same policies and practices—such as economies of scale and vertical integration—that guided other French industries.

Studio expansion and diversification paralleled the growth seen in New York at Edison, Biograph, and especially Vitagraph. But while Paris was marked by the introduction of similar new technologies, building materials, and infrastructural systems, their implementation and the regulatory frameworks that governed their early use had distinct and important

consequences for the film industry. Like New York, Paris was shaped by a mix of creation and destruction. The renovation project known as Haussmannization that began in the 1850s continued to transform the city well into the twentieth century. Thanks, in part, to growing private real estate speculation and new zoning ordinances, Haussmann's legacy included the expansion of private industry on the city's outskirts, where new factories encircled the periphery. It also included the introduction of new municipal infrastructure, especially the Métro system (first opened in 1900) and the city's first electrical grid (implemented from 1888).[6]

As in Manhattan, these infrastructural developments helped engender modern forms of movement, light, entertainment, and consumption. While others have examined how such hallmarks of modernity and modern life created a favorable context for cinema's emergence and early development, this chapter emphasizes the material consequences of their inverse qualities: the chaotic, inconsistent side of industrial modernity that threatened to interrupt the film industry's efforts to systematize and rationalize its production methods and helped pushed those efforts in new directions.[7] From the inconsistent implementation of the electrical system to the risks and regulations associated with new industrial materials such as celluloid, this chapter highlights how Paris and its film industry struggled, at times, to cope with modernity's underbelly, or what historian of technology Peter Soppelsa has termed its "fragility."[8]

Traces of Paris's "fragile" modernity could be found in the physical makeup and practices of the large studio centers—those *cités du cinéma*—where smokestacks betrayed the early and literal iteration of studio "dream factory systems." Gaumont's Cité Elgé and Pathé's facilities in Vincennes and Joinville, on Paris's southeastern periphery, became emblematic sites of the tangible links between cinematic, architectural, and technological development that marked silent cinema.[9] From the electrical stations needed to provide power for buildings left unserved by the city's fledgling electrical networks to the experimental machines designed in studio labs to interface with its unstandardized nodes and the storage depots mandated for safely housing celluloid film stock, cinema's industrialized studios took shape according to their city's evolving form.

That form left its mark no less on the films produced on the studios' ever-larger stages. If, as Giuliana Bruno has argued, the first filmmakers

made cinema "an art form of the street, an agent in the building of city views," they often did so by rebuilding those streets on studio sets.[10] Shifting our focus from film historians' attention to cinema's relationship to the urban environment in actualities, city symphonies, and location shooting, this chapter continues the last chapter's focus on other significant ways that early filmmakers interacted with and physically affected urban space through both films and studios.[11] From their new studio headquarters, Gaumont's and Pathé's film units continued in the tradition of the Lumière operators and other early filmmakers who found ready film subjects in the metropolis. Unlike their predecessors, however, directors such as Alice Guy and Louis Feuillade for Gaumont and Ferdinand Zecca for Pathé also followed Méliès's model, rejecting the contingencies of modern urban life in favor of safely staged interiors.

The first studios had offered a retreat from gawking crowds and meddling authorities, creating a new version of city filmmaking—just off the *trottoir*—that existed alongside street actualities in the early 1900s. As film companies grew, both physically and financially, and strove to broaden their markets by making "art" films targeted at the bourgeoisie, they continued to use subjects culled from beyond the studio gates. Series such as Gaumont's "Scènes de la vie telle qu'elle est" ("Scenes from life as it is"), for instance, made modernity's inconsistency and fragility regular features of the silent screen. But such films did not involve an extensive turn to shooting on location in the city itself. Rather, they tended to use only fragments of city imagery to reproduce the city "as it was," relying upon studio-constructed realism to tell stories about life behind closed doors.

This emphasis on the city's interior spaces is hardly surprising given the utility of studio filmmaking made possible by the efficiently organized, systematized filmmaking centers that Gaumont and Pathé had put in place by 1910. To historians looking back at them with Hollywood in mind, these *cités du cinéma* bear all the trappings of the "dream factory system" that would emerge in Southern California only a few years later. But these similarities should not overshadow the numerous other industrial activities that took form within studio walls and facilitated French cinema's modernization. Put another way, early cinema's real factories were no less important to the industry's development and success than

the "dream factories" next door. To be sure, the industry's economic triumphs in the early 1900s made cinema's prewar expansion possible, but that tells us only so much about what economic success meant. By considering the infrastructure that subtended and developed thanks to those profits, this chapter demonstrates the studio's critical role in shaping the techniques, machines, and practices that propelled the industry into and through the First World War.

INFRASTRUCTURE, INDUSTRY, AND THE POLITICAL ECONOMY OF EARLY FRENCH CINEMA

For all of cinema's importance as product and producer of modern urban life—from the Grand Café to the *grands boulevards*—like most French industries at the fin-de-siècle, early film manufacturing was more of a suburban affair. Méliès's films had to travel six miles from his studio in Montreuil-sous-bois to reach their first screenings at the Théâtre Robert-Houdin. The competing companies that came and went in cinema's first two decades littered the Parisian periphery with studios in places like Neuilly-sur-Seine (two miles west of the Champs Elysées), Boulogne-sur-Seine (three miles southwest of the Eiffel Tower), Courbevoie (two miles northwest of Paris's western periphery), Epinay-sur-Seine (six miles north of the city's northern edge), and Gentilly (just outside the city to the south). Pathé made its initial home a few miles south of Méliès's in Vincennes, and even Gaumont, the closest of the group, laid the groundwork for the eventual Cité Elgé on the far side of the Parc des Buttes Chaumont on Paris's northeastern edge, two and a half miles from the *grand boulevards*, the heart of redesigned Paris.

A remarkable 1902 painting by Pathé set designer Henri Ménessier offers one image of what the early days of film production looked like in these Parisian border zones (fig. 4.2). Set in Vincennes—Pathé's first home and still its primary headquarters in 1902—the painting provides a rare behind-the-scenes glimpse of a film shoot: four actors in period costume perform in front of a wooden shed, goaded on by a gesturing director flanked by his cloaked camera operator. Alongside the shoot, three costumed actors wait for the next scene while an assistant stacks props and

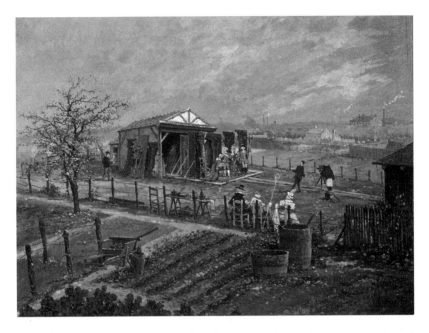

FIGURE 4.2 Henri Ménessier, *Une prise de vues en plein air*, Vincennes, 1902, oil on cardboard, 46 × 60cm (Cinémathèque française, Bibliothèque du film, Service Iconographique)

set pieces against the shed. Of greater interest than the filming itself is the striking image of the suburban context that would condition Pathé's development over the next decade. Beyond the small garden and open fields immediately surrounding the stage, a nearby factory and distant smokestacks foretell the company's (and French cinema's) not-so-distant future. Read from foreground to background, the image offers a brief history of early filmmaking in Paris, from nearly rural production under cloudy skies to suburban industrial cinema in studio factories.

The painting neatly illustrates the broader context of suburban industrial development in which French cinema emerged.[12] From Ménessier's vantage point—perched above and five years removed from Pathé's origins—the conspicuous traces of industrial modernity on the horizon betray the painter's canny awareness that cinema's own artisanal days were soon to end. While images of nature, as art historian T. J. Clark

argues, had previously offered painters like Monet one last refuge of consistency in the immediate environs of a city being reconstructed in the image of capital, Ménessier's view of Paris's border landscape seems to suggest that nature's "presence and unity" would have to be sought elsewhere.[13] In contrast to the way that Monet could, in paintings such as *Le Voilier au Petit-Gennevilliers* (1874), include images of industry that "hardly register as different from signs of nature or recreation [such that] a chimney is not so different from a tree or a mast," in Ménessier's painting industry looms large as the silhouette seen just beyond the stage performers and, just to the right, in the clear form of a nearby factory.

While Ménessier's single painting hardly represents a general approach to representing nature and technology, one is nonetheless left with the sense that it captures something important about the interrelationship between Paris, cinema, and capital. Ménessier's horizon forms a horizon of expectation that links the late-nineteenth-century remaking of Paris in the image of capital with cinema's own remaking—beginning precisely at the moment of the painting's production—to fit the rational demands of capitalization. It also begins to suggest cinema's increasingly important role in remaking Paris in capital's more literal image—torn from reality, framed, and reshaped in 24 frames per second. If the medium of painting was proper to nature, as Clark argues—that painting was "*like* landscape, like the look of sky and water *en plein air*"—cinema, Ménessier's *prise de vues en plein air*, was soon to become more like the city—like the look of the skyline and the ordered spaces beneath it.

That ordering would appear in the massive studios and studio factories that took form according to and in the image of the industrial developments that Ménessier's painting juxtaposes with Pathé's first staged productions. But more than simply the context for French cinema's early development, industrialization played a significant role in shaping the industry's growth. Money bound the two together. Gaumont and Pathé built their film businesses using large capital investments from industrialists who hoped either to shift their investments from older industries such as textiles manufacturing or to build on concurrent profits in new industries, especially electricity. Film's first investors used their expertise in other industries to influence cinema's strategic planning and define cinema's own industrialization. And those other industries formed the backbone

of the modernizing Parisian infrastructure to which film's industrializing studios and new technologies would be forced to conform.[14]

In 1897, the Pathés incorporated their cinema and phonograph businesses with investors in the *Compagnie Général des Phonographes, Cinématographes, et Appareils de Précision* (hereafter, Compagnie), a group that hoped to exploit the growing phonograph industry and take advantage of Pathé's film camera patent.[15] One principal Compagnie investor, Jean Neyret, a former paper mill director with links to the bank Crédit Lyonnais, had interests in the growing electrical, steel, and coal industries. He was president of firms including *Aciéries et Forges de Firminy*, a company specializing in railroad materials, and vice president of *Houillères de Saint-Etienne*, a mining company headquartered in Lyon. Another, Claude Agricole-Grivolas, had been involved in manufacturing machines for the electricity industry since 1875, including *Les Etablissements Grivolas et Sage et Grillet*, which built apparatuses for electrical stations, and the *Compagnie française d'appareillage électrique*.[16] He had also recently acquired the *Manufacture Française d'Appareils de Précision*, a company directed by Victor Continsouza and Henri René Bünzli that maintained a factory in Chatou, one of Paris's important industrial suburbs. The factory—where Pathé's film cameras would soon roll off the same assembly lines used to produce a variety of other precision machines—represents a concrete example of the importance that broader industrial developments had for cinema's own industrialization. Pathé needed factories like Continsouza's to mass produce its film equipment, much as it would soon need the city's emerging electrical and transport systems—the infrastructures built by and/or using the materials produced by companies owned by the likes of Neyret and Grivolas—to produce and supply its machines and films.[17]

Gaumont developed according to similar circumstances. Company founder Léon Gaumont built the business by focusing on photographic instruments with funding from scientists and engineers interested in optics. He began his career as an assistant in the workshop of Jules Carpentier, the technician and inventor who built the first Lumière Cinématographe, and at Max Richard's *Comptoir général de photographie*. In 1892 Gaumont bought Richard out using capital from Gustave Eiffel (who was interested in experimental optical devices) and Joseph Vallot (head

of an observatory at Mont-Blanc).[18] In 1895 he renamed the company the Société Léon Gaumont et Cie. The following year, with more funding from Eiffel, he initiated the Société's first step toward industrialization by building a large machine workshop on a plot of land owned by his wife on Paris's northeastern periphery, just adjacent to the Parc des Buttes Chaumont.

With the new workshop in place, Gaumont focused on designing and manufacturing precision photographic instruments such as lenses, binoculars, and photographic cameras to support the existing photography market. Meanwhile, he worked with Georges Demenÿ to develop what would become the company's film camera. In the summer of 1896 the workshop produced the company's first film projector, Demenÿ's *Chrono*. The following year its products also included Demenÿ's camera, the *Chronophotographe*.[19] Gaumont promoted his new devices by producing films to go with them. He organized a small film production unit that, from May 1897, devoted its efforts to filming actualities in Paris in the fashion of the Lumière operators and Méliès, who had yet to complete his first studio.

Over five years later, Gaumont followed Pathé's lead in modernizing and expanding both his filmmaking and manufacturing facilities. To do so, he needed a new injection of capital. He opted to incorporate the company and cede leadership to a new president, an industry magnate named Pierre Azaria. Like Neyret and Grivolas at Pathé, Azaria brought the company into contact with France's booming electricity business. Alongside his duties as Gaumont's president, Azaria served as president of the *Compagnie générale d'électricité* and was the supervisor for Continental Edison and General Electric's French affiliates.[20] Azaria's interindustry duties would be mirrored in the research labs and on the factory floors that soon defined Gaumont's studio compound.

These repeated links between cinema and the electrical industry signal more than simply the emergence of the tangled political economies that continue to underpin global cinema today. Rather, they represent only one aspect of an intertwined history that significantly affected film's infrastructural and formal developments. For Pathé, the specific patterns of industrial development that shaped Paris's eastern suburbs would help condition the company's infrastructural foundation. Meanwhile, the

creation of Paris's electrical networks would help condition Gaumont's continuing emphasis on technology by framing cinema within a context that necessitated technological intervention beyond the invention of cameras, projectors, and other film-specific machines. In each case, although rationalization and efficiency remained the prevailing ideals of cinema's industrialization, the inconsistency of Paris's modernization and its consequent inefficiency helped determine the form of rationality that Pathé and Gaumont's respective industrial developments would take.

FROM ARTISAN TO INDUSTRY: EARLY INDUSTRIALIZATION AT PATHÉ

How, from its early years shooting on an exterior stage like the one painted by Ménessier, did Pathé become a massive company with studios and factories spread across Paris's southeastern periphery? What guided its development from artisanal production to the economies of scale that made cinema akin to other modern industries? Pathé's development and rise to industry dominance should be attributed in no small part to the industrial experience of its investors.[21] Indeed, although Charles Pathé played a significant role in the Compagnie's cinema business, his eager demands for expansion and repeated calls for new studio space often failed to win the support of the Board.[22]

Instead, under the watchful eye of its cautious backers, Pathé's industrialization and investment in physical infrastructure advanced slowly, especially for the film business. In 1898, with one million francs of capital, the company built a single factory in Chatou for producing phonographs and added another only in 1899 when capital reached two million francs.[23] On the strength of the phonograph profits, it also bought the Vincennes café that housed Charles's film productions that same year. Here, they continued to make films *en plein air* (and possibly in a glass-enclosed room), turning out prints, according to Pathé, at a rate of forty kilometers per day by 1901.[24] In 1902, recognizing the rapid expansion of the cinema market and bolstered by the booming phonograph business, Neyret, Grivolas, and new board member Albert Ivatts approved a series of projects to expand Pathé's cinema production units.[25]

These initial projects focused on expanding production space and sheltering Pathé's filmmakers, much as Méliès had done five years earlier. During late summer and early fall of 1902, Charles Pathé and Albert Ivatts oversaw the construction of a glass-and-iron-roofed "hangar" near the company's courtyard production stage. Perhaps due to its initially cautious and frugal approach to infrastructural development, as well as the small scale of this initial studio, the Compagnie did not hire an industrial architect for the project.[26] Instead, the directors elected to engage a series of Vincennes-based contractors to build the new studio, located at 43, rue du Bois.[27]

The structure offered Pathé director Ferdinand Zecca many of the same advantages already seen in Méliès and R. W. Paul's similar glass-enclosed studios. In this new glass house, Zecca produced films that helped make techniques such as matte inserts and dissolving transitions common industry practices.[28] The studio's increased film output also contributed to the industry's growth. At the Compagnie, cinema profits rose by 32 percent from 1902 to 1903, approaching the formerly dominant phonograph figures.[29]

Despite this success, Pathé and Zecca quickly found the studio lacking, first in light quality, then in size. While historians have tended to date the introduction of electrical lighting in French studios to 1903 or later, the minutes from the Compagnie's Board of Directors meetings suggest that Pathé outfitted its first studio with electrical lights in 1902 after deeming its natural lighting insufficient.[30] In November, Pathé sent word to the Board that the studio's cost had risen by 14,000 francs in order to augment the power available for stage lighting. His report noted: "the current lighting, which is sufficient for small scenes with few actors, is not sufficient for large scenes with many actors on stage."[31] To complement the studio's natural lighting, Pathé added enough power for ten arc lamps that were used with reflectors to redirect light toward the stage in order to create softer, more diffuse illumination. The results, he reported, put the company "in an exceptional position, allowing us rapidly to produce new cinema projects."[32]

Soon, however, it became clear that the studio still lacked sufficient facilities to support the industry's growing demand for films. Pathé sought greater efficiency, and he moved to modernize the company's artisanal

methods by transforming its physical spaces. Although he would continue to use the former café on the rue du Polygone as a workshop for processing film and producing machines, sets, and props, by December Pathé called for a new atelier devoted to set design. After visiting the existing workshop, the Board authorized up to 5,000 francs to build a glass-enclosed hangar on a rented property next to the studio. When negotiations with the neighboring owner fell through, the Board elected to follow a new proposal from Pathé, who suggested adding a glass roof to the rue du Polygone building at a cost of 20,000 francs.[33]

The new project, completed by late February 1903, allowed Pathé to take several important steps toward rationalizing its film output. First and foremost, the new facilities increased production of positive film stock to twelve thousand meters per day.[34] Second, the new architectural space offers evidence of Pathé and Zecca's growing attention to the importance of specialized workspaces and the division of labor among increasingly specialized workers. As Stéphanie Salmon describes, "The project [to build a set design atelier] reveals the need to multiply the spaces to assure the efficiency of tasks as well as the augmentation of numbers."[35] As would be the case for Alice Guy's productions at Gaumont and for Méliès's studio films, such changes helped attract set designers from Paris's theater community.[36] Their insertion into film production helped solidify the industry's connection to the French theater, even as the expansion and modernization of film studios contributed to these professionals' further incorporation into the film community and away from their stage work.

Despite the increased efficiency initially generated by its new workspaces, by early 1904 the new studio and design atelier proved, once again, insufficient for the Compagnie's production needs. The lack of sufficient workspace produced new forms of inefficiency and waste. Pathé reported to the Board that the set design workshop was running at full capacity but limited storage meant that any décors not used for multiple films (a practice often necessitated by the demand for rapid production) had to be destroyed after each shoot. To make matters worse, several property owners surrounding the production studio had built new large buildings that blocked sunlight and thereby shortened the available working hours. Pathé proposed to solve these problems in one fell swoop by demolishing

the existing studio in favor of a new, larger building to house set design workshops, storage facilities, and production stages. The new building would be high enough to avoid shadows from neighboring structures, and Pathé also reached an agreement with the proposed studio's neighbors to restrict the height of their buildings.[37] At the same time, he began plans for another facility in nearby Montreuil that would help maintain production during the construction in Vincennes.

EXPANSION AND DISPERSAL: THE "PROVISIONAL STUDIO" IN MONTREUIL

Pathé's decision to build the studio in Montreuil rather than closer to the Compagnie's current production facilities on the rue du Bois previewed the future dispersal of its facilities across Paris's southeastern suburbs. Montreuil was a sensible location for this initial expansion: the provisional satellite studio would remain close to Vincennes, and Montreuil's patterns of industrialization were favorable for a filmmaking facility. Owing to resistance from its agricultural producers, the community had industrialized slowly and on a small scale. As a result, small factories and ateliers greatly outnumbered the heavy industries seen northwest of Paris in places like Chatou, and as horticulture gave way to manufacturing, small agricultural plots increasingly became available for industry.[38] Pathé thus faced little risk of seeing its studio overshadowed by a large, smoke-spewing factory or, given the small size of the adjacent plots, the kinds of neighboring construction projects that necessitated a new studio in Vincennes.

In early 1904, as preparations for the new Vincennes studio slowly progressed, the Compagnie purchased a lot at 52, rue du Sergent-Bobillot in Montreuil, only a stone's throw from Méliès's studio. Here, Pathé initially proposed a 3,000-franc "glass-and-iron hangar for equestrian and other exterior films."[39] Pathé later altered the plans, calling instead for a large glass house studio. Although often referred to by Pathé and others as the "provisional studio," the resulting building continued to house film production through the 1920s and still stands on the same site today, making it the oldest remaining studio in France.[40]

A number of factors likely influenced Pathé's decision to establish something more permanent in Montreuil. Most importantly, Pathé must have taken the rising demand for films as a signal (and perhaps a selling point for the previously cautious Board) to invest in future film production. Part of this investment would have gone into adding electrical lighting to studio infrastructure. Here, Montreuil proved a good setting for industries of all sorts, for it had access to one of the city's private electrical networks, by no means a given, even in 1904. It also benefited from access to Paris's growing transport infrastructure. From 1899, Montreuil had housed a tramway station facilitating access to and from Paris.[41] Finally, Montreuil had, since at least 1870, been home to significant celluloid production. These patterns in Paris's broader industrialization made Montreuil an ideal setting in which to build a full-fledged studio.

At its completion, the studio's main glass hall covered 22 × 12 meters and, much like Méliès's original studio, initially housed both film production and set design in the same central hall (fig. 4.3).[42] One of the few

FIGURE 4.3 Pathé's Montreuil Studio, Interior. From Frederick A. Talbot, *Moving Pictures: How They Are Made and Worked*, 112.

existing images of the studio's interior offers a sense of the studio's hybrid working conditions. Much as in the earliest studios, set design, construction, staging, and filmmaking in Montreuil often involved the same spaces and workers. While this image, like many others of the time, may have been produced for publicity, there should be little doubt that work in such studios involved the kinds of concurrent activities depicted. Three workers rig a backdrop of a city scene painted in depth, which sits alongside another, angled backdrop for an interior scene. Meanwhile, operators prepare three cameras for shooting, and stagehands, including a worker sawing a board in the foreground, arrange set pieces. Much like the system Zecca and Pathé had begun to institute in Vincennes, these tasks would increasingly be spatially divided in newer and larger studios.

Such would be the case for the new Vincennes studio, a project for which the Compagnie spared little expense. The three-story structure's cost, not including painting and glass, would rise to 95,000 francs, plus another 11,500 for the heating system.[43] The studio marked a notable step in the industrialization of the Compagnie's film division: it would be a modern industrial space designed and built by an industry professional. Pathé entrusted the studio to Eugène Laubeuf, a Chatou-based architect whose firm, Les Etablissements Laubeuf, had completed projects for companies including the Chemin de fer de l'ouest.[44] This turn to professional architects—taken at approximately the same moment by the New York–based companies discussed in chapter 3—marks a decisive shift in which film companies made schematized spaces the basis for increasingly systematized production methods.

Laubeuf's design for Pathé makes such systematization clear. Materially, it resembled French factory architecture of the day, with brick walls and windows on the rear and one side, while the remainder, including the roof, was glazed in iron-and-glass. Its layout points both to the division of tasks that had come to define the industry's working practices and to the ways that architectural demands shaped the organization of those tasks.

Read from the ground up and back down, the three-story structure defined a circular film production process that moved from the arrival of workers and materials to set design, film shooting, and the departure of completed films. The ground floor consisted of four rooms plus a concierge's office. In two ateliers—one for woodwork, the other for

iron—workers processed raw materials into the backings and prototypes for sets and props. An adjacent closet provided storage space for these materials and previously used sets. This floor also housed the film developing laboratory, the placement of which was likely guided not only by the efficiency of being able to send completed films out the door, but also because it would allow workers to escape and fire fighters to enter in the case of an accident.

On the floor above, the set design workshop stood at the midpoint between the raw wood and metal that arrived at the studio door and the artificial worlds assembled on the stages above. Here, the set and prop materials built and stored below took final form alongside the formation of ideas for films. Spatially, the set designers needed to be on an upper floor to ensure sufficient lighting, a fact that would push later studio designers to include design ateliers on the topmost floors, providing access to the same light available for shooting. Alongside the workshop, the floor housed offices for the filmmakers and the studio director as well as Charles Pathé's office, where he held regular meetings with set designers and filmmakers.[45]

Finally, the top floor, with its glass roof, let sunlight in and sheltered production. A system of black and white shades allowed Pathé's directors to control the brightness and diffusion of light to the stage, just as Méliès had done in his first studio.[46] The production space was divided in two, with stages on either side to allow for simultaneous productions. A specialty stage-building company, Wessbecher, designed the two stages, the larger of which included a subsection and trapdoors for trick effects, much like Méliès's studio after its enlargement in 1899.[47]

In addition to promoting production efficiency, the new studios in Montreuil and Vincennes created new aesthetic possibilities.[48] As Noël Burch has noted, their increased size, in particular, led Zecca and Pathé's other directors to explore increasing camera movement in studio films. Shot against the large painted backdrops that came out of the new set design studios, the horizontal panning sequences that distinguish films such as *Au pays noir* (1905) demonstrate the films' new degrees of dynamism.[49] As with Méliès, the shift to new glass-and-iron studios brought increasing spatial fluidity—including not only these horizontal and vertical pans but also spatial tricks such as appearing and disappearing objects,

multiple exposures in the same frame, and the movement of characters and objects across the frame.

These features helped Pathé's popular films dominate the French and American markets, leading to unprecedented growth that necessitated further infrastructural expansion to keep up with demand.[50] Before Pathé could extend its operations in Vincennes, however, its growth took an unexpected turn in the face of Paris's fragile modernization. In the wake of a scandal caused by a celluloid-related fire, new laws governing film storage drove the creation of Pathé's next cinema "city" in the nearby Parisian suburb of Joinville-le-Pont. This shift would change the geographic face of film production and mark French studio cinema for years to come.

"L'AFFAIRE DES FILMS" AND EXPANSION TO JOINVILLE

Just as Laubeuf was putting the finishing touches on the new Vincennes studio in September 1904 and Pathé began to look ahead to further infrastructural development, the cinema industry came under unexpected new pressure from municipal authorities. On Saturday, February 20, 1904, an explosion at a celluloid comb manufacturing workshop in central Paris left fourteen workers dead and numerous others injured. The resulting attention to celluloid storage created what Pathé's Board of Directors referred to as "l'affaire des films" (the film affair). As the company sought to expand its growing film production and manufacturing units, it faced the suddenly difficult task of finding an acceptable location for its facilities.

The celluloid exploded early one afternoon, just after workers returned from lunch. The workshop was located in a multiuse building at the corner of the boulevard de Sébastopol and the rue Etienne-Marcel, a densely populated area in the center of Paris. Onlookers described a horrifying scene. As the fire grew, workers and residents on the upper floors leapt to escape the flames. Descriptions of the "*catastrophe*" filled the popular press, and in the following days many Parisians gathered outside the Paris morgue, hoping to catch a glimpse of the victims, who were not, much to the crowd's dismay, put on display.[51] News of the disaster continued

to occupy the press for more than a week as investigators sought the origins of the explosion and families mourned the victims. The investigation revealed that the fire most likely came as the result of a misplaced cigarette that ignited a stockpile of celluloid.[52]

City officials responded to the tragedy by reinforcing existing laws regulating the storage and use of hazardous materials in the city limits. For the cinema industry, the new policies brought celluloid production, processing, and storage facilities under county regulations as "dangerous, unhealthy or uncomfortable establishments [*établissements dangereux, insalubres ou incommodes*]."[53] Surprisingly, despite the often-described attention to the dangers of film fires in theaters after the Bazar de la Charité disaster of 1897, spaces of film production and storage had remained largely out of regulatory view. Pathé's Board of Directors was thus surprised to receive word in September that the company's positive film stock would be reclassified to conform to the new code. To meet the limitations on celluloid storage, the Board initially intended simply to spread its supply across a series of small rented locations.[54] Two months later, however, the matter remained unresolved.

At first, Pathé divided its stock between four storage sites in order to conform to the new code. It allocated 300 kilos to the studio on the rue du Bois, 1,200 to its nearby processing facilities on the rue du Polygone, 800 to another neighboring site on the rue des Vignerons, and 300 more to the company's headquarters on the rue St. Augustin. City inspectors, however, rejected the rue du Polygone facility (where Pathé stored its original film prints), despite the fact, Pathé noted, that it was built "below ground, with iron cabinets that could be easily flooded, and that the film strips were themselves in iron boxes, sheltered from any exterior contact."[55] The following month, inspectors also rejected the rue des Vignerons storage site, leaving Pathé in dire need of new facilities.[56]

By January the company was becoming desperate. Even if it were able to convince municipal authorities to allow the maximum storage rates at the company headquarters, the Montreuil studio, and the rue du Polygone facilities, it would still run short by more than 3,000 kilograms per day. To make up for the lack of storage space, Pathé resorted to an inconvenient and inefficient system of moving celluloid from facility to facility throughout the day.[57]

These restrictions threatened to slow the company's stunning growth. In February 1905, Pathé reported that the Vincennes factory, which was already producing 8,000 meters of film per day, could not meet the potential market demand. Eager to reduce its reliance on film imports from George Eastman, the Compagnie also sought new facilities for producing its own film stock.[58] While the best course of action would be to enlarge the Vincennes factory, the "film affair" left the company little choice but to retreat to a more remote location. Perforating negative film and processing, developing, printing, and storing positive prints would thus be divided from storing negative film stock and producing films, which would continue at the Vincennes and Montreuil studios. This planned division of the production process anticipated the company's later decision to divest its production arm and instead rent out its production facilities and contract with smaller companies to produce films for distribution.[59]

The Board quickly approved the purchase of a new, two-acre site on the south bank of the river Marne in the neighboring community of Joinville-le-Pont.[60] The site's cost of 80,000 francs satisfied the Compagnie's directors, who also noted that it offered important access to major roads and a railroad station that would facilitate film distribution.[61] After several months of negotiations with the Municipal Council of Joinville and the Public Health and Safety Council of the Department of the Seine, Pathé received authorization in August 1905 to build a storage depot capable of holding up to 10,000 kilograms of celluloid and a series of workshops for celluloid production.[62]

The Public Health Council outlined four specific regulations for the new facilities that would put Pathé in accordance with departmental regulations. First, all celluloid had to be enclosed in metal boxes and placed in a storehouse built of noncombustible materials and surrounded by a masonry wall two meters from the building, all located at least thirty meters from the street and fifteen meters from the other factory buildings. Second, Pathé had to build an "intermediary depot" for the factory's daily output, located in proximity to the workshops. Third, the workshops themselves had to be 20 × 12 meters in size, limited to a single ground level, and built entirely from noncombustible materials. Each had to be equipped with six emergency doors opening onto the exterior. The workshops' steam heating systems had to have effective ventilation shafts,

and all lighting had to be electrical, with switches and fuses placed on the building's exterior. Finally, the individual workshops (each of which had to be limited to a single task) were required to be separated by alleys of at least 5 × 8 meters.[63]

As was the case with Edison's studio in the Bronx and numerous other studios, the building codes designed to regulate modern urban development thus had an important effect on the organization of film production practices. Especially as studios became large industrial centers, they simply could not escape the notice of the city inspectors charged with governing urban modernization. In addition to these requirements, Joinville's Municipal Council negotiated seven further stipulations that focused largely on the aesthetics and environmental effects of the new facility. The Council's regulations required that Pathé design its factory to have "an elegant architectural silhouette," avoid large chimneys, be encircled with gardens, have walls lined with trees, not emit dark or noxious smoke, and deposit waste water into a designated sewer. These provisions reflected the community's reluctance to become part of the growing industrialization of Paris's suburbs—to avoid, that is, the kind of factory encroachment displayed in Ménessier's painting of the first Pathé studio.[64]

Pathé initially met these requirements. Much like Edison, who had hired Hugo Kafka to design the Bronx studio to ensure it would meet Manhattan's building codes, Pathé entrusted the Joinville facilities to a similarly experienced architect. He hired a Vincennes-based architectural firm, *Moisson et fils*, led by Théodore-Léon Moisson, who specialized in hotels and rental properties, and his son, Georges, a recent graduate of the École des Beaux-Arts.[65] The firm completed the first atelier in early December and work continued at a rapid pace. Despite its agreements with the Municipal Council, Pathé also eyed opportunities to expand. In April 1906, as the original construction neared completion, Pathé reported that the facilities were already four times larger than originally projected (and complained that it had again become necessary to add two more ateliers for developing and tinting films).[66]

A fawning article in *Phono-Ciné-Gazette*, a monthly industry magazine with ties to Pathé, celebrated the new factory's grandiosity by taking readers on a behind-the-scenes tour of the five original ateliers, which housed, respectively: (1) machine supplies, projection rooms, shipping

and handling offices, and tinting; (2) perforation, printing, developing, and drying; (3) film cleaning and the heating systems; (4) electricity, and (5) storage. Such articles contributed to the emerging identity of film studios by offering readers a journey into what it described as the "midst of the labyrinths of this city—for it is truly a city."[67]

For the remainder of 1906 and into 1907, Pathé continued to press for further extensions of the new Joinville facilities, even as the existing construction dragged on. These efforts were complicated by Pathé's other ongoing efforts, which included purchasing and enlarging a facility in the northeastern Parisian neighborhood of Belleville to manufacture cameras and projectors, building (and then enlarging) a new factory in Vincennes for coloring film prints, enlarging the film processing facilities in Vincennes, and, for the first time, expanding its operations to America.[68] At the end of 1907, however, Pathé finally approached the Department of the Seine with a new proposal to expand its celluloid storage depot in Joinville to accommodate 30,000 kilograms of film stock. The Préfecture authorized construction of two new depots with capacities of 20,000 and 10,000 kilograms. The Compagnie hired a new architect, Charles Pathé's Vincennes neighbor, Georges Malo, to build these depots as well as an additional series of ateliers and a large smokestack to serve its now enormous printing and processing factory (fig. 4.4).[69]

As images of the resulting facilities demonstrate, Pathé had far exceeded the original provisions of its agreement with Joinville and county authorities. Aside from the trees that line the near factory wall and the proper spacing that separates the line of ateliers to the right, the new construction blatantly ignored the original agreement, including its interdictions against multistory ateliers and, most obviously, large smokestacks and dark fumes. Although these flagrant violations infuriated the Municipal Council, the county ultimately dismissed the city's complaints. Much to its chagrin, Joinville had become a city forever marked by the industrialization of cinema.[70]

Over the next two years, as it led the shift to renting rather than selling films, Pathé continued to expand operations in Joinville and especially in Vincennes. On the rue des Vignerons, the Compagnie further developed its printing and processing facilities while adding more studios. Two new glass-and-iron structures housed, respectively, the studios of the

FIGURE 4.4 "Usines Pathé-Cinéma de Joinville-le Pont [*sic*]. This photograph shows the two-level ateliers, large factories, and smokestack completed after 1907. The photo emphasizes not only the size of Pathé's facilities but also its place at an important crossroads for modern transport—the road that extends to the horizon and the River Marne, which parallels the black fumes that so infuriated the Joinville Municipal Council. From *Le Film Vierge Pathé: Manuel de développement et de tirage* (1926), 8.

Société cinématographique des auteurs et gens de lettres (SCAGL) and Jean Comandon's "studio scientifique." The studios reflected Pathé's new orientation toward subjects targeting middle-class audiences and its focus on renting studios and distributing affiliate companies' films.[71]

A photograph of the rue des Vignerons with these additions reveals a sprawling complex that recedes almost beyond view. In Vincennes, as in Joinville, Pathé controlled a *cité du cinéma* carefully crafted for efficient production and distribution of the machines and films that powered French cinema and made Pathé its most dominant company. Such photographs represented film industry power as a form of spatial dominance created by studios and factories reaching out in every direction and poised to overtake what little remains of the surrounding landscape.

Pathé's chief French competitor, Gaumont, would make such images of industrial strength the familiar iconography of its own studio "city," the Cité Elgé. Like Pathé, Gaumont would produce a model of industrial rationalization, but it would focus its efforts on a single site on Paris's northeastern periphery. Much as Pathé's dispersed development took

form according to Paris's industrialization in the southeast and municipal regulation of industrial materials like celluloid, so Gaumont's concentrated expansion was shaped by the vicissitudes of Paris's modernization. In particular, Gaumont would face a problem that Pathé had largely managed to escape: finding a way to power its new studio city.

GAUMONT'S CITÉ ELGÉ AND THE INCONSISTENCY OF ELECTRICITY IN FIN-DE-SIÈCLE PARIS

The specifics of Gaumont's early development have often been overshadowed both by scholars' attention to Pathé and by the tendency to focus only on Gaumont's central production studio, the largest in the world before World War I. While this studio was no doubt the most visually impressive of Gaumont's facilities, the other buildings that formed the Cité Elgé offer a more complete image of French cinema's industrial growth in the early 1900s. From its origins in photographic technology workshops, Gaumont grew into a company with diverse interests in technological research and development that overlapped and intertwined with its film productions. Those interests came, in no small part, from the necessities created by the company's urban industrial context.

During its industrialization between 1897 and World War I, the Cité Elgé responded and played host to a number of important technological developments in cinema and in the broader processes of modernization that were transforming the city of Paris. In particular, the city's emerging electrical infrastructure and its inconsistent form and patterns of development pushed Gaumont in directions that cannot be accounted for if the company is understood only as a film producer and its studio only as a single, if enormous, production stage. From its studio expansion plans to its research and product development strategies, the broad intermedial scope of technological and artistic production that Gaumont would foster during the 1910s and into the 1920s came as a direct result of the material and financial conditions created by the city's turn-of-the-century infrastructural developments.

Cinema—and France's first studios—would arrive in a city with radically uneven electrical infrastructure and little standardization.

Gaumont recognized its need for machines such as electrical transformers to interface with new urban technologies. This need meant that even as Gaumont devoted more and more resources to film production, the company never shed its roots in technological research and development. The results of urban technological change ensured that at companies like Gaumont, film studio production remained closely aligned with film factory manufacturing.

That the electrical industry, in particular, came to play such a large role in early French cinema should come as no surprise. From as early as 1875, inventors and purveyors of electricity and electrical lighting had begun building an industry in France through the slow but steady process of illuminating cities and transforming industrial power. In Paris, electrical lighting became a viable and desirable alternative to gas systems first in major public spaces: department stores (the Magasin du Louvre and the Bon Marché), spaces of entertainment (the Hippodrome, the Opéra, and the Musée Grévin, each of which installed arc lights in 1878), as well as industrial spaces such as railroad stations and construction sites.[72] The 1881 *Exposition internationale d'électricité* in Paris sparked new industry growth by facilitating an international exchange of ideas, technologies, and enthusiasm, especially for the public debut of Edison's new carbon filament lamp.[73] By the mid-1880s electrical lighting was becoming common in Parisian stores and theaters, and in 1886 the Municipal Council installed electric lights in its administrative headquarters—the Hôtel de Ville—and began considering plans for a municipal lighting system.[74]

The city met strong resistance from France's gas industry, which managed to protract the transition to electricity—with much more success than its American and German counterparts—into the early twentieth century.[75] The 1889 Exposition Universelle, however, went a long way toward convincing the Municipal Council to electrify the city. In addition to constructing buildings and monuments such as the Eiffel Tower, preparations for the Exposition included other efforts to modernize Paris's physical appearance. Municipal authorities were particularly concerned with implementing public electrical installations, lest the Exposition, in historian Alain Beltran's words, "show the whole world that the 'City of Light' scarcely merited its name."[76] Concurrent developments in the private sector underscored the value of transforming the city's illuminating infrastructure.

A series of gas-related accidents at Parisian theaters led to both new city regulations and a more general shift by private owners to electric lighting. On May 27, 1887, a fire at the popular Opéra-Comique killed eighty-four performers and patrons and destroyed the theater. Investigators linked the fire to the theater's gas lighting system, triggering widespread renovations of Parisian theater lighting.[77] The media spectacle and government intervention that followed bear striking resemblance to the aftermath of the infamous film fire at the Bazar de la Charité ten years later, which killed 121 spectators, mostly wealthy noble women whose full skirts provided ready tinder.[78] In response to the Opéra-Comique fire, commercial venues such as the Odéon, Olympia, and Moulin Rouge joined the Palais Royal, Nouveau Cirque, Musée Grevin, and Paris's large hotels in installing new incandescent lighting systems.[79]

Thus even as the Municipal Council began debating plans for building the city's electrical system in 1888, investors and developers had already started the slow process themselves. This existing infrastructure contributed to council debates that focused largely on whether the city's electrical networks would be public or private. The city elected to implement a hybrid form consisting of one municipal system (with an electrical works serving the central markets at Les Halles and the surrounding neighborhoods) and six sectors granted to private suppliers for eighteen years (up to 1907).[80] The introduction of these private electrical providers expanded the market for electrical machines as factories arose in and around the capital, creating ample profits for the electricity investors who later funded the young film industry. Such investments would be only one of the important effects that the city's decision would have on early film development.

As the Municipal Council quickly recognized, the private system was rife with problems that limited its coverage and consistency, problems that would continue into the 1910s. The six private concessions offered widely varying degrees of service and used competing and often incompatible electrical technologies. Four of the six companies employed direct current systems, but only two of those four used compatible technologies.[81] Moreover, much to the Municipal Council's chagrin, the concessions showed little interest in expanding their networks beyond already inhabited areas and the sites of heavy consumption. And why would they? When the city

made it clear in 1899 that it would not renew the concession system past 1907, there was no incentive to develop. In 1904, the city created a commission charged with finding a solution for centralizing electrical production, standardizing the city's networks, and expanding service to areas with little to no electrical infrastructure.[82] Still, by the end of the concession in 1907, northeastern Paris—home to the Cité Elgé—remained almost entirely unserved. The twentieth *arrondissement* did not possess even the most basic electrical network, and the network in the nineteenth remained untenably sparse.

The lack of network coverage in these areas left an indelible mark on Gaumont. In contrast to Pathé, which was served by the *Compagnie Parisienne de l'air comprimé*, Gaumont's facilities remained stranded in an electrical no-man's-land that would not receive municipal power until after World War I.[83] Gaumont responded by mimicking the strategies used at other large industrial and commercial establishments with high levels of electrical consumption. These companies simply produced their own electricity. In 1889 the six concessions provided only about 30 percent of the city's overall consumption from twelve electrical stations (versus twenty-four nonconcession stations), a figure that rose to only 54 percent in 1896.[84] At large Parisian hotels, theaters, and stores such as the Bon Marché, in-house generators remained more practical than linking up with the city's fledgling networks. The basements of sites such as the Opéra and the Grand Café—future site of the first Lumière screening—housed, in Beltran's words, "veritable electrical factories."[85] These private generators at times served multiple buildings or small neighborhoods, creating "islands" of autonomous electrical production that remained legal throughout the concessionary period.[86]

Gaumont's Cité Elgé would become one such electrical island. Not surprisingly, the studio would also become a site of experimentation in electrical technologies and a key node in the circulation of ideas and technologies that helped the growing film industry and its dispersed and shifting networks of distribution and exhibition interface with the city's new electrical networks. The scientists and technicians charged with developing the technologies with which to do so also contributed to cinema's industrialization by redesigning machines and processes from the earliest days of cinema. The Cité Elgé would thus house important industrial

developments not only in its impressive studios, which represent the height of prewar cinema's industrial rationalization, but also in the diverse workshops and manufacturing facilities that made the company much more than just a film concern. Indeed, for all of Louis Delluc's rhetoric about studio production at the Cité Elgé in 1923, the studio's postwar strength would ultimately rest as much on the capacity of its research labs and factory floors as its studio stages.

RATIONALIZATION AND INDUSTRIALIZATION AT THE CITÉ ELGÉ

From its first steps toward industrialization, Gaumont took form according to Paris's infrastructural context. In 1904, the company began expanding the Cité Elgé from a single machine workshop and the partially enclosed stage on which Alice Guy had been producing films since 1898 by replacing the latter with the world's largest film studio—a glass-and-iron cathedral more than six times the size of Méliès's original studio in Montreuil. The structure marked a monumental step in the film industry's growth, not simply for its size but also due to its efficient layout and modern equipment. In particular, the studio was designed to account for the Cité Elgé's need for electricity, both for the studio's lighting and heating systems as well as for the laboratories and workshops that quickly appeared around it. In short, the world's largest film studio would also have to be a power plant.

Contemporary architecture critics did not overlook the studio's importance. Even *Les Nouvelles Annales de la Construction* took a rare detour from its coverage of the development of the Parisian Métro system to devote an article to the studio, accompanied by a photo of the completed glass house (fig. 4.5).[87] The journal's March 1906 article highlights architect Auguste Bahrmann's unique blend of building technologies and the technological systems needed to produce an appropriate climate for film production.

Like studio designers before him, Bahrmann's principal concern remained maximizing the direction and quantity of light to accommodate filmmakers' continuing reliance on daytime shooting for the majority of

FIGURE 4.5 "Vue de Notre Théatre (extérieur)," view from the southwest. Gaumont catalog, January 1906, p. 2. (Courtesy Musée Gaumont, Paris)

their productions. He positioned the two-story building on a north-south axis and aligned the main stage along the eastern side of the wider northern wing's top floor. The studio's thin iron skeleton permitted maximum natural sunlight to reach the stage from midday through the afternoon, and stair access to the ceiling allowed the possibility of suspending diffusing fabrics to distribute light more precisely. On the southern wing's glass-covered top floor, Bahrmann created a large, well-lit atelier for set design.

The ground level's layout focused on cinema's need for darkness, especially in postproduction. Below the set design ateliers on the southern wing, the studio would support, in the *Nouvelles Annales* reporter's words, "the greatest convenience of photographic manipulation."[88] Here, Bahrmann created a system of small dark rooms linked by hatches (*guichets*) for efficient movement of film through the successive stages of processing.

Alongside these processing facilities, the ground floor housed the studio's electrical substation. A steam generator provided the electricity necessary to heat the large building and provide power for electrical lighting

setups used, at least initially, only to accentuate natural illumination. The *Nouvelles Annales* article devotes particular attention to the heating system, a special air-circulating machine designed by Frédéric Fouché and exhibited two years earlier at the International Exposition in St. Louis. Fouché's *Aérocondenseur*, which could heat the entire studio in around one and a half hours, underscores the importance of climate control in modern industrial spaces in general and film studios in particular.[89]

The article also underscores the systematization of the production process that the studio design facilitated. Bahrmann's arrangement of the processing rooms to match the successive stages of postproduction might be expected, but he also designed the studio to enable efficient preproduction and shooting. His design promoted fluid access to the shooting stage to facilitate rapid scene changes. An empty space on the ground level below the stage provided temporary storage and space for staging sets, props, and performers between takes. Two adjacent stairwells connected the ground level and the dressing rooms adjoining the stage above. And a system of pulleys linking the two levels allowed set pieces to be quickly transported to and from the set. Set pieces could also be moved directly from the adjacent design atelier to the stage, then dropped immediately to the floor below for storage.

These pathways did not close off variations in filmmaking practice and film form, including a range of focal lengths, camera angles, and set arrangements. To supplement the possibilities created by the already large size of the stage, Bahrmann's design used large wheeled partitions to allow the annex on the studio's northern end to be used, alternately, as dressing rooms or to extend the stage. In this way, the design would help determine both the content and form of the studio's films. As the *Nouvelles Annales* article noted, the variability of Bahrmann's design would make it possible to stage "historical events" on a grand scale.[90]

With newly hired assistant Louis Feuillade, Alice Guy made just such a confluence of new film subjects and forms the studio's product. Capitalizing on the new set design ateliers, Guy used larger, more elaborate backdrops to accentuate the stage's expanded space. In films such as *Le Statue* (1905), Guy created seemingly boundless views that marked a striking departure from the comparatively enclosed spaces of her earlier studio films. In other cases, the films playfully revel in the studio's lavish

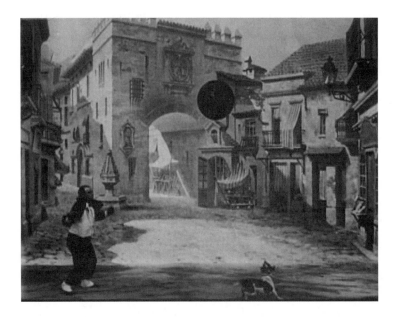

FIGURE 4.6 *Clown, chien, ballon* (Guy, 1905)

size, reflexively celebrating and exploring its expanded frame. In *Clown, chien, ballon* (1905), for instance, the addition of a plaza scene painted in depth creates the illusion of open exterior space for balloon-chasing chaos (fig. 4.6). The act's canine performer and floating prop probe the boundaries of the new studio set, bounding from foreground to background, side to side, and to the backdrop's highest reaches, prefiguring Albert Lamorisse's exploration of Paris in *Le Ballon rouge* (1956).

The studio's large size and set design facilities also allowed Guy to explore complex arrangements of sets, props, and characters. In films such as her celebrated 1906 version of the Passion Play, *La Vie du Christ*, she staged fluid movements of characters into and out of the frame through elaborate wooden sets with multiple levels and large openings painted to appear as stone arches. Her new complex staging stood in marked contrast to her pre-studio films, which feel claustrophobic by comparison. Using these new architectural arrangements, Guy still tended to focus on a single primary action in the center of the frame, but the increased space allowed for more action on the periphery, where the

pantomimed gestures of early actors and actresses often give the films striking new degrees of dynamism.

In the new studio and under Guy's tutelage, Feuillade also mastered this use of depth, a formal strategy that would later earn him accolades in the *Fantômas* and *Les Vampires* series. As David Bordwell has described, Feuillade used sophisticated approaches to staging characters and directing audience attention within the single-tableau format. These strategies responded in part to Gaumont's later demands for rapid filmmaking, often on reused sets, but Feuillade first developed his multilayered staging techniques on the studio's deep stage and its more architecturally sophisticated set pieces, as seen in films such as *La possession de l'enfant* (1909) and later in the "Scènes de la vie telle qu'elle est" series.[91]

In addition to these formal developments, the studio's technological systems also facilitated other shifts in film technique. The electrical substation allowed Guy and Feuillade to control studio light more precisely by supplementing the sun with a growing repertoire of artificial lights. A behind-the-scenes film from 1905—*Alice Guy tourne une phonoscène sur la théâtre de pose des Buttes-Chaumont*—shows the new studio and its lights in action, with Guy directing one of the company's early sound films. Two slow pans reveal large banks of lights to the left and right of the stage (set before the same painted backdrop that appeared in *Le Statue*). After signaling for the lights to be illuminated, Guy sets the Chronophotographe system in motion and begins the scene, a dance sequence featuring a troupe of performers equal to the stage's grand size. The film highlights the sophistication of studio film production that Guy put in place within less than a year in the new studio. Using multiple banks of artificial lights aided by reflectors, Guy developed techniques for creating even lighting across the stage. Such measures were necessary to satisfy audiences who had grown accustomed to well-lit studio productions without the harsh shadows that came to mark films as poorly made and unrealistic.

For all of the transformations to film production that the studio enabled, its initial setup remained consistent with many norms for the period. In particular, the close proximity of pre- and postproduction in a single building continued the practice seen at smaller studios such as Méliès's and Pathé's studios in Montreuil. Although the new studio

streamlined these activities by organizing adjacent work, storage, and improvisational spaces to allow for continuous shooting and rapid processing, soon the increasing demand for films encouraged Gaumont to expand the studio's production capacity.

The company quickly began to surround the giant glass cathedral with workshops to support film production and its continuing production of machines. The Cité Elgé grew to include celluloid storage depots designed to meet municipal requirements for safe storage of film stock and prints for distribution, and adjoining buildings soon housed ateliers devoted to editing films and manufacturing small parts for cameras and projectors. By 1907, the studio had also grown to include workshops for tinting and painting films, laboratories for testing new coloring technologies, and additional facilities for perforating, developing, and printing film stock. Rising electrical usage in these new facilities also forced the company to add additional electrical generators.

In addition to facilities devoted to film production and postproduction, Gaumont made the Cité Elgé an important site for technical research and manufacturing. Encircling the main production studio, a campus of small factories and workshops included separate ateliers for work in metal, brass, and nickel; milling, metal turning, and smelting; and carpentry, cabinet making, and varnishing. These were supported by research and development facilities, including laboratories for research in optics, chemistry, and electricity. Gaumont filled its labs with scientists, especially chemists trained in photography, who came to play an important role at large film manufacturers. One such scientist, Léopold Lobel, a chemist who came to Pathé from the chemical corporation Bayer in 1905 and would go on to be technical director for Lux, later explained that for cinema to industrialize it had needed "a teacher [who was] ready to make it benefit from its science and experience."[92]

These scientists worked with technicians to replace machines and techniques from film's earliest days with new systems capable of supporting the industry's growth. Most importantly, Gaumont's laboratories produced automated processing and printing technologies—including continuous developing machines and systems for washing and drying film prints—necessary for the production and distribution of films on a mass scale.[93] Gaumont also used these

laboratories and workshops to continue developing and manufacturing its line of cameras and projectors.

Other innovations directly addressed problems related to Paris's inconsistent modernization. Several focused on the dangers of celluloid. As they worked to develop safety stock, Gaumont's scientists produced technologies designed to protect projectionists and spectators and meet municipal regulations. These included special boxes for safely transporting celluloid and protective housings for projectors. Gaumont's engineers also developed devices such as electrical transformers to deal with the lack of a reliable municipal electrical grid. Its machines competed with those in development at Pathé as well as non-film companies such as Westinghouse.

As these activities suggest, filmmaking was only one piece of cinema's capitalization and modernization, and studios came to house much more than just film production. The modernization of studio facilities nonetheless made these other technological developments possible. Modern studios provided laboratory space for their development and ready testing sites for new prototypes. And in the case of technologies such as new automatic film processing systems, they profited from the new precise regulation of light and temperature in the studio. In sum, the systematization of studio production, the industry's technological development, and the industrialization of studio infrastructure all developed together.

As new technologies and techniques made celluloid preparation and film processing more efficient, Gaumont added further structures to support all phases of production. In 1908, the company added two large buildings alongside the original glass cathedral: one to house a large new set design department and a second to serve as a printing factory for publicity materials. The new buildings again reveal Bahrmann's attention to how architectural design could contribute to rationalized efficiency. Bahrmann linked the new décor building with the existing studio, creating a direct passage between the stages, the large design shops, and the storage facilities (fig. 4.7). In addition to raising and lowering set pieces to the floor below the stage, assistants could now quickly move them from the adjacent building, which grew to house large collections of props and furniture. These storage houses again contributed to the films' growing realism and expanded storytelling possibilities by putting an expanded repertoire of tools for visual world-building at the filmmaking team's

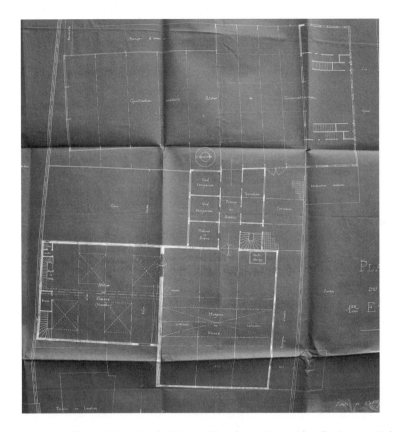

FIGURE 4.7 Ateliers et Magasins de Décors, Plan du 1er Etage (*detail*), Auguste Bahrmann, March 1907 (Archives de Paris). The highlighted portion shows new construction of the set design ateliers, which are linked to the original studio via the small connecting segment at the blueprint's center.

disposal. Any materials that could not be found in the prop storage rooms could be built or painted in the set design and construction shops housed in the new building beside the studio. Beneath a glass-and-iron rooftop, teams of painters, sculptors, and woodworkers fashioned the company's film worlds in large-scale artists' studios—the historical forebears of the film studio now brought into its purview.

The new printing facility that Bahrmann built alongside the set design building allowed Gaumont to accommodate industry changes

brought about by film companies' adoption of the new system of renting rather selling film prints to distributors. This shift in industry practice transferred the burden of producing publicity to the film manufacturers, who needed to create audiences for their films, both among exhibitors and audiences. From its artists' studios and printing facilities, the Cité Elgé produced diverse forms of visual culture—especially its *Feuilles de la Marguerite* posters—that helped construct the meaning of Gaumont's central film texts in ways that prefigure today's "convergent" new media landscape.[94]

Supported by these new facilities, Gaumont's filmmakers grew into a large production team. After Guy's departure to America in 1907, Feuillade took over as studio director and was joined by Léonce Perret and a band of both well-known and now forgotten filmmakers including Roméo Bosetti, animator Émile Cohl, Étienne Arnaud, Gaston Revel, Henri Fescourt, Jacques Feyder, and numerous others who churned out Gaumont productions by the hundreds. In 1911 and 1912, Gaumont again expanded the studio's shooting space, extending the existing glass house and connecting it to a new sound stage to support advancing sound-on-disc research and sound film productions. Here, Gaumont's young filmmakers honed their formal techniques, working side-by-side in the midst of the studio's ever-changing row of sets (fig. 4.8), which Bahrmann again connected directly to a new set design atelier and storage area.

By 1913, the Cité Elgé had grown into a campus of more than two dozen buildings. Publicity materials emphasized the company's range of services, including the studio and sound film studio as well as the factories that produced film machines. Depictions of the Cité gracing Gaumont's catalog covers offered potential buyers an image of industrial rationality, stability, and strength. Ordered rows of industrial buildings frame the central glass cathedral, while smokestacks like those dotting the horizon of Ménessier's 1902 painting now dominate the smoky skyline (fig. 4.9). Such images gave visual form to the studio's fundamental place in cinema's industrialization and capitalization in the century's first decade. Often flanked by financial figures made to match, they project a cinema remade in and defined by the image of capital. That image—built on the shifting infrastructure of a city that

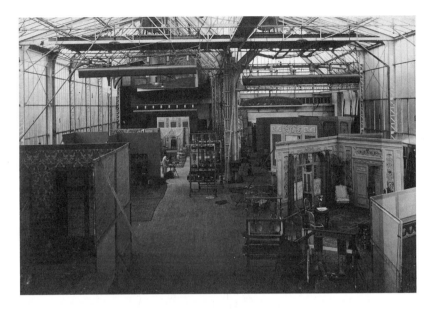

FIGURE 4.8 "Studio Gaumont," Photo Album, n.d., p. 27 (Courtesy Musée Gaumont, Paris). This photo would appear regularly in studio publicity, offering an image of rapid and efficient production to stockholders and the exhibitors who relied on Gaumont to supply them with marketable films.

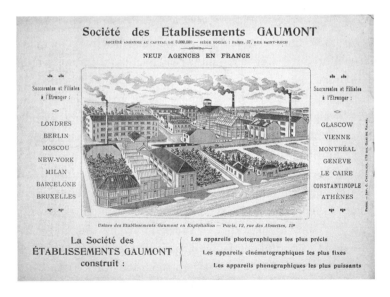

FIGURE 4.9 "Société des Etablissements Gaumont," Gaumont catalog, 1912. (Courtesy Musée Gaumont, Paris)

was, itself, being remade in capital's image—must be understood in its direct relationship to the broader infrastructural context that helped determine its form.

Not surprisingly, the context that shaped the Cité Elgé's growth would also become one focus of the studio's film subjects. Municipal infrastructure and its inconsistencies produced favored cinematic tropes, whether shot on location or remade in the studio. In this way, much as, in T. J. Clark's view, painting was like nature, so cinema would be like the city. Put another way, if, as Clark argues, "no other subject [than nature] . . . offered painting the right kind of resistance, the kind which had the medium seem more real the harder it was pressed in the service of illusion," something similar might be said for cinema's relationship to the city.[95] Rebuilt on studio sets and combined with "real" footage shot in the streets, the Paris of Gaumont's city cinema of the early 1910s helped make cinematic illusion the height of urban realism.

CINEMA, THE CITY, AND STUDIO-PRODUCED REALISM

Gaumont's repeated studio stage expansions reflect the company's focus on studio filmmaking in the prewar period. While filmmakers no doubt explored the area surrounding the studio, both for Gaumont's actuality service and for fictional films set in the Parc des Buttes Chaumont, studio-staged realism dominated. The images that these filmmakers brought back when they did exit the studio offer important evidence of how cinema's relationship to the city developed beyond early actualities. If, as film and urban historians such as Mark Shiel have argued, cinema's "peculiarly spatial form" made it ideally suited for examining urban space, such examinations no doubt included the fictional films that made modern urban life one of their primary backdrops and thematic sources.[96] Indeed, films like the ones made at Gaumont in this period contributed to the development of what Nezar AlSayyad has termed a "cinematic epistemology of the city," a form of knowledge that took shape just as much in fiction films as in their documentary counterparts.[97]

Gaumont's non-studio films made the spaces and technologies of Paris's modernization common settings. Much like Méliès and the Edison and Biograph filmmakers, Guy and Feuillade were drawn to the modern technologies and technological spaces found near the studio, including railroads, bridges, and canals. Such spaces fill Guy's versions of the common "chase film" genre, whose need for extended spatial and temporal narratives was not satisfied by even the massive depth of the central studio stage. In films such as *Une Histoire roulante* (1906) and *La Course à la saucisse* (1907), for instance, the modern mobility of rail travel becomes a spectacular centerpiece in the filmic mobility that guided the chase film's edited linking of disparate spaces. While the chase film helped inaugurate and acclimate audiences to cinematic stories developing across distinct physical spaces and film shots, it did so by presenting space through an often-chaotic morass of bodily energy pouring across the frame. It would thus be fitting that Guy should make the railroad—a symbol of modernity's tension between technological order and technology unhinged—a constituent element in the commotion of the "chase."[98]

In other films, Guy's representations of city infrastructure emphasize its inconsistency, recalling Méliès's similar, if more fantastical, criticisms of modern technology. In *Une Héroïne de quatre ans* (*A Four-Year-Old Heroine*, 1907), for instance, the title character sneaks away from her dozing nanny and into the Buttes Chaumont park, where she begins her heroic afternoon by alerting police to a robbery. As she wanders away from the park's pleasant (if apparently dangerous) environs, the underaged *flânéuse* continues to solve modern "crimes" of another form (fig. 4.10). She first encounters a blind man who has wandered precariously onto a canal lock gate, rescuing him by deftly closing the lock before he tumbles into the trench below. In her final heroic deed, she saves three drunken revelers by closing a gate that bars them from a train barreling across the frame, only feet in front of the camera and the characters that mirror the audience from across the tracks. These fictional representations of very real modern technological changes fit naturally in Gaumont's broader repertoire of actuality subjects and the story films that soon made Paris the focus of Gaumont's renewed attention to modern urban experience.

FIGURE 4.10 *Une Héroïne de quatre ans* (1907). The title heroine directs fellow wanderers to safety at the industrial margins of the modern metropolis.

Alongside Guy's non-studio work, Gaumont's steady use of the studio was consistent with contemporary developments in the French film industry. By 1908, filmmakers and the film trade press were making a concerted effort to promote cinema as an art form. Building on formal techniques developed in Pathé's studios and inspired by American productions, the new films first focused on realistic historical dramas and filmed theatrical productions using stage performers who rejected pantomime in favor of more realistic acting styles.[99] This movement toward filmed realism also included films addressing contemporary social problems.

At Gaumont, these efforts led to the company's "Scènes de la vie telle qu'elle est" series, which promised to transport slices of life to the screen through new degrees of realism. Feuillade, the mastermind behind the series, devoted its films to social commentaries, hard luck tales, and stories of corruption starring a consistent troupe of actors and actresses who began to receive name credit in the films' title sequences. In the manifesto for the series published in the weekly *Ciné-Journal* in April 1911, Gaumont committed itself to the realism of "people and things as they are, not as they should be."[100] Aesthetically, on the other hand, the manifesto promised not so much realism as *studio* realism created through the "magic" of photographers who made lighting and composition "child's play." This notion of realism fit contemporary audience ideas about what counted as "realistic"—that is, films in which technical skill masked the

visible artifice of cinema that might be revealed by poorly designed sets, harsh areas of light or shadow, and overblown acting styles.

Although Feuillade set the first "scènes de la vie" in rural townships, the series' commitment to quotidian struggles soon shifted to urban industrial locations. This shift would seem to suggest new cinematic attention to the city of Paris—and perhaps to the realism of location shooting.[101] But while these films' emphasis on greater realism did often focus, at least thematically, on cinema's urban environment and its "real-life" dramas, surprisingly it did not involve an immediate or extensive return to city filmmaking. Instead, Feuillade continued to use models put in place in earlier socially minded films such as *La possession de l'enfant* (1909).

In this film about a child custody battle and the mother's struggle to care for her son without the financial support of his wealthy father, Feuillade transports the viewer from one staged interior to the next (from the courtroom to a large bourgeois apartment to a small flat) through brief exterior scenes that locate the story in the city. This strategy of juxtaposing the company's deftly staged studio interiors with real locations would become standard in the "Scenes from life as it is" series. Images of the city in these films tend to be restricted to brief shots of building exteriors or familiar urban sites such as train stations or monuments that offer brief moments of "real" settings that supplement the films' characteristic interior scenes.

By the mid-1910s, single-reel and feature-length films such as the episodes in Feuillade's *Fantômas* and *Les Vampires* series gestured toward modern urban life in another form. In these popular films, Feuillade used a similar combination of realistic studio settings and city interludes that appeared in his "Scenes from life as it is" but repackaged them as scenes of fantastical urban nightmares. In their depictions of bands of criminals who terrorize the city, operating in hidden networks of power and corruption, these films played to the exciting and frightening uncertainty of modern urban life taking place just out of sight.

Indeed, this emphasis on studio-produced interiors reflects the ways that, as Geoffrey Nowell-Smith has noted, studios allowed filmmakers to exert complete control over cinematic representation, in this case by presenting a strange version of the modern urban environment in which everything of note seems to take place indoors. As Nowell-Smith argues,

the built environment became something of a "casualty" of this empha-
sis on studio production.[102] In the 1920s, filmmakers such as Marcel
Carné and René Clair would make this loss a battle cry, attacking studio-
produced realism for its failure to capture the fleeting experiences of
urban modernity.[103] Ironically, though, even Carné and Clair continued
to make studio realism the norm as they rebuilt Paris on large studio sets
just south of the city.

Even so, images such as the iconic poster image for Feuillade's 1913
series *Fantômas*—with the title character towering in the midst of Paris,
foot posed on the bank of the Seine—suggests that the built environment
was far from forgotten. Whether through slices of real life or fictional
representations of furtive urban forces, the city offered ready subjects for
its filmmakers, even when they still preferred to remake urban life on the
electrically illuminated stages of their studio cities within the city.

CONCLUSION

The onset of World War I put a stop to filmmaking and studio growth at
Gaumont. The same year saw Universal City build new stages that eclipsed
the Cité Elgé's formerly largest studio. By the time Louis Delluc visited
in the 1920s, even Gaumont's seemingly most advanced studio stages and
technologies—including the Chronophotographe system that had once
promised to make Gaumont the world's first sound film company—had
become out-of-date, leading to massive renovations at the Cité Elgé.
Powered by the municipal electrical networks that finally arrived after
the war, Gaumont slowly converted its glass-and-iron cathedrals into the
electrically illuminated "dark" studios that we think of today. The studios
and factories that made the company a hotbed of technological innova-
tion and filmmaking prowess before the war would soon seem like only so
many square feet for business conglomerates seeking to restructure and
revive French cinema in the shadow of Hollywood.

Gaumont's attention to technological development did, however, con-
tinue through and after the war, helping the company survive the momen-
tary halt and longer term downturn in production. In addition to aerial
photography systems for warplanes and lighting systems for the trenches,

the company used its expertise in sound technologies to develop radio transmission systems for aircraft and warning sirens for Paris. After the war, Gaumont continued to supplement its struggling film business with research, development, and manufacturing of sound systems for radio, telephony, and aircraft, submarine sonar systems and automobile lighting.[104] In sum, for all of its importance as a film company, Gaumont relied upon its research and development labs and factory floors as much as the great glass production stage that has long overshadowed them to keep the company alive after its prewar prominence.

The associations and overlaps between film and industry found at the Cité Elgé or in Joinville-le-Pont were not always so complete, but they were far from unique. The idea of the Hollywood "dream factory system" that appeared in the 1920s had roots in these studios, where efficient production methods found architectural form, and in the real factories that underpinned the growing film industry at Gaumont, Pathé, Vitagraph, and their competitors. While the classical Hollywood studios and their interwar European counterparts would come to be known for their massive sets and spectacular film products, as Gaumont and Pathé's early studio facilities show, filmmaking would be only one of the litany of "nuts-and-bolts" practices that structured studio and industry development through silent cinema and well beyond.

· 5 ·

THE STUDIO BEYOND THE STUDIO

NATURE, TECHNOLOGY, AND LOCATION
IN SOUTHERN CALIFORNIA

Some day, no doubt, when Time shall have granted a past to the motion picture industry . . . a suitable tablet will be imbedded in a certain spot on the grounds of a certain studio in Edendale, a suburb of Los Angeles. The testimony of the tablet will be to this effect: "Here was Born the Great Photoplay Producing Industry of California, June, 1909."

—*Los Angeles Times* (1916)[1]

BY THE 1910S, the relationship between the film studio and nature that had defined film production for almost two decades had come full circle. Dickson and Méliès had made an idealized climate—at once sheltered from and modeled upon the natural environment—the initial measure of studio success. The filmmakers who established the industry in California reversed the formula, making the studio archetype the standard against which natural settings would be judged. As one article put it, some producers thought of California itself as "a natural studio."[2] Their success would depend on both.

The tendency to evaluate natural settings according to studio ideals reflected the latter's persistent importance for western filmmakers. Indeed, within only a few short years, they had re-created the studio's architectural history, which could be found in physical form nestled between Southern California's rolling hills. Between 1909, when the Selig Polyscope Company established Los Angeles's first studio, and 1915, when Universal City opened a few miles north as the world's largest, the region witnessed a curious reinvention of studio form. Following Selig's

lead, competitors dotted the Southern California landscape with open-air stages like those seen in cinema's first half decade. Soon, companies such as Selig and Pathé, prompted by the same concerns about climate control that drove earlier filmmakers, enclosed their stages in glass. As investment in the region increased, glass-enclosed studios equipped with electrical lighting became *de rigeur* for California producers who could afford them. By 1914, no fewer than seventy companies had built or refurbished studios in the Los Angeles region, and their various forms would coexist there, often on the same properties, into the 1920s.

This massive investment in studio infrastructure would seem to contradict two of the most commonly assumed reasons for the film industry's western migration—namely, California's picturesque settings and dependable sunlight. Industry boosters touted the region as a filmmaking utopia of sunny days for winter-weary directors and seductively cinematic landscapes for audiences clamoring for realistic scenes. Film historians have tended to reproduce this rhetoric, in more guarded terms, in their broader accounts of early filmmaking there.[3] But why, if the region's fabled natural lighting was so desirable, did the same types of light-regulating glass and electrical alternatives to sunlight used back East so quickly reappear in the West? Moreover, if one of their principal goals was realism, why did filmmakers so readily reproduce the studio artifice they already knew so well (and that audiences had supposedly come to loathe)?

The answers to these questions lie, in part, in Southern California's imperfect climate and the unrealistic expectations produced by local boosters and enthusiastic reporters who willfully ignored its at times cloudy reality. Indeed, faced with weeks of spring rain and periods in which morning clouds might obscure the sun into the afternoon, filmmakers relied upon studios for shelter and alternative shooting locations. Even on clear days, western studios allowed filmmakers to manipulate and regulate sunlight in order to produce ideal shooting conditions, much as they had learned back East. What's more, the deceptive idea that one *should*, despite the region's variable weather, be able to film there 365 days a year meant that studios became necessary to achieve companies' goals for film output. In short, booster rhetoric and industry competition produced high expectations, and studios offered one way to meet them.[4]

More generally, by 1910 industry norms had made the studio an essential and assumed component of most companies' models of film production and most filmmakers' working practices. At a moment when audiences' and exhibitors' demands for film—spurred by the expansion of exhibition venues during the Nickelodeon boom—had created a growing market for their products, film corporations needed consistent, efficient output to assure reliable profits. Given the success of the industry leaders—especially Edison, Biograph, Vitagraph, and Pathé—that had made significant studio investments central to their businesses, the first companies in California had good reason to copy their chief competitors' studio models.

This chapter reexamines cinema's westward expansion as a history of the studio's reproduction and the material, practical, and conceptual continuities between early studio history and the emergence of studio cinema in Southern California. While we tend to think of early western filmmaking in terms of location shoots and natural light, the studio was always close at hand, both as a physical site for all phases of production (from set construction to film processing) and as part of the conceptual framework for filmmaking practice, whether in the studio or beyond its walls. That framework rested on the studio-born assumption that film space could be created, manipulated, and transformed. Thus even when western-bound filmmakers traded studio sets for landscapes bathed in natural light, they continued to apply this idea of studio plasticity to non-studio settings.

Much as studio production had helped shape filmmakers' approaches to city filming in the 1890s, so the persistence of studio norms influenced location shooting practices in the early 1910s. Indeed, this chapter will argue that the very idea of "location" that developed in the work and discourses of this period's filmmakers, film companies, and industry observers was inextricably tied to studios and to the notions of space and spatial production developed in them. Building on the knowledge that a single studio stage could be adapted to fit a wide range of subjects, filmmakers conceptualized "location" as what I will term the "studio beyond the studio." Put simply, just as they knew that with the right scenery, the film studio could appear to be any place in the world, so filmmakers hoped that, with enough land and the right props and backdrops, so could California.

The idea that the best location was an ideal studio would lead to the development of the most significant studio innovation of the "transitional era": the studio backlot. As filming locations became more contested—at once more fervently desired by competing film units and more strictly controlled by their owners—film companies sought to ensure not simply access to locations but also control over them. They did so by buying up large swaths of land on which to build more and larger studio stages and to construct semipermanent location sets. On these backlots, filmmakers again confronted the persistent tension between their need, on the one hand, for sunlit, natural-looking scenes and, on the other, for technologically mediated working environments.

Unable to escape that tension, they concretized a tenuous but lasting solution: a flexible pro-filmic space comprised of interior studio stages lit by electrical lights, sun-lit backlots built on the principles of studio interiors, and "natural" locations that, like manufactured sets, could serve as repeated shooting sites. In the mid-1910s, that solution came to define the working environment of Southern California filmmaking, and it would characterize Hollywood production in the decade to come. Ultimately, the quests for light and authenticity that had driven filmmakers away from their studio homes led them right back to the studio and to a spatial model for filmmaking with an inescapable name: the "studio system."

QUESTING FOR LIGHT, NATURE, AND AUTHENTICITY OUTSIDE THE STUDIO

The same search for light that shaped the initial development of film studio architecture from the Edison laboratory to the outskirts of Paris also drove cinema's western expansion in the United States. As film historians have often described, in 1907 filmmakers in New York, Philadelphia, and Chicago began leaving their dark, cloudy homes during winter months in search of longer and brighter daylight hours. Made more easily accessible by the increasing mobility of the nation's expanding railroads, warmer and sunnier locales from Florida and Texas to Colorado and California became alternative film production centers—veritable filmmaking "hotspots"—for several months of the year.

This seasonal migration signaled not so much filmmakers' desire for alternatives to studio artifice as their recognition of that artifice's periodic inadequacy. Despite the technological developments that had greatly improved studio lighting in the century's first five years, filmmakers, exhibitors, and critics still preferred the look of films shot in natural light (see chapter 3). That, combined with the high cost of electricity, meant that few companies could rely exclusively on electrical lighting. The annual arrival of winter's short, cloudy days and the resulting decline in productivity thus left filmmakers in need of better lighting conditions, whether naturally sourced or otherwise. Their search for bright sunlight went hand-in-hand with scientists' simultaneous search for better ways of artificially reproducing it. Indeed, the two practices represented two sides of the same coin. Film companies demanded efficient solutions for mass-producing films, and, in the absence of cost-effective artificial means in the studio, they would simply manufacture their scenes elsewhere.

Filmmakers from Chicago led the way in exploring the possibility of off-season production. In the fall of 1907, the Selig Polyscope Company sent stage director Francis Boggs to Los Angeles, where he shot exterior scenes for Selig's one-reel production of *The Count of Monte Cristo* (1908).[5] The next summer, Gilbert M. Anderson (aka "Broncho Billy") led a troupe from another Chicago company, Essanay, on a trip to Golden, Colorado, where he recruited cowboys and began producing what would come to be known as "westerns."

New York–based companies followed suit. The New York Motion Picture Company sent a unit to Los Angeles in late 1909. Soon Vitagraph, working from notes taken by owner Albert Smith during a vacation to Santa Barbara earlier in the year, announced its own plans to send a troupe across Nevada and Southern California that December. And in early 1910, D. W. Griffith's Biograph company arrived in Los Angeles for the first of what would become an annual winter trip.[6]

At the same time, Chicago, Philadelphia, and other New York and New Jersey–based companies sought other suitable filming locations in the South. Florida, in particular, attracted so many film companies that it became, in one historian's estimation, "the first Hollywood."[7] During the winter of 1908–1909, the studio-less Kalem company sent a first group of filmmakers to Florida. The crew set up shop in Jacksonville, which they

chose, in large part, because the city was home to a large station serving the Atlantic Coast Line Railroad.[8] Sigmund Lubin sent filmmakers along the same route from Philadelphia to Jacksonville the following year and later made it the home of Lubin's comedy company. Selig filmmakers from Chicago also arrived in 1910, and between 1912 and 1914 a litany of companies including Essanay, Vitagraph, Edison, and Thanhouser spent at least brief periods in the Jacksonville area.[9]

Other companies took their operations to more far-flung locations. In 1910, Gaston Méliès, responding to the success of film companies in the West, moved from New York to San Antonio, Texas, to produce westerns. Méliès remained there until 1911, when he moved the company to Santa Paula, California, where it worked briefly before setting off on a filmmaking voyage to the South Pacific and East Asia.[10] The IMP company, which included Mary Pickford and later the director Thomas Ince, went to Cuba in 1910, and filmmakers for the Yankee Film Company, Essanay, and Vitagraph ventured as far as Bermuda, Panama, Jamaica, and Mexico.[11]

Their willingness to go where the light required coincided with—and may have contributed to—calls for new film subjects. Jaded by the kinds of studio films that had filled screens during the Nickelodeon boom, at least some audiences and exhibitors demanded new subjects and settings. Taking advantage of their new locations, filmmakers produced new subjects that complemented the more common fare shot in studio interiors and city streets. Like earlier travelogues and fiction films shot on location, the resulting scenes elicited enthusiastic responses from audiences and critics, who reserved particular praise for their depictions of natural landscapes. As one 1911 review described, "It is this element of the big out-of-doors with its sweep and freedom, that makes Western subjects so attractive to the city shut-ins. Melodrama has no thrill to compare with the thrill of big old nature."[12] Such praise was common in contemporary criticism, which often compared these settings with what came to be seen as dull studio-produced interiors. As the same reviewer exclaimed, "How much finer is this than a narrow room with painted settings and Jack making love to Gladys on the sofa!"

Such criticisms of studio films suggest that these voyages out of the studio fulfilled more than simply a need for light or longer working hours. The primacy of mass-produced studio fictions had created a context in

which something different from banal narratives and dull, repetitive visual aesthetics might find success. Nature scenes offered aesthetic alternatives to painted sets and provided an experience of nature for urban dwellers— the "city shut-ins"—who remained embedded within the artificial environments of the modern metropolis.

Audiences' attraction to images of nature in motion was consistent with early responses to natural settings and similar views available in non-fiction films. One has only to think of Georges Méliès's reported fascination at the sight of leaves fluttering in the wind in Louis Lumière's *Repas de bébé* (1895)[13] or spectators' delight at such films as *Rough Sea at Dover* (Robert W. Paul, 1895) and its numerous remakes to grasp the early power of film's technological reproductions of the natural environment.[14] Early filmmakers traveled the globe to capture such scenes, which included the southern and western locales seen in such films as *Royal Gorge* (Edison, 1898), *Old Faithful Geyser* (Edison, 1901), and *Devil's Slide* (Bitzer, Biograph, 1902).[15] Even as film production became largely studio-based, these widely popular films of the natural environment—known variously as "nature studies," "natural scenic films," and, most commonly, "scenics"—remained an important component of travelogue and other nonfiction programs.[16] Their "dream world[s] of cinematic geography," as Jennifer Peterson rightly argues, "simulate[d] the real world in order to allow the spectator to leave [it]."[17]

This simulated escape from urban modernity helped attract eastern city dwellers to western film subjects. As Nana Verhoeff argues, early westerns succeeded, in part, by spicing up the scenery. To the travelogue's vicarious form of travel, westerns simply added adventure, offering "nature as a thrilling and exotic site for escapism for the urban population."[18] As audiences warmed to these western settings, film companies sought to capitalize on their interest by increasing western and southern productions.

They also recognized the utility of producing versions of the West closer to home. During longer and brighter seasons, eastern producers took advantage of undeveloped local landscapes to produce "Easterns" (historical films set and produced in eastern locations) and "Eastern Westerns" (western subjects produced on eastern terrain).[19] Whether produced in California, Colorado, or New York, westerns banked on the perceived authenticity of their natural locations.[20] As an American Film

Manufacturing Company advertisement proclaimed, these were "Real Western Pictures—Real Western Settings."[21]

The success of Eastern Westerns came precisely, however, from viewers' relative disregard for authenticity. As historians of the early western have argued, to urban dwellers the "western" landscape amounted, quite simply, to anything that was not the city.[22] The success of simulations of the West attest to the fact that it wasn't the western landscape *per se* that attracted audiences so much as any natural setting that could pass for it.[23] Filmmakers met these desires by using film technology to bring the natural environment to the spectator's doorstep—another version of the cinematic "enframing" by which studio filmmakers captured urban environments and international expositions.

Representations of nature, in other words, were no less technologically mediated than their studio-produced counterparts and were shaped by many of the same aesthetic and technological considerations. Indeed, even as they addressed their needs for light and authenticity by exiting their studios, filmmakers remained reliant upon studio norms, both for film style and filmmaking practice. The first westerns shot in New York and New Jersey beginning around 1907, for instance, worked consistently, in Scott Simmon's words, to "reinforce the landscape's theatricality." Filmmakers used standard setups in which "the camera [was] generally fixed in place, actors' bodies filmed full length, and each shot held for a relatively long duration."[24] While this style, as Simmon notes, often reproduced conventions developed in picturesque landscape paintings by the likes of Claude Lorraine—"natural theatrical spaces open to the light and usually framed on the sides by overhanging trees"—it also reproduced the basic strategy of the studio tableau.[25] Much as they did in the studio, filmmakers relied on their ability to frame scenes quickly in suitable lighting conditions, a necessity that encouraged formal repetition and the emergence of standard conventions for recording nature. In short, tight shooting schedules privileged reproduction over improvisation, no matter the shooting location.

Even the era's most transitory company, Kalem, which was known for operating without a studio, reproduced studio-like settings around the world. The company's "Airdome studio"—more a standardized model for set construction than a studio proper—consisted of a series of

FIGURE 5.1 Kalem "Airdome" Studio at Glendale, California, *Moving Picture World* (July 6, 1912)

vertical beams on which crew members could mount varying configurations of set pieces and sun screens to generate film sets.[26] Designed with Kalem's ambulatory film units in mind, the Airdome offered mobility, adaptability, and a way to make any location a studio set (fig 5.1). A photo in a July 1912 edition of *Moving Picture World*'s "Studio Saunterings" series, for instance, claims to document the construction of an Airdome studio in Jerusalem.

Such efforts to make the studio transportable would reach their pinnacle in 1915 with director Romaine Fielding's "Collapsible Studio" and an auxiliary mobile lighting system designed to bring studio-quality illumination to remote locations (fig. 5.2).[27] Developed during Fielding's employment with Lubin, the studio consisted of a numbered series of wrought iron pipes and joints, much like the nineteenth-century modular greenhouses developed by Crystal Palace designer Joseph Paxton. Ranging from twenty-six to thirty feet in height, the studio covered 1,200 square feet of working space, all covered in a double layer of canvas sections mounted on the iron skeleton to make the studio waterproof. When packed up, it would fit in a 60-foot baggage car for transport to a new site where a trained crew of ten could reportedly rebuild it in six hours. The mobile lighting unit, also developed by Lubin, was

FIGURE 5.2 Fielding's Collapsible Studio, *Moving Picture World* (February 6, 1915)

transported by a Mitchell automobile and designed, as *Motography* put it, "for field work where it is impracticable to run wires for miles in order to get night photography."[28]

To be sure, even with these elaborate efforts to maintain studio norms outside studio walls, shooting conventions did change as migrating filmmakers encountered new kinds of landscapes. Film technologies and studio techniques were by no means immutable. In their early struggle to find a suitable form for western scenes, D. W. Griffith and Billy Bitzer, for instance, initially responded to unfamiliar western settings by relying on techniques used for eastern shooting and in the studio. As Simmon describes, they used "iris lens effects to limit the surrounding white space" of barren landscapes or simply steered away from the most distinctive of western terrain, instead seeking "woodsy landscapes that could be molded to eastern framing."[29] But they also combined these approaches with new methods, including higher camera angles that brought more of the ground into the frame (to reduce the emptiness of the sky), long shots from high vantage points (again to emphasize varied terrains over open skies), and the use of rock outcroppings and posed figures to anchor otherwise empty settings.[30] In short, Griffith and Bitzer had to adapt studio

techniques to unfamiliar, non-studio spaces. Put another way, just as much as filmmakers sought to capitalize on the West's uniqueness and authenticity, they also worked to overcome or tame new landscapes using both familiar studio techniques and new adaptations of them.

On a more practical level, filming the natural landscape could never be divorced entirely from studio practice. For traveling filmmakers, the studio remained essential for processing and printing film as well as for filming the interior scenes with which they assembled narratives. For filmmakers who went west or south, the initial seasonal travel schedule meant studio scenes simply had to wait for the return home. But in the east, filmmakers developed a rhythm of moving between interior and exterior shoots. Nearby towns such as Coytesville and Shadybranch, New Jersey, became common destinations for location filming commutes from Manhattan. Before Griffith began leading Biograph filmmaking trips to California, for example, the company regularly alternated between its Fourteenth Street studio and location shoots in nearby Fort Lee, New Jersey.[31]

Soon, however, even these short trips seemed superfluous. Instead, filmmakers simply moved closer to their favored shooting locations by taking advantage of cheaper land to establish studios in New Jersey. Fort Lee, in particular, made a desirable alternative for New York City filmmakers in search of natural settings and/or shelter from the Motion Picture Patents Company. In 1910, the Champion film company became the first to establish permanent facilities in Fort Lee when its owner, Mark M. Dintenfass, moved there to escape the MPPC.[32] Dintenfass's initial studio, which *Moving Picture World* described as "unattractive" but "effective," housed the usual necessities that filmmakers setting up shop away from their studio homes demanded. It included prop, set design, and storage rooms, developing and printing facilities, and a machine repair shop.[33] In 1911, emboldened by the company's early success, Dintenfass added a glass-and-iron extension.

Over the next three years, the town that one writer had called an "indefinite place" became a small studio center.[34] New glass studios, notably including the Willat Film Company's large vaulted studios, which would later be home to the Triangle Film Corporation and William Fox's East Coast productions, made it clear that the industry was there to stay. Fort Lee also emerged as an outpost for a growing contingent of French film

companies seeking to avoid import taxes by producing films in America.[35] Eclair arrived first, building a glass studio there in 1911, and Alice Guy brought her Solax company to its own glass studio the following year. In 1914, Eclair's president, Charles Jourjon, started a second company in Fort Lee, the Peerless Feature Producing Company, and built another large glass studio for it.[36]

As the construction of such studios suggests, even as filmmakers made compelling vistas the basis for film aesthetics and emerging genres outside the studio, they continued to fall back on staged productions. Interior scenes and environmental control remained desirable, whether in the rural East, Florida, Texas, or under Southern California's (usually) sunny skies. The quest for light, authenticity, and nature never entirely detached filmmakers from studio techniques; rather, the further incorporation of technologically reproduced natural scenes into longer narrative films contributed to cinema's increasingly holistic production of artificial film worlds.

The seasonal exit from urban studios thus ultimately found filmmakers in new studios, especially as it became clear that southern and western locations would be more than winter destinations. For their new infrastructure, companies like those based in Fort Lee imported studio designs from New York and Chicago. In Southern California, in particular, this return to the studio achieved a scale that would make Los Angeles the preeminent filmmaking capital of America.

REMAKING THE STUDIO IN SOUTHERN CALIFORNIA

In 1911 the Nestor Company opened its western studio at the corner of Sunset Boulevard and Vine Street. As the first in Hollywood proper, Nestor's studio represents the spatial and symbolic origins of the industry that would come to define and dominate the medium's modern narrative form under the name of the "studio system." Taken as an architectural space, however, it was far from modern. In fact, the studio bore closer resemblance to the first exterior production stages from cinema's first half decade than to the large Gaumont, Pathé, and Vitagraph studio factories discussed in the previous two chapters.

Indeed, studios in Southern California did not progress steadily toward the buildings that defined modern Hollywood. Rather, due to a number of factors—including the ephemeral nature of early filmmaking in the West, filmmakers' initial focus on location shooting, and the generally good weather conditions that made exterior stages more viable than back East—the studio would go through an uneven process of development, reinvention, and adaptation before arriving at its more "modern" form in the second half of the 1910s. This process helped shape the future of filmmaking (and Hollywood) by making a blend of interior and exterior filmmaking spaces and shooting practices common at studio complexes, where filmmakers split time between open-air stages, glass house studios, and backlot sets.

Los Angeles's first production spaces were emblematic of the return to studio origins witnessed across Southern California. As in so many places before it, studio production in the city began, quite literally, on a back lot.[37] Located behind a downtown laundry, it was rented in 1909 by Selig director Francis Boggs and would be Selig's Los Angeles home for a brief spring season in which Boggs oversaw the productions of *The Heart of a Race Tout* and *In the Power of the Sultan*, the first staged fictional films made entirely in California. In addition to this backlot space, Boggs also set up an open-air rooftop stage next door, where he directed a one-reel version of *Carmen*.[38] As spring arrived, however, the company abandoned each of these stages and traveled north to film westerns on location while its business manager scouted sites for more permanent studio facilities.[39]

When they returned in August, the Selig troupe moved a few miles north of downtown to Edendale (today located between Echo Park and Silverlake). There, Selig had acquired a small lot of less than an acre containing a house that Boggs used for offices and dressing rooms. Alongside it, he laid a 16 × 20 foot cement pad to serve as a stage.[40] Much as filmmakers had done in the mid-1890s, Boggs and his crew built painted backdrops on the ground and filmed scenes on this open-air set.

Selig's open-air productions remained the norm during the first years of Los Angeles–area filmmaking. Even as companies moved away from the seasonal model that made ephemeral stages a sensible option, they did not immediately seek to establish glass-enclosed studios equipped with electrical lighting like those in their eastern headquarters. Favorable weather

conditions and filmmakers' initial focus on location shooting meant that producers did not need to devote substantial resources to what might ultimately prove to be only a passing trend.

Instead, studio spaces and systems of environmental control more akin to cinema's first decade reappeared in Southern California. Following Selig's lead, in late 1909 the Bison company set up shop only a few blocks away in Edendale. There, Adam Kessel and Fred Balshofer oversaw the transformation of the lot's unused wheat storehouse, barn, and several small shacks into a laboratory, offices, dressing rooms, and an open-air stage. The latter included a system of muslin cloth shades for regulating the sun that echoed those used by Méliès in his first glass studio.[41] Similar versions of Bison's light-regulating system became the norm at competing studios. D. W. Griffith's Biograph troupe, for instance, used just such a shading system at its first facilities in downtown Los Angeles (fig. 5.3). Built at Washington Boulevard and Grand Avenue in 1910, the studio included an approximately 2,000-square-foot exterior stage equipped with a system of vellum cloths on wires.[42] In Hollywood, Nestor's studio included a 40-square-foot raised wooden platform with a comparable configuration of muslin cloths controlled by a network of wires.[43] And in

FIGURE 5.3 Biograph's canvas-covered stage at Girard and Georgia, *Moving Picture World* (July 10, 1915)

nearby Glendale, the Kalem company established a version of its Airdome studio in 1911.

As these light-regulating techniques suggest, filmmakers still demanded control over the filming environment, even in the most favorable weather conditions. Indeed, no climate was beyond reproach. Filmmakers soon discovered that even Edendale was not always the filmmaking "Eden" that many had come to expect. Weather statistics cited in the film trade press advertised "320 days for good photography" each year, but even among those days, more than half included some clouds, often including morning fog.[44] To be sure, these conditions trumped those found back East, but filmmakers hoping for a favorable climate year-round were in for an unpleasant surprise.

Reports from *Moving Picture World*'s western correspondent attest to the delays that plagued film companies, often for days and even weeks at a time. In February and March 1911, for instance, nearly a month of rainy weather halted film production. While Selig and Bison were able to rely on their reserves of finished films, other companies, including Biograph and Pathé, could not meet the usual release dates.[45] In June 1913, more than a week of clouds—what today's Angelenos refer to as "June gloom"—"[cut] down the light to such an extent that most of the companies feared to risk photographing lest they get flat and undertimed pictures."[46]

Such bouts of bad weather must have convinced the owners of the region's larger producers to devote greater resources to studio infrastructure, a process already under way. Given the large demand for films in the nation's expanding theater chains and the success of films produced in California in its first years, companies could justify expanding their land holdings and improving their facilities. Among their first concerns, producers sought to protect studio resources and their players from the weather and curious passers-by. Selig, for instance, wasted no time surrounding its Edendale studio with an ornamental wall that provided privacy, protection, and prestige (fig. 5.4).[47] Designed in the Mission Revival style, Selig's wall would become a model for companies in the region seeking to boost their corporate image and appease local residents' concerns about the new industry by projecting prestige and matching local aesthetics through ornamental architecture.[48]

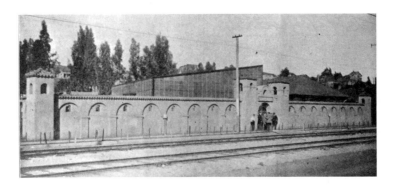

FIGURE 5.4 Selig Edendale Studio, *Moving Picture World* (July 1911).

Inside the walls, more banal structures provided the functionality that made studios run smoothly. The earliest studio building permit applications filed during this period call for an endless array of "sheds" designed to house props, painted backdrops, tools, and automobiles. At Selig, for instance, construction plans approved during 1910 included a 3,300-square-foot shed at a cost of $800, alterations to a 1,100-square-foot building with dressing rooms, an office, a darkroom, and a cellar ($500), 500 square feet of additional dressing rooms ($150), and a 250-square-foot auto shed ($50).[49] While Selig was the earliest company to devote such resources to its western infrastructure, similar patterns would be found at nearby studios over the next two years.

Early studio development was also not limited to companies with film units working in the region year round. Even Biograph, which remained only a seasonal presence, quickly established its own facilities. After their first season at the Washington and Grand studio in 1910, Griffith arranged for a more permanent site nearby at Girard and Georgia Streets (see fig. 5.3). The new studio, which Griffith opened in early 1911, again featured an open-air stage, now surrounded by offices, storerooms, and a developing plant.[50] The studio sat unused during the first few summers, but each fall a studio employee would reopen it in preparation for Griffith's seasonal arrival.

These early developments were only the prelude to the massive expansion of studio infrastructure that began in 1911. As more companies

arrived and existing ones stayed beyond the winter season, permanent studios sprang up across the region. Alongside their open-air stages, companies began to add glass studios, some equipped with electrical lighting. Selig reportedly invested $75,000 in its glass studio in 1911, a plan mimicked at neighboring Pathé.[51] At the nearby Bison compound, New York Motion Picture Company owner Frank Kessel put $30,000 into a glass studio equipped with Cooper Hewitt lamps.[52] In April of that year, *Moving Picture World*'s western correspondent Richard Spencer, citing eight companies with regional studios, first anointed Los Angeles "a producing center."[53]

The expansion had only just begun. During 1912, the number of producers rose to at least thirty-five, and studio infrastructure blossomed thanks to what one report described as "a wave of prosperity" among local motion picture manufacturers.[54] Vitagraph opened a western branch in Santa Monica, where it produced films on a "canvas covered studio."[55] Kinemacolor revamped the former Revier laboratories and added six new buildings at 4500 Sunset Blvd.[56] Keystone took over and renovated the Bison studio in Edendale.[57] Kalem added an additional studio in Santa Monica, where it refurbished a former Pacific Electric Company rail terminal.[58] Gaston Méliès briefly made a studio in Santa Paula his company's headquarters.[59] And finally, IMP, Rex, Powers, and Bison, all operating under the Universal banner, began producing films at studios in Hollywood, Brooklyn Heights, and at the Oak Crest ranch, future home of Universal City.[60]

By the year's end, one estimate put the film industry's investment in the region at more than $1,500,000.[61] That estimate deserves some skepticism given the industry's and local boosters' stake in crowning Los Angeles the center of American cinema. But there can be little doubt that studio infrastructure expanded dramatically and played a critical role, not only in booster rhetoric but also in the industry's development.

The seemingly incessant arrival of new film companies and large-scale expansion by existing ones came with growing pains. By 1914 no fewer than fifty companies had built studios, with plans for new buildings or studio improvements reported almost weekly. *Moving Picture World*'s correspondent Clark Irvine marveled in one 1914 report, "And they still come!"[62] The increasingly saturated market pushed some new companies

out of business.[63] Others faced heretofore unseen problems, including a
lack of extras in early 1913 that some attributed to the number of compa-
nies now offering regular work.[64] Most significantly, the industry's physi-
cal expansion and the number of companies vying for and exploiting
local settings created tensions around access to and treatment of filming
locations. Those tensions and the further expansion of studio infrastruc-
ture by the largest companies would help define the emerging idea of
"location" and eventually make the studio backlot a critical new feature
of California film production.

"PROSPECTING FOR LOCATIONS"

So pervasive was the studio ideal in the early 1910s that even those call-
ing for more non-studio production could do little to avoid its rhetorical
pull. A telling case appears in *Moving Picutre World*'s 1911 series "Let-
ters of an Old Exhibitor to a New Film Maker." In the third installment,
the wizened industry veteran warns young filmmakers not to "stick too
close to your indoor studio or outdoor annex studio." Proclaiming that
"we exhibitors . . . become as familiar with film makers' studios as with
our own backyards," he cautions that audiences, too, "feel the repeti-
tion" of studio settings, and even outdoor annexes "of generous size"
will do little to cure the monotony. The solution, he counsels, is to "Go
out into Nature just as often as you can." But his reasoning for this shift
makes clear that to do so was not so much to sever ties with the studio as
to reproduce its logic in a better place. Indeed, "the best of all studios,"
he declares, "is Nature."[65] This tendency to evaluate nature according to
studio ideals—and not, importantly, the other way around—would soon
shape the development of location shooting and the studio backlot.[66]

Studio designers had been perfecting "Nature" for almost two decades,
and as filmmakers returned to the great outdoors, they brought those
studio principles to their search for natural settings. A 1914 photograph
of Jesse Lasky and Cecil B. DeMille at the newly acquired Lasky ranch
in the San Fernando Valley suggests the logic they used to do so. Out
on horseback, Lasky and DeMille are, as the caption describes, "pros-
pecting for locations" (fig. 5.5).[67] And prospects must have seemed good.

FIGURE 5.5 "Lasky and De Mille Prospecting for Locations," *Moving Picture World* (December 12, 1914)

The photograph neatly encapsulates the rhetoric that dominated popular discourse about California locations in the early 1910s. Framed perfectly in the midst of verdant undergrowth, plentiful evergreens, rolling hills, and distant peaks, all bathed in plentiful sunlight, these film "prospectors" have already struck gold. An accompanying photograph makes the argument complete—Lasky and DeMille, on location, on top of the world, at the top of the motion picture industry. But, what, we might ask, were they looking for at 5,000 feet? What was a "location" for a filmmaker in 1914? What did it mean to "prospect" for one? And how would they even know when they found one that was suitable? The idea of Lasky and DeMille "prospecting" for locations points to a set of answers that lies in the importance of the studio.

The term "prospect" neatly encapsulates both the emerging idea of "location"—as a resource that needed to be secured, controlled, and efficiently accessed—and the means by which California filmmakers did so. As it appeared in the caption accompanying Lasky and DeMille's photo, prospecting points to the similarity between prospectors' pursuit of mineral deposits—especially with reference to the California gold rush and Los Angeles's growing oil industry—and filmmakers' search for suitable backdrops. Indeed, the idea that a location, like a limited resource, might be depleted or overused appears repeatedly in this period, as in a 1913 account of a production company organized to tour the globe, "stay[ing] in each location until it is *pumped dry* of interesting pictorial matter."[68]

As a metaphor for how enterprising film companies might strike it rich by "mining" the California landscape for suitable backgrounds, prospecting points to the real value that locations would have as resources for companies in need of raw materials for filming.

The term also suggests the ways that filmmakers approached locations with established ideas about what a suitable filming site might look like. In its early use, "prospect"—from the Latin *prōspicere*, "to look forward"—could refer both to a view of landscape and the formation of "mental pictures" and "anticipated events."[69] This idea of forming a mental picture and anticipating views well describes what Lasky, DeMille, and filmmakers like them were doing. Prospecting for locations began from an existing idea of what a location would look like. And that idea was in no small part related to how locations were anticipated in film studios. There, location meant painted backdrops—including western landscapes—stored in scenery rooms and called upon when a film idea anticipated a particular setting.

In many filmmakers' minds, location must have become much the same as studio scenery—a resource that could be prepared, stored up, and saved for future use. By the 1920s, maps of studio backlots prepared by professional studio prospectors (aka "location men") packaged this system in easy-to-read formats.[70] But already in the early 1910s, such ideas were a common feature of discourse about California in the popular and trade press and in studio publicity. In his 1911 report about the rise of Los Angeles as a producing center, Richard Spencer noted that, in addition to finding "exteriors from a tropic to a frigid background, and from desert to jungle," one could just as well film scenes requiring an "Atlantic City or Coney Island Background" in California rather than New York.[71] A 1916 *Los Angeles Times* article would similarly note that the California-based director could easily drive from Malibu "to the (apparent) Sahara of Africa, the desperate desolation of Central Asia or the storied wilderness of our own pioneer West."[72] Put another way, California was like a well-stocked scenery supply closet; one need only call up the right background and start filming.[73]

Such ideas were commonplace in film studios back East, where the ability to fake a location was a point of pride. In 1911, for instance, a *Moving Picture World* reviewer created an ideal publicity item for

the Selig Polyscope Company when he mistook a film made on location in Japan for a studio set.[74] Selig took this mistake as an unwitting complement about the quality of its studio fakery and responded by proudly proclaiming,

> when such authorities cannot distinguish between actual scenes from life . . . and scenes built and photographed in the Selig studios—when they believe that these actual 'scenics' are only Selig studio productions, and on the other hand mistake Selig studio productions for actual taken-from-life 'scenics'—then it is an assured and conceded fact that Selig nature reproductions have reached the height of perfection.[75]

It should come as no surprise, then, that many filmmakers in Southern California believed they could make local settings stand in for any place in the world. They had, after all, already made a business and an art out of imagining that the interiors of empty buildings could be made to do the same.[76]

Thus, even if the first filmmakers in Southern California were enticed by variety, diversity, and all that was new about western landscapes, for many film companies locations quickly became new places in which to extend the old, reliable working practices of studio filmmaking. Put another way, they became "studios beyond the studio." This extension of the studio to locations far and wide would come full circle not only on Hollywood studio location maps in the 1920s, but especially on the studio backlots where this way of thinking about location as a resource would be systematized. Ultimately, "prospecting for locations" meant finding filming sites defined by three prosaic qualities: accessibility, control, and efficiency.

DEFINING LOCATION

In August 1913, *Moving Picture World*'s western correspondent P. M. Powell reported that two problems threatened the film industry's future in Southern California. One was price gouging by local merchants seeking to profit on filmmakers' apparent willingness to pay anything to

get props and supplies.[77] The second problem—again involving locals' efforts to profit from the growing industry—centered on filmmakers' ability to shoot on non-studio property. As Powell described, "directors find it harder and harder to obtain backgrounds or 'locations' without submitting to a 'holdup.'" This "holdup," he specified, involved a cash payment—"$5 or $10, or even $25"—demanded by property owners who had come to learn that directors who had "decided on a certain background for a scene" were willing to pay to secure it.[78] This practice and the more general recognition among film companies that quality shooting space was a limited, valuable, and increasingly contested resource would help shape the emerging definition of location.

As Powell's use of scare quotes suggests, "location"—as something to be distinguished from backgrounds or sets—had only begun to enter the industry's vocabulary in 1913. Although the term was common in the industry in its general sense as a particular place (e.g., to build a theater or studio, to position a projector, etc.), it did not begin to acquire its industry-specific connotation until 1913.[79] Even then, location was only one of the terms with which writers tenuously signified the specificity of film spaces. In his July 1913 guide to "Motion Picture Making and Exhibition," for instance, John B. Rathbun instructs scenario writers to "remember that every time that the surroundings or 'locales' are changed you must have a new scene and a new subtitle."[80]

More significantly, as examples such as Rathbun's instruction indicate, "locales" or "locations" did not initially signify non-studio spaces. Rather, "location" also became a common way of describing the shooting sites on film company properties that blurred the line between studio and non-studio filming. A 1913 article about the "Lubinville" studio outside Philadelphia, for instance, notes that its 500-acre Betzwood estate included "almost any location needed in the taking of pictures."[81] Similarly, in his 1914 account of the motion picture industry, Robert Grau emphasizes the filming spaces at Selig's new Los Angeles zoo: "here will be found sets and locations for all classes of plays, from the primeval to the last word in modern presentations. Jungles, morasses, forest effects, battle fields—all will be at hand for the busy producers."[82]

In contrast, by the 1920s studio and location had acquired their commonly understood distinction. David Boughey's 1921 study of the film

industry, for instance, makes clear that a "location" designates a non-studio site found by "the poor *location man*," who "must find some spot, not too far removed from the studio, or at least from civilization, which, with artificial aid, will resemble as near as may be the glowing description of an earthly paradise."[83] Austin Lescarboura similarly differentiates between studio "interiors" and shooting "on location" and notes that "the advent of new efficiency methods" have made finding locations the domain of studio specialists.[84]

Before Hollywood systematized it, however, "prospecting for locations" remained the domain of producers and directors like Lasky and DeMille. As more and more filmmakers went out in search of suitable settings—often looking ahead to the same studio-inflected ideals—producers (and property owners) recognized that locations were neither endless nor equal. In this context, the idea of "location" emerged as an issue of access. A location was something to be obtained and controlled, and it also became a commodity to be traded.

Indeed, while we might doubt that film companies really contemplated leaving the region over the local "holdup game," we can be sure that they were taking steps to ensure access to locations. Selig, for example, treated at least one kind of location—the Spanish mission—as a prized commodity. In 1912, recognizing, one might surmise, their iconic value for evoking western and historical settings, Selig secured exclusive filming rights with all of the local missions. As a result, when Pathé producer James Young Deer wanted to make a film about the early days of Los Angeles, he paid the company's scenery artist to use photographs of a local mission to reproduce a faithful replica of it on a "big open space" (not yet referred to as a backlot) behind the company's studio in Edendale.[85]

This problem of accessibility was not limited to specific places or building types, but also extended to the region's supposedly limitless natural settings. Griffith Park, in particular, became a highly contested site that again brought film companies into conflict with the local community and threatened to limit the industry's access to local scenes. Later immortalized in the telling, if apocryphal quote "a tree's a tree, a rock's a rock, film it in Griffith Park," it was already described during this period as one of the most photographed places in the world.[86] But the park had also been a source of conflict between local residents, park officials, and

film companies from the earliest days of filming in Los Angeles. As Eileen Bowser notes, Angelenos often reported stumbling upon deserted temporary sets.[87] And by 1911, their complaints about filmmakers' uses of the park included the charge that crews tried to control access by harassing motorists and pedestrians who interrupted scenes; that they scared animals by firing blank cartridges; that they left litter and damaged trees and shrubs; and even that one company had intentionally set fire to a ranger's cabin in order to get a realistic scene.[88]

These charges led to calls for a ban on filming in the park, and an ensuing hearing in January 1911 resulted in stricter regulations governing its use. In addition to the blanket provision that a company's filming permit could be revoked at any time, the new rules included two notable requirements. First, that "the scene to be used must be subject to the approval of the park foreman and superintendent." And second, that film companies "must permit no waste, must not cut, mutilate, damage, or destroy any flowers, trees, plants, or other growing things in the park."[89] The requirement for scene-by-scene approval and the potential to have one's permit revoked at a moment's notice threatened access to one of the most sought-after locations in the region. What's more, the edict against transforming the park in any way meant that filmmakers no longer had the kind of control over locations that previously allowed them to manipulate settings to match anticipated ideals.

At least some filmmakers may have responded by cleaning up their act. The following month, Richard Spencer reported that one Griffith Park ranger had praised Fred Balshofer for the Bison Company's "orderliness and cleanliness . . . in leaving the scenes in as good condition as they found them before taking pictures."[90] Even accepting the verity of such reports, which may have been little more than public relations ploys facilitated by the trade press, the park continued to be a contested filming location where filmmakers were subject to further rules and regulations.[91] Not surprisingly, companies thus also sought new places to make films, including nearby locations such as the mountains near Malibu and further afield in areas like Bear Valley, which became a favorite filming location for Bison and Selig in 1912 and later for Vitagraph and Lasky.[92]

More significantly, they also took steps to secure access to desirable locations by buying up tracts of land, in some cases by the hundreds and

thousands of acres. In this period of rapid and massive studio expansion, new studio buildings went up constantly, and company land holdings exploded from small lots to ranches covering 20,000 acres. On the small end of the scale, Pathé acquired thirty-five acres above Edendale in 1912, and the same year the Brand Motion Picture Company established its studio on forty acres near Burbank.[93] Such figures were soon dwarfed by the acquisitions undertaken by Universal, Ince, and Lasky. In 1912, Universal reportedly purchased 20,000 acres at the Oak Crest ranch in the San Fernando Valley and added another 230 acres two years later.[94] By 1914, the New York Motion Picture Company had leased 18,000 acres for "Inceville" in the Santa Monica Canyon, while Lasky and DeMille were out prospecting on 20,000 leased acres of their own.[95]

These corporate land grabs further reduced the distinctions between location and studio filming. Privatization meant that filmmakers no longer needed to fear losing their favorite filming sites or having to obtain permission before executing a scene. By assuring exclusive access for their own filmmakers, the largest companies also limited their competitors' prospects—underscoring location's status and value as a key filmmaking resource. Studio buildings could now be physically closer to shooting locations, a proximity that contributed to even greater continuity between the practices undertaken on each. This combination of the new legal boundaries that governed exterior shooting sites and those spaces' physical convergence with studio buildings and the filming practices used in them would define the Hollywood backlot—a hybrid space, both studio and location; neither studio nor location.

THE STUDIO BEYOND THE STUDIO

The backlot would represent the culmination of filmmakers' competing desires for authenticity and reproducibility; spatial freedom and predictability; and the natural environment and its controllable facsimile. These studio-like exteriors—outside spaces where filmmakers could either build sets like those in the studio or return, again and again, to landscapes that became set-like in their consistency—typify the ways that cinema enframed the natural environment, transforming nature into a standing

reserve for technological reproduction. Responding to the same kind of impulse that saw filmmakers flock to the artificial environments of international expositions, backlot filmmaking made natural environments cinematic showcases. Put another way, they systematized the emergent idea that nature was a studio.

In a sense, filming on studio ranches merely brought the practices being utilized away from studios back into their legal domains, where location would come to be structured, industrialized, and named. The backlot's physical extension of corporate control reduced the already small practical difference between the studio and non-studio techniques being used. On their own ranches, where they could build sets and modify landscapes at their leisure, companies wouldn't need elaborate mobile studio systems such as Kalem's Airdome and Fielding's collapsible studio.[96]

Control of the filmmaking space—which could no longer be assured on public land like Griffith Park or on non-studio private lots where owners might demand a shooting fee—allowed for more systematic and efficient methods of cultivating the landscape according to filmmakers' needs. As Lasky put it, the studio ranch offered the great advantage "of making use at some subsequent time of properties . . . which we have [already] gone to great expense [to build]."[97] Thus, whereas Bison was forced to prepare, in Richard Spencer's words, "crate after crate of scenery and 'props'" when it went to Bear Valley in July 1911, now they could rely upon preexisting sets and supplies stored nearby.[98] And they could shape and manipulate the land as much as they liked without the need to repair it or repeat the process when a future shoot called for the same setting. In short, they could manufacture locations.

At the Bison 101 ranch in Santa Ynez Canyon, for instance, filmmakers complained that during the summer the land often failed to deliver the views that they had anticipated. In response, the New York Motion Picture Company built a waterworks to refresh lake and river beds that needed to be "brought to life again."[99] At Inceville, infrastructural upgrades—including an aqueduct, electrical plant, and the construction and maintenance of roads—facilitated efficient access to a diverse repertoire of locations and semipermanent set pieces. As one reporter described, "[Ince's] shops construct everything from uniforms and furniture to houses. . . . His range of locations travels in leaps and bounds

from . . . the broad Pacific to the wild West, mountain life, Ireland and the Orient and in fact to every country save the extremely tropic."[100]

On the other hand, greater control often meant more waste, as when companies chose to destroy those sets and scenes without fear of reprisal. Indeed, by providing space for the massive sets that would define Hollywood's earliest versions of the silent epic, the development of the backlot not only shaped film content and form in the mid-1910s; it also encouraged that spectacular genre's attendant material excess. This tendency would seem to confirm the fears of those invested in saving Griffith Park from film companies bent on destroying it. As Lasky described in 1914, "when the property is ours we can do as much damage as the interests of the picture may require."[101] At Inceville, Thomas Ince reportedly instituted the practice of burning at least one building each month, both as a tool for visual spectacle and as a way of training the studio's fire department.[102] And at Universal's grand opening in 1915, featured events included the destruction of an entire frontier village set by an artificial flood.[103]

This cycle of construction and destruction defined huge backlot cities such as Ince's Irish Village and Dutch city or Universal's version of Cairo, which was destroyed in a 1915 rainstorm along with neighboring versions of New York City and "little Bombay."[104] Contemporary observers marveled at the unlikely juxtapositions that, although nothing new to studio practice, became newly visible on large exterior sets. On these "great ranches," as a 1915 *Los Angeles Times* article described them:

> you are likely to chance upon big armies of cowboys riding madly to the exigencies of a frontier tale . . . or glimpse a crowd of actors in quaint costume and make-up for a tale of bygone Spanish days . . . [or] you may happen upon an oriental village . . . or it may be ancient Greece . . . or you may find yourself on the battlefield of the Civil War.[105]

As another article describing Los Angles as a "Great Backdrop for the World" suggests, this celebration of the backlot's malleability also included a temporal dimension. These landscapes offered a space "where may be enacted . . . almost any other land or time."[106] By extending the studio's juxtaposition of real, unreal, and often-incompatible times and

spaces, the backlot became both a new tool in and an outward mani-festation of film's role in the modernity-defining collapse of traditional notions of time and space.

Studio backlots provided filmmakers with the predictability needed for rapid productions that were possible with painted backdrops, all while also offering audiences seemingly authentic natural spaces. These stu-dio-owned spaces became preserved forms of nature—ordered natural settings framed and stored for technological reproduction. Indeed, the backlot's transformation of "authentic" landscapes into studio technolo-gies exemplifies the ways that cinema contributed to nature's changing status as something to be technologically reproduced or replaced by its artificial likeness. In their treatment as objects for reproduction, the back-lot's seemingly natural settings became technological spaces. Here, film companies could store and preserve various versions of nature with which to create artificial film worlds.

In their treatment as controllable facsimiles of natural landscapes, backlot locations represented a cinematic version of what Martin Hei-degger describes as nature placed on reserve.[107] Just as, in Heidegger's theory of "modern technics," technology transforms nature into a stand-ing reserve for exploitation, so, on the studio backlot, nature became a reserve for cinematic representation. Rather than seek out natural scenes, filmmakers had only to return to preserved, predictable settings that func-tioned as studio set pieces. Here, they used the camera to retrieve nature, as if from storage, for the screen. Extracted from their surroundings, these slices of backlot reality served as ready signifiers, both for real locations— Greece, Spain, or an "oriental village"—and for the natural environment. Like film itself, the backlot acted as a medium for storing natural scenes— a kind of stock footage not unlike the hours upon hours of snow scene recordings that companies collected in the mountains around Los Angeles during the winter for use later in the year.[108]

This treatment of the natural environment as a resource to be stored for mechanical reproduction fulfilled the same ambitions inaugurated more than two decades earlier in the Black Maria. Dickson's recognition of the technological utility of capturing the sun for producing moving images helped establish a relationship between cinema and nature that continued in studios throughout the early 1900s and to backlots in the

1910s. Cinema's contribution to the human-built world's artificial reproduction of nature operated precisely on this dynamic of capturing natural resources, processing them through film technologies, and reproducing them for welcoming audiences.

The backlot thus represented the logical extension of cinema's transformation of nature into another efficient studio setting. The expansion of the studio out of doors pushed its productions to ever-larger scales and more robust (if still ephemeral) architectural forms that were celebrated in films with lifelike sets such as Griffith's *Intolerance* (1916).[109] Here, cinema reached the pinnacle of studio realism through the utmost artificiality—architectural façades without interiors. These building-less buildings represented the same effort to reproduce features of the natural environment seen in the first studios, adding only a new focus on representational realism. More importantly, they mark the clearest expression of studio cinema's place in the production of the human-built world of industrial modernity. On the studio backlot, the artificial environments created in the first studios became seemingly inhabitable cities that, when processed from film to screen, bore virtually no distinguishing features from real built space.

These studio-built locations helped satisfy the need for consistency and efficiency that gave rise to massive exterior stages such as Universal's row of sixteen sets, the epitome of the mass-produced studio efficiency inaugurated a decade earlier back East and in Europe. By 1915, these same needs for access, control, and efficiency had driven most companies in Southern California to build glass-enclosed studios, usually with electrical lighting, ensuring that location and studio filmmaking would remain closely tied in the early days of Hollywood.[110]

During this period of studio expansion, the idea of location that had been shaped by conceptions of space developed in earlier studios also circled back around to shape the new studios themselves. As larger companies such as Universal put more and more time and money into planning and designing their studios, they recognized that new studio buildings could satisfy their need for consistent, efficient access to a variety of locations, and they built those locations into studio architecture. When the American Film Manufacturing Company built its Santa Barbara studio in 1913, for instance, it designed the exterior in the popular Spanish mission

style, but the interior was designed so that, as one article described, "every foot of building and grounds [will be] of a style that will lend themselves to the taking of moving pictures." Its features included two "set" gardens (one for a "tropical scene"), an 18 × 36 foot reservoir with a "pond effect," and a grape ramada, all designed as potential film sets. The interior buildings would be "as handsome as any Montecito estate," and the exterior wall and smaller interior ones could be used to "add a rustic effect."[111] In its drive for filmmaking efficiency, American imagined that every space was potentially a studio set.

The best examples would be found at Universal's aptly self-described "Chameleon City."[112] As one advertisement enthused, "Universal City is so cleverly constructed that at a moment's notice its entire architecture can be changed from a replica of ancient Greece or Rome to a modern villa—from the laborer's hovel to the King's Palace."[113] Its bridges could be "altered from a Roman arch to an American trestle—from an English causeway to a Japanese pontoon," and its artificial lake and "Universal River" could "float any craft from an Indian Canoe to a full-rigged ship." It included a stadium designed "to stage every kind of play calling for out-of-door sports—from the county fair trotting meet to the Indian Durbar" and a tennis court available for filming and amusement. And it included "every sort of dwelling from the modest bungalow to the twenty-room mansion."[114] In short, the studio itself became a studio set.

In its combination of manufactured locations, reusable backlot cities, and studio buildings designed to mimic any imaginable setting, Universal City marked the height of the efficiency, accessibility, and control that came to define filmmakers' approach to Southern California. Far from creating "Nothing Like It," as one advertisement claimed, Universal City was the epitome of filmmakers' search for spaces in which everything could be made alike.[115] Few companies could afford to produce these conditions on so large a scale, but in the latter half of the 1910s, they would become the industry ideal that defined Hollywood production in the "studio system." Here, filmmakers systematized a method for reproducing any imaginable world by mimicking and re-creating real spaces on screen using functional facsimiles built on studio stages or managed on backlot sets. To be sure, filmmakers still left their studios in search of "natural" locations, but many opted for the efficiency and environmental control offered inside

the studio walls. For even if, as one 1912 article had described, it seemed "that Nature had planned this locality with foreknowledge of the advent of the motion picture industry," places like Universal City betrayed the enduring belief that the industry and its studios could still do it better.[116]

CONCLUSION: STUDIO ARTIFICE, STUDIO SPECTACLE

The often overlooked but far from unlikely return to studio stages that characterized the film industry's shift to Southern California in the 1910s underscores the important role in industry practice that studios had achieved during the previous two decades. Even though natural light remained the ideal for quality-conscious filmmakers, and even as natural settings increasingly appealed to film audiences, studio infrastructure offered the efficiency, economy, and control that filmmakers needed to meet the demands of the transitional era. Studios met those demands by achieving new degrees of artifice that made sunlight and natural settings useful but often either inessential or reproducible. Backlots offered accessible, groomed, and adaptable sites for "location" shooting. And new studios came equipped, as one 1916 *Los Angeles Times* article so fittingly put it, "with 'artificial sun.'"[117]

In a sense, film production had come full circle—from the studio to the "studio beyond the studio" and back again. The common ideas that, on the one hand, studios could reproduce features of the natural environment—even the sun—and, on the other, that nature itself was just another studio, suggest just how highly filmmakers had come to think of their ability to produce artificial film environments by reproducing real ones. It should come as little surprise, then, that they so quickly imported architectural designs and studio technologies from back East to support their new filmmaking operations out West. No matter how good the light was and no matter how diverse the scenery, the studio remained at the heart of the industry to which it would soon give a name.

The departure from East Coast and Midwestern studios at the beginning of the transitional era would end with another somewhat ironic twist. The quest for natural light and "authentic" scenes that helped bring filmmakers to Los Angeles culminated in the behind-the-scenes tours that

made the studio's illusionary quality cause for celebration. In 1915, Universal City opened its doors to tourists and curious local residents who were beckoned into "the world's only movie city." At this "strangest place on earth," as one poster described it, visitors were invited to experience the unique reality of studio production.

The cover of a 1915 souvenir tour guidebook neatly encapsulates the vision of filmmaking that had guided the industry's development in California over the previous half decade (fig. 5.6). Towering over "The Capitol of the Film World," Mercury or Hermes—gods of commerce and communication, travel, and movement between worlds—lassoes the globe with a filmstrip. What better metaphor for studio cinema's power to transport viewers round and round a re-created world? The tour showed visitors how this re-creation worked by presenting a mélange of sensational and ordinary scenes—from cavalry teams, rough riding cowboys, and wild animal trainers to a U.S. Post Office, an ice plant, and a blacksmith shop.

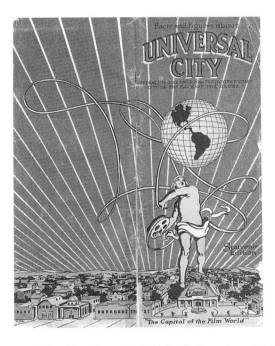

FIGURE 5.6 Universal City Tour Souvenir Guidebook Cover (1915). (Courtesy Dennis Dickens, Universal Stonecutter)

Through this combination of the spectacular and the banal, the tours revealed that Hollywood's fantastic film spaces were built on the backbone of functional places.[118]

The Universal City tour's blending of the spectacular and the banal reproduced the basic dynamic that studios and studio architecture had settled into by 1915. In their glass houses and on open-air stages and backlot sets, filmmakers strove for an operative balance between spectacle, illusion, and realism that they achieved by reproducing natural settings and realistic situations and creating real-enough imaginary worlds. Studio tours offered visitors a glimpse of the authenticity behind the illusion—the real techniques and even more banal day-to-day studio activities that structured their silver-screen fantasies. The studio tour worked through transparency—exposing the machinery behind the illusionary effects of cinema's studio-produced artificiality. But rather than shattering the illusion, the tours promised to ensconce visitors even further in the spectacle of cinema's built environments, physical and virtual alike. For even in unveiling the reality behind the dream, studio tours promised to enhance the spectacle by making the studio itself—cinema's "dream factory"—just as worthy of celebration as the performances and performers hidden behind its walls.

CONCLUSION: MORE THAN "DREAM FACTORIES"

And the studio, around which so great a skein of glamour has been spun, is after all only a great Dream Factory, in which your dreams and others' are woven into a tiny ribbon that is carried half way around the world to be dreams for the tired little shop girl next door and the rich old man in the mansion who has lost all his own.

—G. Harrison Wiley, "The Dream Factory" (1921)[1]

NEARLY A CENTURY later, G. Harrison Wiley's eloquently contradictory description of the film studio—"*only* a great Dream Factory"—remains common parlance for the buildings and industry that dawned in Los Angeles in the decade following World War I. The "dream factory system" may forever, one might surmise, call to mind the assembly line–like churning out of standardized film products whose escapist quality made them fantastic dreams. But as this book has shown, the "dream factory" metaphor may be better understood not by looking forward to classical Hollywood's golden years but rather by returning to the many factors that turned film studios into factories and their film products into dreams in the three preceding decades. Indeed, the more we look back, the more the metaphor seems inadequate for encapsulating the studio's function and importance.

During film's first two decades, filmmakers defined studio cinema not simply as a rationalized form of economic production but also as

a technological and aesthetic system of spatial organization and environmental regulation. The development of studios wasn't about creating dreams, it was about producing two kinds of spaces: real spaces based on scientific principles and practical procedures for registering reflected light; and virtual image spaces defined by the spatial character of the real spaces in which they were produced. Although film scholars have tended to focus on the latter, the emergence of cinematic space cannot be properly understood without knowledge of cinema's first material spaces and the convergence of the building materials, technical expertise, and practical experience that shaped their early forms.

WHENCE THE DREAM FACTORY?

Beneath its "skein of glamour," the early film studio's material reality—its mix of iron and glass, brick and mortar, concrete and steel—betrays a no less complex system of influences. Cinematic space emerged as a confluence of materials and designs drawn from the spaces of modern science, industry, and art. From advanced research labs and hothouses, to factories and mills, to photography studios and artists' ateliers, the spaces that defined modern production furnished the principles for cinema's unique production of space.

 This study has examined the studio's artificial spaces and the film worlds they produced through three main approaches: (1) by situating the first studios in the architectural and technological developments that inspired their designs and material forms, (2) by analyzing the resulting studio structures' effects on film form, and (3) by theorizing the studios' and their films' technological and spatial reproductions of the modern built environment and the new technologies that animated it. From early urban actualities and Edison and Biograph films depicting modern infrastructure to Méliès's critical parodies of technological change and Feuillade's downbeat depictions of modern "life as it is," film technology came to play a key critical role in documenting and evaluating the developments that shaped the urban infrastructures and technologies that had helped shape cinema itself and especially its first studios.

Indeed, if studio films came to offer both critical commentaries on and dreamlike escapes from the realities of modern life, they could so readily do so, in part, because of their close ties to it. Their locations in and around metropolises like Paris and New York meant ready access to stories from the street. And in their material forms, the studios' themselves were re-creations of the artificial characteristics of industrial modernity that also defined their film products.

It is thus no coincidence that studios took on industrial monikers during this period. The machines and practices that produced industrial-manufacturing spaces also shaped the first studios, even before they became literal and figurative "factories." From the technological spaces of the Edison laboratory to the modern materials used to build glass houses and concrete daylight factories, developments in building technologies and architectural designs provided the nineteenth-century conditions of possibility for early-twentieth-century studio cinema. By the 1910s studios were commonly recognized, both architecturally and in their organizational methods, as factory-like. As a representative 1911 article about the Selig Polyscope Company's "Diamond-S" studio in Chicago described, "The Selig plant is an enormous art factory, where film plays are turned out with the same amount of organized efficiency, division of labor and manipulation of matter as if they were locomotives or sewing machines."[2]

As the histories of Gaumont and Pathé demonstrate, that rational economy had important architectural components. Indeed, early studio architects' common backgrounds in industrial design underscore the direct links between architectural efficiency in the studios and the efficient designs that shaped early-twentieth-century factories. What's more, many studios housed much more than just filmmaking. At large studios like Gaumont's Cité Elgé, Pathé's studios in Joinville and Vincennes, and Vitagraph's studio in Brooklyn, film was but one form of industrial output. The tendency to think of studios simply as places in which to make movies has obscured the many other industrial activities that have long structured cinema, and this study's analysis of those film and non-film practices should suggest the value of examining the diverse work of cinematic production spaces into the early sound period and beyond.

TEXTS AND CONTEXTS

Even if cinema had become just another kind of industry, its manipulated "matter" was anything but a straightforward industrial product. Studios produced art, entertainment, and aesthetic experiences that necessarily bore the mark of the industrial contexts from which they emerged. This study contends that film analysis should include greater attention to the aesthetic effects of film production spaces. Studios inherited spatial forms from modern materials and architectural designs, and these spaces and materials helped determine the forms of early studio films. As my analyses suggest, architectural space shaped film form in a variety of ways and to different degrees across studio contexts. The Black Maria's unique architectural design, for instance, produced a distinct, readily identifiable visual form—what I have termed the "framed aesthetic"—that derived from its architectural function (to capture sunlight) and reflected its roots in laboratory and scientific analysis. The "imponderable fluidity" of Georges Méliès's films, on the other hand, bears a more conceptual relationship to his studio's glass-and-iron form. Just as nineteenth-century glass-and-iron structures fascinated contemporary observers by opening architectural space to new degrees of fluidity, so Méliès's studio films wowed audiences by opening cinema to new kinds of spatial manipulation. The flexibility of Méliès's production spaces—and similar ones housing the likes of Zecca, Smith, and Porter—echoed the malleability of glass and iron as building materials, a correlation between architecture and cinema that Elie Faure would later describe as "cineplastics."

As Edison, Vitagraph, Pathé, Gaumont, and other companies built larger, professionally designed studios based on the experience of their predecessors, filmmakers and set designers built larger and more realistic sets to satisfy changing audience demands. Architects such as Hugo Kafka for Edison and Auguste Bahrmann for Gaumont facilitated these developments by using modern materials to create large, brightly illuminated interiors without columns that would block shooting angles, prevent camera movements, or cast unwanted shadows on the set. The flexibility offered by large stages serviced by set design workshops and prop supply rooms helped filmmakers meet producers', audiences', and critics' desires

for longer and more sophisticated narratives and more realistic styles. At the same time, the growing number of filmmakers who left the studio to capture urban scenes and natural landscapes continued to use studio technologies and techniques to frame the outside world as if it were just another studio. As the industry shifted to Southern California, all of these practices helped shape the development of film form on the studio sets and early backlots where filmmakers replicated earlier studio designs and filmmaking techniques.

As these examples suggest, attention to cinema's architectural contexts offers new ways of analyzing the development of film form, style, and content. This study argues that it also opens new avenues for theorizing film space as well as film's contribution to our experience and understanding of the modern world. Architecture and technology shaped early cinema, and cinema, in turn, helped shape the modern world in ways that can be better understood by considering the studio as a key component of cinema's development.

ARCHITECTURE, TECHNOLOGY, AND FILM THEORY

Behind all of the diverse forms with which filmmakers explored and expanded film's spatial techniques, the studio remained a consistent frame—a strange physical site, always present but rarely noticed in its film products. One way of understanding this unusual spatial dynamic, I have proposed, is through Michel Foucault's idea of the "heterotopia." A uniquely modern type of space, the heterotopia embodies precisely the kinds of spatial experimentation the studio made possible. Studios offered key sites for exploring the nature of modern space and spatial experience by juxtaposing simulated versions of any and all real spaces in a single location. Contemporary observers took note. A 1917 cartoon parody of movie studios—Charles Gatchell's "impressions of an amusement factory as seen from the ceiling"—makes light of such juxtapositions by ironically populating the studio with sets that include a working-class restaurant, a bourgeois salon, a rural den, and a faux-Egyptian palace (while set designers paint the backdrop for a city scene in the workshop below).[3] Such scenes of chaotic production and unlikely juxtaposition could indeed be

found on a smaller scale on "any day at any studio," where filmmakers and set decorators made imaginative re-creations of like and unlike places the norm.

The unique possibility for producing, reproducing, and manipulating space in the studio and on film remains important to cinema's potential as a medium for exploring and evaluating space today. As Anthony Vidler argues, "the architecture of film has acted, from the beginning of this century, as a laboratory, so to speak, for the exploration of the built world."[4] Although the studios' physical spaces have increasingly given way to virtual software suites, filmmaking continues to be defined by imaginative creations of space, and architects continue to use forms of moving-image modeling as fundamental tools for imagining future places in the same way that filmmakers have since cinema's first "laboratory," the Black Maria.

These creative spatial practices derived from the broader processes by which modern technologies transformed Western cities into human-built artificial environments beginning in the late nineteenth century. Architects and engineers altered cities with new building materials such as glass, concrete, and steel as well as infrastructures such as electrical lighting grids, water and sewer systems, and human-made parks. The studios became their cultural counterparts: technological spaces that artificially produced favorable conditions of nature for photographic reproduction. Filmic space offered its own artificial environments as it recorded and replayed the ongoing changes to the city for its urban inhabitants. At other times, films captured and repackaged natural landscapes for urbanites hungry for a version of nature outside the city. Such films offered a contradictory form of access to nature—extracted and re-presented by film technology—that was consistent with the ways that film studio technologies enhanced and reproduced features of the natural environment for film representation.

Considered as an architectural technology, the film studio became a key example of what Lewis Mumford and Martin Heidegger separately described as "modern technics." For Mumford, modern technology is defined by the technological replacement of nature: synthetic materials for wood, brick, and stone; machine power for animals, wind, and water; and chemical fertilizers for organic processes. Early studio cinema similarly

developed according to filmmakers' progressive efforts to manipulate, simulate, and replace sunlight in order to produce an idealized version of the natural environment suitable for recording movement. Understanding the studios in this way, I have argued, opens up an interpretation of cinema as a literal form of Heidegger's theory of *enframing*, the process by which modern technology places nature on reserve and sets it before the human subject as a metaphorical image. From the Black Maria to the backlot set, studios enframed nature in order to frame their film subjects. Films, in turn, placed technological slices of the world before viewing subjects. As a "specific art of the machine," cinema would become, and continue to be, a key element of our experience and so-often visual understanding of technology and technological change. When understood, as I have proposed, as a system of interrelated machines, cinema may even be the prototypical example of modern technology. This idea must be borne out through further attention by film and media scholars to how moving images fit in the history of technology and by historians of technology to the importance of representational technologies as much more than recorders and illustrators of technological history.

AFTERLIVES OF THE FIRST STUDIOS

In 1915, as Universal City welcomed studio tourists and a massive filmmaking workforce, Gaumont and Pathé bid *adieu* to workers leaving for the warfront and made room for war supplies, which soon filled their vacant studios. Although World War I changed the dynamics of the global film industry, it did not radically alter the film studio itself. If anything, studios' uses during the war only underscore the close relationship between film and industrial modernity that developed during this period. Gaumont, for instance, put its infrastructure and expertise in optics and sound technology to work in the service of state-sponsored military manufacturing. The least surprising of its wartime products would be its aerial cameras, developed for surveillance as early as 1916. But Gaumont's scientists and engineers also used their knowledge of electricity, studio illumination, and sound recording to design spotlight systems for the trenches, wireless communications systems for aircraft, and submarine sonar systems.

The company adapted its production techniques to military protocols and transformed its Cité Elgé into a literal military-industrial complex. These practices helped Gaumont stay afloat during the war by supplementing its comparatively meager film profits. In the war's aftermath, Gaumont continued to manufacture noncinematic devices, even as film production became profitable again.[5]

The architectural forms and technological processes described in this study did not undergo widespread changes until the 1920s, when advances in artificial lighting technologies led filmmakers to cover their glass-and-iron walls with dark curtains and pushed architects to replace glass houses with dark studios. The next clear breaking point would occur with the widespread shift to sound in the decade's last years. That the 1920s should be such a privileged moment in studies of cinema and architecture reflects the dynamism that came with these shifts in studio architecture, the intermedial experiments that explicitly linked the two mediums, and the numerous critics who celebrated and theorized their similarities. This moment can be better understood, however, by accounting for the long and varied histories of architectural forms and filmmaking practices that preceded it.

If, as Robert Mallet-Stevens argued in 1925, "a unity of conception between cinematic architecture and architecture as it is really lived" seemed so apparent, it was no doubt because the two were products of the same developments of materials and designs in the previous century.[6] This is not to deny the real developments in film form and representation in the 1920s, when architecturally trained filmmakers such as Sergei Eisenstein and architects-turned-set designers such as Mallet-Stevens offered striking new visions of film's potential to explore built space while classical Hollywood set designers such as William Cameron Menzies and Anton Grot made studio set design a modern art form. But those developments need to be situated in a multifaceted history of film's architecturally influenced formal evolution.

Many of the studios described in this study, including Gaumont's Cité Elgé, the Pathé studios in Joinville, and many of the Southern California studios, remained in use in the 1920s and, in renovated form, for decades to come.[7] Although film and building technologies and filmmaking practices changed, the close relationships between cinema, architecture, and

technology forged in cinema's first two decades remain key elements of the studio's basic form and function. Even today, studios continue to be factory-like and their films continue to be technological forms.

The persistent relationship between film technology, architecture, and industry is perhaps no more apparent than at French-led conglomerate Europacorp's new Cité Européenne du cinéma in the northern Paris suburb of Saint Denis. Europacorp has repurposed an Electricité de France factory as the central structure of Europe's largest film studio. This cinema city within the city—France's answer to Italy's Cinecittà and Britain's Pinewood Studios—encompasses more than six acres, including business offices, the École National Supérieure Louis Lumière film school, and 10,000 square meters of shooting stages.

As readers of *Studios Before the System* will understand, the new studio has taken its place in a long tradition of film industry links to industrial architecture and municipal infrastructure. Film studios and modern factories shared the common need for large spaces, efficient lighting, and power; they produced similar (sometimes even the same) products; and they contributed to the same broad processes of technological change. In large studios, cinema became a product not just of dream factories, but of real factories, and their films made—and continue to make—the artificial spaces of industrial modernity the realities of studio moving-image production.

CODA

The first American and French studios—the Black Maria and Georges Méliès's first glass house—did not survive the twentieth century, at least not as film production spaces. Méliès's studio stood undisturbed in Montreuil until, despite protests from historians and cultural figures (including Henri Langlois, reportedly the most outspoken of the studio's defenders), new owners razed it in 1947. Although unused for more than three decades, the studio continued to house a remarkable vitality up to its end. Between the cracks of the studio's forgotten stage, a burgeoning garden thrived under the natural light that once exposed Méliès's film productions—a fitting reminder of the correlation between glass house photochemistry and greenhouse photosynthesis.

Not long after Méliès's studio passed into oblivion, the Black Maria reappeared, revived a half-century after its demolition. In 1954, the Thomas Alva Edison Foundation funded the construction of a life-sized model of the studio that still stands at the Edison National Historic Site in West Orange, New Jersey. No longer fit to house artificial constructions, the Black Maria became one.[8] Ironically, the Edison Foundation initially used the studio replica as a film theater, where Edison enthusiasts could watch 16mm prints of *The Great Train Robbery*. Today, the Black Maria continues to serve as an exhibition space in yet another form. In 2009, British artist Lindsay Seers's *Extramission 6 (Black Maria)*—a video installation projected inside a reconstructed version of the first studio—brought the studio back into public view as part of Tate Modern's 2009 "Altermodern" Triennial.[9] Inside the scaled-down "studio," visitors watch a video that includes scenes of Seers building her Black Maria. That it should become a reference for contemporary art—and a physical presence in museums and galleries—seems a fitting future for the once-derided "ramshackle" building. As architectures and technologies for what would become the dominant form of image production in the twentieth century, studios such as the Black Maria played a key role in defining modern aesthetic experience.

In the first studios, inventors and image-makers imagined and evaluated their world—and their own practice—through a combination of building technologies, architectural designs, and image-making devices, and they continue to do so today, whether on backlots and soundstages, in digital effects studios and software suites, or in artists' studios and galleries. The afterlives of Méliès's glass house and Dickson's Black Maria offer a striking contrast and a puissant conclusion to this study of cinema and architecture, technology and nature, and artificial reproduction: one swallowed by both nature and the tides of progress; the other further fixed in systems of artifice, duplication, simulation, and the spaces of modern visual culture.

NOTES

INTRODUCTION: STUDIOS AND SYSTEMS

1. *The Facts and Figures About Universal City: The One and Only Incorporated Moving Picture City on the Face of the Globe*, Souvenir Edition (1915), 1.
2. Siegfried Kracauer, "Calico World: The Ufa City in Neubabelsberg," in Dietrich Neumann, ed., *Film Architecture: Set Designs from* Metropolis *to* Blade Runner (1996), 191; originally published as "Kalikowelt," *Frankfurter Zeitung*, January 26, 1926.
3. Early filmmakers' accounts of their studios appear in William Kennedy Laurie Dickson and Antonia Dickson, *History of the Kinetograph, Kinetoscope, and Kinetophonograph* (1895); Georges Méliès, "Les Vues Cinématographiques," in *Annuaire général et international de la photographie* (1907), 362–92, translated as "Cinematographic Views," trans. Stuart Liebman, *October* 29 (Summer 1984): 24–34, 25–26; Méliès, "J'ai construit le premier studio du monde: il y a 40 ans," *Pour vous: le plus grand hebdomadaire du cinéma* (December 1, 1937); Alice Guy, "À Propos des débuts de l'industrie cinématographique 1930," Bibliothèque du film, LG374 B51; and Charles Pathé, *De Pathé frères à Pathé cinéma* (1939; rpt., 1970).
4. Gordon Hendricks, for instance, uses W. K. L. Dickson's role in designing the Black Maria as evidence that Dickson invented cinema. See Hendricks, *The Edison Motion Picture Myth* (1961).
5. For a standard account of how these historians—the likes of Terry Ramsaye, Georges Sadoul, Jean Mitry, and Lewis Jacobs—treated early cinema as "primitive," see Charles Musser, *The Emergence of Cinema: The American Screen to 1907* (1990), 15–17.
6. See, for instance, the essays collected in John Fell, ed., *Film Before Griffith* (1983) and the essays in Thomas Elsaesser, ed., *Early Cinema: Space-Frame-Narrative* (1990).
7. This approach builds on James Lastra's effort to rethink the apparatus theory in *Sound Technology and the American Cinema: Perception, Representation, Modernity* (2000).

8. As Brian Larkin argues, "analyzing media as technical infrastructures gives greater analytic purchase on how these technologies operate as technical systems." In this study, I demonstrate the value of expanding our view of film technology to include the studio, the cinematic infrastructure that first put cinema and media into contact with broader infrastructural networks and technical systems. See Larkin, *Signal and Noise: Media, Infrastructure, and Urban Culture in Nigeria* (2008).

9. Throughout the book, I draw parallels between American and French studios and those that fall outside this project's scope. To be sure, compelling variations in working practice and material design could be found outside the United States and France, but I have found remarkable similarity across early studio architecture. This consistency suggests that the architectural roots I describe reflect more general trends that may be explained by the transnational circulation of people, materials, and ideas at the turn of the century. To cite only one example, the first studio designer, W. K. L. Dickson, was born in France to British parents and designed studios for two different American companies and two more for British and French affiliates.

10. One notable variation is the early Japanese studio. The few photographs of these studios that I have seen at the National Film Center in Tokyo reveal that at least some were built with rice paper windows (rather than the glass found in most European and American studios), a feature that would have provided the diffuse lighting that early studio architects and filmmakers created in other ways, most often by using thin fabrics draped in front of glass roofs or over open-air stages.

11. On the Vitascope studio, see Terry Ramsaye, *A Million and One Nights: A History of the Motion Picture Through 1925* (1926), 257; cited in Charles Musser, *Before the Nickelodeon: Edwin S. Porter and the Edison Manufacturing Company* (1991), 69.

12. On Vitagraph's rooftop studio, see Anthony Slide, *The Big V* (1976), 8, and Ramsaye, *A Million and One Nights*, 331. On Lubin, see Musser, *The Emergence of Cinema*, 201, and Slide, *Early American Cinema* (rev. ed., 1994), 19.

13. Klaus Kreimeier claims that Messter built the studio on Friedrichstrasse in November 1896 and that it was "the first artificially illuminated film studio in Germany." See Kreimeier, *The Ufa Story: A History of Germany's Greatest Film Company, 1918–1945* (1996), trans. Robert Kimber and Rita Kimber, 13. Martin Koerber notes that Messter's first shooting space and factory for manufacturing cameras and projectors was located in a factory owned formerly by the optical company Bauer & Betz. See Koerber, "Oskar Messter, Film Pioneer: Early Cinema between Science, Spectacle, and Commerce," in Thomas Elsaesser, ed., *A Second Life: German Cinema's First Decades* (1996), 54.

14. On Paul's studio, see John Barnes, *The Beginnings of the Cinema in England, 1894–1901*, vol. 3: *1898* (1996), 8; Rachel Low and Roger Manvell, *The History of the British Film, 1896–1906* (1997), 30–31; Michael Chanan, *The Dream That Kicks: The Prehistory and Early Years of Cinema in Britain* (2d ed., 1996), 183; and Georges Sadoul, *Histoire générale du cinéma*, vol. 2: *Les Pionniers du cinéma, 1897–1909* (1948), 132.

15. See John Barnes, "The History of the British Mutoscope and Biograph Company and An Account of the Biograph Film Studios, Appendix II," 55. 1992 (Museum of Modern Art, Film Study Center, Biograph Collection, box 8, file 22); Low and Manvell, *The History of the British Film*, 29; and Paul Spehr, *The Man Who Made Movies: W. K. L. Dickson* (2008), 514.

16. On G. A. Smith's studio, see Barnes, *The Beginnings of the Cinema in England, 1894–1901*, vol. 2: *1897* (1996), 83; and Low and Manvell, *The History of the British Film*. 30. On Hepworth, see Low and Manvell, ibid., 29; Barnes, *The Beginnings of the Cinema in England, 1894–1901*, vol. 5: *1900* (1997), 26–28; and Chanan, *The Dream That Kicks*, 183–85. And on Bromhead's studio, which would later house Gaumont British, see Sadoul, *Histoire générale du cinéma* 2:132; Jacques Deslandes and Jacques Richard, *Histoire comparée du cinéma*, vol. 2: *Du cinématographe au cinéma, 1896–1906* (1968); Barnes, *The Beginnings of the Cinema in England 1894–1901*, vol. 4: *1899* (1996), 133; and Chanan, ibid., 187.

17. On Pathé's studios, see chapter 4. On Gaumont's first terrace production stage, see Alice Guy, "À Propos des débuts de l'industrie cinématographique."

18. According to Baron, these sound-on-disc productions achieved limited success. In an interview with Maurice Bessy in 1933, Baron reported that he quickly abandoned his sound recording efforts to focus on silent films. Several dozen of the latter have been restored by the Centre National de la Cinématographie. Many feature distinct shadows across the stage that offer a sense of the studio's glass-and-iron form. One notable example is *Chez le photographe* (1899), a 30-second film in which the two would-be portrait subjects cannot remain seated long enough for the exposure. Here, the shadows from the studio roof give the film realism in a manner that both Méliès and Edwin S. Porter would later use in their own glass studios (see chapters 2 and 3). On Baron's studio, see Charles Ford, *Auguste Baron: Inventeur et Martyr* (1985) and Jean Vivié, "Le Premier studio d'enregistrement de films sonores fut montée en 1898 à Asnières par A. Baron," *Bulletin de l'association française des ingénieurs et techniciens du cinéma* 24.30 (1970): 6–10.

19. Other German studios included the Muto-Studio in Lankwitz (1907), the Treumann-Larsen studio on the Teltow Canal (1912), the Rex studio in Wedding (n.d.), and a Vitascope studio on Belle Alliance-Platz (ca. 1912), as well as on Mark Brandenburg. See Kreimeier, *The Ufa Story*, 42.

20. According to Slide, the Biograph studio was located at 807 175th Street. See Slide, *Early American Cinema*, 13. Eileen Bowser claims that the studio did not become operational until mid-1913. See Bowser, *The Transformation of Cinema, 1908–1915* (1991), 160. See also Gene Fernett, *American Film Studios: A Historical Encyclopedia* (1988), 11; and "The Biograph Company's New Studio," *Cinema News and Property Gazette*, January 22, 1913.

21. On the 1907 studio, see Musser, *The Emergence of Cinema*, 476, and Slide, *Early American Cinema*, 27. On the 1911 additions, see Eugene Dengler, "Wonders of the 'Diamond S' Plant," *Motography* 6.1 (July 1911): 7–19.

22. See "Essanay Will Release Two Reels," *Moving Picture World* (hereafter, *MPW*), November 6, 1909; "Essanay Builds New Studio," *MPW*, December 13, 1913; and "Essanay's New Studios," *MPW*, July 11, 1914.

23. On the 1907 studio, see Musser, *The Emergence of Cinema*, 482. On the 1910 studio, see Joseph Eckhardt, *The King of the Movies: Film Pioneer, Siegmund Lubin* (1997), 81; Slide, *Early American Cinema*, 19; "Lubin Progress," *MPW*, February 5, 1910; "New Plant of the Lubin Manufacturing Company," *MPW*, March 26, 1910; Louis Reeves Harrison, "Studio Saunterings," *MPW*, March 30, 1912; and Dengler, "Some Features of the Lubin Plant," *Motography*, October 1911.

24. See Slide, *Early American Cinema*, 20, and W. Stephen Bush, "Betzwood, the Great," *MPW*, July 11, 1914.

25. On the former, see Ron Mottram, *The Danish Film Before Dreyer* (1988), 20. On the latter, see Jay Leyda, *Kino: A Short History of the Russian and Soviet Film* (1983), 31. Leyda also notes that the Italian company Gloria built a studio in Russia in 1909. See Leyda, ibid., 38.

26. See Kreimeier, *The Ufa Story*, 17, 41–42. See also Siegfried Kracauer on the "genesis of Ufa" in *From Caligari to Hitler: A Psychological History of the German Film* (1947), 35–36.

27. In his description of the Black Maria in the January 1895 issue of *Photographic Times*, R. D. O. Smith refers to the "curious looking building" as the "kinetographic studio," a slight variation on the more common "Kinetographic Theatre," as most called it. The latter included W. K. L. and Antonia Dickson, whose use of "theatre" is notably distinct from their description of the "photographic studio" that Dickson also built at the Edison Laboratory. See R. D. O. Smith, "Some Photographic Talk," *Photographic Times* 26 (1895): 24; and Dickson and Dickson, *History*, 20.

28. Dickson and Dickson, *History*, 19–20.

29. "How They Make Moving Pictures," *Lincoln (Neb) News*, October 28, 1908 (Edison Papers Project, Microfilm Edition, Reel 221).

30. See S.M.G., "Why Is a Movie Studio?" *Los Angeles Times*, April 23, 1916, VI2.

31. My analysis of early film architecture builds on early film historians' attention to the importance of modernity's urban spaces in the formation of cinematic spectatorship. See Anne Friedberg, *Window Shopping: Cinema and the Postmodern* (1993); Giuliana Bruno, *Streetwalking on a Ruined Map: Cultural Theory and the City Films of Elvira Notari* (1993); and the essays collected in Leo Charney and Vanessa R. Schwartz, eds. *Cinema and the Invention of Modern Life* (1995).

32. Mary Ann Doane, *The Emergence of Cinematic Time: Modernity, Contingency, the Archive* (2002), 3–4.

33. See "Doings at Los Angeles," *MPW* (February 8, 1913): 560.

34. Bruno, *Streetwalking on a Ruined Map*, 45. If, as Bruno argues, "film dwells on the borders between interior and exterior," the first glass studios modeled, housed, and helped shape that spatial ambiguity in ways that were consistent with early spectators' experiences of urban glass architecture and early film screens. See Bruno, ibid., 49.

35. Clair, quoted in Paul Virilio, *The Lost Dimension* (1991), trans. Daniel Moshenberg, 69.

36. The 1920s saw architects, filmmakers, and critics develop a variety of theories and practices that celebrated the perceived intimacy between cinema and architecture. Architects such as El Lissitzky, Mallet-Stevens, and Bruno Taut sought new possibilities in film for imagining and producing abstract physical forms to match the cinematic spaces created through set design, camera movements, and editing. At the same time, filmmakers including Eisenstein, Marcel Carné, and Clair explored architecture and urban space as spatial arts. And Walter Benjamin and Kracauer theorized cinema and urban space as modern brethren. For these and other theorists, cinema offered the means to capture the fleeting experiences of an urban modernity whose always-moving and changing ephemerality was in turn perfectly suited to film's materialist aesthetics. On this context, see Anthony Vidler, "The Explosion of Space: Architecture and the Filmic Imaginary," in *Warped Space: Art, Architecture, and Anxiety in Modern Culture* (2000), 99–110.

37. As studio sets became more realistic, filmmakers and critics increasingly denounced their artifice. Carné and Clair, for instance, argued that cinema, as the art form closest to architecture, needed to preserve the reality of an ever-changing urban fabric instead of re-creating it in studios. Ironically, Carné consistently remade city streets and urban locales in the studio. Clair filmed portions of *Paris qui dort* at Pathé's former studios in the suburb of Joinville-le-Pont and shot *Sous les toits de Paris* (1930) entirely on sets built at the former Éclair studio in Epinay-sur-Seine. Meanwhile, architects such as Mallet-Stevens were expressing concern about the tendency in architecture to attempt to mimic cinema, rather than "offer[ing] itself up naturally to filmic action, always preserving the distance between the real and the imaginary." Quoted in Vidler, *Warped Space*, 23. See Marcel Carné, "When Will the Cinema Go Down into the Street," in Richard Abel, ed., *French Film Theory and Criticism: A History/Anthology, 1907–1939* (1988), 2:127–28; originally published as "Quand le cinéma descendra-t-il dans la rue?" *Cinémagazine* 13 (November 1933). On *Sous les toits de Paris*, see R. C Dale, *The Films of René Clair*, vol. 1 (1986), 143.

38. The 1920s have been the standard starting point for more wide-ranging analyses of cinema's relationship to architecture and urban space that have, up to this point, tended to focus only on the architecture of theaters, on-screen buildings and urban spaces, and set design. Key texts include Neumann, ed., *Film Architecture*; François Penz and Maureen Thomas, eds., *Cinema and Architecture: Méliès, Mallet-Stevens, Multimedia* (1997); Mark Lamster, ed., *Architecture and Film* (2000); and Giuliana Bruno, *Atlas of Emotion: Journeys in Art, Architecture, and Film* (2002).

Books about architecture and set design include Juan Antonio Ramírez, *Architecture for the Screen: A Critical Study of Set Design in Hollywood's Golden Age* (2004), trans. John F. Moffitt; and Léon Barsacq, *Caligari's Cabinet and Other Grand Illusions: A History of Film Design* (1976), ed. Elliott Stein, trans. Michael Bullock. And for work on cinema and urban space, see Mark Shiel and Tony

Fitzmaurice, eds., *Cinema and the City: Film and Urban Societies in a Global Context* (2001); Shiel and Fitzmaurice, eds., *Screening the City* (2003); Edward Dimendberg, *Film Noir and the Spaces of Modernity* (2004); Stephen Barber, *Projected Cities* (2002); and Al Sayyad Nezar, *Cinematic Urbanism: A History of the Modern from Reel to Real* (2006).

39. Friedrich Kittler, *Optical Media: Berlin Lectures, 1999* (2010), trans. Anthony Enns, 19; originally published as *Optische Medien / Berliner Vorlesung 1999* (2002).

40. As historian Annette Fiero explains, "For architecture, the birth of iron construction in this period was revolutionary in spatial, representational, and as well technological terms, particularly given the implications of radically changing methods and scales of production." See Annette Fierro, *The Glass State: The Technology of the Spectacle, Paris, 1981–1998* (2003), 49.

41. This study builds on work by film historians such as Kristen Whissel, Frances Guerin, and Lynne Kirby, who have analyzed film's relationship to early twentieth-century technologies such as the railroad, electrical lighting, and networks of technological movement, or what Whissel terms "traffic." See Whissel, *Picturing American Modernity: Traffic, Technology, and the Silent Cinema* (2008); Guerin, *A Culture of Light: Cinema and Technology in 1920s Germany* (2005); and Kirby, *Parallel Tracks: The Railroad and Silent Cinema* (1997).

 It also contributes to work that has highlighted film's technological manipulation of space and time and the ideas about human vision, bodily sensation, and human experience that made film part of scientific and philosophical discourses. See Jonathan Crary, *Techniques of the Observer: On Vision and Modernity in the Nineteenth Century* (1990); Lisa Cartwright, *Screening the Body: Tracing Medicine's Visual Culture* (1995); Leo Charney, *Empty Moments: Cinema, Modernity, and Drift* (1998); and Jonathan Crary, *Suspensions of Perception: Attention, Spectacle, and Modern Culture* (1999).

42. Reyner Banham, *The Architecture of the Well-Tempered Environment* (1969; 2d ed., 1984), 23.

43. Apollinaire, quoted in Georges Méliès, *La Vie et l'oeuvre d'un pionnier du cinéma* (2012), édition établie et présentée par by Jean-Pierre Sirois-Trahan, 16. All translations are mine unless otherwise noted.

44. Banham, *The Achitecture of the Well-Tempered Environment*, 23.

45. By instituting these practices in the early 1910s, filmmakers set the stage for what Jean-Louis Comolli has described as nature's "decorative" status in classical Hollywood. As Comolli argues, "the dominance of studio filming . . . even for the majority of 'exterior scenes,' codified the representation of nature in genre cinema. The role of landscape was reduced to that of 'décor'—the decorative background, the painted canvas. . . . To send a second crew to get some of the Grand Canyon's 'sights' was to confirm the 'truth' of the painted canvasses by duplicating the code, pictorializing natural landscapes in 'decor-fashion.'" Jean-Louis Comolli, "Technique and Ideology: Camera, Perspective, Depth of Field [Parts 3 and 4]," in Philip Rosen, ed., *Narrative, Apparatus, Ideology: A Film Theory Reader* (1986), 421–43, 438.

46. Key texts in this literature include Bertrand Gille, *Histoires des techniques* (1978); Thomas P. Hughes, *Networks of Power: Electrification in Western Society, 1880–1930* (1983) and Hughes, *American Genesis: A Century of Invention and Technological Enthusiasm, 1870–1970* (1989; rpt., 2004); Rosalind Williams, *Notes on the Underground: An Essay on Technology, Society, and the Imagination* (1990); and Thomas P. Hughes, *Human-Built World: How to Think About Technology and Culture* (2004).

47. Rosalind Williams, *Notes on the Underground*, 70.

48. In many histories of technology, cinema tends to be skipped over in favor of more recent media technologies, especially computers and the Internet. See, for instance, Thomas J. Misa, Philip Brey, and Andrew Feenberg, eds., *Modernity and Technology* (2003). Notable exceptions include W. Bernard Carlson, "Artifacts and Frames of Meaning: Thomas A. Edison, His Managers, and the Cultural Construction of Motion Pictures," in Wiebe E. Bijker and John Law, eds., *Shaping Technology/ Building Society: Studies in Sociotechnical Change* (1992), 175–98.

49. Walter Benjamin, "The Work of Art in the Age of Its Technological Reproducibility (Second Version)," trans. Edmund Jephcott and Harry Zohn, in Benjamin, *Selected Writings*, vol. 3: *(1935–1938)* (2002), ed. Howard Eiland and Michael W. Jennings, 101–133. I have used Miriam Hansen's translation from Hansen, "Benjamin, Cinema and Experience: 'The Blue Flower' in the Land of Technology," *New German Critique* 40, Special Issue on Weimar Film Theory (Winter 1987): 179–224, 203–204.

50. Hansen, "Benjamin, Cinema and Experience," 204.

51. To the emerging subfield of "ecocinema," this book offers a counterbalance to work focused on film's use as a tool for activists or on representations of ecological themes and concerns with climate change. Instead, I focus on film's historical materialist dimensions in an effort to offer starting points for thinking about cinema's early relationship to the natural environment.

52. Lewis Mumford, *Technics and Civilization* (1934), 337. Mumford saw, in the photographic apparatus, a kind of cipher for technology at large. "The history of the camera," he argues, "illustrates the typical dilemmas that have arisen in the development of the machine process. . . . Both the special feats of the machine and its possible perversions are equally manifest."

53. In the early twentieth century, he argues, "the flow of time ceased to be representable by the successive mechanical ticks of the clock: its equivalent . . . was the motion picture reel." Mumford, ibid., 243.

54. Ibid., 343.

55. See Francesco Casetti's discussion of these theories in *Eye of the Century: Film, Experience, Modernity*, trans. Erin Larkin with Jennifer Pranolo (2008). Casseti reads cinema "framing the world" through these ideas, particularly the work of Balázs. In this book, I use Martin Heidegger's notion of *enframing* as part of my effort to expand film's theoretical work to include theories of technology.

56. Mumford, *Technics and Civilization*, 344.

57. Ibid., 343.

58. Mumford's analysis later contributed to Kracauer's own efforts to articulate cinema's unique ability to wrest something from "physical reality." In the epilogue of *Theory of Film*, Kracauer falls back on Mumford's analysis of photography's—and, by extension, film's—"capacity for adequately depicting the 'complicated, inter-related aspects of our modern environment.'" For Kracauer, the "redemption of physical reality" was precisely about apprehending and preserving a world from which the "abstract thinking" of science and technology had separated humanity but which film technology could awaken from "its dormant state." See Kracauer, *Theory of Film: The Redemption of Physical Reality* (1960), 298–300.

59. Miriam Hansen, *Cinema and Experience: Siegfried Kracauer, Walter Benjamin, and Theodor W. Adorno* (2012), 139. Hansen further explains that Benjamin "invested the cinema with the hope that it could yet heal the wounds inflicted on human bodies and senses by technologies predicated on the mastery of nature; the hope that film, as a sensory-reflexive medium of second technology, offers a second—though perhaps last—chance for reversing sensory alienation" (195).

60. Indeed, as Hansen notes, Benjamin's hopes for technology did not ignore what he saw as bourgeois culture's tendency to fetishize "an ostensibly pure and primary nature as object of individual contemplation." Hansen, *Cinema and Experience*, 139. As environmental historians have demonstrated, human action transformed nature long before modernity, and the effects of technological change often associated with cities extended well beyond urban environments. See, for instance, William Cronon, *Nature's Metropolis: Chicago and the Great West* (1991)

61. For more on Benjamin and Kracauer's understanding of nature and its roots in Hegel and Marx, see Hansen's discussion of "first" and "second technology" in *Cinema and Experience*, esp. 139.

62. See Martin Heidegger, "The Question Concerning Technology," in *The Question Concerning Technology and Other Essays* (1977), trans. William Lovitt, 3–35; published in German as "Die Frage nach der Technik," *Vorträge und Aufsätze* (Pfullingen: Günther Neske Verlag, 1954), 13–44.

63. Heidegger, "The Question Concerning Technology," 16. Heidegger also describes the process by which the sun's energy is stockpiled and used, long after the fact, in the form of coal mined, stored, and burned into steam.

64. See Anne Friedberg, *The Virtual Window: From Alberti to Microsoft* (2006), 97.

65. Martin Heidegger, "The Age of the World Picture," in *The Question Concerning Technology and Other Essays*, 115–54, 134; published in German as "Die Zeit des Weltbildes," *Holzwege* (1950), 69–104. The published version comes from a lecture titled "Der Grundvorgang der Neuzeit ist die Eroberung der Welt als Bild" (June 19, 1938).

66. See Samuel Weber, "Upsetting the Setup: Remarks on Heidegger's 'Questing After Technics,'" in *Mass Mediauras: Form, Technics, Media* (1996), 55–75, 68. The necessary transformation of nature that occurs in this process can be clearly explained in terms of agriculture, where premodern processes of hoeing and tilling—processes that simply encourage the land to produce plants as it already would—give way to the technological and chemical processes by which modern agriculture goads the land into mass-producing crops. As Heidegger describes:

"Agriculture is now the mechanized food industry. Air is now set upon to yield nitrogen, the earth to yield ore, ore to yield uranium, for example; uranium is set upon to yield atomic energy." Heidegger, "The Question Concerning Technology," 15.

67. Weber, "Upsetting the Setup," 71.

68. Friedberg, *The Virtual Window*, 97. Friedberg uses Heidegger's metaphor of the "frame" as "a grounding metaphysic for the dominance of the frame and its visual system" in modern media. See ibid., 94–98.

1. BLACK BOXES AND OPEN-AIR STAGES

1. Dickson and Dickson, *History of the Kinetograph, Kinetoscope, and Kinetophonograph*, 19 (emphasis added).

2. Paul Spehr's biography of Dickson was a welcome addition to our understanding of the context from which the Black Maria emerged at the Edison lab. Spehr's meticulous research provided invaluable historical detail for the analyses that follow. See Spehr, *The Man Who Made Movies*.

3. As Georges Sadoul notes, another structure that may have prefigured or inspired the Black Maria was the late-nineteenth-century *héliogravure* glass-covered workshop, but Sadoul offers no evidence for this claim. See Sadoul, *Histoire générale du cinéma* 2:134.

4. Mumford outlines this theory most completely in *Technics and Civilization* (1934), but the early seeds of his ideas can be found in his work from the 1920s, including *The Story of Utopias* (1922) and *Sticks and Stones: A Study of American Architecture and Civilization* (1924).

5. Heidegger, "The Question Concerning Technology," 15.

6. Heidegger, "The Age of the World Picture," 115–54. My reading of Heidegger follows Samuel Weber's analysis in the essays collected in Weber, *Mass Mediauras*, esp. "Upsetting the Setup," 55–75, and "Mass Mediauras, or: Art, Aura and Media in the Work of Walter Benjamin," 76–108.

7. Spehr, *The Man Who Made Movies*, 265. See also Musser, *Before the Nickelodeon*, 32. Edison ultimately failed to debut the Kinetoscope in Chicago due to delays in producing the machines. Musser, ibid., 39. The historical details of the Black Maria's construction and film production that follow are taken largely from Spehr, Musser, and George J. Svedja, *The 'Black Maria' Site Study: Edison National Historic Site, West Orange, NJ* (1969).

8. Musser, *Before the Nickelodeon*, 32; Spehr, *The Man Who Made Movies*, 330. Ott's role in the construction is also suggested by an undated work log entry. See Thomas A. Edison Papers, Ott Laboratory Records N-87–11–24 (TAED NL002:35). Some historians have claimed that Dickson was absent during the construction, but Spehr shows that he left the lab (to recover from an apparent nervous breakdown) only after completion of the initial construction. See Musser, *Before the Nickelodeon*. 38; Neil Baldwin, *Edison, Inventing the Century* (1995), 232. See also Hendricks, *The Edison Motion Picture Myth*, 140–41; and Spehr, ibid., 269.

9. Musser, *Before the Nickelodeon*, 32.

10. Spehr, *The Man Who Made Movies*, 265.

11. Dickson and Dickson, *History*, 19.

12. Frank L. Dyer and Thomas Commerford Martin, *Edison: His Life and Inventions*, vol. 2 (1910), 543.

13. "Knocking Out Corbett," *New York Sun*, September 8, 1894, 1–2; quoted in Musser, *Before the Nickelodeon*, 48.

14. See Heidegger, "The Question Concerning Technology," 15.

15. "The movable principle of this building is identical with that of our river swinging bridges, the ends being suspended by iron rods from raised centre-posts." Dickson and Dickson, *History*, 19.

16. Leo Claretie, *La Revue encyclopédique* 154 (March 28, 1896): 50; quoted in Deslandes and Richard, *Histoire comparée du cinéma* 2:14. Deslandes and Richard add that: "The gawkers who line up on the boulevard des Capucines to descend into the Grand Café's Salon Indien, where the Lumière cinematographe flickers, might have the impression that they are going to attend a laboratory experiment."

17. As Lisa Cartwright and Oliver Gaycken have shown, the laboratory would become a key site for film production in early scientific and medical films, including films produced in laboratory-studios such as Jean Comandon's at Pathé and Éclair's special studio at Epinay-sur-Seine. See Cartwright, *Screening the Body*; and Oliver Gaycken, "Devices of Curiosity: Cinema and the Scientific Vernacular" (PhD diss., University of Chicago, 2005), esp. chapter 2 on French vernacular science films produced at Pathé, Gaumont, and Éclair from 1909 to 1914.

18. As Steven Shapin and Simon Schaffer explain, the term "laboratory" was new in the seventeenth century, when access to scientific research machines required special locations for experimenters and, at times, observers. These spaces became sites for controlled, rigorous experimentation that was distinguished from observation that could be tainted by the contingencies of nature. See Steven Shapin and Simon Schaffer, *Leviathan and the Air-Pump: Hobbes, Boyle, and the Experimental Life* (1985), 39 and 57. See also the essays collected in Frank A. J. L. James, ed., *The Development of the Laboratory: Essays on the Place of Experiment in Industrial Civilization* (1989) and, more recently, the essays in Peter Galison and Emily Thompson, eds., *The Architecture of Science* (1999).

19. Frank A. J. L. James, "Introduction," in James, ed., *The Development of the Laboratory*, 2.

20. On these architectural strategies for environmental control, see, for instance, Lawrence Aronovitch, "The Spirit of Investigation: Physics at Harvard University, 1870–1910," in James, ed., *The Development of the Laboratory*, 94; David Cahan, "The Geopolitics and Architectural Design of a Metrological Laboratory: The Physikalisch-Technische Reichsanstalt in Imperial Germany," in James, ibid., 138; and Mari E. W. Williams, "Astronomical Observatories as Practical Space: The Case of Pulkowa," in James, ibid., 131–33.

21. See John Rae, "The Application of Science to Industry," in Alexandra Oleson and John Voss, eds., *The Organization of Knowledge in America, 1860–1920* (1979),

251–53. As Paul Israel explains, the Menlo Park lab "was made possible by the growing interest of large-scale, technology-based companies such as Western Union in acquiring greater control over the inventive process by supporting the work of these inventors." See Paul Israel, *Edison: A Life of Invention* (1998), 119. On the development of industrial research laboratories beginning around 1900, see also Hughes, *American Genesis*, esp. pp. 150–80.

22. As Thomas Hughes notes, Edward Weston, for instance, "had a laboratory remarkably like that at Menlo Park," and Nikola Tesla (who worked for Edison when he first immigrated to America) established an equally important laboratory in Manhattan and later another in Colorado Springs. Other notable laboratories included those directed by Elmer Sperry (1888), William Stanley, Jr. (1883), and Elihu Thompson (1880). See Hughes, *American Genesis*, 34–39; and Hughes, *Networks of Power*, 100–101.

23. Israel, *Edison*, 119. See also Paul Israel, *From Machine Shop to Industrial Laboratory: Telegraphy and the Changing Context of American Invention* (1992); and Baldwin, *Edison*, 194.

24. Baldwin, *Edison*, 194–95.

25. Hughes, *American Genesis*, 24.

26. Hughes, *American Genesis*, 30. On the history of the West Orange laboratory, see W. Bernard Carlson, "Building Thomas Edison's Laboratory at West Orange, New Jersey: A Case Study in Using Craft Knowledge for Technological Invention, 1886–1888," *History of Technology* 13 (1991): 150–67.

27. See the descriptions quoted in Spehr, *The Man Who Made Movies*, 61. See also Israel, *Edison*, 261. This kind of dynamic spatial logic has continued to shape modern laboratories; see, for instance, Robert Venturi, "Thoughts on the Architecture of the Scientific Workplace: Community, Change, Continuity," in Galison and Thompson, eds., *The Architecture of Science*, 388. On the post-World War II context, see Peter Galison and Caroline A. Jones, "Factory, Laboratory, Studio: Dispersing Sites of Production," in Galison and Thompson, ibid., 499.

28. According to Paul Israel, Edison fired Holly due to the architect's negligent management of the building contractors. See Israel, *Edison*, 263. On the shift from one to five laboratory buildings, see Israel, ibid., 261.

29. Israel, ibid., 263; Dyer and Martin, *Edison*, 652–53. Dyer and Martin note that despite the care taken to make the building suitable for precision testing, the workshop would ultimately be thwarted by the construction of a street trolley in West Orange several years later. After this, Dyer and Martin claim, the building was "used for photography and some special experiments on motion pictures," although the nature of these experiments is unclear.

30. Israel, *Edison*, 271. The staff included twenty-five to thirty other experimenters and a labor force of machinists, pattern makers, draftsmen, carpenters, a fireman, a blacksmith, and a gatekeeper.

31. As Dyer and Martin describe, Edison's main workspace on the second floor, Room #12, "is at times a chemical, a physical, or a mechanical room—occasionally a

combination of all, while sometimes it might be called a consultation-room or clinic." Dyer and Martin, *Edison*, 649–50.

32. Israel, *Edison*, 274–75. Edison's process of invention emphasized modeling, for which he retained trusted machinists capable of giving form to early abstract ideas.

33. Dyer and Martin, *Edison*, 648.

34. As Peter Galison argues, in scientific laboratories "it is through appropriation, adjacency, display, and symbolic allusion that space, knowledge, and the construction of the architectural and scientific subject are deeply intertwined." See Galison, "Buildings and the Subject of Science," in Galison and Thompson, eds., *The Architecture of Science*, 3. Dyer and Martin devote seven pages to the lab's library, stock room (a "museum" and "sample-room of nature"), and the third-floor display cases (a "scientific attic"). See Dyer and Martin, *Edison*, 640–48.

35. As Spehr notes, John Ott helped Edison supervise the first designs for a moving-image apparatus due to his skill in producing mechanical models of all types and his expertise with the cylinder phonograph. Edison later added William Heise to the project for his expertise in threading the paper telegraph. Spehr, *The Man Who Made Movies*, 94, 99; Israel, *Edison*, 293. Such ideas also came, no doubt, from the work of other inventors such as Ottomar Anschütz (the German who developed the "Tachyscope" that is known to have influenced Dickson's motion picture apparatus designs), whose ideas were equally the product of smaller-scale but similar laboratory environments.

36. Spehr, *The Man Who Made Movies*, 131.

37. Ibid., 156–57.

38. Dickson may have become Edison's photographer as early as 1884, and at West Orange he became the laboratory's official photographer. Ibid., 64–72. See also Hendricks, *The Edison Motion Picture Myth*, 13–14.

39. Spehr, *The Man Who Made Movies*, 72.

40. Some historians claim that only vibration problems caused Dickson to relocate the experiments (Baldwin, *Edison*, 212); others argue that Dickson's need for light was the key motivation (Hendricks, *The Edison Motion Picture Myth*, 75; Spehr, *The Man Who Made Movies*, 162).

41. Spehr, *The Man Who Made Movies*, 163.

42. Scholars have often noted the links between Muybridge and Marey's contributions to moving-image technology, but few note the similarities between their production spaces or these spaces' influence on studio and film forms.

43. Hendricks, *The Edison Motion Picture Myth*, 78–79. Designs similar to the "glass room" described in Lea's *Manual* became common in the second half of the nineteenth century and helped influence another important strand of the film studio's genealogy—glass-and-iron architecture and the "glass house." That history will be discussed in chapter 2.

44. Matthew Carey Lea, *A Manual of Photography* (1868), 107.

45. According to Spehr, the studio portion "was a single story greenhouse-like structure with sliding glass windows on the front and back walls and a roof mostly of

glass." Spehr, *The Man Who Made Movies*, 160. See also Hendricks, *The Edison Motion Picture Myth*, 78–79.

46. Spehr, *The Man Who Made Movies*, 160.

47. Ibid., 163.

48. Hendricks, *The Edison Motion Picture Myth*, 27. According to Hendricks, after Muybridge's lecture in Orange, New Jersey, on February 25, 1888, Edison asked Muybridge to make a selection of his plates to be sent to the West Orange laboratory. Muybridge's photo agency, the Photo Gravure Company, delivered the plates on November 15, 1888, and Edison immediately put them on display in the library.

49. See images of Muybridge's "outdoor camera house" in the Eadweard Muybridge Collection at the University of Pennsylvania; available online at http://hdl.library.upenn.edu/1017/d/archives/20020829001 (accessed August 1, 2014).

50. As Marta Braun explains, "Marey had begun his photographic experiments with the fixed-plate camera at one edge of this field in early summer of 1882. He had erected his black background at the rim of the outer oval and placed his camera about forty meters in front of it, so that the angle from which the figures were photographed would not change appreciably and so that the complete movements would be captured as they extended against the entire width of the background." Braun, *Picturing Time: The Work of Étienne-Jules Marey (1830–1904)* (1992), 74–76.

51. Méliès, for instance, cites the weather as his primary motivation for building his first studio, and others, including Alice Guy and Robert W. Paul, similarly identified spatial control as a primary advantage of the studio. See chapter 2.

52. Spehr claims that both of these backgrounds were recessed according to Marey's instructions in an 1887 article in the *Scientific American Supplement*. The photograph of the studio's interior, however, shows a flat background, and a diagram Dickson produced for Will Day in 1933 similarly identifies a "black background" with no mention of a recessed area. In fact, Dickson seems to have adopted Marey's instructions for the recessed black "tunnel" only for the Black Maria. See Étienne-Jules Marey, "Photography of Moving Objects, and the Study of Animal Movement by Chrono-Photography," *Scientific American Supplement* 579 (February 5, 1887): 9245; cited in Spehr, *The Man Who Made Movies*, 164.

53. Hendricks, *The Edison Motion Picture Myth*, 79; Spehr, *The Man Who Made Movies*, 174–77.

54. Spehr, *The Man Who Made Movies*, 201–203.

55. Spehr quotes a letter from Dickson in 1933 in which Dickson notes that they needed the sun to come *straight* in to the building to avoid side shadows. Ibid., 265.

56. Henry Peach Robinson's recently published *The Studio and What to Do in It* (1891) may have provided another source.

57. Lea, *A Manual of Photography*, 110.

58. Spehr, *The Man Who Made Movies*, 265.

59. Dickson and Dickson, *History*, 20.

60. Dickson also links the Black Maria to a much earlier architectural effort to capture sunlight, writing: "we are vaguely reminded [while standing in the Black Maria as it rotates] of that indissoluble chain of ideas which links the past with the present, and into the commonplace of existing facts come memories of that chamber in the golden house of Nero so arranged that 'by means of skillfully planned machinery it moved on its axis, thus following the motions of the heavens, so that the sun did not appear to change in position, but only to descend and ascend perpendicularly.'" Dickson and Dickson, *History*, 22. The Dicksons offer neither the source for this quote nor the name of the structure, which may be the Domus Aurea (Golden House), built in Rome in the last years of Nero's life (AD 64–68). The Domus Aurea included an octagonal room with an open dome that may have been surmounted by a rotunda that "rotated day and night like the heavens." See David Watkin, *A History of Western Architecture* (1986; 4th ed., 2005), 73.

61. Braun, *Picturing Time*, 75–79.

62. Marey, "Photography of Moving Objects, and the Study of Animal Movement by Chrono-Photography."

63. Braun, *Picturing Time*, 104.

64. Ibid., 146. Braun notes that images such as several plates of Demenÿ playing the violin represent failed attempts to move the glass plate during recording, a process that Marey hoped would allow him to create more clear, nonoverlapping images on a single plate.

65. See Gunning, "The Cinema of Attractions: Early Film, Its Spectators and the Avant-Garde," in Elsaesser, ed., *Early Cinema*, 56–62; originally published in *Wide Angle* 8.3/4 (Fall 1986): 63–70.

66. Neil Harris, *Humbug: The Art of P. T. Barnum* (1973; rpt., 1981).

67. Most historians have emphasized the transition from experimentation to production (Musser, for instance, notes that it "was made easier by continuity in personnel," e.g., Dickson and Heise), but the two practices no doubt continued in tandem. See Musser, *The Emergence of Cinema*, 75.

68. One might venture that the film bids homage to Marey and Demenÿ's earlier influence. Dickson's appearance with the violin recalls an experimental plate made by Marey featuring Demenÿ, clad all in white, playing the violin against the black tunnel at the Station Physiologique. See "Demenÿ playing the violin" (1887), Bibliothèque du film.

69. Musser, *The Emergence of Cinema*, 88. On the phonograph studio, see André J. Millard, *America on Record: A History of Recorded Sound* (1995), 258, and David L. Morton, *Sound Recording: The Life and Story of a Technology* (2004), 24. In the early 1910s, in fact, the phonograph studio area on the third floor of the main laboratory building would be used as a studio for producing Edison's educational film series. See André J. Millard, Duncan Hay, and Mary Grassick, *Edison Laboratory: Edison National Historic Site, West Orange, New Jersey* (1995).

70. I will refer to American Mutoscope and Biograph as simply "Biograph," as it was renamed in 1910.

71. Spehr, *The Man Who Made Movies*, 410–12.

72. See, for instance, the American Mutoscope and Biograph version of *Sandow* at http://memory.loc.gov/mbrs/varsmp/0077.mov (accessed August 10, 2014).

73. Spehr, *The Man Who Made Movies*, 487, 514, 523.

74. Svetlana Alpers, "The Studio, the Laboratory, and the Vexations of Art," in Caroline Jones and Peter Galison, eds., *Picturing Science, Producing Art* (1998), 416.

75. Ibid., 412. Alpers goes so far as to argue that artists such as Cézanne used their studios to rethink their ways of painting landscapes in ways that "alter[ed] the nature of painting."

76. As Alpers argues elsewhere, "the [artist's] studio serves as a place to conduct experiments with light not possible in the diffused universal light or the direct solar light of the world outside." See Svetlana Alpers, *The Vexations of Art: Velázquez and Others* (2005), 19.

77. These films contributed to and profited from the broader practices of "industrial tourism" that included popular factory tours. See Allison C. Marsh, "The Ultimate Vacation: Watching Other People Work, A History of Factory Tours in America, 1880–1950" (PhD diss., Johns Hopkins University, 2008).

78. I return to these films in chapter 2, where I analyze Méliès's representations of travel technologies. See also the essays in Jeffrey Ruoff, ed., *Virtual Voyages: Cinema and Travel* (2006).

79. Anne Friedberg, "Troittoir Roulant: The Cinema and New Mobilities of Spectatorship," in John Fullerton and Jan Olsson, eds., *Allegories of Communication: Intermedial Concerns from Cinema to the Digital* (2004), 263–76, 269 and 273. For Friedberg's full treatment of this paradoxical experience of modern space, see *Window Shopping*.

80. Whissel, *Picturing American Modernity*, 128.

81. Walter Hines Page, *The World's Work*, quoted in Thomas E. Leary and Elizabeth C. Sholes with the Buffalo and Erie County Historical Society, *Buffalo's Pan-American Exposition* (1998), 51.

82. Whissel, *Picturing American Modernity*, 120.

83. Weber, "Mass Mediauras," 86.

84. Mumford, *Technics and Civilization*, 6 and 343.

2. GEORGES MÉLIÈS'S "GLASS HOUSE"

1. Méliès, "J'ai construit le premier studio du monde: il y a 40 ans."

2. Dickson's Black Maria, his Biograph rooftop studio in Manhattan, and Oskar Messter's rooftop studio on Friedrichstrasse in Berlin all predated the first Méliès studio. On Messter, see Kreimeier, *The Ufa Story*, 13; and Koerber, "Oskar Messter, Film Pioneer," 51–61, 54–55.

3. Elie Faure, "The Art of Cineplastics" (trans. Walter Patch), in Abel, ed., *French Film Theory and Criticism* 1:260; originally published as "De la cinéplastique," *L'Arbre d'Eden* (Paris: G. Crès, 1922), 277–304.

4. See Hughes, *Human-Built World*, and Rosalind Williams, *Notes on the Underground*. Hughes and Williams argue that the industrial revolution that began in Great Britain in the eighteenth century and the second industrial revolution that transformed everyday life in Western cities in the latter half of the nineteenth century are only two aspects of a larger technological revolution: "the creation of a new habitat for human existence." Rosalind Williams, *Retooling: A Historian Confronts Technological Change* (2002), 22.

5. Georg Kohlmaier and Barna von Sartory, *Houses of Glass: A Nineteenth-Century Building Type* (1986), trans. John C. Harvey, 57; originally published as *Das Glashaus. Ein Bautypus des 19. Jahrhunderts* (Munich: Prestel-Verlag, 1981). On Watt, see Kenneth Frampton, *Modern Architecture: A Critical History* (4th ed., 2007), 29.

6. Kohlmaier and Sartory, *Houses of Glass*, 58 and 60; Frampton, *Modern Architecture*, 33; Sigfried Giedion, *Space, Time, and Architecture: The Growth of a New Tradition* (1941), 251.

7. As Annette Fierro notes, the Galeries "continuously challenged previously known structural concepts and scales of enclosed spaces." See Fierro, *The Glass State*, 9.

8. Giedion, *Space, Time, and Architecture*, 251.

9. Boileau, quoted in ibid., 267 (emphasis added).

10. On the Gare de l'Est, see Carroll Meeks, *The Railroad Station: An Architectural History* (1956), 61–62. For the Bibliothèque National, see Giedion, *Space, Time, and Architecture*, 222–25. And for Les Halles and the Bon Marché, see Giedion, ibid., 230–41. See also Michel Chevalier, "Exposition Universelle: Le fer et la fonte employés dans les constructions monumentales," in *Journal des débats* (June 1, 1855).

11. Wolfgang Schivelbusch, *The Railway Journey: The Industrialization of Time and Space in the 19th Century* (1986), 48.

12. Adolf Gotthold Meyer, *Construire en fer: Histoire et esthétique* (2005), trans. Marielle Roffi and Léo Biétry; originally published as *Eisenbauten: ihre Geschichte un Aesthetik* (1907). My translation is from the French. As Giedion similarly argues, "the seeds of this new architecture were planted at the moment when handwork gave place to industrialized production." Giedion, *Space, Time, and Architecture*, 182. See also Sigfried Giedion, *Building in France, Building in Iron, Building in Ferroconcrete* (1995), trans. J. Duncan Berry; originally published as *Bauen in Frankreich, bauen in Eisen, bauen in Eisenbeton* (1928).

13. See Walter Benjamin, *The Arcades Project* (2002), [Convolute F3a,5]. Benjamin begins the convolute by asking "whether, at an earlier period, technical necessities in architecture (but also in the other arts) determined the forms, the style, as thoroughly as they do today." He uses Meyer to support his idea that this was not the case in earlier periods but has become so since at least the introduction of iron. See also Benjamin, "The Work of Art in the Age of Its Technological Reproducibility (Second Version)," 101–33.

14. Charney and Schwartz, eds., *Cinema and the Invention of Modern Life*, 3; Tom Gunning, "From the Kaleidoscope to the X-Ray: Urban Spectatorship, Poe,

Benjamin, and *Traffic in Souls* (1913)," *Wide Angle* 19.4 (1997): 25–61; Bruno, *Streetwalking on a Ruined Map*; and Friedberg, *Window Shopping*. On the Paris Morgue, see Vanessa R. Schwartz, *Spectacular Realities: Early Mass Culture in Fin-De-Siècle Paris* (1998). On technologies of movement, see Friedberg, "Trottoir Roulant," 263–76.

15. See Jacques Malthête, *Méliès: images et illusions* (1996), 49.

16. Méliès, "J'ai construit le premier studio du monde: il y a 40 ans."

17. Notwithstanding recent corrections by Jacques Malthête, French historians have recounted the history of the studio's design, construction, and modification in more or less the same terms since Maurice Noverre's extensive description published in 1929. Noverre's remains the most comprehensive account. Except where otherwise noted, the following description is drawn from Noverre, "L'oeuvre de Georges Méliès: Étude retrospective sur le premier 'studio cinématographique' machine pour la prise de vues théâtrales," *Le Nouvel Art cinématographique* 2.3 (Brest, July 1929): 64–83.

 See Jacques Malthête, "Les Deux Studios de Georges Méliès," in Jacques Malthête and Laurent Mannoni, eds., *Méliès: magie et cinéma: Espace EDF electra, 26 avril-1er septembre 2002* (2002), 134–69; and Malthête, "L'appentis sorcier de Montreuil-sous-Bois," in André Gaudreault and Laurent Le Forestier, eds., *Méliès, carrefour des attractions: Suivi de Correspondances de Georges Méliès (1905–1937)* (2014), 145–56. See also Sadoul, *Histoire générale du cinéma*, vol. 2. The full text of Noverre's article is reproduced in Sadoul, *Georges Méliès* (1961), 150–56. Jean Mitry also uses Noverre's description in *Histoire du cinéma: art et industrie*, vol. 1: *1895–1914* (1968). The best English description is in Paul Hammond, *Marvelous Méliès* (1974), 31–33.

18. Using Méliès's production notes and the dates of the films, Malthête places the beginning of production in the spring of 1897. See Malthête, "Les Deux Studios de Georges Méliès," 138. For the studio's dimensions and diagrams, see Malthête, *Melies: images et illusions*, 57.

19. For instance, see Jacques Deslandes, *Le Boulevard du cinéma à l'époque de Georges Méliès* (1963); Malthête, *Melies: images et illusions*; and John Frazer, *Artificially Arranged Scenes: The Films of Georges Méliès* (1979).

20. Georges Méliès, "Cinematographic Views," trans. Stuart Liebman, *October* 29 (Summer 1984): 24–34, 25–26. Méliès later disclosed that: "Immediately I put on paper a design of a staging 'workshop' (because after all, that is what one called the glass photography workshops, which were situated generally on the sixth floor of buildings, or on the roof)." See Méliès, "J'ai construit le premier studio du monde: il y a 40 ans."

21. Elizabeth Anne McCauley, *Industrial Madness: Commercial Photography in Paris, 1848–1871* (1994), 50.

22. The numerous rooftop studios built in cities such as New York, Philadelphia, and Berlin during cinema's first decade are no doubt a continuation of this tradition.

23. On the relationship between photography and early cinema, see Tom Gunning, "Embarrassing Evidence: The Detective Camera and the Documentary Impulse,"

in Jaine M. Gaines and Michael Renov, eds., *Collecting Visible Evidence* (1999), 46–64; and Gunning, "Tracing the Individual Body: Photography, Detectives, and Early Cinema," in Charney and Schwartz, eds., *Cinema and the Invention of Modern Life*, 15–45. On the use of lighting techniques from photographic portraiture in early Hollywood, see Patrick Keating, "From the Portrait to the Close-Up: Gender and Technology in Still Photography and Hollywood Cinematography" *Cinema Journal* 45.3 (2006): 90–108.

24. On Méliès and the Robert-Houdin, see Matthew Solomon, *Disappearing Tricks: Silent Film, Houdini, and the New Magic of the Twentieth Century* (2010), ch. 3.

25. The *carte de visite* was a kind of photographic business card, typically two-and-a-half by four inches in size, that became popular in Europe and the United States in the 1860s.

26. Elizabeth Anne McCauley, *A. A. E. Disdéri and the Carte De Visite Portrait Photograph* (1985), 23. See also McCauley, *Industrial Madness*, 73. Christian Fechner notes that "the presence of a photographic laboratory over the theater always posed the threat of flood or fire to the small room, which, in 1881, at the time of Émile Robert-Houdin's ownership, and in 1901, during Méliès's, almost did not escape." See Christian Fechner, "Le Théâtre Robert-Houdin, de Jean Eugène Robert-Houdin à Georges Méliès," in Malthête and Mannoni, eds., *Méliès: magie et cinéma*, 87. See also Disdéri's portrait of Robert-Houdin in Fechner, ibid., 75.

27. On "modern life," see the essays in Charney and Schwartz, eds., *Cinema and the Invention of Modern Life*. On boulevard culture in Paris, see Deslandes, *Le Boulevard du cinéma à l'époque de Georges Méliès*; and Schwartz, *Spectacular Realities*. On the telephone demonstration, see Fechner, "Le Théâtre Robert-Houdin," 74.

28. McCauley, *A. A. E. Disdéri*, 51.

29. On the phantasmagoria, see Tom Gunning "Phantasmagoria and the Manufacturing of Illusions and Wonder: Towards a Cultural Optics of the Cinematic Apparatus" in André Gaudreault, Catherine Russell and Pierre Veronneau, eds., *The Cinema, A New Technology for the 20th Century* (2004), 31–44.

30. McCauley describes the studio entry as follows: "The main salon de réception . . . included a view of Aurora on the ceiling, allegories of chemistry, physics, painting, and sculpture in the corners, and medallions of Jacopo della Porta (the supposed inventor of the camera obscura), Niepce, Daguerre, and Talbot." McCauley, *A. A. E. Disdéri*, 51.

31. As McCauley notes, "photography itself retained an aura of magic" that made Disdéri's association with the magical theater and its owner below "more than fortuitous." Ibid., 23.

32. The film is sometimes referred to as *Une Chute du cinquième étage*.

33. McCauley's description of early portrait photography is apt here: "For many visitors to the new studios . . . the experience recalled the anxiety of visiting a dentist, a man of dubious professional skills who forced his clients to undergo incomprehensible, painful procedures." McCauly, *Industrial Madness*, 17.

34. This is difficult to see in a still reproduction—the film uses a painted backdrop that extends across the entirety of the back of the frame. The left wall of the depicted photography studio also looks fake (as if it is part of this painted set), but it is actually a flimsy wooden frame that extends out from the back wall. The painted backdrop behind this wooden frame enhances the illusion of depth.

35. As John Frazer points out, the names appearing on the painted backdrop refer to Méliès collaborators: Claudel was Méliès's set decorator and "Micho" most likely refers to his cameraman, Michaut. See Frazer, *Artificially Arranged Scenes*, 166. See also Madeleine Malthête-Méliès, Anne-Marie Quevrain, and Jacques Malthête, *Essai de reconstitution du catalogue français de la Star-Film* (1980).

36. Emile Tourtin took over the studio above the Robert-Houdin, and Délié (the self-proclaimed "successor of Disdéri") moved into the studio next door. McCauley, A. A. E. *Disdéri*, 215–17.

37. According to some historians, Claude-Antoine Lumière rented the studio for Maurice (Georges Sadoul refers to Maurice as Lumière's "right-hand man"). Sadoul, *Lumière et Méliès* (1985), 35. Madeleine Malthête-Méliès claims that Méliès suggested the photography studio to Maurice and Lumière and that Méliès even saw the Lumières' first film devices there before the Grand Café screening. See Madeleine Matlhête-Méliès, *Méliès l'enchanteur* (1973), 147–48. See also Deslandes, *Le Boulevard du cinéma à l'époque de Georges Méliès*, 15, 20, Bernard Chardère, Guy Borgé, and Marjorie Borgé, eds., *Les Lumière* (1985), 96, as well as the letters from the Lumières to Maurice in Jacques Rittaud-Hutinet, ed., *Auguste et Louis Lumière: Correspondances, 1890–1953* (1994).

38. According to Méliès: "M. Lumière came frequently because of his interests in [Maurice's] business, to which he supplied photographic plates. I knew [Maurice] from often encountering him when leaving my office. One night, around five o'clock, I saw [Lumière] arrive, beaming, and he asked me 'Are you free this evening?' " Cited in Chardère, Borgé, and Borgé, eds., *Les Lumière*, 96. See also Malthête-Méliès, *Méliès l'enchanteur*, 157.

39. See the essays in the *Historical Journal of Film, Radio and Television* 22.3 (2002), a Special Issue dedicated to early nonfiction cinema. On the tension between realism and fiction in Muybridge, Marey, and the Lumière actualities, see Anthony R. Guneratne, "The Birth of a New Realism: Photography, Painting and the Advent of Documentary Cinema," *Film History* 10.2 (1998): 165–87. For a broader set of considerations of such issues as reality and fiction, documentary and spectacle, and shifting conceptions of vision in photography and moving images, see the essays in Patrice Petro, ed., *Fugitive Images: From Photography to Video* (1995).

40. Alice Guy-Blaché noted that one of the primary reasons that Gaumont built its first studio was to avoid the chaos of shooting on public streets caused by curious onlookers and the police. Alice Guy, "À Propos des débuts de l'industrie cinématographique 1930," Bibliothèque du film, LG 374 B 51.

41. As I describe in chapter 4, Zecca may have been working in a glass studio much earlier but is otherwise an exception to this trend. Similarly, Alice Guy produced trick

films before Gaumont built its studio in 1905. In each case, however, their initial tricks were likely borrowed from Méliès, and their later innovations took form in their respective studios.

42. Salt writes, "he was working in the one place, his studio stage, whereas everyone else making multi-scene films was working in a number of different real locations in the one film, and these locations tended to put some pressures on the way the action in each shot should be staged." Barry Salt, "Film Form: 1890–1906," in Elsaesser, ed., *Early Cinema*, 35.

43. Mary Ann Doane has described this as an aesthetic of "implausibility." See Doane, *The Emergence of Cinematic Time*, 134.

44. Méliès learned this trick, according to his version of the effect's often-cited, apocryphal origin story, when the camera's crank jammed during a location shoot, literally halting the film's movement for several moments. See Méliès, "Cinematographic Views."

45. Tom Gunning, "Non-Continuity, Continuity, Discontinuity: A Theory of Genres in Early Films," in Elsaesser, ed., *Early Cinema*, 90.

46. On Méliès's use of editing for these tricks, see Jacques Malthête, "Méliès, technicien du collage," in Madeleine Malthête-Méliès, ed., *Méliès et la naissance du spectacle cinématographique* (1984), 169–84.

47. A notable variation on this scenario is *Les Affiches en goguette (The Hilarious Posters, 1906)*, in which a wall of advertisements posted on a public street come to life, much to the dismay of passersby, including the police, who are showered with flour and vegetables.

48. Faure, "The Art of Cineplastics," 261.

49. British filmmaker R. W. Paul used a similar effect in 1899 in the film *Upside Down, or The Human Flies*, in which Paul creates the illusion of a family playing games on the ceiling after a "professor of spiritualism" levitates them. A Pathé film from 1902, *La Soubrette ingénieuse*, uses the technique to depict a housekeeper who climbs the walls to clean picture frames. On the latter film, see Richard Abel, *The Ciné Goes to Town: French Cinema 1896–1914* (1994), 79.

50. Black backgrounds are also common in other early trick films such as those by R. W. Paul, Segundo de Chomón, Alice Guy, Edwin S. Porter, J. Stuart Blackton, and Ferdinand Zecca, to name only a few. Méliès likely based his use of the black background not only on motion studies and Edison's Kinetoscope films but also on tricks learned from spirit photography and magical stage shows that mimicked spirit photography's effects. See Tom Gunning, "Phantom Images and Modern Manifestations: Spirit Photography, Magic Theater, Trick Films, and Photography's Uncanny," in Petro, ed., *Fugitive Images*, 42–71.

51. Michel Foucault, "Of Other Spaces," translated by Jay Miskowiec, *Diacrtics* 16.1 (Spring 1986): 25; originally published as "Des Espaces Autres" in *Architecture-Mouvement-Continuité* (October 1984). Foucault formulated the idea of the heterotopia in an effort to conceptualize the new spatial epoch that, like many of his contemporaries, he situated in the early twentieth century. In an era, he argues,

in which rapid transport and modern media created new degrees of proximity and interrelation of diverse spaces, the space that can bring all other spaces under its purview becomes a crucial site for investigating the spatial system as a whole. Alongside museums, libraries, fairgrounds, and gardens, Foucault cites the film theater as one such critical modern space. But as a sight of dynamic spatial experimentation and critical evaluation of modern space, the studio should be understood as perhaps the prototypical heterotopia.

For another account of changes to modern space, see Henri Lefebvre, *The Production of Space*, translated by Donald Nicholson-Smith (1991); originally published as *La production de l'espace* (1974). Lefebvre argues that modern space's break with the past occurs around 1910 and includes, among other things, a departure from "classical perspective and geometry, developed from the Renaissance onwards on the basis of the Greek tradition (Euclid, logic) and bodied forth in Western art and philosophy, as in the form of the city and town" (25). On the "spatial turn," see Philip J. Ethington, "Placing the Past: 'Groundwork' for a Spatial Theory of History," *Rethinking History* 11.4 (2007): 465–93.

52. See, for instance, *Cendrillon* (*Cinderella*, 1899), *Jeanne d'Arc* (1900), *Rêve de Noël* (*The Christmas Dream*, 1900), *Barbe-bleue* (*Blue Beard*, 1901), *Le Voyage dans la lune* (*A Trip to the Moon*, 1902), and *Le Voyage de Gulliver à Lilliput et chez les géants* (*Gulliver's Travels*, 1902).

53. Abel, *The Ciné Goes to Town*, 70–71.

54. Malthête, "Les Deux Studios de Georges Méliès," 143–45.

55. Méliès, "Cinematographic Views," 26.

56. See Salt, "Film Form: 1890–1906," 31–44; and Gunning, "Non-Continuity, Continuity, Discontinuity," 86–94. On the development of story films, see Musser, *The Emergence of Cinema*, ch. 11.

57. It should be noted that at times the transition between shots *does* involve the passage of time, but because the dissolve is used irrespective of temporality between shots, it cannot be said to signify that change. The dissolve between shots would also have discouraged exhibitors from cutting multi-shot films into pieces rather than showing them in their entirety. On exhibitors' roles as "editors" in early cinema, see Musser, *The Emergence of Cinema*, 258–61.

58. Barry Salt, "Dissolved Away," *The Velvet Light Trap* 64 (Fall 2009): 79.

59. See Méliès, "Cinematographic Views."

60. On the Méliès factory and Méliès's role in and eventual rejection of the family business, see Malthete-Méliès, *Méliès l'enchanteur*.

61. In *Le Bulletin hebdomadaire Pathé*, 1912. Cited in Laurent Le Forestier, "L'Enregistrement Fantastique, ou Quelques Réflexions sur la Nature et l'Utilisation des Trucages Méliésiens," in Malthête and Mannoni, eds., *Méliès: magie et cinéma*, 211–39, 212.

62. Additionally, as many have argued, even these films are more composites of various nineteenth-century cultural forms (including Verne's stories as well as other literature, contemporary theater, and scientific lectures) than "adaptations." For

instance, see Thierry Lefebvre, "Le Voyage dans la Lune, Film Composite," in Malthête and Mannoni, eds, *Méliès: magie et cinéma*, 171–209.

For details on Verne's *voyages extraordinaires*, see Herbert R. Lottman, *Jules Verne: An Exploratory Biography* (1996). See also Rosalind Williams, *The Triumph of Human Empire: Verne, Morris, and Stevenson at the End of the World* (2013), and the biographies by William Butcher, *Jules Verne: The Definitive Biography* (2006), and (in French) Joëlle Dusseau, *Jules Verne* (2005).

63. See Arthur B. Evans, "Jules Verne and the French Literary Canon," in Edmund J. Smyth, ed., *Jules Verne: Narratives of Modernity* (2000), 15. See also Michel Serres, *Jouvences sur Jules Verne* (1974); Arthur B. Evans, *Jules Verne Rediscovered: Didacticism and the Scientific Novel* (1988); Timothy Unwin, *Jules Verne: Journeys in Writing* (2005); and Smyth, ed., *Jules Verne*.

64. Just as Méliès is often remembered as the "father" of science fiction film, popular audiences, critics, and scholars have tended to define Verne's *Voyages* as "science fiction" (a retroactively assigned term that did not appear commonly until the 1930s in the United States and the 1950s in France) in large part due to the perception that Verne imagined nonexistent technologies and predicted future events (such as space flight to the moon). See Unwin, *Journeys in Writing*, 3. See also Evans, "Jules Verne in the French Literary Canon."

65. As Michael Serres describes, "our ignorance has made Verne's work a dream of science. It is a science of dreams. The fiction of the Voyages is what one calls science fiction. That is, quite simply, false. Never is a mechanical rule exceeded, nor is a natural or physical law, the physical properties of materials, or biology generalized." Serres, *Jouvences sur Jules Verne*, 82. See also Unwin, "The Fiction of Science, or the Science of Fiction," 48, and David Meakin, "Future Past: Myth, Inversion and Regression in Verne's Underground Utopia," 94–108, both in Smyth, ed., *Jules Verne*.

66. Flying balloons date to the eighteenth century and were common sights in the nineteenth century (notably including Nadar's *Le Géant*, built in 1863). The automobile was also a well-known invention by the end of the nineteenth century (in France, Gustave Trouvé's electrically powered automobile was exhibited in Paris in 1881, and in 1896 Armand Peugeot built a factory to produce automobiles with internal combustion engines). Mechanically powered submarines date to the 1860s (and inspired Verne's *Vingt mille lieus sous les mers*), as do early flying machines. In France, Jean-Marie Le Bris made well-documented flights in his "Albatros artificiel" glider in 1856 and 1868 (when Nadar photographed it).

67. As Edmund Smyth argues about Verne: "his texts both incorporate and perforate the modern, by encompassing the spirit of the scientific age *and articulating some of its limitations and agonies*." Smyth, "Verne, SF, and Modernity: An Introduction," in Smyth, ed., *Jules Verne*, 2 (emphasis added). See also Marie-Hélène Huet, *The Culture of Disaster* (2012), esp. ch. 8 on Verne's "polar novels."

68. As Lynne Kirby has described, the drama and spectacle of railroad accidents were immensely popular on the early screen. See Kirby, *Parallel Tracks*.

69. See esp. ch. 3, "Sensationalism and Urban Modernity," in Ben Singer, *Melodrama and Modernity: Early Sensational Cinema and Its Contexts* (2001).

70. Méliès's critical view of modern technology contributed to a broader tradition of *fin-de-siècle* fiction that allegorized technological change. As historians of technology have argued, late-nineteenth-century writers on both sides of the Atlantic made contemporary technologies the subtext of a range of stories about the experience of modern life in an increasingly artificial, human-built world. By the early twentieth century, technological alterations to the environment were prompting anxieties specifically focused on the future of built space. See Rosalind Williams, *Notes on the Underground*, 4. See also David Pike, *Subterranean Cities: The World Beneath Paris and London, 1800–1945* (2005).

71. Malthête, *Méliès: images et illusions*, 63.

72. Malthête, "Les Deux Studios de Georges Méliès," 151–53. Chapter 3 will discuss the use of Cooper Hewitt lamps in studios beginning in 1902 with the American Mutoscope and Biograph studio in Manhattan, the first studio to be entirely lit by artificial light.

73. Malthête, *Méliès: images et illusions*, 63.

74. Méliès's decline—fictionalized most recently in Martin Scorsese's *Hugo* (2011)—was prompted by a series of factors including reduced audience interest in the *féeries*, Méliès's failure to shift to longer, more popular story films, the theft of three hundred negatives from Méliès's New York factory in 1907, and Gaston's embezzlement of Star Films profits in the United States. See Abel, *The Ciné Goes to Town*, 36–37. The five Pathé films also include *Les Hallucinations du Baron de Münchausen* (1911), a remake of Méliès's 1899 hit *Cendrillon* (1911), a medieval adventure titled *Le Chevalier des neiges* (1912), and a final travel film, *Le Voyage de la famille Bourrichon* (1913).

75. Other polar films were made in the early 1910s by European, American, and Japanese filmmakers at both the Arctic and Antarctic poles. See Stephen Bottomore, "Polar Expedition Films," in Richard Abel, ed., *Encyclopedia of Early Cinema* (2005), 523–24.

76. Production of the film came less than two years after Henri Farman's famed first cross-country flight from Châlons to Reims and amidst widespread experimentation that included aeronautical salons in Paris, research labs such as Gustave Eiffel's Laboratoire du Champ de Mars at the base of the Eiffel Tower (moved to Auteuil the year of Méliès's film), and flying schools. See Richard Hallion, *Taking Flight: Inventing the Aerial Age from Antiquity Through the First World War* (2003), 265. See also Tom D. Crouch, *Wings: A History of Aviation from Kites to the Space Age* (2004).

3. DARK STUDIOS AND DAYLIGHT FACTORIES

1. "Edison, the Peaceful," *The (New York) Sun*, May 14, 1905 (Edison Papers Project, Microfilm Edition, Reel 221).

2. See, for instance, Friedberg, *Window Shopping*; Bruno, *Streetwalking on a Ruined Map*; the essays collected in Charney and Schwartz, eds., *Cinema and the Invention of Modern Life*; and Schwartz, *Spectacular Realities*.

3. See, for instance, Jan-Christopher Horak, "Paul Strand and Charles Sheeler's *Manhatta*," in Jan-Christopher Horak, ed., *Lovers of Cinema: The First American Avant-Garde, 1919–1945* (1995); William Uricchio, "The City Viewed: The Films of Leyda, Browning, and Weinberg," in Horak, ed., ibid.; Juan A. Suárez, "City Space, Technology, Popular Culture: The Modernism of Paul Strand and Charles Sheeler's 'Manhatta,'" *Journal of American Studies* 36.1 (2002): 85–106; and Bruno, *Atlas of Emotion*, esp. ch. 1.

4. Although this chapter focuses on the three major companies based in New York, similar architectural developments could also be found in Philadelphia, where Siegmund Lubin followed his competitors' lead in establishing a large studio and factory, and in Chicago, where the Selig Polyscope Company and Essanay built notable studios based on similar principles.

5. The Nickelodeon period, generally understood to have lasted in America from 1905 to 1907, takes its name from the storefront theaters that emerged throughout the United States, beginning in Pittsburg in June 1905. These small theaters, which typically exhibited film programs for a nickel, helped transform the film industry by altering its exhibition model. As Charles Musser describes, the nickelodeon came about as a result of several developments in American cinema: "a large and growing audience base, a minimal level of 'feature' production, a rental system of exchanges, the conception of a film program as an interchangeable commodity (the reel of film), frequent program changes, a continuous-exhibition format, and cinema's relative independence from more traditional forms of entertainment (except illustrated songs)." See Musser, *The Emergence of Cinema*, 417.

6. Keith Revell, *Building Gotham: Civic Culture and Public Policy in New York City, 1898–1938* (2003), 3.

7. In historian of technology Matthew Gandy's words, "the rapidly growing settlement . . . faced the prospect of social and economic collapse." Matthew Gandy, *Concrete and Clay: Reworking Nature in New York City* (2002), 2.

8. Max Page, *The Creative Destruction of Manhattan, 1900–1940* (1999).

9. Gandy, *Concrete and Clay*, 93; on Central Park, see ch. 3. The construction of artificial "natural" urban spaces also affected film production in Paris, where Gaumont built the world's largest pre-WWI studio adjacent to the Parc des Buttes Chaumont (where the company often filmed). On electrical lighting, see David Nye, *Electrifying America: Social Meanings of a New Technology, 1880–1940* (1990). Although private domestic lighting would not become common until the 1910s, already by the 1880s locations including factories, workshops, train stations, construction sites, exhibition halls, theaters, and city streets began to install first electric arc lighting, then Edison's incandescent light technology. By 1900, as Nye argues, Americans understood electricity—as a source of lighting, industrial power, streetcar traction, and spectacular entertainment—as a key aspect of life, from the city to the suburbs, and from factory labor to recreation.

10. On the development of water and sewer systems in New York City, see Gandy, *Concrete and Clay*, ch. 2. With the creation of the New York State Water Commission in 1833 and the completion of the Croton Aqueduct nine years later, New York joined other Western cities in gradually transforming its water system "from an organic form . . . into a modern hydrological structure." Gandy, ibid., 22.

11. Nye, *Electrifying America*, 2. Wolfgang Schivelbusch reminds us that gas lighting had a similar effect—as a "triumph over the natural order"—both before and contemporaneously with electrical lighting. But Schivelbusch notes that arc lighting was qualitatively different from earlier public gas lighting systems because "in arclight, the eye saw as it did during the day, that is with the retinal cones, while in gaslight, it saw as it did at night, with retinal rods." See Schivelbusch, *Disenchanted Night: The Industrialization of Light in the Nineteenth Century* (1988), 153, 115.

12. Nye, *Electrifying America*, 73. The Edison Electric Light Company and its customers wasted no time capitalizing on the public's fascination with electricity, installing 334 lighting plants within two years following Edison's first demonstration of the incandescent lighting system in 1879. In 1882 the company began commercial operation of the world's first central generating station on Pearl Street in lower Manhattan. Electrical lighting spread quickly in the city's commercial establishments and outlying factories, and reached massive proportions at international expositions that created "visions of a fully electrified world" (Nye, ibid., 33). On the Pearl Street Station and Edison's early electricity companies, see Hughes, *Networks of Power*, 39.

13. Page, *The Creative Destruction of Manhattan*, 26.

14. Musser, *Before the Nickelodeon*, 143. Edison also hoped to lessen its dependence on its licensees, who produced most of the company's films as filmmaking at the Black Maria declined after 1897 (especially Albert Smith and J. Stuart Blackton's American Vitagraph, which had been producing films on an open-air rooftop stage at the Morse Building, 140 Nassau Street, since 1898). On American Vitagraph's rooftop studio, see Slide, *The Big V*, 8, and Charles Musser, "The American Vitagraph, 1897–1901: Survival and Success in a Competitive Industry," in Fell, ed., *Film Before Griffith*, 30.

15. George Blaisdell, "Edwin S. Porter: A Sketch of the Treasurer and Director of the Famous Players—His New Studio," *Moving Picture World* 14.10 (December 7, 1912): 961–62, 961.

16. Hinkle Iron Company and Edison Manufacturing Company, Construction Agreement, October 12, 1900 (Edison Papers Project, Microfilm Edition, Reel 214).

17. The Hinkle Iron Co. to Wm. Simpkin, October 23, 1900 (Edison Papers Project, Microfilm Edition, Reel 186), and The Hinkle Iron Co. to Wm. Simpkin, January 12, 1901 (Edison Papers Project, Microfilm Edition, Reel 187).

18. Musser, *Before the Nickelodeon*, 158. Musser also reproduces the studio's blueprints on page 160.

19. On the copyright case, see Musser, *Before the Nickelodeon*, 177–78. See also Musser, *The Emergence of Cinema*, 305–307.

20. Musser, *Before the Nickelodeon*, 196.

21. In short, Edison's direct current system delivered a steady stream of electricity at low voltage but could not efficiently distribute current across large distances. Tesla and Westinghouse's alternating current, on the other hand, could deliver electricity cheaply across great distances, but the current had to be scaled down upon delivery for use in lighting or machinery and its high-voltage distribution was seen (and presented by Edison) as extremely dangerous.

22. Hughes, *Networks of Power*, 106–139. See also Jill Jonnes, *Empires of Light: Edison, Tesla, Westinghouse, and the Race to Electrify the World* (2003), ch. 9.

23. The "battle of the currents" would continue to effect early cinema into the 1910s in both production and exhibition. Like factory and mill owners and other industrialists, studio personnel and exhibitors often had to contend with converting between AC and DC systems to meet machine compatibility. At least as early as 1900, Cecil Hepworth noted that alternating current was inferior to DC for film projection using arc lamps because the variable current strength contributed to flicker. As I discuss in the next chapter, some film companies (such as Gaumont in Paris) even designed and marketed their own converters to support steady electrical lighting for studios and arc lights for film projection, thereby further industrializing cinema and expanding the spaces and functions of studios. See Hepworth, *Animated Photography: The ABC of the Cinematograph* (1900).

24. Westinghouse's investments included the Nernst lamp (Westinghouse formed the Nernst Lamp Company in 1897), tungsten filament lamps, and finally Cooper Hewitt's mercury vapor lamp.

25. It is possible that Biograph was already planning an electrically lit studio using arc lights such as those that would later be combined with the Cooper Hewitt lamps but switched to the mercury vapor tubes for their greater efficiency and actinic value (see note 31). In a letter from 1920, Robert K. Bonine, an early Biograph and Edison filmmaker, mentions correspondence with a Cooper Hewitt employee who "fitted out the American Mutoscope and Biograph plant at No. 11 East 14th Street." See Robert K. Bonine to William L. Jamison, March 5, 1920 (MoMA Film Study Center, Biograph Collection, box 7, file 23).

26. Austin Celestin Lescarboura, *Behind the Motion-Picture Screen* (1919), 140. Janet Staiger notes that by 1918 the motion picture industry trailed only automobile manufacturers, munitions manufacturers, and machine tool builders in the use of mercury vapor lamps. See David Bordwell, Janet Staiger, and Kristin Thompson, *The Classical Hollywood Cinema: Film Style and Mode of Production to 1960* (1985), 273.

27. See "Alterations Consent for 11 East 14th Street" (MoMA Film Study Center, Biograph Collection, box 7, file 20).

28. Musser, *The Emergence of Cinema*, 340.

29. An updated lease from December 20, 1905, shows that the company leased the three rooms at $700 per year. In 1906, to support the studio's expansion to three additional rooms on the building's third floor, the company added sixteen Cooper Hewitts and sixteen floor-mounted arc lamps. Two years later they added twelve

more arc lamps, followed by twenty-five incandescent lamps and an additional six "flame-arc" lamps in 1909. See "Lease for No. 11 East 14th Street" (MoMA Film Study Center, Biograph Collection, box 8, file 14).

30. Henry G. Prout, *A Life of George Westinghouse* (1921), 235.

31. Actinic value refers to the amount of light that exposes photographic stock. In the period before color photography, lights that lacked red and violet wavelengths were suitable because orthochromatic film stock registered the blue-green end of the color spectrum. See Janet Staiger's excellent description in Bordwell, Staiger, and Thompson, *The Classical Hollywood Cinema*, 271.

32. *Film Index* (December 15, 1906): 4; quoted in Musser, *The Emergence of Cinema*, 337 (emphasis added).

33. Bedding's 16-part series "The Modern Way in Moving Picture Making" appeared between March and June 1909. Chapter 3, "The Studio," was published in *MPW* 4.13 (March 27, 1909): 360.

34. Ibid.

35. Ibid.

36. George C. Keech, "Mercury Lamps for Moving Pictures," *The Nickelodeon* (May 1, 1910): 233.

37. Bedding, "The Modern Way, Ch. 3," 360. Even with the transition to Southern California, electrical lights would become essential components of both studio and location filming. One 1919 book, for instance, would underscore the new industry's continuity with these early problems of producing "natural" light, noting: "In fact, we are replacing the good old sunshine, and it is only when we try to replace that great source of light that we appreciate how powerful it is." Lescarboura, *Behind the Motion-Picture Screen*, 140.

38. Gunning situates the beginning of "narrative integration" around 1906, and Abel argues that a new system of representation and narration developed in France beginning in 1905. See Gunning, "The Cinema of Attractions," in Elsaesser, ed., *Early Cinema*, 56–62; and Abel, *The Ciné Goes to Town*, 136. The use of electrical lighting and its relationship to film form in France will be discussed in chapter 4.

39. Chapter 5 will discuss the shift to location shooting in the late 1900s and early 1910s and its relationship to studio norms developed in eastern studios like those discussed here.

40. See the inspection reports in MoMA Film Study Center, Biograph Collection, box 8, file 6; on the Aristo lamps, see also Robert K. Bonine to William L. Jamison, March 5, 1920 (note 25 above). Staiger also describes the film industry's use of Bogue and Kliegl lamps, each of which began as stage lighting companies but eventually targeted film studios as well. See Bordwell, Staiger, and Thompson, *The Classical Hollywood Cinema*, 274.

41. Bordwell, Staiger, and Thompson, *The Classical Hollywood Cinema*, 273.

42. To be sure, film theaters also contributed to electrical companies' attention to cinema. By the early 1910s, the need for film theater lighting supported the emergence of companies focusing solely on cinema. A 1911 *Moving Picture World* article, for

instance, announced the creation of the Hudson Electric Supply Company, organized to provide electrical materials and services to New York City theaters. Its competitors included the Detroit Engine Works, which marketed its "Detroit" moving-picture electric light plant as a current-saving innovation and a source of power in locations without electrical service. See "Hudson Electric Supply Co. Enters the Moving Picture Field," *MPW* (April 8, 1911): 760; and "Individual Electric Light Plants," *Motography* (April 1911): 53.

43. Frank C. Perkins, "The Mercury Vapor Lamp for Photographic Work," *Scientific American*, August 13, 1904.

44. As David Nye argues, "no American institution was in more rapid transformation in the 1890s than the factory." Nye, *Electrifying America*, 184.

45. A 1910 article on the Cooper Hewitt lamps notes that "the demand for motion pictures of industrial plants has caused several picture concerns to equip themselves with portable sets of Cooper Hewitt lamps which may be taken to these plants and set up to illuminate the moving machinery." Keech, "Mercury Lamps for Moving Pictures," *The Nickelodeon* (May 1, 1910): 233. Such films were only a subset of a broader production of what the 1902 Biograph catalog lists as "Machinery" films (films often used by traveling salesmen) as well as the railroad publicity films that date from the earliest days of cinema.

46. As Oliver Gaycken has explained, the films were shown at the Westinghouse display at the 1904 Louisiana Purchase Exposition (films from the exposition also appear alongside the Westinghouse films in Biograph's catalog). See Gaycken, "The Cinema of the Future: Visions of the Medium as Modern Educator, 1895–1910," in Devin Orgeron, Marsha Orgeron, and Dan Streible, eds., *Learning with the Lights Off: Educational Film in the United States* (2011), 67–89, 74. The films may also have been shown at the Westinghouse Works for worker training and/or as part of the company's "Electric Club" (created in 1902). See H. W. Peck, "The Electric Club: An Account of Its Organization and of Its Social and Technical Departments," *The Electric Club Journal* 1.1 (February 1904): 19. Biograph, for its part, likely expected the films to be popular subjects, for, as Steven J. Ross describes, by at least 1905 workers were the main audience for the movies. See Ross, *Working-Class Hollywood: Silent Film and the Shaping of Class in America* (1998), 6–7.

47. Walter Benjamin, "On Some Motifs in Baudelaire," in *Illuminations*, ed. Hannah Arendt, trans. Harry Zohn (1968), 175 (emphasis added).

48. As Dietrich Neumann notes, "Translucent, light-diffusing glasses such as rough plate glass, ground on both sides, or corrugated glass with horizontal grooves were used from the 1880s onwards to provide factories with an evenly distributed light." See Neumann, " 'The Century's Triumph in Lighting': The Luxfer Prism Companies and Their Contribution to Early Modern Architecture," *Journal of the Society of Architectural Historians* 54.1 (March 1995): 24.

49. "The Vitagraph Plant and Personnel," *The Nickelodeon* 5.1 (January 7, 1911): 9–10. The studio would continue to have value well into the middle part of the century as an outpost for Warner Bros., which renovated it in 1934. See the Brooklyn Studio file 1578A (USC Warner Bros. Archive, Los Angeles).

50. Jon Gartenberg, "Vitagraph Before Griffith: Forging Ahead in the Nickelodeon Era," *Studies in Visual Communication* 10.4 (Fall 1984): 8–9.

51. Musser, *The Emergence of Cinema*, 368–72.

52. "Vitagraph Executive Office Moved to Factory," *MPW* (August 27, 1910): 472; quoted in Slide, *The Big V*, 58. See also "The Vitagraph Plant and Personnel," *The Nickelodeon*, 9.

53. An early description of the studio appears in *Film Index* (August 25, 1906): 6, which notes "the entire roof and upper part of the building is covered with a specially designed prismatic glass." Quoted in Musser, *The Emergence of Cinema*, 468.

54. Neumann, " 'The Century's Triumph in Lighting,' " 24.

55. Or, as a contemporary building journal put it, to avoid "cutting and patching the completed work of the architect, [and] marring walls and ceilings with clumsy mouldings, which form lines that destroy the harmony of the architecture." The same article notes, "The more thoughtful and progressive men belonging to the architectural and electrical professions have for some time felt the necessity of some well-defined plan or system through which they can cooperate." See "Architects and Electrical Engineers," *The Builder and Woodworker* 30, part 5 (May 1894): 65.

56. Neumann, " 'The Century's Triumph in Lighting,' " 29.

57. Vitagraph's Brooklyn studio and the Gaumont and Pathé studios discussed in the next chapter initiated the expansion of studio stages into cinematic "cities," a process that film scholars such as Mark Shiel have too readily associated with Hollywood studios like Universal and Studio City. See Shiel, *Hollywood Cinema and the Real Los Angeles* (2012), ch.3.

58. Bedding emphasized that, for all of artificial light's virtues, "current is costly." See Bedding, "The Modern Way, Ch. 3," 360.

59. Guerin, *A Culture of Light*, 24.

60. Ibid., 26.

61. Jenney and Sullivan each used prismatic glass to light the lower floors of skyscrapers, and Wright worked for Luxfer designing both prism glass tiles and prototypes for skyscrapers with prismatic glass windows. In Europe, Luxfer prisms were manufactured in Liège, Belgium, at the Val St. Lambert glass factories and at the St. Gobain factories near Paris, and featured in the work of architects including Loos. In Berlin, the Deutsches Luxfer Prismen Syndikat emerged as one of the most successful of the company's branches and the source of a new combination of prismatic glass with concrete—Glasseisenbeton—that would be embraced by the Bauhaus and prominently featured in Taut's 1914 exhibition pavilion at the Werkbund Ausstellung in Cologne. See Neumann, " 'The Century's Triumph in Lighting,' " 41–43.

62. An alteration blueprint from 1917 confirms that the original buildings were built from concrete blocks but does not specify what form of blocks were used. See F. P. Hipple, "Vitagraph Company of America. Brooklyn, N.Y.," Plan #10163 (July 31, 1917). Brooklyn Studio file 1578A (USC Warner Bros. Archive).

63. Pamela H. Simpson, "Quick, Cheap, and Easy: The Early History of Rockfaced Concrete Block Building," *Perspectives in Vernacular Architecture* 3 (1989):

108–118, 111. As we will see in the next section, the Edison Portland Cement Company played a significant role in these developments. In contrast to scholars' claims that concrete did not become part of studio architecture (except for poured concrete floors) until the 1920s, the Vitagraph and Edison concrete studios prefigure the later adoption of concrete by Hollywood sound studios by two decades. For one such claim, see Shiel, *Hollywood Cinema and the Real Los Angeles*, 162.

64. Neumann, "'The Century's Triumph in Lighting,'" 35. The dearth of archival materials on Vitagraph makes it difficult to confirm if the studio was built from these specific concrete blocks, but photographic evidence supports the idea, as do architectural diagrams (obtained by Warner Bros. when it bought the studio from Vitagraph in the 1920s) that confirm that the studio had concrete walls (USC Warner Bros. Archives). Natural pitched stone was also the most common style of concrete block ornamentation and came standard with block-making machines sold by Sears and Roebuck beginning in 1906.

65. F. H. Richardson, "The Home of Vitagraph," *MPW* (January 24, 1914): 401.

66. Simpson, "Quick, Cheap, and Easy," 117.

67. See William Uricchio and Roberta Pearson, *Reframing Culture: The Case of the Vitagraph Quality Films* (1993)

68. That symbolic function was especially important in studio photographs that featured prominently in film catalogs, internal publications, and even on company letterhead. These promotional images of the studio were the prelude to later images of studio stars and stock companies.

69. Louis Reeves Harrison, "Studio Saunterings," *MPW* (June 8, 1912): 906–910, 908.

70. George Blaisdell, "At the Sign of the Flaming Arcs," *MPW* (November 15, 1913): 742. See also "Vitagraph Notes," *MPW* (July 5, 1913): 52.

71. See F. H. Richardson, "The Home of Vitagraph," 401.

72. As yet, I have been unable to retrieve any building permits or design documents for the Vitagraph studios from before 1917. At the Brooklyn Department of Buildings, it seems that no files remain for the lots that were home to Vitagraph's studios.

73. Quoted in Musser, *Before the Nickelodeon*, 384.

74. Musser, *Before the Nickelodeon*, 384, 455. On the extension, see "Lybrand and Ross Bros. and Montgomery to Edison," June 30, 1909 (Edison Papers Project, Microfilm Edition, Reel 193).

75. Arthur F. Cosby, *Code of Ordinances of the City of New York* (1906). The 1906 *Code* followed earlier amendments to the 1882 law, including the 1889 *Code* and the "Tenement House Act" of 1901, which notably required improved lighting, ventilation, and plumbing conditions in public housing. On the legal context for concrete construction in the early twentieth century, see Amy E. Slaton, *Reinforced Concrete and the Modernization of American Building, 1900–1930* (2001), esp. ch. 3.

76. Semper's writings on art, architecture, and industry would soon inspire the development of the Bauhaus. On Kafka, see Landmarks Preservation Commission (LPC), *Joseph Loth and Company Silk Ribbon Mill* (LP-1860), report prepared by

Betsy Bradley (New York, 1993), 6–7; LPC, *Louis A. and Laura Stirn House* (LP-2069), report prepared by Gale Harris (New York, 2001), 3; and Kafka's obituary in *American Institute of Architects Journal* 3 (1915), 305. On Schwarzmann's trip to the Vienna Exposition, see John Maass, *The Glorious Enterprise: The Centennial Exhibition of 1876 and H.J. Schwarzmann, Architect-in-Chief* (1973).

77. On Rendle, see "The New Orleans Exposition," *New York Times*, February 17, 1884, and March 5, 1885. Rendle's system of glazing is advertised in numerous trade journals as well as Rendle's sales catalogs beginning in the 1880s.

78. See chapter 2 and Brian R. Jacobson, "The 'imponderable fluidity' of Modernity: Georges Méliès and the Architectural Origins of Cinema," *Early Popular Visual Culture* 8.2 (May 2010): 189–207.

79. Conflicting reports suggest that Kafka, Sr. may have retired from the firm sometime between 1903 and 1906 due to rheumatoid arthritis. See the LPC reports by Betsy Bradley (1993) and Gale Harris (2001).

80. Information about the mill comes largely from the LPC report by Bradley (1993).

81. Plan 1057, September 15, 1905 (Bureau of Buildings for the Borough of the Bronx, Bronx, New York; hereafter, BBBB).

82. Bedding, "The Modern Way, Ch. 3," 360. Bedding may have been referring to Biograph's dark studio, which the company replaced with a new studio between 175th and 176th Streets in 1911. As a *Motography* report about the new studio noted, "The Biograph players have always been a trifle restricted in the old studio on account of the lack of room and it will undoubtedly be very satisfying to them to be given greater scope for effective western settings." See "New Biograph Studio," *Motography* (November 1911): 245. On Biograph's approach to "western settings" (which were likely being shot in and around Los Angeles by 1911), see chapter 5.

83. See Cosby, *Code of Ordinances of the City of New York*, pt. 6, secs. 27 and 32.

84. "Amendment to Application No. 1057," November 28, 1905 (BBBB).

85. Petition, November 28, 1905 (BBBB).

86. "Amendment to Application No. 1057," December 18, 1905 (BBBB).

87. William Pelzer to W. E. Gilmore, January 12, 1906 (Edison Papers Project, Microfilm Edition, Reel 190).

88. "Edison Progress: A Visit to the Great Bronx Moving Picture Studio," *MPW* (December 11, 1909): 833–35, 833.

89. Ibid., 835.

90. Reyner Banham, *A Concrete Atlantis: U.S. Industrial Building and European Modern Architecture, 1900–1925* (1986), 43.

91. Ibid., 56.

92. While the American factories' concrete frames did not represent a revolution in structural engineering, Banham argues that they offered powerful symbolic associations between modern ideals of rational design and a romanticized vision of American industrial modernity. Banham, *A Concrete Atlantis*, 9–21.

93. Ibid., 104–105. Banham argues that concrete became "the exciting material at the turn of the century, and its use, as measured by the quantity of cement consumed, is

reckoned to have increased some fifteen-hundred fold in the United States between 1880 and 1910!"

94. Israel, *Edison*, 403.

95. "Seven Wonders of Today's World Eclipse Old 'Seven Wonders,'" *St. Paul Daily News*, January 27, 1908 (Edison Papers Project, Microfilm Edition, Reel 221).

96. Thomas A. Edison, "Strides in Concrete, Pictures and Fuel," *Hopkinsville (KY) New Era*, July 3, 1909, Science Progress (Edison Papers Project, Microfilm Edition, Reel 221).

97. "Edison, the Peaceful," *The (New York) Sun*, May 14, 1905 (Edison Papers Project, Microfilm Edition, Reel 221).

98. Baldwin, *Edison*, 279.

99. See "Alterations,"*New York Times*, December 13, 1908. See also Horace Moyer to Frank Dyer, March 1, 1909 (Edison Papers Project, Microfilm Edition, Reel 193). Moyer's company—the Moyer Engineering and Construction Co.—and the Edison Manufacturing Company maintained close links, a fact underscored by former Edison VP, GM, and CEO William E. Gilmore's role as president of the Moyer company.

100. Robert Mallet-Stevens, "Le cinéma et les arts; l'architecture," *Les cahiers du mois* 16/17 (1925): 95–98, 97.

101. Walter Gropius, pamphlet for the "Exhibition of Unknown Architects" (1919); quoted in Frampton, *Modern Architecture*, 123.

4. STUDIO FACTORIES AND STUDIO CITIES

1. The reference to "cités du cinéma" in this chapter's title refers both to Delluc's description of the Cité Elgé in 1923 and to more recent descriptions of both Gaumont and Pathé's respective studio centers. In particular, it makes reference to another *cité du cinéma* that recently opened on Paris's northern periphery in Saint-Denis. Built at a cost of 150 million euros, Luc Besson and EuropaCorp's Cité—France's answer to Italy's Cinecittà and Britain's Pinewood Studios—encompasses more than six acres, including business offices, the École National Supérieure Louis Lumière film school, and 10,000 square meters of shooting stages. Built in and around a former Électricité de France factory, the studio represents a striking modern version of France's first *cités du cinéma*. As this chapter shows, the new Cité will take its place in a long tradition of film industry links to industrial architecture and Paris's electrical infrastructure. For a recent invocation of the "Cité du Cinéma" moniker for Pathé, see François Sauteron, *Une si jolie usine: Kodak-Pathé Vincennes* (2008).

2. Louis Delluc, "L'Envers du cinéma: Le Studio," *Magasin Pittoresque* (1923), 108–109, 109 (Paris: Bibliothèque du film, DELLUC59-B4).

3. Delluc notably criticizes the "incredible" sets for which Italian cinema was known—and often remembered today—for "neglecting this law and [thus] leaving us somewhat amazed but not very entertained." See Delluc, "Douglas Fairbanks

et «ROBIN DES BOIS»," *Magasin Pittoresque* (1923), 109. (Paris: Bibliothèque du film, DELLUC59-B4).

4. Delluc, "L'Envers du cinéma: Le Studio," 109.

5. Sadoul argues that the change took only five years: ". . . en cinq ans [1903–1908], le cinéma, d'artisanat, devient une grande industrie." Sadoul, *Histoire générale du cinéma* 2:221. Sadoul discusses this transition in chapters 14 and 16, pp. 221–36, 253–64.

6. In municipalities along Paris's southeastern edge, such as Montreuil, the site of Méliès's studios and one of Pathé's, and Vincennes, home of Pathé's studio head-quarters, industrialization radically changed the landscape from the 1850s to World War I. See Centre de documentation d'histoire des techniques, *Evolution de la géographie industrielle de Paris et sa proche banlieue au XIXe siècle* (1976). See also Tyler Stovall, *The Rise of the Paris Red Belt* (1990), ch. 1, pp. 9–40.

7. Scholars have examined modernity's "dark side" from a number of perspectives, largely drawn from the evocative commentaries of Simmel, Weber, Benjamin, and Kracauer. These include Ben Singer's focus on physical danger and disorienting distraction, Tom Gunning's analysis of "shocks and flows," and Miriam Hansen's work (shifting the focus from Paris to Berlin and to the twentieth century) on "mass production, mass consumption, and mass annihilation, of rationalization, standardization, and media publics." See Singer, *Melodrama and Modernity*; Gunning, "The Cinema of Attractions," in Elsaesser, ed., *Early Cinema*, 63–70, and "Modernity and Cinema: A Culture of Shocks and Flows," in Murray Pommerance, ed., *Cinema and Modernity* (2006), 297–315; and Miriam Bratu Hansen, "America, Paris, the Alps: Kracauer (and Benjamin) on Cinema and Modernity," in Charney and Schwartz, eds., *Cinema and the Invention of Modern Life*, 363.

8. See Peter S. Soppelsa, "Finding Fragility in Paris: The Politics of Infrastructure After Haussmann," *Proceedings of the Western Society for French History* 37 (2009): 233–47; and Soppelsa, "The Fragility of Modernity: Infrastructure and Everyday Life in Paris, 1870–1914" (PhD diss., University of Michigan, 2009)

9. The large Parisian studios discussed in this chapter show that film studio expansion was by no means restricted to the wide open spaces of Southern California and the south of France. As we will see in the next chapter, LA's relatively undeveloped land aided but did not determine the film industry's move west.

10. Bruno, *Atlas of Emotion*, 27. "The landscape of the city," Bruno argues, "ends up interacting closely with filmic representations, and to this extent, the streetscape is as much a filmic 'construction' as it is an architectural one."

11. See, for instance, the essays in Mark Shiel and Tony Fitzmaurice, eds., *Cinema and the City*; Dietrich Neumann, ed., *Film Architecture*; François Penz and Maureen Thomas, eds., *Cinema and Architecture*; and Linda Krauss and Patrice Petro, eds., *Global Cities: Cinema, Architecture, and Urbanism in a Digital Age* (2003), as well as the essays in the special issue "Cityscapes I," ed. Clark Arnwine and Jesse Lerner, *Wide Angle* 19.4 (1997).

12. For Parisians in the late nineteenth century, the suburbs—or *banlieue*—carried special symbolic value as a new liminal space between town and country that Victor Hugo described as "made up of two different natures" and especially made for "reverie" and "the dreamer." As T. J. Clark describes, modernist painters such as Georges Seurat and Vincent van Gogh helped shape the idea and experience of social division and anomie that came with this emerging modern space. The studio-produced films discussed at the end of this chapter may have played a similar role in creating an idea of modern life in its urban and suburban locales. See T. J. Clark, *The Painting of Modern Life: Paris in the Art of Manet and His Followers* (1984), 43. Hugo quote reprinted in Clark, ibid., 23.

13. Ibid., 182.

14. Georges Sadoul notes in passing, "here we find financial links that often unite cinema and electricity, at Eclipse as at Gaumont as at Edison as at Biograph" ["nous retrouvons ici les liens financiers qui unissent souvent le cinéma et l'électricité, chez *Eclipse*, comme chez *Gaumont*, comme chez *Edison*, comme à la *Biograph*"] (*Histoire générale du cinéma* 2:330). Surprisingly, Sadoul fails to explore the broader significance of these links between the two young industries.

15. Émile took charge of the phonograph business, while Charles directed the initially much smaller film unit. According to Jean Mitry, the Compagnie approached the Pathés only after failing to attract the attention of Méliès. See Mitry, *Histoire du Cinéma* 1:96. For more details about the Compagnie's early formation, see Stéphanie Salmon, *Pathé: À la conquête du cinéma, 1896–1929* (2014), 50–53.

16. On Neyret, see Mitry, *Histoire du Cinéma* 1:95. On Grivolas, see Jacques Deslandes and Jacques Richard, *Histoire comparée du cinéma* 2:299–301. For a more detailed history of the Compagnie's principal investors—Neyret, Grivolas, and Léon Devilaine—see Salmon, who notes that Neyret also administered companies including la Compagnie des Chemins de fer à Voie, la Société de charbonnage d'Urikany, la Compagnie des Fiacres Automobiles à Taximètre, la Société d'éclairage électrique de Cannes, la Société française d'Appareillage Électrique, and la Compagnie générale des glaces hygiéniques, the latter three founded by Grivolas (*Pathé*, 37–45).

17. The importance of Continsouza and Bünzli's factory as a site for the diverse forms of machine work and expertise needed to produce Pathé's film machines recalls the key role (described in chapter 1) that Edison's machine rooms and precision engineers at the West Orange laboratory played in cinema's invention. On Continsouza and Bünzli's factory, see Richard Abel, "In the Belly of the Beast: The Early Years of Pathé-Frères." *Film History* 5.4, Institutional Histories (December 1993): 364. Abel notes that Pathé would soon be the factory's largest customer. See also Henri Bousquet, "L'âge d'or: De «L'Arrivée d'un train» à «L'Histoire d'un crime»" in Jacques Kermabon, ed., *Pathé, premier empire du cinéma* (1994), 48.

18. As Gilles Venhard notes, Gaumont was eager to transform the business of his newly acquired enterprise from an exclusive sales model to development, production, and sales. See Venhard, "Les vertes années de la marguerite, 1896–1924," in Philippe d'Hugues and Dominique Muller, eds., *Gaumont, 90 ans de cinéma* (1986), 21. See

also the correspondence collected in Marie-Sophie Corcy, Jacques Malthête, and Laurent Mannoni, eds., *Les Premières années de la société Gaumont et Cie: correspondance de Léon Gaumont, 1895–1899* (1999).

19. François Garçon, *Gaumont, un siècle du cinéma* (1994), 14.

20. Garçon, *Gaumont*, 18; Mitry, *Histoire du Cinéma* 1:154.

21. Stéphanie Salmon, "Les Débuts d'une industrialization Pathé (1898–1903)." *Archives* 93 (Institut Vigo—Cinémathèque de Toulouse) (June 2003): 1–12.

22. See Laurent Le Forestier, *Aux sources de l'industrie du cinéma: le modèle Pathé, 1905–1908* (2006). See also Salmon, *Pathé*, 70–75.

23. Charles Pathé, *De Pathé frères à Pathé cinéma*, 51; Deslandes and Richard, *Histoire comparée du cinéma* 2:303–304, and Salmon, *Pathé*, 54–55. Pathé dates the phonograph facilities in Chatou to 1899, but the company's *Conseils d'Administration* show that by October 1898, Grivolas was already requesting capital to enlarge the factories to support growing consumer demand. See Compagnie Général des Phonographes, Cinématographes, et Appareils de Précision, *Conseil d'Administration* (hereafter, CA), October 11, 1898, 14–15.

24. Salmon notes that an 1899 corporate inventory mentions a "salle vitrée," or glass room. See Salmon, *Pathé*, 73. For Pathé's version of these early days, see *De Pathé frères à Pathé cinéma*, 58. See also Mannoni, "Les Studios Pathé de la Région Parisienne (1896–1914)," in Michel Marie and Laurent Le Forestier, eds., *La Firme Pathé Frères, 1896–1914* (2004), 60.

25. From late May 1902, Charles Pathé launched repeated requests to the Compagnie board for more resources. The board responded with active investigation and support for expanding its film facilities. See the CA reports for May 26, July 7, and August 25, 1902. Ivatts, like Neyret and Grivolas, who he replaced as managing director (*administrateur délégué*), had a background in industry, having worked for a coal mine in Vietnam, and in municipal infrastructural development as an administrator for la Société de Pavage et des Asphaltes de Paris. See Salmon, *Pathé*, 82.

26. The 16 × 11 meter studio quickly turned out to be much too small to respond to the rising growth of production. See Salmon, *Pathé*, 108; and Mannoni, "Les Studios Pathé," 63.

27. These local artisans included a contractor, Castella, and two builders, Genteix and Dignaud. See Salmon, "Les Débuts d'une industrialization Pathé," 8.

28. See Barry Salt, *Film Style and Technology: History and Analysis* (1983), 52.

29. Salmon, "Les Débuts d'une industrialization Pathé," 2.

30. The CA minutes contradict Charles Pathé's recollection of the first studio, which, he explains was "sans autre installation électrique que celle qu'on trouve dans tous les immeubles." It may be that the additional expenses cited in the CA reports refer to outfitting the building for electricity beyond the state when Pathé purchased the building, but Pathé makes no further reference to the studio in his memoirs. See Pathé, *De Pathé frères*, 59. Mannoni, closely following Pathé's account of the studio, ignores the possibility of electrical lighting there. See Mannoni, "Les Studios Pathé," 64. The CA minutes confirm Barry Salt's recognition of "extra artificial

lighting . . . in a few films from all the three major film companies." See Salt, *Film Style and Technology*, 41–42.

31. CA, November 21, 1902: "l'éclairage actuel suffisant pour les petites scènes avec peu de personnage, est pas suffisant pour les grandes scènes avec beaucoups de personnages sur la scène."

32. Ibid.: "cette nouvelle escalation nous mettre dans une frontière exceptionnelle nous permettant de produire rapidement de nouveaux projets cinématographiques." That Pathé should be using electrical lighting at this date is not surprising—as Salt has described, arc lighting was becoming a common means for effects or fill lighting that he identifies in Pathé films by 1904. More interesting, however, is that Pathé's decision to adopt arc lights already in 1902 may explain why French studios would not begin using the Cooper Hewitt lamps that became popular in America in 1903, first at Biograph, until the early 1910s. See Salt, *Film Style and Technology*, 40. On French adoption of the Cooper Hewitt lamps, see Mannoni, "Les Studios Pathé," 71.

33. CA, December 20, 1902.

34. Abel, *The Ciné Goes to Town*, 20.

35. Salmon, "Les Débuts d'une industrialization Pathé," 8.

36. As set designer-turned-historian Léon Barsacq notes, Pathé's decorators initially included Maurice Fabrège, Albert Colas, Gaston Dumesnil, and Vasseur, all products of the same design studio. Léon Barsacq, *Le Décor de Film, 1895–1969* (1985), 16. See also Mannoni, "Les Studios Pathé," 60.

37. CA, February 29, 1904. On Pathé's agreement with the neighboring owner (Georges Malo, who later became the Compagnie's architect), see CA, April 26, 1904.

38. Jérôme Decoux, *Montreuil, patrimoine industriel* (2003), 3.

39. CA, March 29, 1904: "un hangar en fer et de verre . . . pour les prises de vues équestres et autres en plein air." See also Hugues Laurent, "Le Décor de cinéma et les décorateurs," *Bulletin de l'association françaises des ingénieurs et technicians du cinéma* 16 (1957): 6; Mannoni, "Les Studios Pathé," 63; and Salmon, *Pathé*, 140.

40. In the 1920s, the studio housed the Albatross film company, led by a group of Russian immigrants. Today, the building, designated a Monument Historique, houses an acting school. See Decoux, *Montreuil, patrimoine industriel*, 29.

41. Ibid., 16. Montreuil received electricity beginning in 1890 from the Compagnie parisienne d'air comprimé, one of six private concessions established by the Muncipal Council in 1889. See the following discussion of Gaumont for a more complete description of electrical development in Paris and its effects on film studio development, particularly at Gaumont's Cité Elgé, where municipal electricity would not arrive until after World War I.

42. The studio's construction continued into the winter, but already by March 1904 filmmakers and designers began production on its open-roofed stage. According to Board reports, production continued *en plein air* through at least July. See CA, August 18, 1904. Set designer Hugues Laurent would later recall that Pathé's artists often ran into Méliès's team, with whom they happily shared ideas (without revealing too much). Laurent, "Le Décor de cinéma," 6–7.

43. CA, March 29, 1904, and September 10, 1904. On the Vincennes studio, see Salmon, *Pathé*, 137–38.

44. CA, February 29, 1904, and March 29, 1904. See Jean-Luc Rigaud, "Un patrimoine disparaît: Recherches autour du cas de l'industrie du disque à Chatou" (Memoire de master II Histoire des Techniques, Université Paris 1 Panthéon-Sorbonne, 2009), 64. Laubeuf may have been chosen for the project due to his company's proximity to the Pathé phonograph works in Chatou, the success of which, Rigaud argues, helped entice Laubeuf and other industrialists to establish operations there (96).

 Laubeuf and his son André, an engineer trained at the École nationale des Arts et Metiers, would continue to play an important role in Pathé's later construction in Vincennes. In 1911, the younger Laubeuf created a new company in Montreuil producing metal frames used to build factories for numerous industrial manufacturers, including Pathé and later for Kodak. See Cécile Katz and Jérôme Decoux, eds., Base Architecture-Mérimée, Ministère de la Culture de la France, direction de l'Architecture et du Patrimoine, Ref. IA93000054 (Inventaire général, 2000). Available online at www.culture.gouv.fr/documentation/memoire/HTML/IVR11/IA93000054/index.htm (accessed December 7, 2010). La Société Laubeuf, presently based in Saint-Mandé, not far from Montreuil, continues to build glass-enclosed structures, notably including airport buildings such as Roissy Charles de Gaule's Terminal 2E. For details, see Laubeuf's corporate website: www.laubeuf.com/fr/realisations (last accessed December 20, 2013).

45. Mannoni, "Les Studios Pathé," 63. See also Laurent, "Le Décor de cinéma," 7, who notes that each Monday morning Pathé brought together the directors of the studios in Montreuil and Vincennes, along with the directors, set designers, and camera operators to outline the week's work.

46. Laurent, "Le Décor de cinéma," 8.

47. Ibid.

48. Even with the eventual completion of the Vincennes studio, Pathé enlarged the "provisional" Montreuil studio in 1906 and made it a permanent part of the Compagnie's production. See Le Forestier, *Aux sources de l'industrie du cinéma*, 140.

49. Noël Burch, *Life to Those Shadows*, trans. Ben Brewster (1990), 170.

50. See Richard Abel, *The Red Rooster Scare: Making Cinema American, 1900–1910* (1999), 29. In describing Pathé's dominant position in the American market, Abel cites an article by W. L. Larned, who argued in 1908 for the importance of set design, noting that in Pathé films "a room on film became a REAL room." See W. L. Larned, "The Public and the Filmmakers," *Views and Films* Index (January 25, 1908): 3; quoted in Abel, ibid., 69.

51. "La Catastrophe du boulevard de Sébastopol," *Le Petit Journal*, February 22, 1904, 3.

52. Ibid., February 24, 1904, 3.

53. The new regulations did not come from the city of Paris but rather from the larger Department of the Seine, the county regulatory commission that oversaw laws governing Paris as well as local communities such as Vincennes and Joinville where Pathé would develop its new infrastructure. On Pathé's discussions with the authorities in Vincennes, see Salmon, *Pathé*, 139–40, and, on the affair in general, 145–47.

54. CA, September 10, 1904.

55. CA, November 9, 1904. Inspectors further surprised the Board by accepting the less secure conditions on the rue du Bois, where negative film stock was stored in plain view through corridors on the second floor.

56. CA, December 12, 1904.

57. CA, January 9, 1905.

58. Pathé also continued to purchase stock from Lumière, but as production increased with the new facilities in Joinville, the Compagnie became increasingly eager to own its own facility for producing film stock. From mid-1905 into early 1906, Pathé engaged in negotiations to purchase the Blair Company's film factory in London, eventually completing the deal in March 1906. See CA, September 6, 1905–April 5, 1906.

59. See Abel, *The Ciné Goes to Town*, 41.

60. CA, February 3, 1905. See also Thierry Lefebvre, "L'usine de Joinville, établissement dangereux," in Marie and Le Forestier, eds., *La Firme Pathé Frères*, 50; and Salmon, *Pathé*, 147.

61. Pathé's move to Joinville foretold the removal of all heavy industry from Paris, including the removal of the central markets at Les Halles in the 1960s.

62. CA, August 8, 1905.

63. Lefebvre, "L'usine de Joinville," 53.

64. Ibid., 52. Lefebvre quotes the Municipal Council: "Une ville qui vit surtout de la promenade et de la villégiature des Parisiens et des étrangers doit sauvegarder la beauté de ses paysage et en particulier pour Joinville [...] empecher l'enlaidissement des bords de la rivière qui la fait vivre."

65. CA, March 6, 1905. On Moisson et fils, see Louis Thérèse David de Pénanrun, Edmund Augustin Delaire, and Louis François Roux, eds. *Les architectes élèves de l'Ecole des beaux-arts, 1793–1907* (1907), 350.

66. CA, April 24, 1906.

67. "au milieu des dédales de cette ville,—car c'est une vrai cité." François Valleiry, "Les Pellicules cinématographiques (Leur Fabrication)," *Phono-Ciné-Gazette* 35 (September 1, 1906): 332, continued as "Fabrication des vues cinématographiques (suite)" (October 15, 1906): 391–92. The article offers a unique account of the production processes put in place in early film factories.

68. The Belleville plant owned by Victor Continsouza already produced precision machinery, including various film machines. Pathé sought to increase its production of cameras and projectors by bankrolling an expansion project at the Continsouza works. In exchange, the factory would in effect become an exclusive Pathé affiliate. Negotiations continued through 1907, and the project dragged on with numerous difficulties into 1908. Pathé expanded its Vincennes coloring facility in April 1906 to house its stencil method and later for its automatic coloring machines. See CA, April 24, 1906, and Joshua Yumibe, *Moving Color: Early Film, Mass Culture, Modernism* (2012), 83–86.

69. Malo had experience in atelier design and, on the strength of his friendship with Charles Pathé and his future involvement in Pathé's construction projects, would go

on to a prominent career. See Anne Dugast and Isabelle Parizet, eds., *Dictionnaire par noms d'architectes: des constructions élevées à Paris aux XIXe et XXe siècles, Période 1876–1899*, vol. 3 (1993), 79. The Compagnie elected to replace Moisson due to the firm's poor treatment of the initial Joinville project and complications arising from its failure to bill contractors properly. See CA, December 28, 1906, and Lefebvre, "L'usine de Joinville," 54.

70. Lefebvre, "L'usine de Joinville," 56–57. Pathé's smokestack continues to define Joinville's skyline, and the ateliers are—at the time of writing—being sold by real estate developers as lofts and marketed as a "Cité du Cinéma."

71. See Abel, *The Ciné Goes to Town*, 41.

72. Schivelbusch, *Disenchanted Night*, 54. For the dates of electrical lighting's introduction in Parisian venues, see Shelley Wood Cordulack, "A Franco-American Battle of Beams: Electricity and the Selling of Modernity," *Journal of Design History* 18.2 (2005): 147–66.

73. Alain Beltran, *La Fée Electricité* (1991), 84; Schivelbusch, *Disenchanted Night*, 58.

74. Beltran, "La Distribution: des installations privées aux stations centrales: les débuts de l'électrification parisienne," in François Caron and Fabienne Cardot, eds., *Histoire général de l'électricité en France*, vol. 1: *Espoirs et conquêtes* (1991), 405.

75. Beltran, "L'éclairage électrique: la concurrence entre énergies," in Caron and Cardot, eds., *Histoire général de l'électricité en France* 1:386–87.

76. Beltran, "La Distribution," 406. Beltran's quote reads, ". . . l'Exposition universelle de 1889 (qui risquait de montrer au monde entier que la Ville lumière méritait bien peu son nom . . .)."

77. Ibid.

78. The response to the Opéra-Comique fire prefigured the increased regulation of spectacular exhibition spaces and illumination technologies seen in the wake of the fire at the Bazar de la Charité. On the latter, see Deslandes and Richard, *Histoire comparée du cinéma* 2:23–26.

79. See Cordulack, "A Franco-American Battle of Beams," 147–66.

80. Beltran, "La Distribution," 408.

81. Caron and Beltran, "Chapitre III: Conclusion," in Caron and Cardot, eds., *Histoire général de l'électricité en France* 1:456. The *Place Clichy* and *Compagnie Parisienne de l'air comprimé* sectors used a 4 × 110 volt system with five wires, whereas the *Edison* sector used 2 × 110 volts with three wires, the *Société d'éclairage et de force* sector used a simple 110-volt system, and the two remaining sectors—the *Champs-Elysées* and *Rive Gauche*—used alternating monophase current.

82. Henri Morsel, "L'Electricité thermique," in Caron and Cardot, eds., *Histoire général de l'électricité en France* 1:567.

83. Beltran, "La Distribution," 408; see also the map in Beltran, *La Ville-lumière et la fée électricité: service public et enterprises privées: l'énergie électrique dans la region parisienne* (2002), 308. On Gaumont's electrical system and its postwar connection to the city network, see below and G. Mareschal, "L'éclairage dans les studios," *La Technique Cinématographique* 100/101 (July–August 1950): 185–86.

84. Beltran, *La ville-lumière*, 136; Caron and Beltran, "Chapitre III: Conclusion," 456.

85. Beltran, *La Fée Electricité*, 102: "leurs sous-sol abritaient de véritables usines électriques." In some cases the concessionary companies also installed electrical generators in basements to supplement power in high-usage venues. One such venue was none other than the Grand Café, site of a huge explosion caused by an electrical generator in 1890, only five years before the Lumières would use the same basement to set off an "explosion" of enthusiasm for moving images. On the Grand Café explosion, see Caron and Beltran, "Chapitre III: Conclusion," 455.

86. Caron and Beltran, "Chapitre III: Conclusion," 456.

87. E. Revoalen, "Notes et Documents: Ateliers de Cinématographie, rue des Alouettes (XIXe), à Paris: M. A. Bahrmann, architecte; M. A. Michelin, constructeur," *Les Nouvelles Annales de la Construction* 6.613 (March 1906): 33–38.

88. Revoalen, "Notes et Documents," 34.

89. Ibid., 34. On the *Aérocondenseur Fouché*, see M. Compère, *Exposition internationale de Saint Louis (USA) 1904. Section française. Rapport du Département E. [Machines]* (1906), 429–31.

90. On the studio's roof, an observation deck similarly suggested—at least to the *Nouvelles Annales* writer—a potential site for "capturing natural, meteorological, or other scenes for science or historical curiosity." Revoalen, "Notes et Documents," 34.

91. See David Bordwell, *Figures Traced in Light: On Cinematic Staging* (2005), ch. 2. Bordwell offers a telling quote from Feuillade, who wrote that, "the cinema proceeds as much, if not more, from the art of the painter than from that of the stage director, since cinema addresses itself to our eyes by combinations of light and changing tonalities, and by qualities of composition" (49). This attitude would be consistent with the studio's emphasis on large-scale painted backdrops and attention to deft studio lighting.

92. Léopold Lobel, "Quelques Souvenirs," *La Technique cinématographique*, 100/101 (July–August 1950): 182.

93. On Gaumont's continuous developing machines, see Salt, *Film Style and Technology*, 63. See also Lobel, "L'évolution des ateliers de traitement de films," *La Technique cinématographique*, 100/101 (July–August 1950): 183–84; and G. Mareschal, "L'Évolution des machines à developer les films cinématographiques depuis 50 ans," *Bulletin de l'association française des ingéneiurs et techniciens du cinéma* 6.11 (1952): 3–8.

94. See the Gaumont exhibition catalog, *Les Premières feuilles de la marguerite: Affiches Gaumont, 1905–1914* (Gallimard, (1994). These studio products deserve further attention from film and media scholars, who would do well to note how early studios set the stage for "media convergence" long before the so-called new media revolution. Such examples offer useful historical precedents for the practices described, for instance, in Jay David Bolter and Richard Grusin, *Remediation: Understanding New Media* (2000); Lev Manovich, *The Language of New Media*

(2002); and Henry Jenkins, *Convergence Culture: Where Old and New Media Collide* (2006).

95. Clark, *The Painting of Modern Life*, 182.

96. Mark Shiel, "Cinema and the City in History and Theory," in Shiel and Fitzmaurice, eds., *Cinema and the City*, 5.

97. AlSayyad's study of this cinematic epistemology looks only as early as the 1920s, beginning with Walter Ruttmann's commonly cited city symphony, *Berlin: Symphony of a Big City* (1927). AlSayyad, *Cinematic Urbanism*.

98. Such representations of technology, as we have seen in Méliès's films, offer a much earlier form of what David Clarke refers to as modernity's "dystopian *alter ego*," which he identifies in films such as *Blade Runner* (Ridley Scott, 1982) or even Fritz Lang's meditation on the modern city, *Metropolis* (1927). David Clarke, ed., *The Cinematic City* (1997), 6.

99. This movement is expressed most clearly in the emergence of new companies such as Film d'art and the Société cinématographique des auteurs et gens de lettres that focused on historical dramas and staged theater. In France, its most vocal proponents included the weekly periodical *Phono-Ciné-Gazette*, which had ties to Pathé, who sought to benefit from a shift in the legal status of cinema from entertainment to an art form like theater. The "film as art" movement had parallels in other contexts such as America, where Vitagraph's "quality films" helped the company lead American production in the early 1910s. See Abel, *The Ciné Goes to Town*, 246–77 and 302–325. On Vitagraph, see Uricchio and Pearson, *Reframing Culture*.

100. François Sauteron, "Scènes de la vie telle qu'elle est," *Ciné-Journal* 139 (April 22, 1911), 19. Translated and reprinted in Abel, ed., *French Film Theory and Criticism* 1:54.

101. This attention to labor appeared more generally in early industrial films and, later, in the pointed critiques of class relations that historians such as Steven Ross have examined in classical Hollywood cinema. See Ross, *Working-Class Hollywood*.

102. Geoffrey Nowell-Smith, "Cities: Real and Imagined," in Shiel and Fitzmaurice, eds., *Cinema and the City*, 100.

103. See, for instance, Carné, "When Will the Cinema Go Down into the Street?" in Abel, ed., *French Film Theory and Criticism* 2:127–28.

104. For more on Gaumont's diverse interests during and after World War I, see Jacobson, "Infrastructure and Intermediality: Network Archaeology at Gaumont's Cité Elgé," *Amodern* 2 (2013); available online at http://amodern.net/article/infrastructure-and-intermediality/. On Pathé's contribution to the war, see Salmon, *Pathé*, 317.

5. THE STUDIO BEYOND THE STUDIO

1. Lanier Bartlett, "How the Motion Picture Industry Thrives Here," *Los Angeles Times*, January 1, 1916, sec. 3, p. 67. From its "certain" spatial vagaries, the article continues by more specifically identifying this first studio: "For here, hidden away now between the big steel-and-glass studio and immense concrete property-house of the Selig Polyscope Company's Edendale plant, is the first permanent moving

picture stage built in California—the first footprint, as it were, of an industry which, in the six years since the pioneer producing company of actors arrived from Chicago, has impressed in tremendous degree the life of Southern California."

2. "New York Motion Picture Company's Notes," *MPW* (March 19, 1910): 429.

3. Other commonly cited reasons for the move to Los Angeles included distance from the Motion Picture Patents Company (MPPC) for the independent producers, inexpensive real estate, weak labor unions, and a ready workforce. See Eileen Bowser, *The Transformation of Cinema*, 149–65; Allen J. Scott, *On Hollywood: The Place, the Industry* (2005), 12; Robert Sklar, *Movie-Made America: A Cultural History of American Movies* (1975), 67–85; and Steven J. Ross, "How Hollywood Became Hollywood: Money, Politics, and Movies," in Tom Sitton and William Deverell, eds., *Metropolis in the Making: Los Angeles in the 1920s* (2001), 257–8.

4. On the ways that Los Angeles boosters helped attract and retain film companies, see Denise M. McKenna, "The City That Made the Pictures Move: Gender, Labor, and the Film Industry in Los Angeles, 1908–1917" (PhD diss., New York University, 2008), ch. 1.

5. See Bowser, *The Transformation of Cinema*, 151; Kalton C. Lahue, ed., *Motion Picture Pioneer: The Selig Polyscope Company* (1973), 13; and Slide, *Early American Cinema*, 28.

6. Bowser, *The Transformation of Cinema*, 151–52. On Vitagraph, see "Vitagraph Activity," *MPW* (December 18, 1909): 878; and "Notes and Comments," *MPW* (March 20, 1909): 335.

7. Shawn C. Bean, *The First Hollywood: Florida and the Golden Age of Silent Filmmaking* (2008), 43.

8. The importance of modern infrastructure to film's expansion should be underscored. As Tom Gunning has pointed out, railway networks helped link even remote rural locations to the "topography of modernity," the experience of which was by no means limited to "crowded city streets." See Gunning, "Systematizing the Electric Message: Narrative Form, Gender, and Modernity in *The Lonedale Operator*," in Charlie Keil and Shelley Stamp, eds., *American Cinema's Transitional Era: Audiences, Institutions, Practices* (2004), 28.

9. Bowser, *The Transformation of Cinema*, 154–55; Bean, *The First Hollywood*, 66–8.

10. See "The Melies Company Now in Texas," *MPW* (November 26, 1910: 1219; "Gaston Melies in New York," *MPW* (November 4, 1911): 368; and "Mr. Gaston Melies," *MPW* (July 27, 1912): 334.

11. Bowser, *The Transformation of Cinema*, 156–58. On Vitagraph, see "Observations by Our Man About Town," *MPW* (February 5, 1910): 160.

12. *Nickelodeon* 5.1 (January 7, 1911): 23; quoted in Nanna Verhoeff, *The West in Early Cinema: After the Beginning* (2006), 48 and 195.

13. Georges Méliès, "Propos sur les vues animées," in Pierre Véronneau, ed., *Dossiers de la Cinémathèque* 10 (1982): 17–18. A contemporary journalist, Henri de Parville, similarly remarked upon the "trembling of the leaves." For the Parville reference, see Georges Sadoul, *Histoire générale du cinéma*, vol. 2: *L'Invention du cinéma,*

1832–1897 (1948), 291. Siegfried Kracauer cites Parville by way of Sadoul in his own analysis of the Lumières and, significantly, the ways their films opened onto elements of life "accessible only to the camera." Once again, the idea of nature made uniquely available to the camera recalls Lewis Mumford's impression of cinema as specific technology of the machine. See Kracauer, *Theory of Film*, 31. For a more recent discussion of the responses to this film, see Nico Baumbach, "Nature Caught in the Act: On the Transformation of an Idea of Art in Early Cinema," *Comparative Critical Studies* 6 (2009): 373–83.

14. As Charles Musser notes, *Rough Sea at Dover* was "the hit film" at the New York premier of Edison's Vitascope projector in April 1896, and Edison would remake the film as *Surf at Long Branch* (1896). See Musser, *The Emergence of Cinema*, 118, 180.

15. For a list of "North American landscape films" held in the Library of Congress's Paper Print collection, see Iris Cahn, "The Changing Landscape of Modernity: Early Film and America's 'Great Picture' Tradition," *Wide Angle* 18.3 (1996): 85–100.

16. See Charles Musser, "The Travel Genre in 1903–1904: Moving Towards Fictional Narrative," *Iris* 2.1 (1984): 47–59, reprinted in Elsaesser, ed., *Early Cinema*, 123–32; and Jennifer Lynn Peterson, "Travelogues and Early Nonfiction Film: Education in the School of Dreams," in Keil and Stamp, eds., *American Cinema's Transitional Era*, 195. See also Peterson, *Education in the School of Dreams: Travelogues and Early Nonfiction Film* (2013).

17. Peterson, *Education in the School of Dreams*, 206–207.

18. Verhoeff, *The West in Early Cinema*, 48.

19. On "Easterns," see ibid., 77–95. On "Eastern Westerns," see Scott Simmon, *The Invention of the Western Film: A Cultural History of the Genre's First Half Century* (2003). Verhoeff deftly shows how these films contributed to the idea of the nation by reconstructing the past (the "elsewhen") through the image of the "elsewhere." In this reading, the natural landscape thus triggers nostalgia for the recent past of colonial times and the early days of the now vanishing frontier.

20. See Richard Abel, *Americanizing the Movies and "Movie-Mad" Audiences, 1910–1914* (2006), 63–64; and Verhoeff, *The West in Early Cinema*, 96–107. As historians of early westerns often note, characterizations of the West as "authentic" or "real" were far from ideologically neutral. As Giorgio Bertellini has argued, these representations of the natural environment—particularly in the picturesque mode with which early filmmakers visually ordered America's "wild" western landscape—promoted "a contemplative, imaginative, and touristic mode of consumption that concealed power-laden, exploitative, and merely utilitarian relationships." See Bertellini, *Italy in Early American Cinema: Race, Landscape, and the Picturesque* (2010), 98.

21. See the American Film Manufacturing Company's advertisement for *The Ranchman's Vengeance* and *A Cowboy's Sacrifice* in *MPW* (May 20, 1911): 1111. For an earlier example see the World Films advertisement for *Ingratitude* and *The Red*

Man—promoted as "the only real Western pictures made in the real deep west"—in *MPW* (June 19, 1909): 848.

22. Verhoeff, *The West in Early Cinema*, 190.

23. To be sure, westerns became popular for more than just their natural settings. For more on the importance of these films' melodramatic plots, action scenes, stock characters, and the broader context of dime novels and the tradition of western iconography that contributed to their success, see Abel, *Americanizing the Movies*, ch. 2.

24. Simmon, *The Invention of the Western Film*, 15.

25. Ibid. As Tom Gunning has similarly explained, Claude's work provided an early aesthetic norm for reproducing landscape and inspired a form of imaging technology—the Claude Glass—that "processed nature optically." Studio norms offered a similar kind of technological processing of nature. Gunning's larger analysis of how "cinema transformed the possibilities of landscape, both as a form of imagery and as a way of experiencing nature" focuses on the importance of movement and cinema's production of a sublime experience of nature that was prefigured by the panorama and seen most clearly in early "phantom rides." Studio norms and the mobile studio technologies discussed later point to the picturesque landscape tradition's continuing importance alongside this newer cinematic sublime. See Gunning, "Landscape and the Fantasy of Moving Pictures: Early Cinema's Phantom Rides," in Graeme Harper and Jonathan Rayner, eds., *Cinema and Landscape: Film, Nation and Cultural Geography* (2010), 35–36.

26. Slide, *Early American Cinema*, 35; Robert Florey, *Hollywood Village: Naissance des studios de Californie* (1986), 87; and Louis Reeves Harrison, "Studio Saunterings," *MPW* (July 6, 1912): 23.

27. See images of the studio's construction in "Fielding's Collapsible Studio," *MPW* (February 6, 1915): 840. See also "Fielding Builds Collapsible Studio," *Motography* (February 6, 1915): 196.

28. "Romaine Fielding Gives Film World Something New," *Motography* (August 21, 1915): 335–36; and "Lubin Has a New Asset—Portable Lighting Plant," *Motography* (August 28, 1915): 408–409.

29. Simmon, *The Invention of the Western Film*, 41.

30. Ibid., 42.

31. See Richard Koszarski, *Fort Lee: The Film Town* (2004), 58.

32. Koszarski, *Fort Lee*, 76.

33. "The Champion Enterprise," *MPW* (November 18, 1911): 542; reprinted in Koszarski, *Fort Lee*, 77.

34. "American Éclair Studio," *MPW* (October 7, 1911): 24–25, 24; reprinted in Koszarski, *Fort Lee*, 100.

35. French companies also sought natural settings for film production, both in American communities such as Fort Lee, Bound Brook, N.J., and Flushing, N.Y., as well as in French coastal areas such as Nice, where Gaumont established its "Victorine" studio in 1913.

36. Pathé also had a studio in Jersey City and made films in Fort Lee from as early as 1910. See Koszarski, *Fort Lee*, 142; and Abel, *The Ciné Goes to Town*, 45, 52. Alice Guy established Solax after leaving Gaumont's studio and processing facilities in Flushing, New York (managed by her husband, Herbert Blaché).

37. The lot was located on Olive Street between 7th and 8th. See Bowser, *The Transformation of Cinema*, 151; and Slide, *Early American Cinema*, 28. On the rooftop studio, see Gene Fernett, *American Film Studios*, 210; and Lahue, ed., *Motion Picture Pioneer*, 32.

38. Slide, *Early American Cinema*, 28. On *In the Power of the Sultan*, see Kevin Brownlow, *The Parade's Gone By . . .* (1976), 30.

39. Andrew A. Erish, *Col. William N. Selig, the Man Who Invented Hollywood* (2012), 84.

40. Ibid., 86.

41. Florey, *Hollywood Village*, 111–13. Fernett describes the original structure as an abandoned grocery store. Fernett, *American Film Studios*, 152.

42. Florey, *Hollywood Village*, 25. Fernett claims that Biograph's Washington and Grand studio rotated like its earlier rooftop studio in Manhattan, but I have found no evidence to support this claim. Fernett, *American Film Studios*, 11.

43. See Fernett, *American Film Studios*, 147; and Bowser, *The Transformation of Cinema*, 161.

44. Richard V. Spencer, "Los Angeles as a Producing Center," *MPW* (April 8, 1911): 768.

45. Richard V. Spencer, "Los Angeles Notes," *MPW* (February 18, 1911): 360; and Spencer, "Los Angeles," *MPW* (March 4, 1911): 466.

46. "Doings at Los Angeles," *MPW* (June 21, 1913): 1238.

47. Selig's application for this wall appears first in the file of building permit applications for the Selig lot at the Los Angeles Department of Building and Safety (LADBS). See Permit No. 2457, "Application for the Erection of 'Class B & C' Buildings," March 28, 1910 (LADBS).

48. For more on the importance of these ornamental walls, see Brian R. Jacobson "Fantastic Functionality: Studio Architecture and the Visual Rhetoric of Early Hollywood," *Film History* 26.2 (2014): 52–81.

49. Further additions in 1911 included a new office and two new sheds costing more than $2,000 (Building Permits, LADBS).

50. See Florey, *Hollywood Village*, 26; Bowser, *The Transformation of Cinema*, 159; and "Biograph Company Migrates to the Land of Sunshine and Flowers," *MPW* (January 29, 1910): 120.

51. Spencer, "Los Angeles as a Producing Center." Two weeks later, Spencer reported that Selig had plans to expand the studio for a total investment of $500,000. See Spencer, "Los Angeles Notes," *MPW* (April 22, 1911): 889.

52. Spencer, "Los Angeles Notes," *MPW* (March 25, 1911): 644.

53. Spencer, "Los Angeles as a Producing Center."

54. "Doings at Los Angeles," *MPW* (September 14, 1912): 1067.

55. "Scene in Vitagraph Western Studio," *MPW* (November 30, 1912).

56. Kinemacolor added at least five new "sheds" and dressing rooms for approximately $1,000 in 1912 and three additional sheds and a 2,000-square-foot developing laboratory (at a cost of $1,800) in 1913. See the permits for 4500–4544 Sunset Blvd (LADBS). See also "Doings at Los Angeles," *MPW* (October 19, 1912): 234.

57. "Doings at Los Angeles," *MPW* (October 5, 1912): 32.

58. "Marion Optimistic," *MPW* (March 23, 1912): 1052.

59. "Doings in Los Angeles," *MPW* (July 20, 1912): 235; and "Mr. Gaston Melies," *MPW* (July 27, 1912): 334.

60. See "Mace to Head an Imp Company," *MPW* (June 29, 1912): 1218; "Doings at Los Angeles," *MPW* (November 16, 1912): 653; and "Southern California Claims the Palm," *MPW* (December 28, 1912): 1286.

61. "Doings at Los Angeles," *MPW* (December 28, 1912): 1286. Other companies working in the region for parts of 1912 included the United States Motion Picture Company (at Temple and Lake Shore); the Monopol Feature Company (at 1339 Gordon Street in Hollywood); a company owned by Frank Egan (on Temple street by Echo Park); and the Brand Advanced Motion Picture Company, which reportedly planned to invest $500,000 in four 4,000-square-foot glass studios near Glendale. See "Doings at Los Angeles," *MPW* (August 24, 1912): 760.

62. Clark Irvine, "Doings at Los Angeles," *MPW* (July 11, 1914): 243. New companies arriving in 1913 included the Balboa Motion Picture Co. (at Vine and Selma in Hollywood), the Balboa Amusement Producing Co. (in Long Beach), Edison, Famous Players, the Graphic Motion Picture Company, a new Lubin company, the Majestic Company, Seltagraph (Scenic, Educational, Local, Topical, Artistic), the St. Louis Motion Picture Company (in the Santa Paula studio formerly owned by Gaston Méliès), Thanhouser, and the West Coast Motion Picture Producing Company.

63. The Graphic Motion Picture Company went bankrupt in 1913, leaving a vacant studio at 55 East Avenue. See "Doings at Los Angeles," *MPW* (June 14, 1913): 1141. Thanhouser left for a new studio in New Rochelle, New York, in April. See "Thanhouser Goes East," *MPW* (May 17, 1913): 690. And Kinemacolor closed its studio and began returning supplies to New York in June. See "Doings at Los Angeles," *MPW* (June 14, 1913): 1141; and "Doings at Los Angeles," *MPW* (June 21, 1913): 1238.

64. See "Doings at Los Angeles," *MPW* (February 22, 1913): 766. In April of the same year, *Moving Picture World* reported that Richard Garrick, a former Universal employee, had established a new company to supply "extra people" and already had a list of more than 500 persons. See "News Briefs," *MPW* (April 5, 1913): 34.

65. "Letters of an Old Exhibitor to a New Filmmaker," *MPW* (August 26, 1911): 532.

66. A 1911 *Moving Picture World* report about Bison's plans to shoot footage of a wildfire in the San Bernardino Mountains underscores this commonly held idea that nature had become a kind of studio. In a description likely to vex any Angeleno who has watched acre upon acre destroyed on the evening news, the article depicts the fire as a source for "a number of magnificent and awe-inspiring western

pictures with one of the most terrible and fearsome 'sets' that nature can afford—that of a forest of giant trees swept by a tornado of flame and smoke." See "With the Western Producers," *MPW* (September 9, 1911): 697.

67. "Jesse L. Lasky Returns from Coast," *MPW* (December 12, 1914): 1501.

68. Hugh Hoffman, "Ernest Shipman's World Tour," *MPW* (July 5, 1913): 34 (emphasis added). A 1912 article about the American Film Manufacturing Company's plans to move from its La Mesa, California, home to a new studio similarly points to the idea that locations could be used up, noting, "all good locations in and about La Mesa had been extensively used in 'Flying A' pictures." See "Americans [*sic*] Moves Its Western Studio," *Motography* (July 15, 1912): 31.

69. For "prospect," see *New Oxford American Dictionary*, edited by Angus Stevenson and Christine A. Lindberg (Oxford: Oxford University Press, 2010).

70. See examples of Paramount's studio maps in Karie Bible, Marc Wanamaker and Harry Medved, *Location Filming in Los Angeles* (2010).

71. See Spencer, "Los Angeles as a Producing Center." As Ed Dimendberg has argued, during the silent period "studio filmmakers rapidly became adept at making [Los Angeles] look like someplace else and generally did." See Dimendberg, "Cinema and the Making of a Modern City," in William Deverell and Greg Hise, eds., *The Blackwell Companion to Los Angeles* (2010), 349.

72. Bartlett, "How the Motion Picture Industry Thrives Here." See also "California, the Producers' Eden," *Motography* (May 1912): 227–28. See also Mark B. Sandberg's analysis of location and place substitution in the early Danish film industry in Sandberg, "Location, 'Location': On the Plausibility of Place Substitution," in Jennifer M. Bean, Anupama Kapse, and Laura Horak, eds., *Silent Cinema and the Politics of Space* (2014), 23–46.

73. A 1913 report about Siegmund Lubin's new studio in East Los Angeles notes, for instance, that "the property overlooks the Arroyo Seco, one of the greatest *storehouses of beautiful outdoor moving picture backdrops* in Southern California." See "Doings at Los Angeles," February 8, 1913, 560 (emphasis added).

74. "The Ramdon [*sic*] Shots of a Picture Fan," *MPW* (October 21, 1911): 198.

75. Selig advertisement, *MPW* (November 4, 1911): 391.

76. As described in chapter 3, the first film studios embodied the principal characteristics of what Michel Foucault terms the *heterotopia*, a type of space resulting from the rationalization and increasing importance of spatial relations in modern life. Just as the film studio staged such juxtapositions and offered a site in which to explore their bounds, so filmmakers' early conception of California (and, later, the studio backlot—a miniature form of filmmakers' creative California geographies) reproduced the unlikely spatial juxtapositions with which cinema probed and transformed modern spatial experience. See Foucault, "Of Other Spaces," *Diacritics* 16.1 (Spring 1986): 24.

77. In response, one producer had reportedly resorted to buying costumes back East, while another of the major companies had begun to manufacture its own furniture for props. See P. M. Powell, "Doings at Los Angeles," *MPW* (August 16, 1913): 731.

78. Ibid.

79. Powell's reference to "location" precedes the earliest listing in the Oxford English Dictionary, which dates its use in this specific sense to a 1914 *Scribner's Magazine* article that refers to "'locations' . . . as are called the scenes and backgrounds of a moving-picture play," a description that notably obscures the distinction between studio and non-studio settings. The OED's examples do not make that distinction clear until 1918. See "location, n.," OED Online (June 2013), Oxford University Press, at www.oed.com/view/Entry/109574 (accessed July 12, 2013).

80. John B. Rathbun, "Motion Picture Making and Exhibiting," *Motography* (July 12, 1913): 21. Elsewhere, writers seem to have used "location" intuitively to describe film spaces in ways that would later acquire industry specificity. In a June 1913 description of the filming of a new Reliance film starring Rodman Law, for example, the writer notes that "[the film crew] found that the location of the St. John Falls was not in keeping with the situation called for in the drama, while the Stillwater Falls were better suited." See "Rodman Law in New Thriller," *Motography* (June 28, 1913): 466.

81. "Betzwood on the Perkiomen," *Motography* (August 23, 1913): 122.

82. Robert Grau, *The Theatre of Science: A Volume of Progress and Achievement in the Motion Picture Industry* (1914), 172.

83. David Boughey, *The Film Industry* (1921), 55 (emphasis in the original). A 1916 *Los Angeles Times* article describes the work of the "location men" who might "relieve the director of this duty [to look over exterior locations]." See Bartlett, "How the Motion Picture Industry Thrives Here."

84. Lescarboura, *Behind the Motion-Picture Screen*, 162–64.

85. "Young Deer Builds Mission," *MPW* (June 29, 1912): 1218.

86. Thanks go to Daniel Steinhardt for introducing me to this quote, which has been attributed, in slightly varying forms, to any number of Hollywood producers, including Louis B. Mayer, Jack Warner, and Samuel Goldwyn.

87. Bowser, *The Transformation of Cinema*, 160.

88. See Richard V. Spencer, "Los Angeles Letter," *MPW* (January 21, 1911): 137; and "Adopt Rules for Local Producers," *MPW* (January 28, 1911): 199.

89. "Adopt Rules for Local Producers."

90. Richard V. Spencer, "Notes of the Los Angeles Studios," *MPW* (February 11, 1911): 302.

91. In May 1914, for instance, *Moving Picture World* reported new limits on filming in the park, again associated with alleged damage caused by companies using too many animals in scenes. See "Doings at Los Angeles," *MPW* (May 9, 1914): 808.

92. On Malibu, see Spencer, "Los Angeles Notes," *MPW* (April 1, 1911): 704. On the Bison Company in Bear Valley, see Spencer, "With the Western Producers," *MPW* (July 15, 1911): 22; and "With the Western Producers," *MPW* (September 9, 1911): 697. On Selig, see the report about Herbert Bosworth in "Doings at Los Angeles," *MPW* (August 24, 1912): 760. On Vitagraph, see the reports about Rollin S. Sturgeon's film troupe, which reportedly got stranded in Bear Valley in December 1914

after waiting to shoot "wintry scenes," in Clarke Irvine, "Doings at Los Angeles," *MPW* (December 5, 1914): 1363; and Irvine, "Doings at Los Angeles," *MPW* (January 9, 1915): 205.

93. On Pathé's purchase of the lot—referred to as "Donegan's Hill"—see "Doings at Los Angeles," *MPW* (September 14, 1912): 1067. On Brand, see Powell, "Doings at Los Angeles," *MPW* (September 21, 1912): 1160.

94. On Universal, see Powell, "Doings at Los Angeles," *MPW* (October 26, 1912): 331; and Mark Garrett Cooper, *Universal Women: Filmmaking and Institutional Change in Early Hollywood* (2010), 64.

95. On Ince, see Irvine, "Doings at Los Angeles," *MPW* (December 12, 1914): 1504. On Lasky, see "Jesse L. Lasky Returns from the Coast," *MPW* (December 12, 1914): 1501. See also Grace Kingsley, "Los Angeles the Globe's Moving Picture Center," *Los Angeles Times*, January 1, 1915, sec. 5, p. 146.

96. Even Fielding himself traded his collapsible studio for a permanent one, quitting the Lubin Company in late 1915 to establish a permanent studio on a plot of land in Phoenix, Arizona. See "Fielding Heads Cactus Films," *Motography* (December 11, 1915): 1218.

97. See "Jesse L. Lasky Returns from the Coast."

98. Spencer, "With the Western Producers," *MPW* (July 22, 1911): 114.

99. "Western Operations of the New York Motion Picture Company," *MPW* (August 24, 1912): 777.

100. W. E. Wing, "Tom Ince, of Inceville," *New York Dramatic Mirror* 70.1827 (December 24, 1913): 34; reproduced in George C. Pratt, *Spellbound in Darkness: A History of the Silent Film* (1973), 144.

101. Including, as Lasky lamented, destroying a fruit-bearing orange grove to build a glass studio on the ranch. See "Jesse L. Lasky Returns from the Coast," *MPW* (December 12, 1914): 1501.

102. Irvine, "Doings at Los Angeles," *MPW* (December 5, 1914): 1363.

103. See "Universal City Opened," *MPW* (March 27, 1915): 1908; and "Guests Lavishly Entertained," *Motography* (April 3, 1915): 533.

104. "Flood Devastates Universal City," *MPW* (February 13, 1915): 958.

105. Kingsley, "Los Angeles the Globe's Moving Picture Center."

106. As such, they created what Foucault terms "heterochronies"—"slices in time" that trouble traditional temporal relations in the same manner as their spatial counterparts. See "Los Angeles Great Backdrop for the World," *Los Angeles Times*, January 14, 1912, sec. 6, p. 9; and Foucault, "Of Other Spaces," 26.

107. See chapter 1 and Martin Heidegger, "The Question Concerning Technology," 3–35.

108. As the *Los Angeles Times* described, "it is a remarkable fact that even 'snow pictures' . . . are made more successfully here in California than anywhere else. Every winter, companies of players . . . garner literally miles of film of the most marvelous stormbound scenes for the entertainment of perspiring humanity the world over during the summer months." Bartlett, "How the Motion Picture Industry Thrives Here."

109. On the emergence of the backlot and its use for larger standing sets, see Bordwell, Staiger, and Thompson, *The Classical Hollywood Cinema*, 220–21.

110. Trade press reports suggest that studio lighting began to become the norm around 1914. See, for instance, Clarke Irvine's dispatches in *Moving Picture World* about "Jessie J. Robbins and his electric system of lighting" and the Favorite Players studio, which was "among the numerous studios to equip with electric lights" and thus "ready for all the fogs that care to come." Irvine, "Doings at Los Angeles," *MPW* (August 29, 1914): 1230; and Irvine, "Doings at Los Angeles," *MPW* (December 26, 1914): 1826. See also "New Lasky Glass Studio Now Complete," *MPW* (January 23, 1915): 524.

111. "American's Santa Barbara Plant," *MPW* (February 8, 1913): 559.

112. "Universal's Chameleon City: The Most Remarkable Town Ever Built," *Universal Weekly*, September 26, 1914, 4–5, 8–9, 37, cited in Cooper, *Universal Women*, 202n1.

113. "Has Faith in You," *MPW* (September 26, 1914): 1717.

114. "Nothing Like It," *MPW* (September 26, 1914): 1720. See also Mark Garrett Cooper's description of the studio's versatility in Cooper, *Universal Women*, 64–68.

115. "Nothing Like It,"*MPW* (September 26, 1914).

116. Powell, "Doings at Los Angeles," *MPW* (August 17, 1912): 654.

117. Bartlett, "How the Motion Picture Industry Thrives Here."

118. In this way, the tours also revealed and reproduced what Mark Garrett Cooper has described as the dynamic between work and play that defined Universal City in the mid-1910s. See Cooper, *Universal Women*, ch. 3.

CONCLUSION: MORE THAN "DREAM FACTORIES"

1. G. Harrison Wiley, "The Dream Factory," *The Photodramatist* 3.4 (September 1921): 21.

2. Eugene Dengler, "Wonders of the Diamond-S Plant," *Motography* 6.1 (July 1911): 19.

3. See Charles Gatchell, "Any Day at Any Movie Studio," *Picture Play* (August 1917). On the *Picture Play* cartoons by Gatchell and R. L. Lambdin, see Koszarski, *Fort Lee*, 192–97.

4. Vidler, "The Explosion of Space: Architecture and the Filmic Imaginary," 99.

5. In addition to its ongoing research into military technologies, Gaumont further diversified its industrial output, producing, for instance, starters and lighting systems for the auto industry. See Jacobson, "Infrastructure and Intermediality."

6. Robert Mallet-Stevens, "Le cinéma et les arts; l'architecture," *Les cahiers du mois* 16/17 (1925), 97.

7. Pathé's Joinville studios, for instance, were home to productions for the Pathé-Natan conglomerate by filmmakers including Jean Renoir, Maurice Tourneur, Jean Cocteau, Marcel l'Herbier, and Pierre Prévert. In Los Angeles, Thomas Ince's Culver City studio became RKO-Pathé before welcoming visitors to Selznick

International Pictures, both as its studio home and in the title sequence of films like *A Star Is Born* (1937) and *Spellbound* (1945). Vitagraph's L.A. studio became a Warner Bros. site, and it remains a studio today—The Prospect Studios—with the same façade at the corner of Prospect Avenue and Talmadge Street in Los Feliz, only a short walk from where parts of this book were written.

8. An Edison archive curator used two photographs of the studio as guides to prepare three drawings that a local architectural firm adapted and executed. Svedja, *The 'Black Maria' Site Study*, 32.

9. See www.tate.org.uk/art/artworks/seers-extramission-6-black-maria-t12975 (accessed November 1, 2013).

FILMS CITED

Les Affiches en goguette (*The Hilarious Posters*, Méliès, 1906)
À la conquête du pôle (Méliès, 1911)
Alice Guy tourne une phonoscène sur la théâtre de pose des Buttes-Chaumont (Gaumont, 1905)
Au pays noir (Pathé, dir. Zecca, 1905)
Annie Oakley (Edison, dir. Heise, 1894)
Amy Muller (Edison, dir. Heise, 1896)
Athlete with Wand (Edison, dir. Dickson and Heise, 1894)
L'Auberge du bon repos (*The Inn Where No Man Rests*, Méliès, 1903)
L'Auberge ensorcelée (*The Bewitched Inn*, Méliès 1897)
Le Ballon rouge (Lamorisse, 1956)
Barbe-bleue (*Blue Beard*, Méliès, 1901)
Black Diamond Express (Edison, 1900)
Building Made Easy, or How Mechanics Work in the Twentieth Century (Edison, 1901)
Cendrillon (*Cinderella*, Méliès, 1899)
Le Château hanté (*The Haunted Castle*, Méliès, 1897)
Chimmie Hicks at the Races (Biograph, 1900)
Chirurgie fin de siècle (Méliès, 1900)
Une Chute de cinq étages (Méliès, 1906)
Clown, chien, ballon (Gaumont, dir. Guy, 1905)
Le Coffre enchanté (*The Bewitched Trunk*, Méliès, 1904)
The Count of Monte Cristo (Selig, dir. Boggs, 1908)
La Course à la saucisse (Gaumont, dir. Guy, 1907)
A Cowboy's Sacrifice (American, 1911)

Crissie Sheridan (Edison, 1897)

Demolishing and Building Up the Star Theatre (Biograph, dir. Armitage, 1901)

Devil's Slide (Biograph, dir. Bitzer, 1902)

Dickson Experimental Sound Film (Dickson and Heise, 1895)

Dickson Greeting (Dickson and Heise, 1891)

Electrocuting an Elephant (Edison, 1903)

Escamotage d'une dame chez Robert-Houdin (Méliès, 1896)

Execution of Czolgosz (Edison, dir. Porter, 1901)

Faust aux enfers (Méliès, 1903)

La guirlande merveilleuse (*The Marvelous Wreath*, Méliès, 1903)

The Heart of a Race Tout (Selig, dir. Boggs, 1909)

Une Héroïne de quatre ans (*A Four-Year-Old Heroine*, Gaumont, dir. Guy, 1907)

Une Histoire roulante (Gaumont, dir. Guy, 1906)

Hugo (Scorsese, 2011)

L'Homme-mouche (*The Human Fly*, Méliès, 1902)

L'Homme à la tête en caoutchouc (*The Man with the Rubber Head*, Méliès, 1901)

L'Homme orchestre (*The One-Man Band*, Méliès, 1900)

Un Homme de tête (*The Four Troublesome Heads*, Méliès, 1898)

In the Power of the Sultan (Selig, dir. Boggs, 1909)

Ingratitude (World Films, 1909)

Interior NY Subway 14th Street to 42nd Street (Biograph, dir. Bitzer, 1905)

Intolerance (D. W. Griffith, 1916)

Jack and the Beanstalk (Edison, dir. Porter and Fleming, 1902)

Jeanne d'Arc (Méliès, 1900)

Joan the Woman (Cecil B. DeMille, 1916)

Le Locataire diabolique (*The Diabolical Tenant*, Méliès, 1909)

La lune à un mètre (*The Astronomer's Dream*, Méliès, 1898)

Le magicien (Méliès, 1898)

Manhatta (Sheeler and Strand, 1921)

Mr. Edison at Work in His Chemical Laboratory (Edison, dir. White and Heise, 1897)

Old Faithful Geyser (Edison, 1901)

The Old Maid Having Her Picture Taken (Edison, dir. Porter and Fleming, 1901)

Opening Ceremonies, New York Subway, October 24, 1904 (Edison, 1904)

Opening of New East River Bridge (Edison, 1903)

Pan-American Exposition by Night (Edison, dir. Porter and White, 1901)

Panorama of Machine Company Aisle (Biograph, dir. Bitzer, 1904)

Panorama View, Streetcar Motor Room (Biograph, dir. Bitzer, 1904)

Passaic Falls (Edison, dir. Heise, 1896)

La Photographie électrique à distance (Méliès, 1908)

Le Portrait mystérieux (*The Mysterious Portrait*, Méliès, 1899)

Le Portrait spirite (*A Spiritualistic Photographer*, Méliès, 1903)

La possession de l'enfant (Gaumont, dir. Feuillade, 1909)

Les Quatre cents farces du diable (Méliès, 1906)

Le Raid New York–Paris en automobile (Méliès, 1908)

The Ranchman's Vengeance (American, 1911)

The Red Man (World Films, 1909)

Repas de bébé (Louis Lumière, 1895)

Rêve de Noël (*The Christmas Dream*, Méliès, 1900)

Robetta and Doretto (Edison, dir. Dickson and Heise, 1894)

Robin Hood (United Artists, dir. Allan Dwan, 1922)

Rough Sea at Dover (Birt Acres and R. W. Paul, 1895)

Royal Gorge (Edison, 1898)

Sandow (Biograph, 1896)

A Shocking Incident (Biograph, 1903)

Skyscraper Symphony (Florey, 1929)

La Sortie des usines Lumière (1895)

Le Statue (Gaumont, dir. Guy, 1905)

La Soubrette ingénieuse (Pathé, dir. Zecca, 1902)

Surf at Long Branch (Edison, 1896)

Le Tripot clandestine (*The Scheming Gamblers' Paradise*, Méliès, 1906)

Twentyfour-Dollar Island (Flaherty, ca. 1926)

Union Iron Works (Edison, 1898)

Upside Down, or The Human Flies (R. W. Paul, 1899)

La Vie du Christ (Gaumont, dir. Guy, 1906)

Vingt milles lieus sous les mers (Méliès, 1907)

Visite sous-marine du Maine (Méliès, 1898)

Le Voyage à travers l'impossible (Méliès, 1904)

Le Voyage dans la lune (*A Trip to the Moon*, Méliès, 1902)

Le Voyage de Gulliver à Lilliput et chez les géants (*Gulliver's Travels*, Méliès, 1902)

Le Voyage de la famille Bourrichon (Méliès, 1913)

Westinghouse Air Brake Company (Biograph, dir. Bitzer, 1904)

What Happened on Twenty-Third Street, New York (Edison, 1901)

BIBLIOGRAPHY

PRIMARY SOURCES

ARCHIVAL SOURCES

Archives de Paris, Paris
 Bulletin Municipal Officiel
 Permits de Construire
Bibliothèque du film (Cinémathèque française), Paris
 Espace Chercheurs
 Fonds Lucien Aguettand
 Fonds Commission de Recherche Historique
 Fonds Wilfred Ernest Lytton Day
 Fonds Louis Delluc
 Fonds Louis Gaumont
 Fonds Georges Méliès
 Fonds Georges Sadoul
 Iconothèque
 Fonds d'Affiches et de Dessins
 Fonds Photographique
Brooklyn Department of Buildings, Brooklyn, New York
Bureau of Buildings for the Borough of the Bronx, Bronx, New York (BBBB)
Edison Papers Project, Microfilm Edition
 Reels 186, 187, 190, 193, 214, 221
Fondation Jérôme Seydoux-Pathé, Paris
 Conseil d'Administration (CA; Compagnie Général des Phonographes,
 Cinématographes, et Appareils de Précision), Vols. 1 and 2
Los Angeles Department of Building and Safety (LADBS)
Los Angeles Public Library
Manhattan Municipal Archives, New York
 Alteration Docket Books, 1900

New Docket Books, 1891–1899
Property Folders
Margaret Herrick Library, Los Angeles, CA
 J. Stuart Blackton Papers
 Thomas H. Ince Photographs
 William Selig Papers
Musée Gaumont, Paris
Museum of Modern Art, New York
 Merritt Crawford Papers
Museum of Modern Art, Film Study Center, New York
 Biograph Collection
 Production Records, 1899–1912 (MFILM 0125)
Smithsonian Institution
Thomas A. Edison Papers
Thomas Edison National Historical Park, West Orange, NJ
 Thomas Alva Edison, Inc., Motion Picture Division Records, Series 1
 Motion Picture Patents Company Records, Series 1, 2, 4
USC Warner Bros. Archive, Los Angeles

PERIODICAL SOURCES

American Institute of Architects Journal (1915)
Brooklyn Daily Eagle (1901)
The Builder and Woodworker (1894)
Ciné-journal (1908–1916)
Cinema News and Property Gazette (1913)
The Electric Club Journal (1904)
Film Index (1906)
Harper's Weekly (1885)
The International Photographer (1933)
Los Angeles Times (1912–1916)
Motography (1911–1915)
Moving Picture World (MPW) (1907–1916)
New York Sun (1894)
New York Times (1908)
The Nickelodeon (1909–1911)
Les Nouvelles Annales de la Construction (1906)
Le Petit Journal (1904)
Phono-Ciné-Gazette (1905–1909)
Photographic Times (1895)
Photoplay Magazine (1916)
Picture Play (1917)
Scientific American (1904–1907)

SECONDARY SOURCES

Abel, Richard. *Americanizing the Movies and "Movie-Mad" Audiences, 1910–1914.* Berkeley: U of California P, 2006.

———. *The Ciné Goes to Town: French Cinema, 1896–1914.* Berkeley: U of California P, 1994.

———. "In the Belly of the Beast: The Early Years of Pathé-Frères." *Film History* 5.4, Institutional Histories (December 1993): 363–85.

———. *The Red Rooster Scare: Making Cinema American, 1900–1910.* Berkeley: U of California P, 1999.

Abel, Richard, ed. *French Film Theory and Criticism: A History/Anthology, 1907–1939.* 2 vols. Princeton, NJ: Princeton UP, 1988.

Alpers, Svetlana. "The Studio, the Laboratory, and the Vexations of Art." In Caroline Jones and Peter Galison, eds., *Picturing Science, Producing Art,* 401–417. New York: Routledge, 1998.

———. *The Vexations of Art: Velázquez and Others.* New Haven: Yale University Press, 2005.

The American Film Institute Catalog of Motion Pictures Produced in the United States: Film Beginnings, 1893–1910. Metuchen, NJ, and London: Scarecrow Press, 1995.

AlSayyad, Nezar. *Cinematic Urbanism: A History of the Modern from Reel to Real.* New York: Routledge, 2006.

Andrew, Dudley, ed. *The Image in Dispute: Art and Cinema in the Age of Photography.* Austin: U of Texas P, 1997.

Arnwine, Clark and Jesse Lerner, eds. "Cityscapes I." *Wide Angle* 19.4 (1997).

Aronovitch, Lawrence. "The Spirit of Investigation: Physics at Harvard University, 1870–1910." In James, ed., *The Development of the Laboratory,* 83–103.

Asendorf, Christoph. *Batteries of Life: On the History of Things and Their Perception in Modernity* (1984). Translated by Don Reneau. Rpt., Berkeley: U of California P, 1993.

Association Les Amis de Georges Méliès. *158 scénarios de films disparus de Georges Méliès.* Paris: Association Les Amis de Georges Méliès, 1986.

Balász, Béla. *Theory of Film (Character and Growth of a New Art).* Translated by Edith Bone. London: Dennis Dobson, 1952.

Baldwin, Neil. *Edison, Inventing the Century.* New York: Hyperion, 1995.

Banham, Reyner. *The Architecture of the Well-Tempered Environment* (1969). 2d ed. Chicago: U of Chicago P, 1984.

———. *A Concrete Atlantis: U.S. Industrial Building and European Modern Architecture, 1900–1925.* Cambridge: MIT Press, 1986.

———. *Los Angeles: The Architecture of Four Ecologies.* Berkeley: University of California Press, 2001. Original publication, London: Allen Lane, 1971.

Barber, Stephen. *Projected Cities.* London: Reaktion, 2002.

Barnes, John. *The Beginnings of the Cinema in England, 1894–1901.* 5 vols: vol. 2, *1897;* vol. 3, *1898;* vol. 4, *1899;* vol. 5, *1900.* Exeter: U of Exeter P, 1996 (vol. 5, 1997).

Barsacq, Léon. *Caligari's Cabinet and Other Grand Illusions: A History of Film Design.* Edited by Elliott Stein. Translated by Michael Bullock. New York: Little, Brown, 1976.

———. *Le Décor de Film, 1895–1969.* Paris: H. Veyrier, 1985.

Baumbach, Nico. "Nature Caught in the Act: On the Transformation of an Idea of Art in Early Cinema." *Comparative Critical Studies* 6 (2009): 373–83.

Bean, Shawn C. *The First Hollywood: Florida and the Golden Age of Silent Filmmaking.* Gainesville: UP of Florida, 2008.

Beckman, Karen and Jean Ma, eds. *Still Moving: Between Cinema and Photography.* Durham, NC: Duke UP, 2008.

Beltran, Alain. "La Distribution: des installations privées aux stations centrales: les débuts de l'électrification parisienne." In Caron and Cardot, eds., *Histoire générale de l'électricité en France* 1:403–409.

———. "L'éclairage électrique: la concurrence entre énergies." In Caron and Cardot, eds., *Histoire générale de l'électricité en France* 1:385–87.

———. *La Fée Electricité.* Paris: Gallimard, 1991.

———. *La Ville-lumière et la fée électricité: service public et enterprises privées: l'énergie électrique dans la région parisienne.* Paris: Éditions Rive Droite; Institut d'histoire de l'industrie, 2002.

Benjamin, Walter. *The Arcades Project.* Cambridge: Harvard UP, 2002.

———. "On Some Motifs in Baudelaire." In *Illuminations,* 155–200. Edited by Hannah Arendt. Translated by Harry Zohn. New York: Schocken Books, 1969.

———. "The Work of Art in the Age of Its Technological Reproducibility (Second Version)." Translated by Edmund Jephcott and Harry Zohn. In Benjamin, *Selected Writings,* vol. 3: *(1935–1938),* 101–133. Edited by Howard Eiland and Michael W. Jennings. Cambridge: Belknap Press, Harvard UP, 2002.

Bertellini, Giorgio. *Italy in Early American Cinema: Race, Landscape, and the Picturesque.* Bloomington: Indiana UP, 2010.

Bible, Karie, Marc Wanamaker, and Harry Medved. *Location Filming in Los Angeles* (Charleston, SC: Arcadia, 2010.

Bolter, Jay David and Richard Grusin, *Remediation: Understanding New Media.* Cambridge: MIT Press, 2000.

Bordwell, David. *Figures Traced in Light: On Cinematic Staging.* Berkeley: U of California P, 2005.

———. *On the History of Film Style.* Cambridge: Harvard UP, 1997.

Bordwell, David, Janet Staiger, and Kristin Thompson. *The Classical Hollywood Cinema: Film Style and Mode of Production to 1960.* New York: Columbia UP, 1985.

Bottomore, Stephen. "Polar Expedition Films." In Richard Abel, ed., *Encyclopedia of Early Cinema,* 523–24. London: Routledge, 2005.

Boughey, David. *The Film Industry.* London: Pitman, 1921.

Bousquet, Henri. "L'âge d'or: De «L'Arrivée d'un train» à «L'Histoire d'un crime»." In Jacques Kermabon, ed., *Pathé, premier empire du cinéma,* 47–73. Paris: Centre Georges Pompidou, 1994.

Bowser, Eileen. *The Transformation of Cinema, 1908–1915.* New York: Scribner's, 1991.

Bradley, Betsy. *Joseph Loth and Company Silk Ribbon Mill* (LP-1860). New York: Landmarks Preservation Commission, 1993.

Braun, Marta. *Picturing Time: The Work of Étienne-Jules Marey (1830–1904)*. Chicago: U of Chicago P, 1992.

Brownlow, Kevin. *The Parade's Gone By* Berkeley: U of California P, 1976.

Bruno, Giuliana. *Atlas of Emotion: Journeys in Art, Architecture, and Film*. New York: Verso, 2002.

——. *Streetwalking on a Ruined Map: Cultural Theory and the City Films of Elvira Notari*. Princeton, NJ: Princeton UP, 1993.

Burch, Noël. *Life to Those Shadows*. Translated by Ben Brewster. Berkeley: U of California P, 1990.

——. "Porter or Ambivalence." *Screen* 19 (Winter 1978–79): 91–105.

Butcher, William. *Jules Verne: The Definitive Biography*. New York: Thunder's Mouth, 2006.

Cahan, David. "The Geopolitics and Architectural Design of a Metrological Laboratory: The Physikalisch-Technische Reichsanstalt in Imperial Germany." In James, ed., *The Development of the Laboratory*, 137–54.

Cahn, Iris. "The Changing Landscape of Modernity: Early Film and America's 'Great Picture' Tradition." *Wide Angle* 18.3 (1996): 85–100.

Carlson, W. Bernard. "Artifacts and Frames of Meaning: Thomas A. Edison, His Managers, and the Cultural Construction of Motion Pictures." In Wiebe E. Bijker and John Law, eds., *Shaping Technology/Building Society: Studies in Sociotechnical Change*, 175–98. Cambridge: MIT Press, 1992.

——. "Building Thomas Edison's Laboratory at West Orange, New Jersey: A Case Study in Using Craft Knowledge for Technological Invention, 1886–1888." *History of Technology* 13 (1991): 150–67.

Carné, Marcel. "When Will the Cinema Go Down into the Street" (1933). In Abel, ed., *French Film Theory and Criticism* 2:127–28. Originally published as "Quand le cinéma descendra-t-il dans la rue?," *Cinémagazine* 13 (November 1933).

Caron, François and Alain Beltran, "Chapitre III: Conclusion." In Caron and Cardot, eds., *Histoire général de l'électricité en France* 1:454–60.

Caron, François and Fabienne Cardot, eds. *Histoire général de l'électricité en France*. Vol. 1: *Espoirs et conquêtes*. Paris: Fayard, 1991.

Cartwright, Lisa. *Screening the Body: Tracing Medicine's Visual Culture*. Minneapolis: U of Minnesota P, 1995.

Casetti, Francesco. *Eye of the Century: Film, Experience, Modernity*. Translated by Erin Larkin with Jennifer Pranolo. New York: Columbia UP, 2008.

Centre de documentation d'histoire des techniques. *Evolution de la géographie industrielle de Paris et sa proche banlieue au XIXe siècle*. Paris: Conservatoire National des Arts et Métiers, 1976.

Chanan, Michael. *The Dream That Kicks: The Prehistory and Early Years of Cinema in Britain*. 2d ed. London; New York: Routledge, 1996.

Chardère, Bernard, Guy Borgé, and Marjorie Borgé, eds. *Les Lumière*. Lausanne: Payot, 1985.

Charney, Leo. *Empty Moments: Cinema, Modernity, and Drift.* Durham, NC: Duke UP, 1998.

Charney, Leo and Vanessa R. Schwartz, eds. *Cinema and the Invention of Modern Life.* Berkeley: U of California P, 1995.

Chevalier, Michel. "Exposition Universelle: Le fer et la fonte employés dans les constructions monumentales." *Journal des débats* (June 1, 1855).

Claretie, Leo. *La Revue encyclopédique* 154 (March 28, 1896): 50.

Clark, T. J. *The Painting of Modern Life: Paris in the Art of Manet and His Followers.* Princeton, NJ: Princeton UP, 1984.

Clarke, David, ed. *The Cinematic City.* London: Routledge, 1997.

Comolli, Jean-Louis. "Technique and Ideology: Camera, Perspective, Depth of Field [Parts 3 and 4]." In Rosen, ed., *Narrative, Apparatus, Ideology,* 421–43.

Compère, M. *Exposition internationale de Saint Louis (USA) 1904. Section française. Rapport du Département E. [Machines].* Paris: Comité français des expositions à l'étranger, 1906.

Cooper, Mark Garrett. *Universal Women: Filmmaking and Institutional Change in Early Hollywood.* Urbana: U of Illinois P, 2010.

Corcy, Marie-Sophie, Jacques Malthête, and Laurent Mannoni, eds. *Les Premières années de la société Gaumont et Cie: correspondance de Léon Gaumont, 1895–1899.* Paris: Association française de recherche sur l'histoire du cinéma, 1999.

Cordulack, Shelley Wood. "A Franco-American Battle of Beams: Electricity and the Selling of Modernity." *Journal of Design History* 18.2 (2005): 147–66.

Cosandey, Roland and François Albera, eds. *Cinéma sans frontières 1896–1918.* Lausanne: Payot, 1995.

Cosby, Arthur F. *Code of Ordinances of the City of New York.* New York: Banks Law Publishing, 1906.

Crafton, Donald. *Talkies: America's Transition to Sound, 1926–1931.* Berkeley: U of California P, 1999.

Crary, Jonathan. *Suspensions of Perception: Attention, Spectacle, and Modern Culture.* Cambridge: MIT Press, 1999.

——. *Techniques of the Observer: On Vision and Modernity in the Nineteenth Century.* Cambridge: MIT Press, 1990.

William Cronon, *Nature's Metropolis: Chicago and the Great West.* New York: Norton, 1991.

Crouch, Tom D. *Wings: A History of Aviation from Kites to the Space Age.* New York: Norton, 2004.

Dale, R. C. *The Films of René Clair.* Vol. 1. Metuchen, NJ: Scarecrow Press, 1986.

de Pénanrun, Louis Thérèse David, Edmund Augustin Delaire, and Louis François Roux, eds. *Les architectes élèves de l'École des beaux-arts, 1793–1907.* Paris: École nationale supérieure des beaux-arts, 1907.

Decoux, Jérôme. *Montreuil, patrimoine industriel.* Paris: l'Association pour le patrimoine de l'Île-de-France, 2003.

Deslandes, Jacques. *Le Boulevard du cinéma à l'époque de George Méliès.* Paris: Cerf, 1963.

Deslandes, Jacques and Jacques Richard. *Histoire comparée du cinéma*. Vol. 2: *Du ciné-matographe au cinéma, 1896–1906*. Paris: Casterman, 1968.

Deverell, William and Greg Hise, eds. *The Blackwell Companion to Los Angeles*. Cambridge, MA: Blackwell, 2010.

Dickson, William Kennedy Laurie and Antonia Dickson. *History of the Kinetograph, Kinetoscope, and Kinetophonograph*. New York: Albert Bunn, 1895.

Dimendberg, Edward. "Cinema and the Making of a Modern City." In Deverell and Hise, eds., *The Blackwell Companion to Los Angeles*, 346–65.

——. *Film Noir and the Spaces of Modernity*. Cambridge: Harvard UP, 2004.

Doane, Mary Ann. *The Emergence of Cinematic Time: Modernity, Contingency, the Archive*. Cambridge: Harvard UP, 2002.

Douy, Max and Jacques Douy. *Décors de cinéma: Les studios français de Méliès à nos jours*. Paris: Éditions du Collectionneur, 1993.

Dugast, Anne and Isabelle Parizet, eds. *Dictionnaire par noms d'architectes: des constructions élevées à Paris aux XIXe et XXe siècles, Période 1876–1899*. Vol. 3. Paris: Service des Travaux Historiques, 1993.

Dusseau, Joëlle. *Jules Verne*. Paris: Perrin, 2005.

Dyer, Frank L. and Thomas Commerford Martin. *Edison: His Life and Inventions*. Vol. 2. New York: Harper, 1910.

Eckhardt, Joseph. *The King of the Movies; Film Pioneer, Siegmund Lubin*. Madison, NJ: Farleigh Dickinson UP, 1997.

Elsaesser, Thomas, ed. *Early Cinema: Space-Frame-Narrative*. London: British Film Institute, 1990.

Erish, Andrew A. *Col. William N. Selig, the Man Who Invented Hollywood*. Austin: U of Texas P, 2012.

Ethington, Philip J. "*Ab urbe condita*: The Regional Regimes of Los Angeles Since 13,000 Before Present." In Deverell and Hise, eds., *The Blackwell Companion to Los Angeles*, 177–215.

——. "Placing the Past: 'Groundwork' for a Spatial Theory of History." *Rethinking History* 11.4 (2007): 465–93.

Evans, Arthur B. "Jules Verne and the French Literary Canon." In Smyth, ed., *Jules Verne*, 11–39.

——. *Jules Verne Rediscovered: Didacticism and the Scientific Novel*. Westport, CT: Greenwood Press, 1988.

The Facts and Figures About Universal City: The One and Only Incorporated Moving Picture City on the Face of the Globe. Los Angeles: Universal Pictures, 1915.

Faure, Elie. "The Art of Cineplastics" (1922). Translated by Walter Patch. In Abel, ed., *French Film Theory and Criticism* 1:258–67. Originally published as "De la cinéplas-tique," *L'Arbre d'Eden*, 277–304 (Paris: G. Crès, 1922).

Fechner, Christian. "Le Théâtre Robert-Houdin, de Jean Eugène Robert-Houdin à Georges Méliès." In Malthête and Mannoni, eds., *Méliès: magie et cinéma*, 72–115.

Fell, John, ed. *Film Before Griffith*. Berkeley: U of California P, 1983.

Fernett, Gene. *American Film Studios: A Historical Encyclopedia*. Jefferson, NC: McFarland, 1988.

Fielding, Raymond. "Hale's Tours: Ultrarealism in the Pre-1910 Motion Picture." In Fell, ed., *Film Before Griffith*, 116–30.

Fierro, Annette. *The Glass State: The Technology of the Spectacle, Paris, 1981–1998*. Cambridge: MIT Press, 2003.

Fischer, Lucy. "City of Women: Busby Berkeley, Architecture, and Urban Space." *Cinema Journal* 49.4 (2010): 111–30.

——. "'The Shock of the New': Electrification, Illumination, Urbanization, and the Cinema." In Pomerance, ed., *Cinema and Modernity*, 19–37.

Florey, Robert. *Hollywood Village: Naissance des studios de Californie*. Paris: Éditions Pygmalion, 1986.

Ford, Charles. *Auguste Baron: Inventeur et Martyr*. Bois d'Arcy: Service des archives du film du centre national de la cinématographie, 1985.

Foucault, Michel. "Of Other Spaces." Translated by Jay Miskowiec. *Diacrtics* 16.1 (Spring 1986): 22–27. Originally published as "Des Espaces Autres" in *Architecture-Mouvement-Continuité* (October 1984).

Frampton, Kenneth. *Modern Architecture: A Critical History*. New York: Thames and Hudson, 2007.

Frazer, John. *Artificially Arranged Scenes: The Films of Georges Méliès*. Boston: Hall, 1979.

Friedberg, Anne. "Troittoir Roulant: The Cinema and New Mobilities of Spectatorship." In John Fullerton and Jan Olsson, eds., *Allegories of Communication: Intermedial Concerns from Cinema to the Digital*, 263–76. Rome: John Libbey, 2004.

——. *The Virtual Window: From Alberti to Microsoft*. Cambridge: MIT Press, 2006.

——. *Window Shopping: Cinema and the Postmodern*. Berkeley: U of California P, 1993.

Galison, Peter. "Buildings and the Subject of Science." In Galison and Thompson, eds., *The Architecture of Science*, 1–25.

Galison, Peter and Caroline A. Jones. "Factory, Laboratory, Studio: Dispersing Sites of Production." In Galison and Thompson, eds., *The Architecture of Science*, 497–540.

Galison, Peter and Emily Thompson, eds. *The Architecture of Science*. Cambridge: MIT Press, 1999.

Gandy, Matthew. *Concrete and Clay: Reworking Nature in New York City*. Cambridge: MIT Press, 2002.

Garçon, François. *Gaumont, un siècle du cinéma*. Paris: Gallimard, 1994.

Gartenberg, Jon. "Vitagraph Before Griffith: Forging Ahead in the Nickelodeon Era." *Studies in Visual Communication* 10.4 (Fall 1984): 7–23.

Gaycken, Oliver. "The Cinema of the Future: Visions of the Medium as Modern Educator, 1895–1910." In Devin Orgeron, Marsha Orgeron, and Dan Streible, eds., *Learning with the Lights Off: Educational Film in the United States*, 67–89. Durham, NC: Duke UP, 2011.

——. "Devices of Curiosity: Cinema and the Scientific Vernacular." PhD diss., University of Chicago, 2005.

Gaudreault, André. "Detours in Film Narrative: The Development of Cross-Cutting." *Cinema Journal* 19 (Fall 1979): 39–59.

Gaudreault, André, Catherine Russell and Pierre Véronneau, eds. *Le Cinématographe, nouvelle technologie du XXe siècle = The Cinema, A New Technology for the 20th Century* (French and English). Lausanne: Éditions Payot, 2004.

Giedion, Sigfried. *Building in France, Building in Iron, Building in Ferroconcrete.* Translated by J. Duncan Berry. Santa Monica, CA: Getty Center for the History of Art and the Humanities, 1995. Originally published as *Bauen in Frankreich, bauen in Eisen, bauen in Eisenbeton* (1928).

——. *Mechanization Takes Command: A Contribution to Anonymous History.* London: Oxford UP, 1948.

——. *Space, Time, and Architecture: The Growth of a New Tradition.* Cambridge: Harvard UP, 1941.

Gille, Bertrand. *Histoires des techniques.* Paris: Gallimard, 1978.

Giret, Noëlle. "Les Studios Gaumont." In Philippe d'Hugues and Dominique Muller, eds., *Gaumont, 90 ans de cinéma,* 101–107. Paris: Ramsey/La Cinémathèque Française, 1986.

Grau, Robert. *The Theatre of Science: A Volume of Progress and Achievement in the Motion Picture Industry.* New York: Broadway Publishing, 1914.

Griffiths, Alison. *Wondrous Difference: Cinema, Anthropology, and Turn-of-the-Century Visual Culture.* New York: Columbia UP, 2002.

Guerin, Frances. *A Culture of Light: Cinema and Technology in 1920s Germany.* Minneapolis: U of Minnesota P, 2005.

Guneratne, Anthony R. "The Birth of a New Realism: Photography, Painting and the Advent of Documentary Cinema." *Film History* 10.2 (1998): 165–87.

Gunning, Tom. "An Aesthetic of Astonishment: Early Film and the (In)Credulous Spectator." *Art and Text* 34 (Spring 1989): 31–43.

——. "The Cinema of Attractions: Early Film, Its Spectators and the Avant-Garde." *Wide Angle* 8.3/4 (Fall 1986): 63–70. Reprinted in Elsaesser, *Early Cinema,* 56–62.

——. *D. W. Griffith and the Origins of American Narrative Film: The Early Years at Biograph.* Urbana: U of Illinois P, 1991.

——. "Embarrassing Evidence: The Detective Camera and the Documentary Impulse." In Jaine M. Gaines and Michael Renov, eds., *Collecting Visible Evidence,* 46–64. Minneapolis: U of Minnesota P, 1999.

——. "From the Kaleidoscope to the X-Ray: Urban Spectatorship, Poe, Benjamin, and *Traffic in Souls* (1913)." *Wide Angle* 19.4 (October 1997): 25–61.

——. "Landscape and the Fantasy of Moving Pictures: Early Cinema's Phantom Rides." In Graeme Harper and Jonathan Rayner, eds., *Cinema and Landscape: Film, Nation and Cultural Geography,* 31–70. Bristol: Intellect, 2010.

——. "Modernity and Cinema: A Culture of Shocks and Flows." In Pomerance, ed., *Cinema and Modernity,* 297–315.

——. "Non-Continuity, Continuity, Discontinuity: A Theory of Genres in Early Films." In Elsaesser, ed., *Early Cinema,* 86–94.

——. "Phantasmagoria and the Manufacturing of Illusions and Wonder: Towards a Cultural Optics of the Cinematic Apparatus." In Gaudreault, Russell, and Veronneau, eds., *The Cinema, A New Technology for the 20th Century*, 31–44.

——. "Phantom Images and Modern Manifestations: Spirit Photography, Magic Theater, Trick Films, and Photography's Uncanny." In Petro, ed., *Fugitive Images*, 42–71.

——. "Systematizing the Electric Message: Narrative Form, Gender, and Modernity in *The Lonedale Operator*." In Keil and Stamp, eds., *American Cinema's Transitional Era*, 15–50.

——. "Tracing the Individual Body: Photography, Detectives, and Early Cinema." In Charney and Schwartz, eds., *Cinema and the Invention of Modern Life*, 14–45.

——. "An Unseen Energy Swallows Space: The Space in Early Film and Its Relation to American Avant-Garde Film." In Fell, ed., *Film Before Griffith*, 355–66.

Hallion, Richard. *Taking Flight: Inventing the Aerial Age from Antiquity Through the First World War*. Oxford: Oxford UP, 2003.

Hammond, Paul. *Marvelous Méliès*. London: Fraser, 1974.

Hansen, Miriam. "America, Paris, the Alps: Kracauer (and Benjamin) on Cinema and Modernity." In Charney and Schwartz, eds., *Cinema and the Invention of Modern Life*, 362–402.

——. *Babel and Babylon: Spectatorship in American Silent Film*. Cambridge: Harvard UP, 1991.

——. "Benjamin, Cinema and Experience: 'The Blue Flower' in the Land of Technology." *New German Critique* 40, Special Issue on Weimar Film Theory (Winter 1987): 179–224.

——. *Cinema and Experience: Siegfried Kracauer, Walter Benjamin, and Theodor W. Adorno*. Berkeley: U of California P, 2012.

Harris, Gale. *Louis A. and Laura Stirn House* (LP-2069). New York: Landmarks Preservation Commission, 2001.

Harris, Neil. *Humbug: The Art of P. T. Barnum* (1973). Rpt., Chicago: U of Chicago P, 1981.

Heidegger, Martin. "The Age of the World Picture." In *The Question Concerning Technology and Other Essays*, 115–54. Translated by William Lovitt. New York: Harper and Row, 1977. Published in German as "Die Zeit des Weltbildes," *Holzwege*, 69–104 (Frankfurt am Main: Vittorio Klostermann, 1950).

——. "The Question Concerning Technology." In *The Question Concerning Technology and Other Essays*, 3–35. Translated by William Lovitt. New York: Harper and Row, 1977. Published in German as "Die Frage nach der Technik," *Vorträge und Aufsätze*, 13–44 (Pfullingen: Günther Neske Verlag, 1954).

Hendricks, Gordon. *The Edison Motion Picture Myth*. Berkeley: U of California P, 1961.

Hepworth, Cecil B. *Animated Photography: The ABC of the Cinematograph*. London: Hazell, Watson and Viney, 1900.

Horak, Jan-Christopher. "Paul Strand and Charles Sheeler's *Manhatta*." In Horak, ed., *Lovers of Cinema*, 267–87.

Horak, Jan-Christopher, ed. *Lovers of Cinema: The First American Avant-Garde, 1919–1945*. Madison: U of Wisconsin P, 1995.

Huet, Marie-Hélène. *The Culture of Disaster*. Chicago: U of Chicago P, 2012.

Hughes, Thomas P. *American Genesis: A Century of Invention and Technological Enthusiasm, 1870–1970*. New York: Viking Penguin, 1989; rpt., Chicago: U of Chicago P, 2004.

——. *Human-Built World: How to Think About Technology and Culture*. Chicago: U of Chicago P, 2004.

——. *Networks of Power: Electrification in Western Society, 1880–1930*. Baltimore: Johns Hopkins UP, 1983.

"Hugo Kafka" (obituary). *American Institute of Architects Journal* 3 (1915): 305.

Israel, Paul. *Edison: A Life of Invention*. New York: John Wiley, 1998.

——. *From Machine Shop to Industrial Laboratory: Telegraphy and the Changing Context of American Invention*. Baltimore: Johns Hopkins UP, 1992.

Jacob, Mary Jane and Michelle Grabner, eds. *The Studio Reader: On the Space of Artists*. Chicago: U of Chicago P, 2010.

Jacobson, Brian R. "Fantastic Functionality: Studio Architecture and the Visual Rhetoric of Early Hollywood," *Film History* 26.2 (2014): 52–81.

——. "The 'imponderable fluidity' of Modernity: Georges Méliès and the Architectural Origins of Cinema." *Early Popular Visual Culture* 8.2 (May 2010): 189–207.

——. "Infrastructure and Intermediality: Network Archaeology at Gaumont's Cité Elgé." *Amodern* 2 (2013): available at http://amodern.net/article/infrastructure-and-intermediality/.

James, Frank A. J. L., ed. *The Development of the Laboratory: Essays on the Place of Experiment in Industrial Civilization*. Basingstoke: Macmillan Press, 1989.

Jenkins, Henry. *Convergence Culture: Where Old and New Media Collide*. New York: NYU Press, 2006.

Jonnes, Jill. *Empires of Light: Edison, Tesla, Westinghouse, and the Race to Electrify the World*. New York: Random House, 2003.

Katz, Cécile and Jérôme Decoux, eds. Base Architecture-Mérimée, Ministère de la Culture de la France, direction de l'Architecture et du Patrimoine, Ref. IA93000054. Inventaire général, 2000.

Keating, Patrick. "From the Portrait to the Close-Up: Gender and Technology in Still Photography and Hollywood Cinematography." *Cinema Journal* 45.3 (2006): 90–108.

——. *Hollywood Lighting from the Silent Era to Film Noir*. New York: Columbia UP, 2009.

Keil, Charlie. " 'To Here From Modernity': Style, Historiography, and Transitional Cinema." In Keil and Stamp, eds., *American Cinema's Transitional Era*, 51–65.

Keil, Charlie and Shelley Stamp. "Introduction." In Keil and Stamp, eds., *American Cinema's Transitional Era*, 1–11.

Keil, Charlie and Shelley Stamp, eds. *American Cinema's Transitional Era: Audiences, Institutions, Practices*. Berkeley: U of California P, 2004.

Kern, Stephen. *The Culture of Time and Space 1880–1918*. Cambridge: Harvard University Press, 1983.

Kirby, Lynne. *Parallel Tracks: The Railroad and Silent Cinema*. Durham, NC: Duke UP, 1997.

Kittler, Friedrich. *Optical Media: Berlin Lectures, 1999*. Translated by Anthony Enns. Cambridge: Polity Press, 2010. Originally published as *Optische Medien / Berlin Vorlesung 1999* (2002).

Koerber, Martin. "Oskar Messter, Film Pioneer: Early Cinema Between Science, Spectacle, and Commerce." In Thomas Elsaesser, ed., *A Second Life: German Cinema's First Decades*, 51–61. Amsterdam: Amsterdam UP, 1996.

Kohlmaier, Georg and Barna von Sartory. *Houses of Glass: A Nineteenth-Century Building Type*. Translated by John C. Harvey. Cambridge: MIT Press, 1986. Originally published as *Das Glashaus. Ein Bautypus des 19. Jahrhunderts* (Munich: Prestel-Verlag, 1981).

Koszarski, Richard. *Fort Lee: The Film Town*. Rome: John Libbey, 2004.

Kracauer, Siegfried. "Calico World: The Ufa City in Neubabelsberg." In Neumann, ed., *Film Architecture*, 191–93. Originally published as "Kalikowelt," in *Frankfurter Zeitung* (January 18, 1926).

——. *From Caligari to Hitler: A Psychological History of the German Film*. Princeton, NJ: Princeton UP, 1947.

——. *Theory of Film: The Redemption of Physical Reality*. London and New York: Oxford UP, 1960.

Krauss, Linda and Patrice Petro, eds. *Global Cities: Cinema, Architecture, and Urbanism in a Digital Age*. New Brunswick, NJ: Rutgers UP, 2003.

Kreimeier, Klaus. *The Ufa Story: A History of Germany's Greatest Film Company, 1918–1945*. Translated by Robert Kimber and Rita Kimber. New York: Hill and Wang, 1996. Originally published as *Die UFA-Story: Geschichte eines Filmkonzerns* (Frankfurt: Fischer, 2002).

Lahue, Kalton C., ed. *Motion Picture Pioneer: The Selig Polyscope Company*. South Brunswick, NJ: A. S. Barnes, 1973.

Lamster, Mark, ed. *Architecture and Film*. New York: Princeton Architectural Press, 2000.

Larkin, Brian. *Signal and Noise: Media, Infrastructure, and Urban Culture in Nigeria*. Durham, NC: Duke UP, 2008.

Lastra, James. *Sound Technology and the American Cinema: Perception, Representation, Modernity*. New York: Columbia UP, 2000.

Laurent, Hugues. "Le Décor de cinéma et les décorateurs." *Bulletin de l'association françaises des ingénieurs et technicians du cinéma* 16 (1957): 3–11.

Lawton, Stephen. *Santa Barbara's Flying A Studio*. Santa Barbara: Fithian Press, 1997.

Le Film Vierge Pathé: Manuel de développement et de tirage. Paris: Les Etablissements Pathé-Cinéma, 1926.

Lea, Matthew Carey. *A Manual of Photography*. Philadelphia: Benerman and Wilson, 1868.

Leary, Thomas E. and Elizabeth C. Sholes with the Buffalo and Erie County Historical Society. *Buffalo's Pan-American Exposition*. Charleston, SC: Arcadia, 1998.

Lefebvre, Henri. *The Production of Space*. Translated by Donald Nicholson-Smith. Malden, MA: Blackwell, 1991. Originally published as *La production de l'espace* (Paris: Éditions Anthropos, 1974).

Lefebvre, Thierry. "Le Voyage dans la Lune, Film Composite." In Malthête and Mannoni, eds., *Méliès: magie et cinéma*, 171–209.

———. "L'usine de Joinville, établissement dangereux," In Marie and Le Forestier, eds., *La Firme Pathé Frères*, 49–58.

Le Forestier, Laurent. *Aux sources de l'industrie du cinéma: le modèle Pathé, 1905–1908*. Paris: L'Harmattan, 2006.

———. "L'Enregistrement Fantastique, ou Quelques Réflexions sur la Nature et l'Utilisation des Trucages Méliésiens." In Malthête and Mannoni, eds., *Méliès: magie et cinéma*, 211–39.

Lescarboura, Austin Celestin. *Behind the Motion-Picture Screen*. New York: Scientific American, 1921.

Leyda, Jay. *Kino: A Short History of the Russian and Soviet Film*. Princeton, NJ: Princeton UP, 1983.

Lobel, Léopold. "L'évolution des ateliers de traitement de films." *La Technique cinématographique* 100/101 (July–August 1950): 183–84.

———. "Quelques Souvenirs," *La Technique cinématographique* 100/101 (July–August 1950): 181–83.

Lottman, Herbert R. *Jules Verne: An Exploratory Biography*. New York: St. Martin's, 1996.

Low, Rachel and Roger Manvell. *The History of the British Film, 1896–1906*. New York: Routledge, 1997.

Lyons, Timothy J. *The Silent Partner: the History of the American Film Manufacturing Company* (1972). Rpt., New York: Arno Press, 1974.

Maass, John. *The Glorious Enterprise: The Centennial Exhibition of 1876 and H. J. Schwarzmann, Architect-in-Chief*. Watkins Glen, N.Y.: American Life Foundation, 1973.

Mallet-Stevens, Robert. "Le cinéma et les arts; l'architecture." *Les cahiers du mois* 16/17 (1925): 95–98.

Malthête, Jacques. "L'appentis sorcier de Montreuil-sous-Bois." In André Gaudreault and Laurent Le Forestier, eds., in collaboration with Stéphane Tralongo, correspondence edited by Jacques Malthête, *Méliès, carrefour des attractions: Suivi de Correspondances de Georges Méliès (1905–1937)*, 145–56. Rennes: Presses Universitaires de Rennes, 2014.

———. "Les Deux Studios de Georges Méliès." In Malthête and Mannoni, eds., *Méliès: magie et cinéma*, 134–69.

———. *Méliès: images et illusions*. Paris: Exporégie, 1996.

———. "Méliès, technicien du collage." In Malthête-Méliès, ed., *Méliès et la naissance du spectacle cinématographique*, 169–84.

Malthête, Jacques and Laurent Mannoni, eds. *Méliès: magie et cinéma: Espace EDF electra, 26 avril-1er septembre 2002.* Paris: Paris musées, 2002.

Malthête-Méliès, Madeleine. *Méliès l'enchanteur.* Paris: Hachette, 1973.

Malthête-Méliès, Madeleine, ed. *Méliès et la naissance du spectacle cinématographique.* Paris: Klincksieck, 1984.

Malthête-Méliès, Madeleine, Anne-Marie Quevrain, and Jacques Malthête, eds. *Essai de reconstitution du catalogue français de la Star-Film.* Bois d'Arcy: Service des Archives du Film, 1980.

Mannoni, Laurent. *Le Grand art de la lumière et de l'ombre: Archéologie du cinéma.* Paris: Nathan Université, 1994.

——. "Les Studios Pathé de la Région Parisienne (1896–1914)." In Marie and Le Forestier, eds., *La Firme Pathé Frères,* 59–106.

Mannoni, Laurent and Jacques Malthête. *L'Oeuvre de Georges Méliès.* Paris: Éditions de la Martinière, 2008.

Manovich, Lev. *The Language of New Media.* Cambridge: MIT Press, 2002.

Mareschal, G. "L'éclairage dans les studios." *La Technique cinématographique* 100/101 (July–August 1950): 185–86.

——. "L'Évolution des machines à developer les films cinématographiques depuis 50 ans." *Bulletin de l'association française des ingéneiurs et techniciens du cinéma* 6.11 (1952): 3–8.

Marey, Étienne-Jules. "Photography of Moving Objects, and the Study of Animal Movement by Chrono-Photography." *Scientific American Supplement* 579 (February 5, 1887): 9245.

Marie, Michel, and Laurent Le Forestier, eds. *La Firme Pathé Frères, 1896–1914.* Paris: AFRHC, 2004.

Marsh, Allison C. "The Ultimate Vacation: Watching Other People Work, A History of Factory Tours in America, 1880–1950." PhD diss., Johns Hopkins University, 2008.

Marx, Leo. *The Machine in the Garden: Technology and the Pastoral Ideal in America* (1964). Rpt., Oxford: Oxford UP, 2000.

McCauley, Elizabeth Anne. *A. A. E. Disdéri and the Carte De Visite Portrait Photograph.* New Haven: Yale UP, 1985.

——. *Industrial Madness: Commercial Photography in Paris, 1848–1871.* New Haven: Yale UP, 1994.

McKenna, Denise M. "The City That Made the Pictures Move: Gender, Labor, and the Film Industry in Los Angeles, 1908–1917." PhD diss., New York University, 2008.

Meakin, David. "Future Past: Myth, Inversion and Regression in Verne's Underground Utopia." In Smyth, ed., *Jules Verne,* 94–108.

Meeks, Carroll. *The Railroad Station: An Architectural History.* New Haven: Yale UP, 1956.

Méliès, Georges. "Cinematographic Views." Translated by Stuart Liebman. *October* 29 (Summer 1984): 24–34. Originally published as "Les Vues Cinématographiques," in *Annuaire général et international de la photographie,* 362–92 (Paris: Plon, 1907).

——. "J'ai construit le premier studio du monde: il y a 40 ans." *Pour Vous: le plus grand hebdomadaire du cinéma* (December 1, 1937).

———. *La Vie et l'oeuvre d'un pionnier du cinéma*. Édition établie et présentée par Jean-Pierre Sirois-Trahan. Paris: Les Éditions du Sonneur, 2012.

———. "Propos sur les vues animées." In Pierre Véronneau, ed., *Dossiers de la Cinématheque* 10: 17–18. Quebec: La Cinémathèque québécoise—Musée du cinéma, 1982.

Meusy, Jean-Jacques. *Paris-Palaces ou le temps des cinémas (1894–1918)*. Paris: CNRS, 1996.

Meyer, Adolf Gotthold. *Construire en fer: Histoire et esthétique*. Translated by Marielle Roffi and Léo Biétry. Paris: Infolio, 2005. Originally published as *Eisenbauten: ihre Geschichte und Aesthetik* (1907).

Millard, André J. *America on Record: A History of Recorded Sound*. Cambridge: Cambridge UP, 1995.

Millard, André J., Duncan Hay, and Mary Grassick. *Edison Laboratory: Edison National Historic Site, West Orange, New Jersey*. Harpers Ferry, WV: Division of Historic Furnishing, Harpers Ferry Center, National Park Service, 1995.

Misa, Thomas J., Philip Brey, and Andrew Feenberg, eds, *Modernity and Technology*. Cambridge: MIT Press, 2003.

Mitry, Jean. *Histoire du cinéma: art et industrie*. Vol. 1: *1895–1914*. Paris: Éditions universitaires, 1968.

Morsel, Henri. "L'Électricité thermique." In Caron and Cardot, eds., *Histoire général de l'électricité en France* 1:551–93.

Morton, David L. *Sound Recording: The Life and Story of a Technology*. Westport, CT: Greenwood Press, 2004.

Mottram, Roy. *The Danish Film Before Dreyer*. Metuchen, NJ: Scarecrow Press, 1988.

Mumford, Lewis. *Sticks and Stones: A Study of American Architecture and Civilization*. New York: Boni and Liveright, 1924.

———. *The Story of Utopias*. New York: Boni and Liveright, 1922.

———. *Technics and Civilization*. New York: Harcourt, Brace, 1934.

Musée des Arts Décoratifs. *Exposition commémorative du centenaire de Georges Méliès*. Paris: Musée des arts décoratifs, 1961.

Musser, Charles. "The American Vitagraph, 1897–1901: Survival and Success in a Competitive Industry." In Fell, ed., *Film Before Griffith*, 22–66.

———. *Before the Nickelodeon: Edwin S. Porter and the Edison Manufacturing Company*. Berkeley: U of California P, 1991.

———. "The Early Cinema of Edwin Porter." *Cinema Journal* 19 (Fall 1979): 1–38.

———. *The Emergence of Cinema: The American Screen to 1907*. New York: Scribner, 1990.

———. "The Travel Genre in 1903–1904: Moving Towards Fictional Narrative." *Iris* 2.1 (1984): 47–59. Reprinted in Elsaesser, ed., *Early Cinema*, 123—32.

Neumann, Dietrich. " 'The Century's Triumph in Lighting': The Luxfer Prism Companies and Their Contribution to Early Modern Architecture." *Journal of the Society of Architectural Historians* 54.1 (March 1995): 24–53.

Neumann, Dietrich, ed. *Film Architecture: Set Designs from* Metropolis *to* Blade Runner. Munich and New York: Prestel-Verlag, 1996.

"The New Orleans Exposition." *New York Times*, February 17, 1884, and March 5, 1884.

Niver, Kemp. *Biograph Bulletins, 1896–1908*. Los Angeles: Artisan Press, 1971.

——. *Motion Pictures from the Library of Congress Paper Print Collection, 1894–1912*. Berkeley: U of California P, 1967.

Noverre, Maurice. "L'oeuvre de Georges Méliès: Étude retrospective sur le premier 'studio cinématographique' machine pour la prise de vues théâtrales." *Le Nouvel Art cinématographique* 2.3 (Brest, July 1929): 64–83.

Nowell-Smith, Geoffrey. "Cities: Real and Imagined." In Shiel and Fitzmaurice, eds., *Cinema and the City*, 99–108.

Nye, David E. *American Technological Sublime*. Cambridge: MIT Press, 1994.

——. *Electrifying America: Social Meanings of a New Technology, 1880–1940*. Cambridge: MIT Press, 1990.

O'Brien, Charles. *Conversion to Sound: Technology and Film Style in France and the U.S.* Bloomington: Indiana UP, 2005.

Page, Max. *The Creative Destruction of Manhattan, 1900–1940*. Chicago: U of Chicago P, 1999.

Pathé, Charles. *De Pathé frères à Pathé cinéma* (1939). Rpt., Lyon: SERDOC, 1970.

Penz, François and Maureen Thomas, eds. *Cinema and Architecture: Méliès, Mallet-Stevens, Multimedia*. London: British Film Institute, 1997.

Peterson, Jennifer Lynn. *Education in the School of Dreams: Travelogues and Early Nonfiction Film*. Durham, NC: Duke UP, 2013.

——. "Travelogues and Early Nonfiction Film: Education in the School of Dreams." In Keil and Stamp, eds., *American Cinema's Transitional Era*, 191–213.

Petro, Patrice, ed. *Fugitive Images: From Photography to Video*. Bloomington: Indiana UP, 1995.

Pike, David L. *Subterranean Cities: The World Beneath Paris and London, 1800–1945*. Ithaca, NY: Cornell UP, 2005.

Pomerance, Murray, ed. *Cinema and Modernity*. New Brunswick: Rutgers University Press, 2006.

Pratt, George C. *Spellbound in Darkness: A History of the Silent Film*. Greenwich, NY: New York Graphic Society, 1973.

Les Premières feuilles de la marguerite: Affiches Gaumont, 1905–1914. Paris: Gallimard, 1994.

Prout, Henry G. *A Life of George Westinghouse*. New York: American Society of Mechanical Engineers, 1921.

Rabinowitz, Lauren. *For the Love of Pleasure: Women, Movies, and Culture in Turn-of-the Century Chicago*. New Brunswick, NJ: Rutgers UP, 1998.

Rae, John, "The Application of Science to Industry." In Alexandra Oleson and John Voss, eds., *The Organization of Knowledge in America, 1860–1920*, 249–68. Baltimore: Johns Hopkins UP, 1979.

Ramírez, Juan Antonio. *Architecture for the Screen: A Critical Study of Set Design in Hollywood's Golden Age*. Translated by John F. Moffitt. Jefferson, NC: McFarland, 2004.

Ramsaye, Terry. *A Million and One Nights: A History of the Motion Picture Through 1925*. New York: Simon and Schuster, 1926.

Rathbun, John B. *Motion Picture Making and Exhibiting*. Chicago: Charles C. Thompson, 1914.

Relph, Edward C. *The Modern Urban Landscape: 1880 to the Present*. Baltimore: Johns Hopkins UP, 1987.

Renzi, Thomas C. *Jules Verne on Film: A Filmography of the Cinematic Adaptations of His Works, 1902 Through 1997*. Jefferson, NC: McFarland, 1998.

Revell, Keith. *Building Gotham: Civic Culture and Public Policy in New York City, 1898–1938*. Baltimore: Johns Hopkins UP, 2003.

Rigaud, Jean-Luc. "Un patrimoine disparaît: Recherches autour du cas de l'industrie du disque à Chatou." Memoire de master II Histoire des Techniques, Université Paris 1 Panthéon-Sorbonne, 2009.

Rittaud-Hutinet, Jacques, ed. *Auguste et Louis Lumière: Correspondances, 1890–1953*. Paris: Cahiers du cinéma, 1994.

Robinson, Henry Peach. *The Studio and What to Do in It*. London: Piper and Carter, 1891.

Roney, Fatimah Tobing. *The Third Eye: Race, Cinema, and Ethnographic Spectacle*. Durham, NC: Duke UP, 1996.

Rossell, Deac. *Living Pictures: The Origins of the Movies*. Albany: State University of New York Press, 1998.

Rosen, Philip, ed. *Narrative, Apparatus, Ideology: A Film Theory Reader*. New York: Columbia UP, 1986.

Ross, Steven J. "How Hollywood Became Hollywood: Money, Politics, and Movies." In Tom Sitton and William Deverell, eds., *Metropolis in the Making: Los Angeles in the 1920s*, 255–76. Berkeley: U of California P, 2001.

——. *Working-Class Hollywood: Silent Film and the Shaping of Class in America*. Princeton, NJ: Princeton UP, 1998.

Ruoff, Jeffrey, ed. *Virtual Voyages: Cinema and Travel*. Durham, NC: Duke UP, 2006.

Sadoul, Georges. *Georges Méliès*. Paris: Éditions Seghers, 1961.

——. *Histoire générale du cinéma*. Vol. 1: *L'Invention du cinéma, 1832–1897*. Paris: Denoël, 1948.

——. *Histoire générale du cinéma*. Vol. 2: *Les Pionniers du cinéma, 1897–1909*. Paris: Denoël, 1948.

——. *Lumière et Méliès*. Paris: Lherminier, 1985.

Salmon, Stéphanie. "Les Débuts d'une industrialization Pathé (1898–1903)." *Archives* 93 (Institut Vigo—Cinémathèque de Toulouse) (June 2003): 1–12.

——. *Pathé: À la conquête du cinéma, 1896–1929*. Paris: Éditions Tallandier, 2014.

Salt, Barry. "Dissolved Away." *The Velvet Light Trap* 64 (Fall 2009): 79.

——. "Film Form: 1890–1906." In Elsaesser, ed., *Early Cinema*, 31–44.

——. "Film Form, 1900–1906." *Sight and Sound* 47 (Summer 1978): 148–53.

——. *Film Style and Technology: History and Analysis*. London: Starword, 1983.

Sandberg, Mark B. *Living Pictures, Missing Persons: Mannequins, Museums, and Modernity.* Princeton, NJ: Princeton UP, 2003.

——. "Location, 'Location': On the Plausibility of Place Substitution." In Jennifer M. Bean, Anupama Kapse, and Laura Horak, eds., *Silent Cinema and the Politics of Space,* 23–46. Bloomington: Indiana UP, 2014.

Sauteron, François. "Scènes de la vie telle qu'elle est." *Ciné-Journal* 139 (April 22, 1911): 19. Trans. and reprinted in Abel, ed., *French Film Theory and Criticism* 1:54.

——. *Une si jolie usine: Kodak-Pathé Vincennes.* Paris: L'Harmattan, 2008.

Schwartz, Vanessa R. *Spectacular Realities: Early Mass Culture in Fin-De-Siècle Paris.* Berkeley: U of California P, 1998.

Schivelbusch, Wolfgang. *Disenchanted Night: The Industrialization of Light in the Nineteenth Century.* Berkeley: U of California P, 1988.

——. *The Railway Journey: The Industrialization of Time and Space in the 19th Century.* Berkeley: U of California P, 1986.

Scott, Allen J. *On Hollywood: The Place, the Industry.* Princeton, NJ: Princeton UP, 2005.

Serres, Michel. *Jouvences sur Jules Verne.* Paris: Éditions de Minuit,, 1974.

Shapin, Steven and Simon Schaffer. *Leviathan and the Air-Pump: Hobbes, Boyle, and the Experimental Life.* Princeton, NJ: Princeton UP, 1985.

Shiel, Mark. "Cinema and the City in History and Theory." In Shiel and Fitzmaurice, eds., *Cinema and the City,* 1–18.

——. *Hollywood Cinema and the Real Los Angeles.* London: Reaktion Books, 2012.

Shiel, Mark and Tony Fitzmaurice, eds. *Cinema and the City: Film and Urban Societies in a Global Context.* Oxford: Blackwell, 2001.

——, eds. *Screening the City.* London: Verso, 2003.

Simmon, Scott. *The Invention of the Western Film: A Cultural History of the Genre's First Half Century.* Cambridge: Cambridge UP, 2003.

Simpson, Pamela H. "Quick, Cheap, and Easy: The Early History of Rockfaced Concrete Block Building." *Perspectives in Vernacular Architecture* 3 (1989): 108–118.

Singer, Ben. *Melodrama and Modernity: Early Sensational Cinema and Its Contexts.* New York: Columbia UP, 2001.

Sklar, Robert. *Movie-Made America: A Cultural History of American Movies.* New York: Vintage Books, 1975.

Slaton, Amy E. *Reinforced Concrete and the Modernization of American Building, 1900–1930.* Baltimore: Johns Hopkins UP, 2001.

Slide, Anthony. *The Big V: A History of the Vitagraph Company.* Metuchen, NJ: Scarecrow Press 1976.

——. *Early American Cinema* (1970). Rev. ed. Metuchen, NJ: Scarecrow Press, 1994.

Smyth, Edmund J. "Verne, SF, and Modernity: An Introduction." In Smyth, ed., *Jules Verne,* 1–10.

Smyth, Edmund J., ed. *Jules Verne: Narratives of Modernity.* Liverpool: Liverpool UP, 2000.

Solomon, Matthew. *Disappearing Tricks: Silent Film, Houdini, and the New Magic of the Twentieth Century.* Urbana: Illinois UP, 2010.

Sopocy, Martin. "A Narrated Cinema: The Pioneer Story Films of James A. Williamson." *Cinema Journal* 10 (Fall 1978): 1–28.

Soppelsa, Peter S. "Finding Fragility in Paris: The Politics of Infrastructure After Haussmann." *Proceedings of the Western Society for French History* 37 (2009): 233–47.

——. "The Fragility of Modernity: Infrastructure and Everyday Life in Paris, 1870–1914." PhD diss., University of Michigan, 2009.

Spehr, Paul. *The Man Who Made Movies: W. K. L. Dickson*. Eastleigh: John Libbey, 2008.

Starr, Kevin. *Material Dreams: Southern California Through the 1920s*. New York: Oxford UP, 1990.

Stewart, Jacqueline Najuma. *Migrating to the Movies: Cinema and Black Urban Modernity*. Berkeley: U of California P, 2005.

Stovall, Tyler. *The Rise of the Paris Red Belt*. Berkeley: U of California P, 1990.

Suárez, Juan A. "City Space, Technology, Popular Culture: The Modernism of Paul Strand and Charles Sheeler's 'Manhatta.'" *Journal of American Studies* 36.1 (2002): 85–106.

Svedja, George J. *The 'Black Maria' Site Study: Edison National Historic Site, West Orange, NJ*. Washington, D.C.: Division of History, Office of Archaeology and Preservation, 1969.

Talbot, Frederick A. *Moving Pictures: How They Are Made and Worked*. Rev. ed. London: Heinemann, 1912; Philadelphia: Lippincott, 1912.

Tsivian, Yuri. *Early Cinema in Russia and Its Cultural Reception*. Translated by Alan Bodger, with a foreword by Tom Gunning. New York: Routledge, 1994.

Unwin, Timothy. "The Fiction of Science, or the Science of Fiction." In Smyth, ed., *Jules Verne*, 46–59.

——. *Jules Verne: Journeys in Writing*. Liverpool: Liverpool UP, 2005.

Uricchio, William. "The City Viewed: The Films of Leyda, Browning, and Weinberg." In Horak, ed., *Lovers of Cinema*, 287–314.

Uricchio, William and Roberta Pearson. *Reframing Culture: The Case of the Vitagraph Quality Films*. Princeton, NJ: Princeton UP, 1993.

Venhard, Gilles. "Les vertes années de la marguerite, 1896–1924." In Philippe d'Hugues and Dominique Muller, eds., *Gaumont, 90 ans de cinéma*, 18–33. Paris: Ramsey/La Cinémathèque Française, 1986.

Venturi, Robert. "Thoughts on the Architecture of the Scientific Workplace: Community, Change, Continuity." In Galison and Thompson, eds., *The Architecture of Science*, 385–98.

Verhoeff, Nanna. *The West in Early Cinema: After the Beginning*. Amsterdam: Amsterdam UP, 2006.

Vidler, Anthony. "The Explosion of Space: Architecture and the Filmic Imaginary." In *Warped Space: Art, Architecture, and Anxiety in Modern Culture*, 99–110. Cambridge: MIT Press, 2000.

Virilio, Paul. *The Lost Dimension*. Translated by Daniel Moshenberg. New York: Semiotext(e), 1991.

Vivié, Jean. "Le Premier studio d'enregistrement de films sonores fut montée en 1898 à Asnières par A. Baron." *Bulletin de l'association française des ingénieurs et techniciens du cinéma* 24.30 (1970): 6–10.

Wannamaker, Marc and Harry Medved. *Location Filming in Los Angeles*. Charleston, S.C.: Arcadia, 2010.

Watkin, David. *A History of Western Architecture* (1986). 4th ed. London: Laurence King, 2005.

Weber, Samuel. "Mass Mediauras, or: Art, Aura and Media in the Work of Walter Benjamin." In *Mass Mediauras: Form, Technics, Media*, 76–108. Palo Alto: Stanford UP, 1996.

——. "Upsetting the Setup: Remarks on Heidegger's 'Questing After Technics.'" In *Mass Mediauras*, 55–75.

Weihsmann, Helmut. "The City in Twilight: Charting the Genre of the 'City Film', 1900–1930." In Penz and Thomas, eds., *Cinema and Architecture*, 8–27.

Weiss, Mark A. "Skyscraper Zoning: New York's Pioneering Role." *Journal of the American Planning Association* 58.2 (1992): 201–212.

Weitze, Karen J. *California's Mission Revival*. Los Angeles: Hennessey and Ingalls, 1984.

Westcott, Thompson. *Centenniel Portfolio: A Souvenir of the International Exhibition at Philadelphia*. Philadelphia: Thomas Hunter, 1876.

Whissel, Kristen. *Picturing American Modernity: Traffic, Technology, and the Silent Cinema*. Durham, NC: Duke UP, 2008.

Wiley, G. Harrison "The Dream Factory." *The Photodramatist* 3.4 (September 1921): 21–24.

Williams, Mari E.W. "Astronomical Observatories as Practical Space: The Case of Pulkowa." In James, ed., *The Development of the Laboratory*, 118–36.

Williams, Rosalind. *Notes on the Underground: An Essay on Technology, Society, and the Imagination*. Cambridge: MIT Press, 1990.

——. *Retooling: A Historian Confronts Technological Change*. Cambridge: MIT Press, 2002.

——. *The Triumph of Human Empire: Verne, Morris, and Stevenson at the End of the World*. Chicago: U of Chicago P, 2013.

Yumibe, Joshua. *Moving Color: Early Film, Mass Culture, Modernism*. New Brunswick, NJ: Rutgers UP, 2012.

Zhen, Zhang. *An Amorous History of the Silver Screen: Shanghai Cinema, 1896–1937*. Chicago: U of Chicago P, 2006.

Zielinski, Siefgried. *Audiovisions: Cinema and Television as Entr'Actes in History* (1989). Translated by Gloria Custance. Amsterdam: Amsterdam UP, 1999.

INDEX

FILM AND CULTURE A SERIES OF COLUMBIA UNIVERSITY PRESS
EDITED BY JOHN BELTON